NORTHERN LIGHT

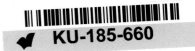

Vilhelm Hammershøi: **Dust Motes Dancing in the Sunlight** 1900 (Cat. No. 32)

KIRK VARNEDOE

NORTHERN LIGHT

NORDIC ART AT THE TURN OF THE CENTURY

Yale University Press · New Haven and London

1988

Published by

Yale University Press, New Haven and London 1988

Copyright © 1988 by J.M. Stenersens Forlag A.S, Oslo, Norway

English edition set in 12/13 Garamond Original by Heien Fotosats A.s, Spydeberg, Norway and printed and bound by Fabritius A.S., in Oslo, Norway

Library of Congress Catalog Card Number 87–50644

ISBN 0-300-04146-2

CONTENTS

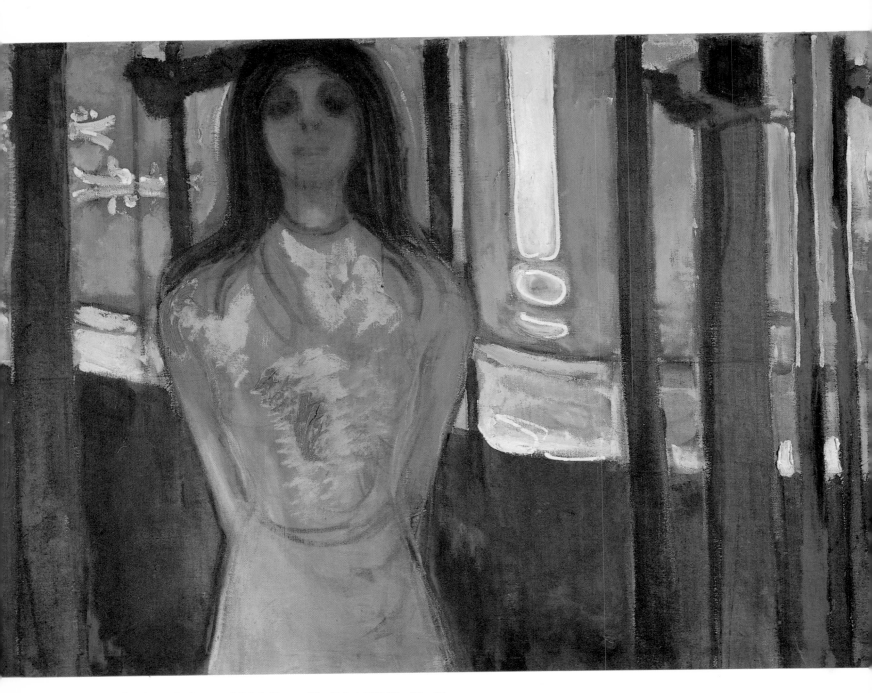

Edvard Munch: **Summer Night's Dream (The Voice)** 1893 (Cat. No. 73)

PREFACE

The origins of the present book lie in a publication prepared to accompany the exhibition *Northern Light: Realism and Symbolism in Scandinavian Painting, 1880–1910*. That exhibition was organized by the Brooklyn Museum, and shown at the Corcoran Art Gallery in Washington, D.C. (September 8 – October 17, 1982); The Brooklyn Museum (November 10, 1982 – January 6, 1983); The Minneapolis Institute of Arts (February 6 – April 10, 1983); and the Göteborgs Konstmuseum (Summer 1983).

The *Northern Light* exhibition (whose sponsorship will be detailed below) was not intended to be a complete survey of turn-of-the-century art in the Nordic nations. Instead, it tried to present a selection that would have the thematic and visual unity required of an exhibition, and that would illuminate one prominent line of development in the styles of early modern artists from these five lands. The selection of works for the exhibition was designed to introduce Scandinavian art to an American audience not previously familiar with it, in a fashion likely to be both appealing and informative.

In reshaping the exhibition catalogue as a book, for a broader audience and without the demands of an exhibition, I have attempted to include several painters and paintings that were not present in the original version, and thereby to correct some notable imbalances or injustices. I have also, however, attempted to keep the book focused on the original organizing premise, demonstrating the complex interchange between Realism and Symbolism in this period of Nordic art. Perhaps the most prominent exception to this has been the addition of post-1900 works by Munch, Jansson, and Willumsen which – in their replacement of Symbolist nocturne by vitalist sun-worship – announce a "next step" into the art of the twentieth century. Even with such additions, the book still presents only a selective introduction to its subject, and omits many painters – Magnus Enckell and Hugo Simberg of Finland, for example; or Frits Thaulow of Norway – and many works of art that others may feel are essential to the period's legacy.

The book owes its existence to the enthusiasm of Mr. Johan H. Stenersen of J.M. Stenersens Forlag, whose idea it was to produce this volume in all the languages neccessary to reach a Nordic audience. The research and writing that lie behind the book were encouraged and supported by many other people, some of whom I would like to acknowledge here. Mr. Brooke Lappin and Dr. Patricia McFate of the American Scandinavian Foundation

first brought me to the project of the *Northern Light* exhibition, and supported me throughout. Michael Botwinick, then Director of the Brooklyn Museum, committed the support of his institution at a crucial moment, and followed through in the finest fashion. My colleague Sarah Faunce, Curator of European Paintings at the Brooklyn Museum, worked with me on every phase of the exhibition project, and played an invaluable role in making the plans become reality.

In Scandinavia, my knowledge of the paintings and their history, and my work on the selection of them, owed much to the cooperation of many scholars. Knut Berg, Director of the Nasjonalgalleriet of Norway, with his curators Magne Malmanger and Tone Skedsmo, was especially supportive. Similarly Swedish museum officials – Per Björström, the Director of the Nationalmuseum in Stockholm, and his curators Pontus Grate and Görel Cavalli-Björkman; and Björn Fredlund of the Göteborgs Konstmuseum – gave invaluable advice and encouragement. I would also like to thank Ulf Linde of the Thiel Gallery in Stockholm, Alf Bøe of the Munch Museum in Oslo, Selma Jónsdóttir of the National Gallery of Iceland, and Salme Sarajas-Korte of the Fine Arts of Academy of Finland for their generous assistance. Carl Thomas Edam, Secretary General of "Scandinavia Today" for the Secretariat for Nordic Cultural Cooperation, was the invaluable organizer who kept our team together.

Several of these scholars contributed essays to the original *Northern Light* catalogue. Though these have not been included in the present volume, I have tried to include some of their thoughts, and to acknowledge my considerable debt to their work, in my essay here. Others among my Scandinavian colleagues, notably Magne Malmanger and Pontus Grate, have been generous in making suggestions for improving the present, expanded selection of paintings.

The original *Northern Light* exhibition and its catalogue were a part of the broader initiative of the "Scandinavia Today" year of celebration of Scandinavian culture. "Scandinavia Today" was organized with the cooperation of the Governments of Denmark, Finland, Iceland, Norway, and Sweden, through the Secretariat for Nordic Cultural Cooperation and with the aid of a grant from the Nordic Council of Ministers. The exhibition, as part of this program, was sponsored and administered by the American-Scandinavian Foundation, and made possible by support from Volvo, Atlantic Richfield Company, the (United States') National Endowment for the Humanities, and the National Endowment for the Arts. The exhibition was furthermore made possible by a major grant from the Robert Wood Johnson Jr. Charitable Trust, with additional support from Royal Caribbean Cruise Line A/S, Storebrand Insurance Company, Ltd., the Tidemann Group, Leif Hoegh & Co. A/S, Nordic American Banking Corporation, Stolt-Nielsen, Inc., and Wilh. Wilhelmsen. Without this enlightened patronage, the work that lies behind this book could not have been undertaken.

My final and most personal debt of thanks goes to the students at New York University's Institute of Fine Arts (identified individually in the "Catalogue Notes") who worked so long and hard to produce the texts on the individual painters and paintings. Among them extra-special gratitude and praise is owed to Patricia Berman; without her brains, organizational ability, and daunting capacity for copious, infallibly efficient work, neither the original catalogue nor the present book would ever have made it to the printer.

<div align="center">

Kirk Varnedoe

New York, February 1987

</div>

Akseli Gallen-Kallela: **Waterfall at Mäntykoski** (Cat. No. 25)

CATALOGUE NOTES

The paintings are organized alphabetically by artist, with the artist's biography appearing just before his or her initial painting. Dimensions are in centimeters (inches in parentheses); height precedes width. For the convenience of readers, we have also provided (p. 39) a classification of the painters by country; as well as (p. 40) a chronological ordering of the paintings.

The biographies of the artists, and the individual entries on the paintings, were compiled for the original catalogue in a complex fashion. Colleagues in the Nordic nations provided me and my students at New York University's Institute of Fine Arts with biographical and historical data, which the students then assimilated into texts which they wrote and I edited. For the present book, we have retained the full citation, by initials at the end of each text, of all those who contributed to the entries. As will be clear in the case of single authorship cited in several instances, many new entries and biographies have been prepared and written wholly by the persons cited, especially for this book.

Please note that the alphabetical order of the artists in this book follows the Scandinavian alphabet. The letter ä is placed at the end of the alphabet and should not be read as a version of the english letter a.

Catalogue Contributors
SCANDINAVIA

[GCB] Görel Cavalli-Björkman
[BF] Björn Fredlund
[PG] Pontus Grate
[SSK] Salme Sarajas-Korte
[MM] Magne Malmanger
[KM] Kasper Monrad
[BN] Bera Nordal
[TS] Tone Skedsmo
[OT] Oscar Thue

U.S.A.

[EB] Emily Braun
[PGB] Patricia Gray Berman
[AC] Alan Chong
[MF] Michelle Facos
[ADG] Alison De Lima Greene
[SRG] Shellie R. Goldberg
[RH] Rosemary Hoffmann
[WPM] Wendy Persson-Monk
[SMN] Sasha M. Newman

NORDIC ART AT THE TURN OF THE CENTURY: ELEMENTS OF A NEW HISTORY

The last decades of the nineteenth century, and the first years of the twentieth, were a "golden age" for Scandinavian art. This period held all the elements of a great moment in the cultural history of Northern Europe: a proliferation of artists of talent and ambition; aesthetic and political issues interwoven in watershed rebellions against the established order; and a particularly revealing dialogue between the traditionally more isolated Scandinavian cultures and the avant-garde developments of Europe's central cosmopolitan centers. With such a cast, setting, and dramatic content, this seems a great story, begging to be told; yet it is one that has not been widely appreciated, and indeed only partially known. With the exception of Edvard Munch, Scandinavian art has been largely excluded from the writing of the broader history of early modern art in Europe.

Certainly one reason for this deficit is that the key illustrations and inspirations for the story, the paintings themselves, have been only selectively accessible. Most of the best Scandinavian art of the early modern period has remained – for reasons we shall examine further on – in Scandinavia, and often within its country of origin. This has helped keep foreign scholars unaware and hence relatively uninterested. In turn, it may also have encouraged nationalistic, and thereby too narrowly focused or sectarian, viewpoints on the part of many compatriot writers. It is moreover true that until recently writing about the broader history of *fin-de-siècle* European art has been dominated by a narrow lineage of master artists, predominantly French; and by highly exclusive notions of quality and progress derived from a selective formal reading of their art. It is not only a new international awareness of the Scandinavian paintings themselves, but also a revision and broadening of the history of early modernism, that has in the past decade set the stage for fresh perspectives on the broader picture of Nordic art at the turn of the century.

The challenge in such new accounts would be to balance two things: on the one hand a revised notion of the continuities that bound the art of the Nordic nations together, and linked it to broader European currents; and on the other a respect for the special historical particularities of the Nordic contexts and artists, and the ways in which they defy the familiar patterns of other European developments. In particular, it should be clear at the outset

that developments in Scandinavian painting from 1880 to 1910 do not conform to the sequence of stylistic progress we know so well from the often-described evolution of French Impressionism and Post-Impressionism. Scandinavian painters of the time took a different path to modernity. Even if our eventual goal is to integrate them more fully into the broader European picture, we must begin, not with the ambition of fitting them to familiar historical molds, but with close attention to what was local and particular to the Scandinavian situation.

Specific factors of geography, history, and politics distinguished – and in some cases linked – the art of the Nordic nations at the close of the last century. Iceland, the smallest and most isolated of the five nations now in the Nordic alliance, remained outside the major artistic currents of the 1880s and 1890s. Although the island's saga literature, linguistic purity, and democratic traditions commanded international as well as Nordic admiration during this period, its first true painters were only just beginning to celebrate the exceptional local landscape (See Ásgrimur Jónsson, Cat. Nos. 51 and 52; and Thórarinn B. Thorláksson, Cat. Nos. 104, 105, and 106).[1] The other, more interconnected nations of Scandinavia might be seen as forming two rough pairs: Denmark and Sweden on the one hand, Norway and Finland on the other. Denmark, distinct from all its Nordic neighbors by the relatively placid nature of its countryside, was similar to Sweden in significant cultural aspects. Though no longer bound together under one rule as they had been from the eleventh to the sixteenth century, both nations had long histories of active cultural exchange with continental Europe, and well-developed heritages of arts and letters grounded in royal patronage and in European Enlightenment experience. Sweden had strong ties to France, and Swedish art had made an international mark via the early Romantic sculptor Johan Tobias Sergel (1740–1814). Denmark, in turn, was bound culturally as well as geographically to Germany; its grand era of Neoclassicism, prolonged by the sculpture of Bertel Thorvaldsen (1770–1844), had been supplemented by a Golden Age of Danish *Biedermeier* Naturalist painting in the 1830s and 1840s. Just as Denmark was similar to Sweden in traditions shared with the larger nations of Europe, so Norway resembled Finland in its relative detachment from those same European traditions. As the Romantic landscapes of Johan Christian Dahl (1788–1857) demonstrate, Norwegian painting had since early in the nineteenth century reflected the artists and academies of Germany. Even in the early 1800s, however, Norwegians had begun to nurture an independent pride in their separate national identity – based in the land's uniquely spectacular mountain-and-fjord topography, and in its rugged peasant life and Viking traditions. This nationalist temperament, strengthened by a continuing push for political independence (Norway became free from Swedish rule only in 1905), gave important impetus to Norwegian culture of the late nineteenth century. A similar anti-Swedish spirit, and striving for independence, prevailed in Finland in the same

14

period; and even though Finland and Norway are geographically far apart and shared no historical or political linkage, their forms of National Romanticism and cultural self-assertion showed notable parallels. Even though Sweden had not ruled Finland politically since 1809 (when the Swedes ceded Finland to Russia), the "Finnish Renaissance" of the 1890s was as much a reaction against the prolonged dominance of Swedish language and culture as it was a manifestation of protest over the expansionist pressures of the Russian Czar. As in Norway, this anti-Swedish feeling led to celebrations of the country's wilderness and its own heroic mythology and folk style.

Despite such varying local conditions of the Scandinavian nations, however, there is at least one common pattern in the development of their art during the last decades of the nineteenth century. This pattern, reflected in the particular mix of paintings selected for the present book, hinges on two periods of change. First, around 1880, the relative isolation of Scandinavian art was broken by an incursion of modern European Realism and Naturalism – an incursion that had already been evident in literature and theater. A new gamut of images appeared in painting, showing the working classes, scenes of modern life, and *plein-air* landscape. At the same time, young Scandinavian artists directed their attention beyond their traditional training centers in Northern Europe, chiefly toward France.[2] Then, around 1890, a second major change occurred, as Scandinavia's international orientation of the 1880s was replaced by a strong resurgence of nationalist, isolationist sentiment that brought Scandinavian painters back to their homelands. Turning to specifically native Nordic themes, these painters generally abandoned the French Realism that had marked their earlier work and adopted a variety of styles distinguished by the deepened subjectivity, unnatural color, and more obtrusive formal patterning associated with Symbolism. While the exact dates of these changes vary according to the artist or the country – Sweden's artists pioneering in the discovery of French Realism, Norway's painters returning home years before those of other nations – the basic phenomenon is clear, consistent, and omnipresent: roughly a decade of internationalism and Realism followed by a decade of nationalism and Symbolism.

These changes in artistic modes of expression were, furthermore, everywhere linked to pressures for political change, both within the artistic communities and in society at large. The young artists who embraced Realism in the later 1870s and early 1880s, for example, were almost universally committed as well to leftist, or specifically socialist, political positions. And the subsequent Symbolist emphasis on returning to the homeland coincided with the rise, throughout Europe, of intense nationalism as a political force, replacing the cosmopolitan notions of liberalism with a more emotional appeal to the power of "natural" collectivities; and relinquishing parliamentarian, republican ideals (which had constituted a part of France's allure, as a progressive Republic, in the late 1870s and early 1880s) in favor of a new drift toward mass-movement politics.

On more specific, local political levels, new allegiances in art called for new institutional structures; and thus, throughout the 1880s and 1890s, innovative Scandinavian artists everywhere rebelled against official methods of instruction, and against traditional systems for the display and purchase of new art – often forming in the process counter-groups to further their causes. The first indication of this pattern came in Copenhagen in 1879, when students at the Royal Academy of Fine Arts broke away – albeit with the sanction and funding of the government – to form a splinter program devoted to painting from live models, the Artists' Model School (subsequently called the Artists' Study School). Danish art life thereafter was shaped by the opposition between the Academy and this officially sponsored offspring – though here, as in Sweden, ample official support for art training tempered the younger artists' rift with their elders. The young Swedes' rebellion, though already fomenting when the Danes acted in the late 1870s, crystallized only in 1885, following the landmark Stockholm exhibition, *From the Banks of the Seine,* staged by young artists imbued with the aesthetics of Paris. The Swedish counter-group, the Artists' Union, started with a more overtly contentious, socialist character than its Danish counterpart; but its force was soon diminished by internal dissension, and by the post-1890 emergence of nationalist sentiment among artists previously more disdainful of Sweden itself.[3]

As Bo Lindwall has pointed out, Swedes and Danes initially vented their energies in a rejection of the provinciality of their native locales, and an eager embrace of lessons learned in Germany, France, and Italy; while the most aggressive activities and manifestoes of the young Norwegian and Finnish artists of the 1880s were by contrast already linked to assertions of national consciousness. Even as they brought home the aspects of Realism they had learned abroad, the painters of these latter two countries were insisting by the mid-1880s that immediate local situations (see Christian Krogh's *Albertine,* Cat. No. 59) or the special character of their lands and peoples (See Erik Werenskiold's *On the Plain,* Cat. No. 108; or Akseli Gallen-Kallela's *Old Woman and Cat,* Cat. No. 23) were the most valid subjects for their art. The political frustrations of the two nations, and their desire to break free of neighboring domination, translated into an artistic polemic less exclusively concerned with opening up to foreign innovations, and more dedicated to the revelation of local truths.

In establishing their own systems of exhibition, the Norwegian and Finnish painters, like their Danish and Swedish contemporaries, frequently confronted not only state art policy but also entrenched, semi-official organizations that controlled access to private patronage. The Christiania Art Association in Norway's capital, the Stockholm Art Association, and the Finnish Art Association were all dominated by conservative spirits who, through their regular exhibitions, attempted to control taste. As the French Impressionists had before them, the young Scandinavian artists of the 1870s

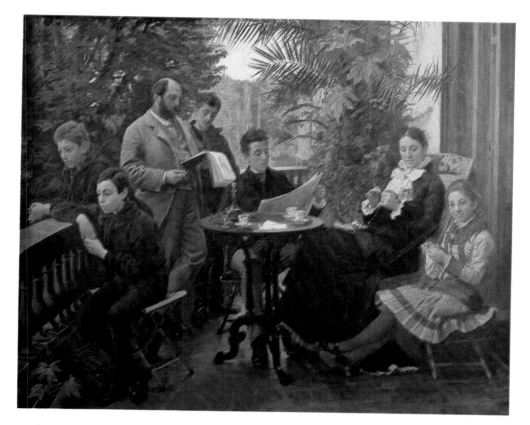

Fig. 1.
Peder Severin Krøyer
**Portrait of the
Hirschsprung Family**
1891
Det Hirschsprungske
Familiebillede
Oil on canvas, 108.0 x
128.0 cm (42½ x 50⅜
in.)
*Collection: Den
Hirschsprungske Sam-
ling, Copenhagen*

and 1880s sought to circumvent these censorial mediating groups, by appealing directly to the public in exhibitions juried by the artists themselves. These new appeals to a broader public – the Autumn Exhibitions in Christiania (now Oslo), the Free Exhibition in Copenhagen, et al. – also coincided with the democratic-socialist ideals of many of the artists, who felt that the new art could have a pioneering role in a spiritual and political reform of their societies.[4]

Ultimately, however, the rebel artists secured their place in history not so much because they converted state institutions to their point of view (though some innovators had become official national spokesmen by c. 1900 – Louis Sparre and Akseli Gallen-Kallela, who decorated the Finnish National Pavilion at the 1900 World's Fair, being notable examples); nor because they succeeded in basing their art on broad democratic appeal; but because they eventually found a small nexus of enlightened collectors whose patronage was marked by a special blend of personal sympathy for the artists and desire to enhance national cultural patrimony.[5] The names of some of these men still designate the museums that house the great collections of the period's art. Heinrich Hirschsprung (Fig. 1), whose collection in Copenhagen houses fine Danish work from the entire nineteenth century, worked with the guidance of the artist P.S. Krøyer. Rasmus Meyer followed and then went beyond the advice of the painter Erik Werenskiold in forming

17

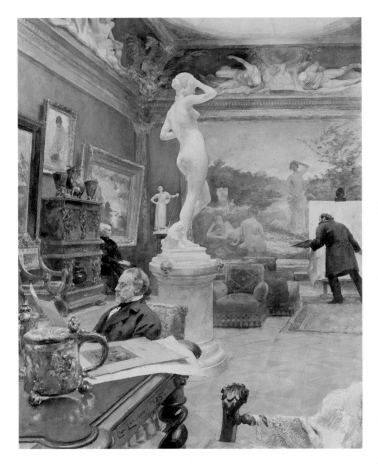

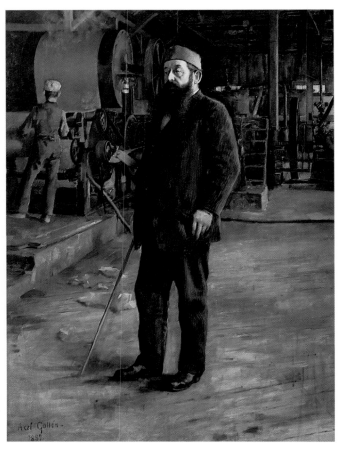

his large collection in Bergen. Some of the great collections, like those of Ernst Thiel in Stockholm and Wilhelm Hansen (the Ordrupgaard Collection) in Copenhagen, were amassed in the process of a broader pattern of international acquisition (Thiel and Hansen owned choice French paintings as well). However, prominent figures such as Prins Eugen of Stockholm and Pontus Fürstenberg of Göteborg (Fig. 2) devoted their energy as well as their money specifically to the tasks of supporting the new art of their own nation, and of preserving for the nation its masterpieces. (A similar patriotism impelled Bjørn Bjarnason, who founded the National Gallery of Iceland in 1884 even before he had the money to support it or a building in which to house the few initial paintings. His initiative however, rather than merely responding to Icelandic art, helped create it – by spurring the eventual development of an indigenous school of painting.[6]) As Tone Skedsmo has shown, other major patrons, such as H.F. Antell and G.A. Serlachius (Fig. 3) in Finland, were perhaps even more important for their financial support of progressive art, directly and through legacies, than they were for the pictures they commissioned or purchased.

The money all these men expended on art came from diverse sources in industry and finance, often through inheritance. Meyer and Serlachius ran

large lumber mills, Thiel was a financier and Hansen an insurance magnate, while Hirschsprung was heir to a tobacco fortune and Olaf Schou (Meyer's rival and the great benefactor of Oslo's Nasjonalgalleriet) was the son of a successful brewer. In general, it seems that second-generation money stemming from the expansion of industry in Scandinavia was essential fuel for the fire of artistic innovation at the turn of the century; and that the civic-minded nationalist sentiment prevalent among this particular band of patrons helped keep the masterpieces of the period grouped together in (eventually public) local collections. It is tempting to see in such patronage – especially in the turn-of-the-century veneration of Symbolist nationalism with its concentration on inner spirit rather than activist conflict – a familiar pattern of radicalism tamed, and specifically of entrepreneurial capital moving from a pioneering generation's material acquisition and expansion, to the inheriting sons' search for cultural consolidation.

Such historical currents offer the grist for a classic two-part narrative of rebuked struggle and hailed achievement, rebellion and then reconciliation, marking the displacement of outworn cultural leadership by new ideas and new money – a set of stories whose particular details and special local circumstances are best revealed in the individual biographies of artists, and in the histories of particular pictures, as set forth in the main portion of this book. What remains to be considered further in an introductory overview, however, are the deeper complexities of the other two-stage pattern suggested at the outset, and equally evident in the individual histories of the painters presented here – the pattern in which the careers of almost all these artists were marked by a dichotomy between Realist beginnings and Symbolist "conversions". Although this dichotomy appeared as a sharply demarcated crisis in numerous artists' careers (compare, for example, pre-1890 and post-1890 works by J.F. Willumsen, Cat. Nos. 113 and 114), in several key senses the two sides of the demarcation – the seemingly opposite domains of internationalist Realism and nationalist Symbolism – were in fact interdependent. The nationalist and Symbolist currents that would dominate Scandinavian art of the 1890s were already latent in, and in important respects nourished by, the Scandinavian artists' experiences in France in the 1880s.

It was no accident, but a desired effect of the French government's art policies, that Paris became a mecca for foreign artists like the young Scandinavians. The liberal, business-minded opportunists who controlled the Third Republic's affairs in the late 1870s and 1880s saw French culture – particularly the Realism which they felt embodied their ideals of secular materialism and positivist science – as a kind of propaganda for the dispersion of their progress-oriented values. The diversity of exhibitions and the activity of the private art market made Paris an open laboratory that enticed artists from all over the world to come and study in an atmosphere of modern permissive liberalism unheard of in their native lands (Fig. 4).

19

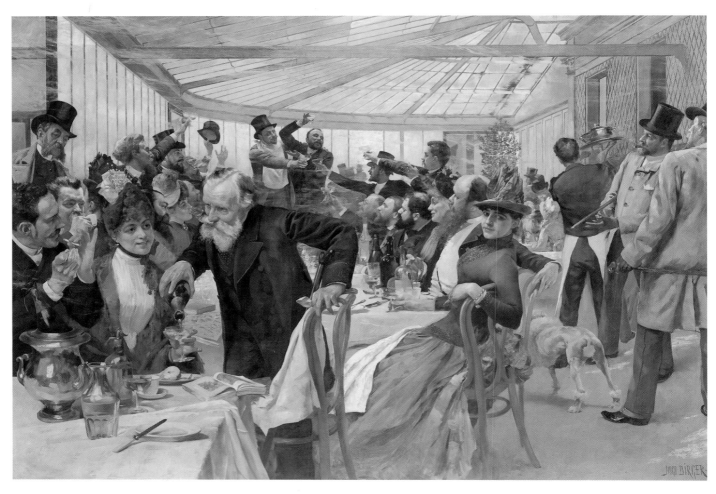

For the Scandinavians however, this cosmopolitan experience had a paradoxical effect: it fueled a new appreciation of the virtues of the Northern homelands, and prepared the way for a return to insular nationalism. The pluralism of Paris – especially the blend of independent artistic movements and exhibitions – gave the young Scandinavian artists a model for the reform of their native academies. At the same time, the formation of expatriate artists' communities in Paris and its environs resulted in an increased sense of separate Nordic cultural identity – a new awareness of a shared Nordic spirit that had been less evident within Scandinavia itself, because of the fragmenting effect of frontiers and competitive internecine politics. The expatriate artists' groups were key breeding grounds for the return-to-the-folk attitudes that became the hallmark of growing Nordic National Romantic movements. Already, in the oscillation between Paris and the North that characterized the travels of some Scandinavian artists of the 1880s, we can see the interaction of seeming opposites: metropolis and wilderness, progressive internationalism and resolute parochialism – each alternating with and depending upon the other.

Even the Scandinavian artists most involved in the Parisian art world kept their home ties, in part because the French critics and the market they sought to please valued not only a foreign artist's technical competence but also the sincere demonstration of the artist's national origins.[7] More fundamentally, though, the very premise of Realism – the call for an art that dealt not in studio-fabricated ideals but in the precise particulars of individual experience – demanded truth to local character as a mark of authenticity. In their embrace of progressive Realism, young Scandinavian painters were encouraged both to study the techniques of the Parisians *and* to isolate and depict the special conditions of light, topography, and physiognomy that characterized their Northern homelands. In such ways Realism encouraged a new concentration on the distinct and separate qualities of Scandinavia, strengthening the sense of Nordic consciousness that was developing within Scandinavia itself in artists' enclaves like the one at Skagen.

The fishing village of Skagen, on the very northern tip of Jutland in Denmark, would seem to be the antithesis of Paris; while the artists' community that formed there around 1880 (Fig. 5), to paint the pre-industrial folk life of fishermen and their families, might appear to be only a provincial anachronism. Yet several artists participated jointly in the Paris and Skagen communities; and just as the Paris experience paradoxically fostered a new sense of the special qualities of the Nordic lands, so the isolated little group at Skagen was in fact significantly connected to major artistic developments more international in nature. The admiration for isolated folk life that drew painters to Skagen (see for example works by Christian Krohg, Cat. No. 54; Anna Ancher, Cat. No. 2; and P.S. Krøyer, Cat. Nos. 61 and 62) belonged to a current that was widespread in the European art of the 1880s, and that was to figure prominently in Nordic art of the 1890s: the desire to give modern art a grounding in deeper, more primal conditions of human experience and tradition, by the artist's contact with rural or "primitive" societies, untainted by the complexities and corruptions of an increasingly urbanized and industrialized modern way of life.

Such nostalgia for less modernized ways of life, appearing as an ethnographic-documentary aspect of Realism in the early 1880s, also held a reactionary spirit potentially hostile to Realism's positivist premises. In the latter part of the decade, dissatisfaction with Realism's concentration on appearances dovetailed with a broad-based rejection of the crass materialism of modern urban society. At the same time, a new reverence for spiritual truths beyond the visible surface of things linked up with a full-blown folk primitivism, venerating the superior moral and psychic force of a life lived in pre-rational, pre-capitalist contact with nature and tradition. Although this primitivism was a powerful aspect of Symbolist art and thought throughout Europe (it can be seen in Van Gogh's love of Arles, and in Gauguin's restless desire to escape "civilization"), it was especially important for Scandinavian art. In contrast to France, where primitivism ran against the grain of the na-

21

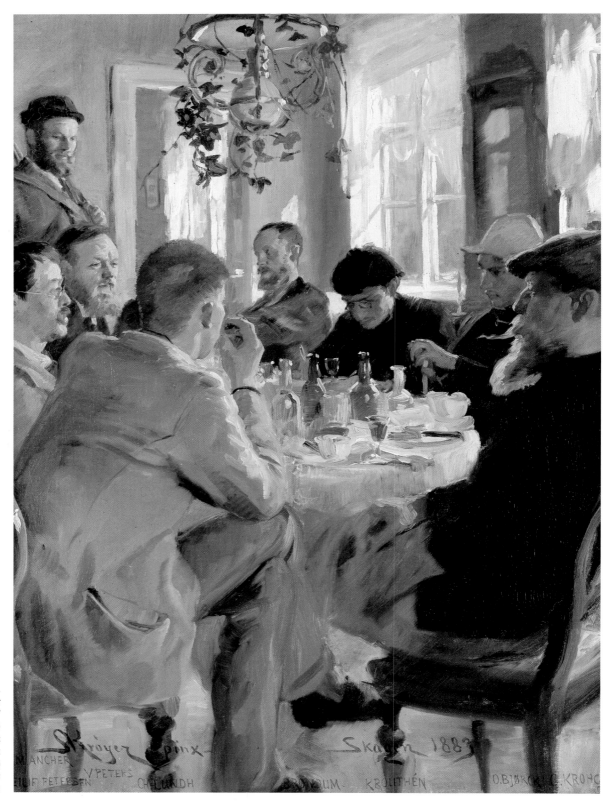

Fig. 5.
Peder Severin Krøyer
The Artists'
Luncheon 1883
Kunstnerfrokost
Oil on canvas, 82.0 x
61.0 (32¼ x 24)
Collection: Skagens
Museum

tion's grand dynastic history as well as its century-old commitment to modernization, in the Scandinavian nations the newly potent veneration of folk spirit and folk culture dovetailed precisely with the tenor of increasingly assertive Nordic nationalism. In Scandinavia, Symbolism's general concentration on the mysticism of nature and the inner life of "natural" man received a special impetus by linkage to a collective mythologizing of Nordic national identities. The separateness of the Nordic countries, formerly seen as a contingent fact of geography and history, and as a deficit, now increasingly came to be regarded by locals and foreigners alike as an intrinsic part of a spiritual destiny, and as a virtue.

By lagging behind in industrialization and urbanization for much of the nineteenth century, Scandinavia found itself in the position to be a leader in the *fin-de-siècle* rejection of material progress and city values. In the 1870s and early 1880s, coming late to the full effects of expansionist industrialization, the Northerners could be condescended to as provincial parvenus by the French; and could themselves feel a sense of inferiority, not only in local culture but also in local nature – in the seeming inadaptability of the distinctive Nordic landscape to traditional French or Italianate ideals of beauty. But as major economic reversals and the increasing polarization of social politics throughout Europe contributed to a deepening pessimism over modernization, and loss of faith in its rewards, Northern lands and thought came to hold a special prestige; and less "spoiled" Scandinavia gained a more positive sense of its separateness. What we see in much of the European art of the late 1880s and the 1890s is an inversion of values: modernity becomes passé, the timeless becomes the progressive, a deeply local art comes to be seen as the privileged way to universality, and the marginal members of contemporary civilization – holding out against the consuming spread of progress – become one of that civilization's central concerns.[8]

It could well be argued that, whatever force these myths of Nordic land and soul had on contemporary imaginations, the realities within Scandinavia were of a very different order; that industrialization continued apace, and that the natural landscape there continued to be developed and exploited – lumber mills being a key and particularly destructive example. However, in the officially projected self-image, and certainly in the eyes of city-dwellers elsewhere, the "untainted" air of the North came in the 1890s to be touted as a panacea for the woes of progress, and the rugged Nordic landscape to be seen as the locus of a tougher spiritual purity that could renew or replace the fatigued values of an over-refined, decadent Europe.

In this intellectual/political climate, all the Scandinavian nations – even those with little that would pass for "primitive" in their landscape or cultural heritages – intensified their nationalist spirit and gave new attention to indigenous traditions. Danish painters, for example, fused Symbolist tendencies with a revival of the simpler, lucid style of their Golden Age Naturalism (see works by Vilhelm Hammershøi, Cat. No. 37 and 38; and Ludvig Find, Cat.

No. 18). This *Biedermeier* revival entailed the nostalgic recovery, in a period of increasingly threatening socialist politics, of an early, more "heroic", moment in the assertion of a progressive, explicitly middle-class taste. Yet the revival's stylistic paradoxes were uniquely *fin-de-siècle* in character, linking an almost febrile, subtly nuanced aestheticism to a spare, proto-modernist classicism. (See for example Cat. No. 37. A similar blend can in turn be found in turn-of-the-century *Biedermeier* revivals in countries like Austria; and a rustic variant can be seen in the cheerily uncluttered domestic interiors of Sweden's Carl Larsson, for example Cat. No. 65).

Even more obviously and polemically, though, the Romantic revival of the Norwegian and Finnish artists insisted on a return to the deeper past. Taking the image of their nations as less "civilized" in the cosmopolitan sense, and turning it now to advantage, they asserted their distance from the traditions of Europe. They celebrated instead the unconventional and untamed ruggedness of specifically Nordic landscape, and revived national roots in Nordic myths and sagas such as Finland's epic tale of origins, the *Kalevala*. The stylistic inspiration for their work, moreover, came at least in part from a new attention to the decorative patterning of folk styles. (See for example Gerhard Munthe, Cat. No. 81; and Akseli Gallen-Kallela, Cat. Nos. 25 and 27).[9]

Especially in these latter two nations, as well as later in Sweden, the most pervasive and powerful themes in Scandinavian painting at the turn of the century were those that fused two strains of anti-rationalism: the general Symbolist current of inward-turning subjectivity, and the local motifs of nation-affirming Nordic identity. Rural folk, for example, were perceived and depicted not only as psychically privileged in their direct contact with nature, but also as surviving exemplars of a primordial national soul. Similarly, "Nordic-ness" became a characteristic goal of Scandinavian landscape painting, moving beyond Naturalistic topographical description to evoke the eerie blue mood of forest and water nocturnes, or emblematically monumentalizing rugged sites to speak of history rooted in the land. (See for example Karl Nordström's *Varberg Fort*, Cat. No. 84; or Albert Edelfelt's *Särkkä*, Cat. No. 87.)

Foremost among these themes of Scandinavian Symbolism was the Nordic summer night, with its traditional overtones of the erotic, the atavistic, and the cosmic. (See examples in the work of Edvard Munch, Cat. No. 74 and 79; Eilif Peterssen, Cat. No. 86; Richard Bergh, Cat. No. 7; P.S. Krøyer, Cat. No. 63.) By evoking the fatal power of nature to crumble the artifices of civilization, the midsummer night proved attractive both to those who were trying to link inner psychological forces with nature's scheme, and to those who sought to ground nationalism in the cycle of the seasons and its accompanying folk rituals. This magic and achingly ephemeral night of sensuality, when the pulse of the seasons seemed to magnetize the body, thus became a familiar motif, fusing changing ideas of the self and state, and

reflecting the singularly charged complexity of this period in Scandinavian self-consciousness.[10]

This fusion of inward-turning psychology and a newly spiritualized sense of racial/ethnic political collectivity is not, however, only an aspect of this one theme, or simply a phenomenon peculiar to Northern Symbolism. One need only think of the contradictions inherent in the Arts-and-Crafts or Art Nouveau movements in England, France, and Belgium – with their uneasy double ideals of concern for the private mysteries of man's inner life and for the supra-individual unities of a newly integrated social community – to identify one larger European context for Nordic developments of the 1890s. In fact, paradoxical as it may at first seem, it is in the newly awakened sense of isolation and atavism, in the self-conscious exploitation of specifically local themes such as the Nordic summer night, that Scandinavian painting enters most prominently and creatively into major currents of early modern European art.

Many of these currents and patterns in early modernism have been only imperfectly mapped out, and many important channels of connection – such as the Arts-and-Crafts ideals that bound artists in Finland to those in Russia, Belgium, England, and elsewhere – have until recently been relegated to the margins of historians' concerns.[11] Standard overviews of late nineteenth-century art have often been determined by a retrospective idea of a "great chain of progress" centering on the French *avant-garde* from the Impressionists through Cézanne toward Cubism. This view of history has excluded Scandinavian developments not just because of its geographical focus, but perhaps even more because of its vision of progress as a linear narrative – a vision which tends to chart modern art's origins in terms of a baton-race of stylistic innovation, with each artist in turn handing on the lead to an inheritor. Such a view is little interested in the issues of meaning and motivation which link Northern painting to the broader European picture. It is also ill-designed to help us understand the peculiar combinations of the regressive and the progressive, of the passé and the premonitory, that mark Scandinavian art stylistically as well. The particular character of passage we previously described, from Realism into Symbolism, is for example a key instance in which narrowly linear historical patterns do not seem to apply to Scandinavian art, or to help our understanding of it. Some revised, more flexible model of the interaction of these styles, and of progress in general, seems to be called for.

In the canonical view, Realism would be an essentially dead issue, or at least a sterile territory for true innovation, after the 1860s; and Symbolism would be seen as a wholly separate, anti-naturalist domain, stemming out of and yet rejecting Impressionism, in the 1880s and 1890s. Moreover, their two world views would be completely incommensurable: Realism tied to an empiricist, science-oriented materialism; and Symbolism, valuing the irrational and spiritual, wedded to the world of the imagination rather than that

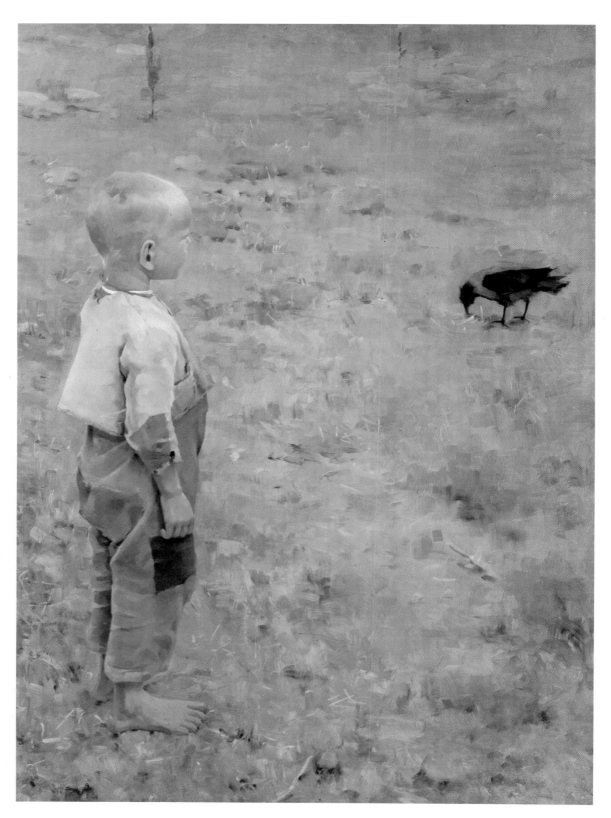

Fig. 7.
Akseli Gallen-Kallela
Boy with a Crow
1884
Poika ja Varis
Oil on canvas, 86.5 x
72.5 cm.
(34 x 28½ in.)
*Collection: Ateneu-
min Taidemuseo,
Helsinki*

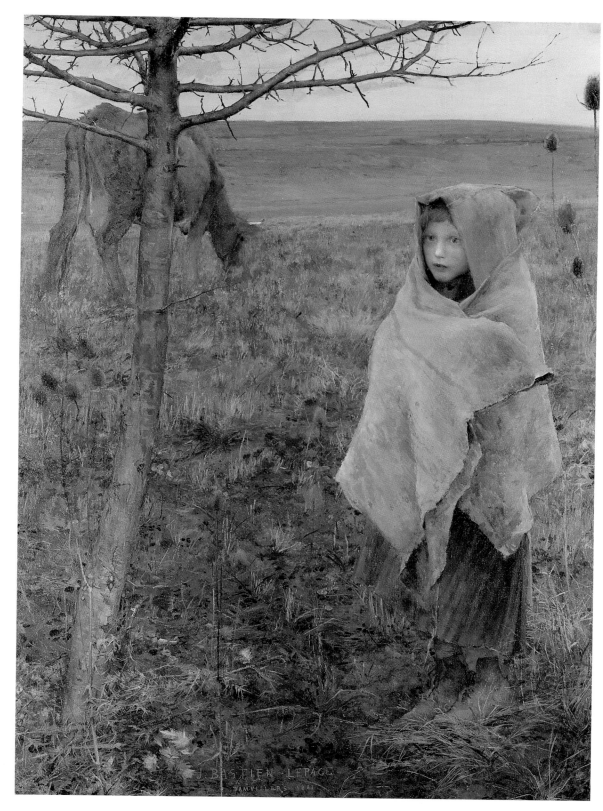

Fig. 6.
Jules Bastien-Lepage
Pauvre Fauvette 1881
Oil on canvas, 162.5 x
125.7 cm.
(64 x 49½ in.)
*Collection: Glasgow
Art Gallery
and Museum*

27

of the eye. Yet many of the paintings included in this book do not seem to fit into such a linear notion of stylistic development, nor to respect these firm divisions. These paintings (see for example Gallen-Kallela's *Waterfall at Mäntykoski*, Cat. No. 25; or Prins Eugen's *The Forest*, Cat. No. 15; or Hammershøi's *Five Portraits*, Cat. No. 33) seem outmoded for the period in some respects, and ahead of their time in others. And they appear as hybrids: both Realist and Symbolist, both descriptive and abstract, both objective and expressive. How can we explain such anomalies?

In dealing with French art and literature, we are, as suggested above, accustomed to thinking of Realism as a force that was innovative primarily in the 1850s and '60s, in the work of Gustave Courbet, Gustave Flaubert, and the early Émile Zola. Less attention has been paid to the Realism of the 1870s and '80s, especially in painting, where Impressionist and Post-Impressionist developments are usually held to have subsumed and surpassed all that was important in Realism. But for foreigners with different backgrounds and expectations – especially for outsiders like the Scandinavians, to whose countries modernization came relatively late, and within a more tradition-bound social structure – later European Realism had an intense catalytic effect, and strongly marked their response to Symbolist currents.[12] From the art of seemingly derivative and stylistically cautious second-wave French Realist painters, like Jules Bastien-Lepage, the Scandinavians isolated and appropriated more progressive and radical lessons than one might expect. By their "creative misinterpretations", they extrapolated from later Realism provocative artistic strategies – such as tilted or funneled perspective structures, ambiguous narrative devices, or obsessive accumulation of detail – which they felt announced new possibilities. Paradoxically, these possibilities often pointed directly away from the self-proclaimed objectivity of Realism, toward deepened subjectivity of mood and self-declared artificiality of formal organization.

The Finn Akseli Gallen-Kallela and the Swede Bruno Liljefors, for example, looked at the combination of sharply focused figures and blurred, raking backgrounds characteristic of French Salon Realism in the early 1880s (see Bastien-Lepage's *Pauvre Fauvette*, Fig. 6), and immediately derived a more insistently spaceless, nearly abstract effect that contrasted with the true-to-nature "photographic" accuracy intended by the French painters, while foreshadowing the decorative flatness of their own anti-Naturalist work of the 1890s (see Gallen-Kallela's *Boy With a Crow*, Fig. 7, also Cat. No. 21; and Liljefors' *Dovehawk and Black Grouse*, Fig. 10, also Cat. No. 66). At the same time, the young Scandinavian painters seem to have ignored the more brilliant palette of full-fledged Impressionism to find, in the comparatively timid grayness of that same Salon Realism, something closer to the tonalism and monochromatic harmonies of Symbolist taste.

In yet another such paradox, the personal, lens-truthful variant of German Realism developed by the Norwegian Christian Krohg in the early

1880s had a drastic literalness even more "progressive" in the boldness of its spatial arrangements than his adaptation of Impressionist compositional devices (for example, in Cat. No. 56) during the same period. The airless deadpan style of *The Sick Girl* (Cat. No. 55), for instance, has some of the formal and psychological condensation normally associated with the charged iconic human confrontations found in Edvard Munch's work of the next decade. Likewise Munch, a pupil of Krohg, is himself a prime example of how Scandinavian Symbolism had its roots in "misinterpretations" of later Realism. In his masterpieces of the 1890s, such as *Evening on Karl Johan Street* (see sketch and painting, Figs. 8 and 9), we see, transformed and intensified by the color and line of Gauguin, structures of perspective and narrative organization that are ultimately derived from Realist pictorial strategies visible in Gustave Caillebotte's city views of the late 1870s and Krohg's social polemic paintings of the mid-1880s (such as *Struggle for Existence,* Fig. 11).[13]

Similar phenomena occurred in Scandinavian drama and literature of the period – in Ibsen's particularly tense and moralizing Naturalism, which came to appear timely and congenial to Parisian Symbolists in the 1890s; and in the special reading given to Zola's Naturalistic novels by the Danish critic Georg Brandes, who emphasized the expressive and symbolic aspects of their relentlessly detailed descriptive passages.[14] On another level, the call for scientific detachment posed by Zola's *Roman expérimental* had unexpectedly extreme consequences in the fevered and ultimately destructive *vie expérimentale* of promiscuity and self-willed moral neutrality that the bohemian writers and artists of the Norwegian capital of Christiania lived out in Zola's name in the 1880s.[15] In all these instances, the impact of Realism was not merely delayed in time compared to France, but more immediately associated with the revolt against positivism, with Symbolism and modern subjectivity.

This distinctive phenomenon of interrelation and overlap between the ostensibly opposite tendencies of Realism and Symbolism appeared in matters of content as well as aspects of tone and style in an extraordinarily diverse range of Scandinavian art. The Swedish animal painter Liljefors might seem, for instance, to be only a marginal and eccentric presence in the art of the late nineteenth century. Yet his development embodies clearly the dominant issues of style and meaning we have been discussing, and in telling ways his case can be studied as paradigmatic. From the 1880s to the 1890s, remaining all the while within the framework of his stated desire to show the natural order of the world beyond human control, Liljefors' imagery of birds moved from sharply focused Realist narrative (see *Dovehawk and Black Grouse,* Fig. 10, also Cat. No. 66) to brooding Symbolist nocturne (see *Horned Owl Deep in the Forest,* Fig. 12, also Cat. No. 67). In this shift from a focus on the predatory cycle to an emphasis on the moody harmony of creature and nature, furthermore, it is easy to see analogies to changing notions of society and individuality. Just as Liljefors' dramatization of the

29

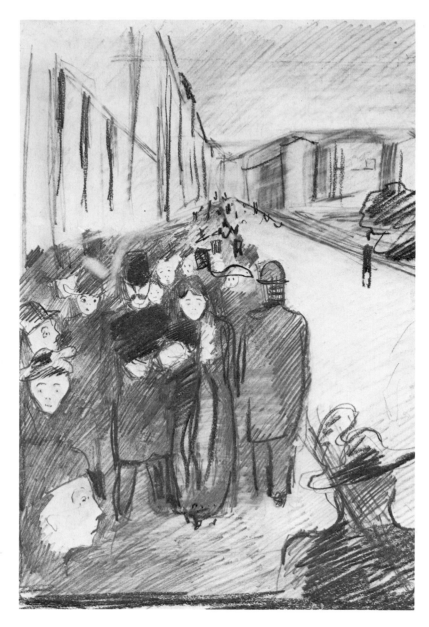

Fig. 8.
Edvard Munch
Evening on Karl Johan Street *circa* 1892
Aften på Karl Johan
Pencil and charcoal on paper
33.0 x 25.1 cm. (13 x 9⅞ in.)
Collection: Munch-Museet, Oslo

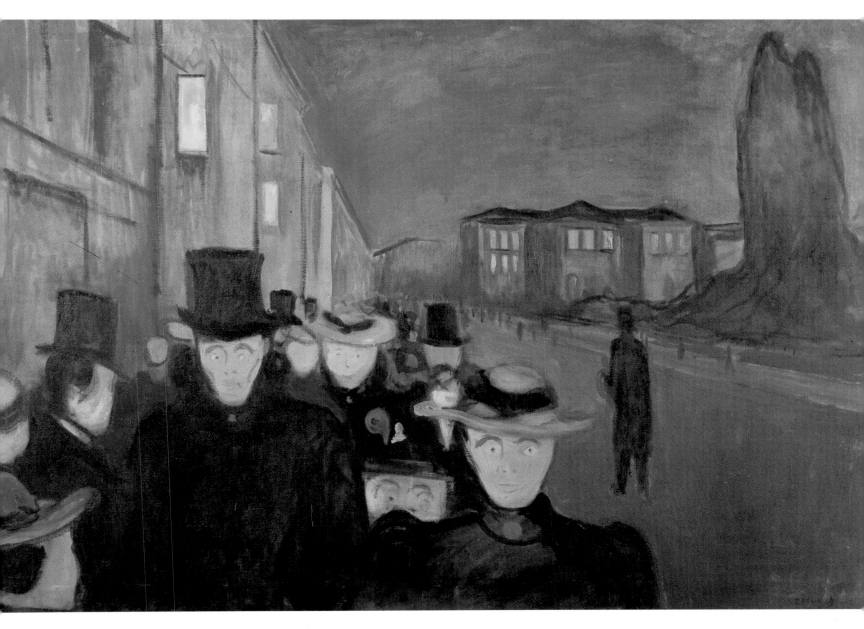

Fig. 9.
Edvard Munch
Evening on Karl Johan Street 1893
Aften på Karl Johan
Oil on canvas, 114.9 x 121.0 cm (33¼ x 47⅝ in.)
Collection: Rasmus Meyers Samlinger, Bergen
Munch's preparatory drawing for
the Symbolist masterpiece shows
that the original compositional
idea was remarkably similar
to – and may have derived
from – Christian Krohg's Realist
street scene, *Struggle for Existence* (p. 32)

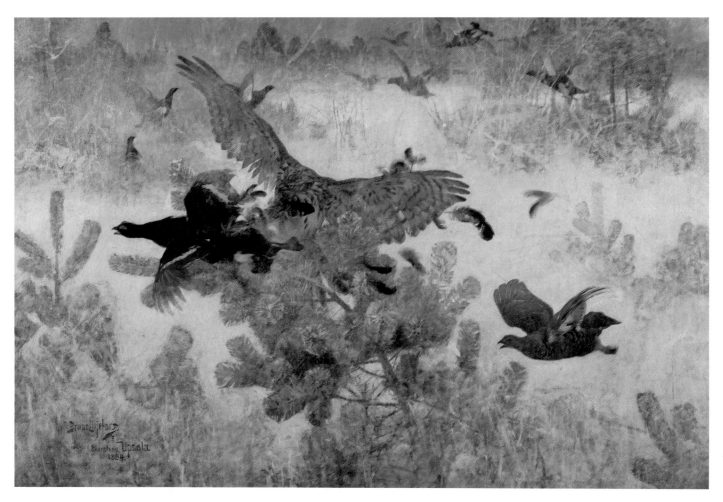

Fig. 10.
Bruno Liljefors
Dovehawk and Black Grouse 1884
Duvhök och orrar
Oil on canvas, 143.0 x 203.0 cm. (56¼ x 79⅞ in.)
Collection: Nationalmuseum, Stockholm

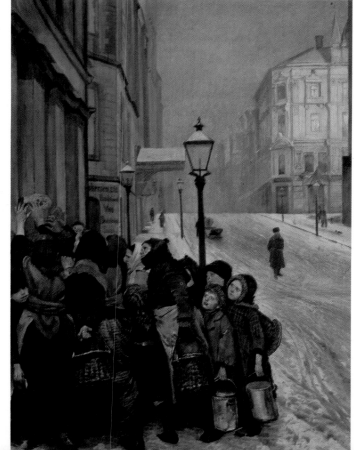

Fig. 11.
Christian Krohg
Struggle for Existence 1889
Kampen for tilvaerelsen
Oil on canvas, 300.0 x 225.0 cm. (118⅛ x 88⅝ in.)
Collection: Nasjonalgalleriet, Oslo
Krohg shows the poor of Christiania (Oslo)
fighting for stale bread handed out as charity
each winter morning by a bakery.

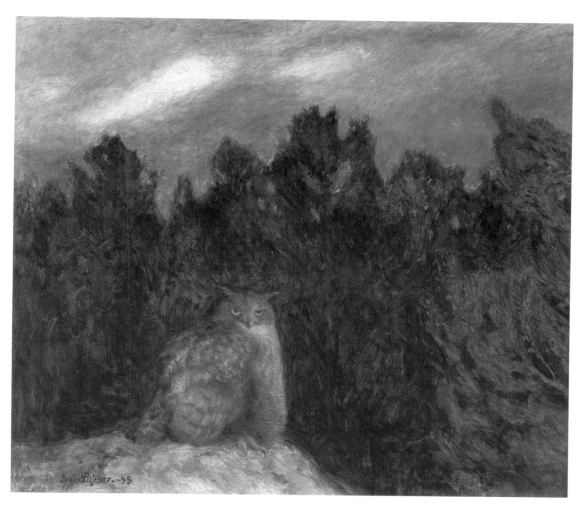

Fig. 12.
Bruno Liljefors
**Horned Owl Deep in the
Forest** 1895
Uven djupt inne i skogen
Oil on canvas, 166.0 x
191.0 cm. (65⅜ x 75¼ in.)
*Collection: Göteborgs
Konstmuseum*

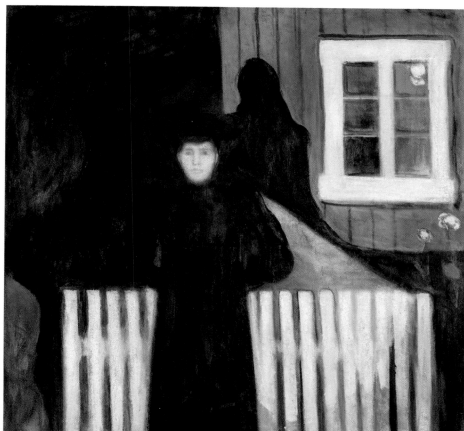

Fig. 13.
Edvard Munch
Moonlight 1893
Måneskinn
Oil on canvas, 140.5 x 135.0 cm. (55¼ x 53⅛ in.)
Collection: Nasjonalgalleriet, Oslo

Darwinian battle for survival in the wild echoes Krohg's critique of Social Darwinism (see *Struggle for Existence,* Fig. 11), so does his later nocturne recall the "psychic Naturalism" of Munch (see *Moonlight,* Fig. 13, also Cat. No. 72).[16] Liljefors' paintings of the late 1890s then go on to integrate the animal into nature even more forcefully. Following his theory that the animal is a kind of self-portrait made by nature, the landscape settings are no longer based solely on scrupulous observation, but on a synthetic extrapolation of the colors and designs of the animals themselves. While these later images (see *Young Seagull,* Fig. 14) are still tied to initial Naturalist goals, they have become strongly abstracted, decoratively colored constructs of an ideal of universal harmony (see also *Evening, Wild Ducks,* Cat. No. 68).[17] They are unexpectedly – though in fact not at all coincidentally – quite close to the work of the German Expressionist painter Franz Marc (see *The White Hound,* Fig. 15), whose vividly colored work of 1910–1914 embodied a desire to paint the world in terms of the unity experienced by an animal consciousness free from the corruptions of human thought.[18]

The change from Liljefors to Marc, from the world of Darwin to that of psychic spiritualism, is expressed in an artistic progression from detailed descriptive Realism through Symbolism to the edge of abstraction – a progression remarkably seamless in its underlying continuity. Strands of the "backward" and the "avant-garde", of rational scientific observation and imaginative psychological projection, seem thus woven together in a fashion that makes of Liljefors' career a suggestive distillation of major currents in the Nordic art of his time. The development of modernism out of Symbolism, and Symbolism out of Realism, seems in this case linked to an evolving idea of natural science; and parallel developments in the human imagery of other Scandinavian painters seem to reflect similar connections to changing sociological and psychological theory in the same period. These examples encourage the idea that late nineteenth-century developments in the natural and human sciences might provide not only the intellectual substructure for much of Northern Realism and Symbolism, but also a model pattern of interchange between these two domains of artistic investigation.

Although the pattern in question typically begins with the urge to analyse and the keenly attentive description of variable specificities in the visible world (weather, motion, facial expression, social types, and so on), this urge leads inexorably toward an eventual supplanting of the analytic by the synthetic, to the positing of new notions of unity and collectivity beyond the perceivable world of fragmented data – and thus to the conviction that "truth to nature" is achieved not through observation and description, but through the intuition or intellectual fabrication of ideal forms and abstract schemata. This type of shift took place in the sciences at the end of the nineteenth century, as faith in induction and empirical experiment yielded to a deepening conviction that the world was more profoundly to be understood in terms of underlying rules to be intuited or deduced. A very similar line of

movement seems to govern the ways in which, in Scandinavian painting, the rural becomes the *volkisch*, present politics are displaced by mythic saga, and the topography of Scandinavia comes to be revered as Nordic Nature.

In tracking the history of science, we are accustomed to recognize the interplay and interdependency of the inductive and the deductive, and to think in more complex terms about the ways in which, in history, one model of thought and inquiry is supplanted by another that grows from it.[19] In terms of painting in the later nineteenth century, we need to direct this kind of attention to our models of progress – to recognize, for example, the complex potential of the theoretical programs and structures of expression that underlay the self-styled objectivity of later Realism; and similarly to emphasize the ongoing Naturalist foundations of Symbolist ideals. A better, more supple model of interaction, disavowing simplistic "either-or" oppositions, would allow us to understand the continuities that we recurrently observe, throughout the pictures in this book, in later Realism's prefigurations of Symbolism, and in Symbolism's adaptation of the content and style of later Realism. This is a problem with broad implications for the history of early modernism, but it seems to be particularly at issue in Scandinavian art, where so many artists and works show the possibility of progress toward modern art by independent and directly spliced linkages between supposedly disparate – Realist and Symbolist, retarded and advanced – modes of painting.

Why, then, if Scandinavian painting can so effectively challenge our received ideas, and can add key elements to a new and revised understanding of the shaping currents of European art in the early modern period, has it been slighted or ignored by foreign writers – who have often been willing to spend attention generously on less original and less challenging offshoots of the French tradition? Language barriers, and the special patterns of collecting mentioned earlier, may have helped to keep consideration of this art a local affair. Furthermore, a general bias in favor of France and against Germany – which by extension has meant against much of Northern art in general – has dominated much of post-World War II writing on modern art. But the neglect may also have something to do with the desire to see a connection between modernization and the idea of modern art's progress, and with tendencies to equate the avant-garde in art with assertive individualism and liberal (or more radically anti-traditional) societal values. In many of the paintings gathered in this book, the energy that fueled innovation and creativity was that of a reaction away from modern civilization toward a greater inwardness, a purer moment in history, or the authority of blood, the soil, and the seasons. Longstanding ignorance of Nordic painting of this period may have more than a little to do with a failure – perhaps a reluctance – to inquire more searchingly about the role such impulses have played in the development of modern art and thought. In this respect, as in so many others, if we can reconsider Scandinavian art in terms that escape the frag-

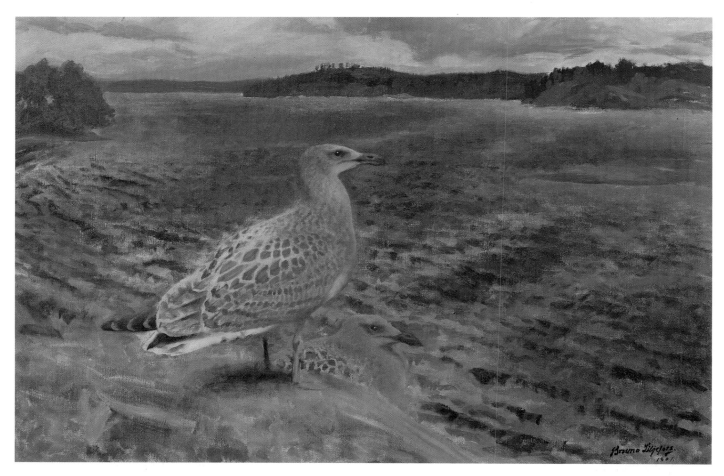

Fig. 14.
Bruno Liljefors
Young Seagull
1901
Unga havstrutar
Oil on canvas,
87.0 x 130.0 cm.
(34¼ x 51⅛ in.)
*Collection: Thiel-
ska Galleriet,
Stockholm*

mentation of localities, and move it from the margins into the mainstream of
our histories of art at the turn of the century, we will not only be rewarded
by the rich story Nordic art represents in itself, but also challenged to ex-
pand and reform our broader understanding of the complexities of the mod-
ern tradition.[20]

Fig. 15.
Franz Marc
**The White
Hound (Hound
Overlooking the
World)** 1912
*Der Hund vor der
Welt*
Oil on canvas,
111.0 x 83.0 cm.
(43¾ x 32¾ in.)
*Private Collection,
Switzerland*

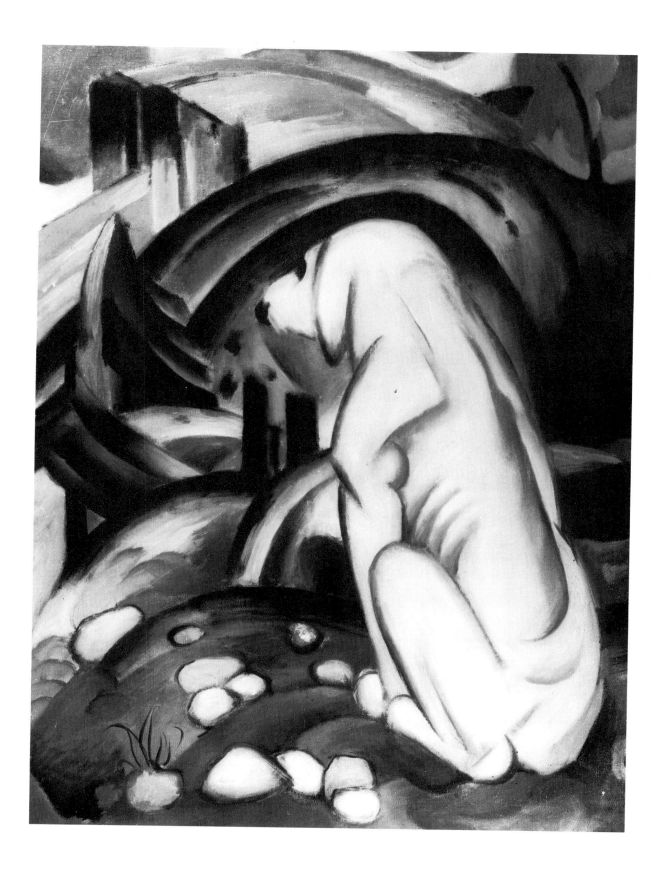

CATALOGUE

The catalogue is arranged alphabetically by artist; the works by each artist are in chronological order. Dimensions are in centimeters (inches in parentheses); height precedes width. Unless otherwise indicated, the medium is oil on canvas.

The addition of an* following an artist's name indicates that biographical information on the artist is included in this catalogue.

The following is a list of the artists by nationality (for a chronological list of the paintings, see pages 39–41).

Denmark	Anna ANCHER
	Niels BJERRE
	Ludvig FIND
	Vilhelm HAMMERSHØI
	Peder Severin KRØYER
	Ejnar NIELSEN
	Laurits Andersen RING
	Harald SLOTT-MØLLER
	Jens Ferdinand WILLUMSEN

Finland	Albert EDELFELT
	Akseli GALLEN-KALLELA
	Pekka HALONEN
	Eero JÄRNEFELT
	Helene SCHJERFBECK
	Louis SPARRE
	Ellen THESLEFF

| Iceland | Ásgrímur JÓNSSON |
| | Thórarinn B. THORLÁKSSON |

Norway	Harriet BACKER
	Halfdan EGEDIUS
	August EIEBAKKE
	Karl Gustav JENSEN-HJELL
	Kitty KIELLAND
	Christian KROGH
	Edvard MUNCH
	Gerhard MUNTHE
	Eilif PETERSSEN
	Christian SKREDSVIG
	Harald SOHLBERG
	Niels Gustav WENTZEL
	Erik Theodor WERENSKIOLD

Sweden	Björn AHLGRENSSON
	Richard BERGH
	Prins EUGEN
	Gustaf FJAESTAD
	Eugène JANSSON
	Ernst JOSEPHSON
	Carl LARSSON
	Bruno LILJEFORS
	Karl NORDSTRÖM
	August STRINDBERG
	Carl WILHELMSON
	Anders ZORN

CHRONOLOGICAL LIST
OF PAINTINGS

1879
Christian KROHG · *The Net Mender* (Cat. 54)
Peder Severin KRØYER · *Sardine Cannery at Concarneau* (Cat. 60)
1880
Anna ANCHER · *Lars Gaihede Carving a Stick* (Cat. 2)
1881
Christian KROHG · *The Sick Girl* (Cat. 55)
1882
Christian KROHG · *Portrait of Karl Nordström* (Cat. 56)
Peder Severin KRØYER · *In the Store During a Pause from Fishing* (Cat. 61)
Nils Gustav WENTZEL · *Breakfast I* (Cat. 107)
1883
Harriet BACKER · *Blue Interior* (Cat. 3)
Ernst JOSEPHSON · *Jeanette Rubenson* (Cat. 48)
Christian KROHG · *Sleeping Mother* (Cat. 57)
Peder Severin KRØYER · *The Artists' Luncheon* (Cat. 62)
Carl LARSSON · *The Old Man and the New Trees. Grèz.* (Cat. 64)
Erik WERENSKIOLD · *On the Plain* (Cat. 108)
1884
Richard BERGH · *After the End of the Modelling Session (Music in the Studio)* (Cat. 5)
Akseli GALLEN-KALLELA · *Boy with a Crow* (Cat. 21)
Akseli GALLEN-KALLELA · *A Loft at Hoskari, Keuruu* (Cat. 22)
Ernst JOSEPHSON · *The Water Sprite* (Cat. 49)
Bruno LILJEFORS · *Dovehawk and Black Grouse* (Cat. 66)
Karl NORDSTRÖM · *Garden in Grèz* (Cat. 83)
Eilif PETERSSEN · *Meudon Landscape* (Cat. 85)
Laurits Andersen RING · *The Lineman* (Cat. 87)
1885
Akseli GALLEN-KALLELA · *Old Woman and a Cat* (Cat. 23)
Christian KROHG · *Portrait of Gerhard Munthe* (Cat. 58)
Laurits Andersen RING · *Young Girl Looking Out of a Window* (Cat. 88)
1886
Kitty KIELLAND · *After Sunset* (Cat. 53)
Eilif PETERSSEN · *Summer Night* (Cat. 86)
Anders ZORN · *Our Daily Bread* (Cat. 116)
1887
Richard BERGH · *Hypnotic Séance* (Cat. 6)
Albert EDELFELT · *Luxembourg Garden* (Cat. 9)
Karl Gustav JENSEN-HJELL · *At the Window* (Cat. 47)
Christian KROHG · *Albertine in the Police Doctor's Waiting Room* (Cat. 59)
Laurits Andersen RING · *Evening. The Old Woman and Death* (Cat. 89)
1888
Akseli GALLEN-KALLELA · *Démasquée* (Cat. 24)
Eero JÄRNEFELT · *Lefranc, Wine Merchant, Boulevard de Clichy, Paris* (Cat. 44)
Harald SLOTT-MØLLER · *The Poor: The Waiting Room of Death* (Cat. 93)
1889
Albert EDELFELT · *Kaukola Ridge at Sunset* (Cat. 10)
Edvard MUNCH · *Inger on the Beach (Summer Night)* (Cat. 69)
Christian SKREDSVIG · *The Willow Flute* (Cat. 92)
Jens Ferdinand WILLUMSEN · *In a French Laundry* (Cat. 113)

1890

Harriet BACKER *By Lamplight* (Cat. 4)
Eero JÄRNEFELT *Portrait of Professor Johan Philip Palmén* (Cat. 45)
Ernst JOSEPHSON *The Holy Sacrament (The Angel's Sermon)* (Cat. 50)
Edvard MUNCH *Night (Night at St. Cloud)* (Cat. 70)
Edvard MUNCH *A Spring Day on Karl Johan Street* (Cat. 71)
Harald SLOTT-MØLLER *Georg Brandes at the University of Copenhagen* (Cat. 94)

1891

August EIEBAKKE *Laying the Table* (Cat. 14)
Louis SPARRE *First Snow* (Cat. 99)
Anders ZORN *Midnight* (Cat. 117)
Anders ZORN *The Omnibus I* (Cat. 118)

1892

Prins EUGEN *The Forest* (Cat. 15)
Pekka HALONEN *Karelian Playing the Kantele* (Cat. 29)
Gerhard MUNTHE *Horse of Hades* (Cat. 81)

1893

Peder Severin KRØYER *Summer Evening on the South Beach at Skagen* (Cat. 62)
Edvard MUNCH *Moonlight* (Cat. 72)
Edvard MUNCH *Summer Night's Dream (The Voice)* (Cat. 73)
Edvard MUNCH *The Scream* (Cat. 74)
Edvard MUNCH *Death in the Sickroom* (Cat. 75)
August STRINDBERG *The Night of Jealousy* (Cat. 100)
Jens Ferdinand WILLUMSEN *Jotunheimen* (Cat. 114)

1894

Albert EDELFELT *Särkkä* (Cat. 11)
Akseli GALLEN-KALLELA *Waterfall at Mäntykoski* (Cat. 25)
Akseli GALLEN-KALLELA *Symposium (The Problem)* (Cat. 26)
Karl NORDSTRÖM *Varberg Fort* (Cat. 84)
Ellen THESLEFF *Spring Night* (Cat. 102)

1895

Halfdan EGEDIUS *The Dreamer* (Cat. 12)
Carl LARSSON *In a Corner* (Cat. 65)
Bruno LILJEFORS *Horned Owl Deep in the Forest* (Cat. 67)
Edvard MUNCH *Self-Portrait with Cigarette* (Cat. 76)

1896

Halfdan EGEDIUS *Play and Dance* (Cat. 13)
Prins EUGEN *The Cloud* (Cat. 16)
Edvard MUNCH *The Sick Girl* (Cat. 77)
Ellen THESLEFF *Violin Player* (Cat. 103)
Anders ZORN *Self-Portrait* (Cat. 119)

1897

Niels BJERRE *The Prayer Meeting, Harboøre (The Children of God)* (Cat. 8)
Akseli GALLEN-KALLELA *Lemminkäinen's Mother* (Cat. 27)
Ludvig FIND *Portrait of a Young Man. The Painter Thorvald Erichsen* (Cat. 18)
Anders ZORN *Midsummer Dance* (Cat. 120)

1898

Ejnar NIELSEN *The Blind Girl. Gjern* (Cat. 82)
Carl WILHELMSON *Scene from the Swedish West Coast* (Cat. 110)

1899

Pekka HALONEN *Wilderness* (Cat. 30)
Eugène JANSSON *Dawn over Ridderfjärden* (Cat. 39)
Eugène JANSSON *The Outskirts of the City* (Cat. 40)
Edvard MUNCH *Melancholy (Laura)* (Cat. 78)
Laurits Andersen RING *In the Month of June* (Cat. 90)
Harald SOHLBERG *Summer Night* (Cat. 95)
Thórarinn B. THORLÁKSSON *Woman at a Window* (Cat. 104)
Carl WILHELMSON *Fisherwomen Returning from Church* (Cat. 111)

1900

Richard BERGH *Nordic Summer Evening* (Cat. 7)
Vilhelm HAMMERSHØI *A Farm at Refsnaes* (Cat. 31)

Vilhelm HAMMERSHØI — *"Dust Motes Dancing in Sunlight", View from the Artist's Home at 30 Strandgade* (Cat. 32)
Edvard MUNCH — *The Dance of Life* (Cat. 79)
Thórarinn B. THORLÁKSSON — *Thingvellir* (Cat. 105)

1901
Prins EUGEN — *Still Water* (Cat. 17)
Vilhelm HAMMERSHØI — *Five Portraits* (Cat. 33)
Eugène JANSSON — *Self-Portrait* (Cat. 41)
Bruno LILJEFORS — *Evening, The Wild Ducks (The Panther Skin Rug)* (Cat. 68)

1902
Akseli GALLEN-KALLELA — *Landscape under Snow* (Cat. 28)
Vilhelm HAMMERSHØI — *Christianborg Palace* (Cat. 34)
Vilhelm HAMMERSHØI — *The Buildings of the East Asiatic Company* (Cat. 35)
Eugène JANSSON — *Hornsgatan at Night* (Cat. 42)
Carl WILHELMSEN — *The Daughter on the Farm* (Cat. 112)

1903
Björn AHLGRENSSON — *Glowing Embers at Dusk* (Cat. 1)
Helene SCHJERFBECK — *The Seamstress* (Cat. 91)
August STRINDBERG — *Coast Landscape* (Cat. 101)
Thórarinn B. THORLÁKSSON — *Eyjafjalla Glacier* (Cat. 106)

1904
Ásgrímur JÓNSSON — *Tindafjöll* (Cat. 51)
Harald SOHLBERG — *Night* (Cat. 96)

1905
Gustaf FJAESTAD — *Freshwater* (Cat. 19)
Vilhelm HAMMERSHØI — *Open Doors (White Doors)* (Cat. 36)
Eero JÄRNEFELT — *Lake Shore with Reeds* (Cat. 46)
Harald SOHLBERG — *Flower Meadow in the North* (Cat. 97)
Jens Ferdinand WILLUMSEN — *After the Storm I* (Cat. 115)

1907
Gustaf FJAESTAD — *Winter Evening by a River* (Cat. 20)
Vilhelm HAMMERSHØI — *Interior with a Punchbowl* (Cat. 37)
Edvard MUNCH — *Bathing Men* (Cat. 80)

1908
Vilhelm HAMMERSHØI — *Interior with a Seated Woman* (Cat. 38)

1909
Ásgrímur JÓNSSON — *Hekla* (Cat. 52)

1911
Eugène JANSSON — *Ring Gymnast Number I* (Cat. 43)

1914
Harald SOHLBERG — *Winter Night in Rondane* (Cat. 98)

BJÖRN AHLGRENSSON

Sweden 1872–1918

Björn Ahlgrensson was born in Stockholm in 1872, the only son of a theater scene painter and an actress-singer. The Ahlgrensson family moved to Copenhagen in 1874 and to Paris three years later. Björn began to take music lessons and to play the violin, and when his mother and sister returned to Stockholm in 1886 to join his father (who had returned three years earlier to seek a fortune as a newspaper publisher), the fourteen-year-old boy remained in Paris with family friends to pursue his musical studies.

In 1890 Ahlgrensson was called back to Stockholm. His father had died of tuberculosis, and the family, never well off, was facing a financial crisis. Ahlgrensson put his musical aspirations aside and apprenticed himself to Carl Grabow, the chief scene painter of the Stockholm Opera. Encouraged by Fritz Lindström, a young painter whom he had met through his work at the theater, he began taking painting classes at the Artists' Union.

On the recommendation of the Union's president, Richard Bergh*, Ahlgrensson won a travel grant to France in 1893. Although none of the work from his nine-month stay in Paris has been recovered, it is clear from the memoirs of his friend Axel Erdman, who was a member of the Swedish artists' community there, that Ahlgrensson was open to advanced French painting, particularly Synthetism and certain aspects of Neo-Impressionism.

In 1899 Ahlgrensson married Fritz Lindström's sister Elsa and moved to the Lindström villa in Värmland (western Sweden). There he became part of the artists' community centered around Gustaf Fjaestad* at Lake Racken. The landscapes and moody interiors from his home in Rackstaad, among them *Glowing Embers at Dusk*, show his technique in his primary medium, tempera, at its most refined stage.

Ahlgrensson's horizons were rather limited by his self-imposed isolation in Värmland, and he was not in contact with the new generation of painters who came into prominence in Sweden around 1910. Suddenly in 1911, after finishing an altarpiece for the Arvika church, he left the confines of home and family and visited artists' communities in Copenhagen, Visby, Jämtland, Stockholm, and Paris. His style and choice of motifs unchanged, he returned to Rackstaad in August 1915 and died there three years later of the Spanish influenza. [SMN/PG]

1
Glowing Embers at Dusk *1903*
Skymningsglöden
Tempera on canvas
83.0 x 120.0 (32⅛ x 47¼)
Signed lower left: "B. Ahlgrensson/1903"
Göteborgs Konstmuseum

Evening or twilight interior views of his home in Värmland, most often including his wife, were important subjects for Björn Ahlgrensson from 1899 until 1910. Glowing Embers at Dusk *and Ahlgrensson's other important work from 1903,* Late Summer Evening (Hedenskog), *are about feminine realms of solitude in which silent interiors are charged with the mystery of the everyday.* Glowing Embers at Dusk *depicts a moment of winter twilight in which the progression of time is only vaguely suggested by the fading light from the window in the next room and the dying embers of the fire. Ahlgrensson mixes the woman's reverie and our contemplation in a manner reminiscent of Jan Vermeer and other seventeenth-century Dutch masters of the interior.*

This style links him to the widespread Vermeer revival of the late nineteenth century and relates his quiet interiors to the work of Vilhelm Hammershøi*. The tightly wrought decorative surface of the painting, in which the divisionist brushstrokes derived from Neo-Impressionism are controlled by the clearly defined contours of figure and objects, is also related to the linear rhythms of the Swedish Art Nouveau style so important to the group led by Gustaf Fjaestad*.

Glowing Embers at Dusk resonates with the life of the imagination; even the placement of the woman's fingers against her head suggests inner absorption. Yet the viewer's focus is not the seated figure but the fireplace, the object of her contemplation, which is curiously provocative in its Art Nouveau elegance. The swelling shapes of the fireplace and indeed many objects in this spare room – the vacant chair, the unplayed lute and violin upon the wall – are feminine and resonate with the spiritual and physical presence of the dreaming woman. All exist in a suspended state, and, keyed by the withdrawn figure and the banked fire, the room becomes implicitly charged with the force of male absence.

Ahlgrensson's interiors have often been compared to those by his contemporary Carl Larsson*. Yet Larsson's sunlit illustrations of happy, active family life have little to do with Ahlgrensson's penetration into psychology and silence. Glowing Embers at Dusk is more related to the sets that Maurice Denis, Paul Sérusier, Paul Ranson, and Édouard Vuillard designed for Lugné Poë's Théâtre de l'Oeuvre (which Ahlgrensson would certainly have attended since it opened in 1893, his year in Paris), and particularly to Vuillard's interiors of the early nineties. The Théâtre de l'Oeuvre presented modern Symbolist theatre which was primarily foreign and Northern: except for French works by Maurice Maeterlinck, only work in translation was performed, with a concentration on plays by Ibsen, Bjørnson, Strindberg*, and the German Gerhart Hauptmann. Its sets, true to Maeterlinck's feeling for the static theatre of quotidian life, were fragmentary statements suggesting rather than portraying the tensions lurking beneath the surface of simple domesticity (R. Goldwater, Symbolism, 1979, pp. 109–110). Yet like Vuillard, Ahlgrensson also cherished the material comforts and serenity of everyday life, which he blended so evocatively with the blue Nordic twilight. [SMN/PG]

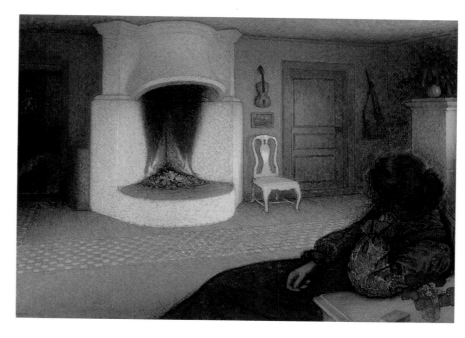

Clarence Hudson White
Evening – Interior 1899
Platinum print
19.0 x 15.2 (7½ x 6)
The Museum of Modern Art, New York
The moody introspection of women in much of the imagery associated with the Photo-Seccession of the 1890s belongs to a female typology widespread in Symbolism and is echoed in Ahlgrensson's portrait of his wife in *Glowing Embers at Dusk*.

ANNA ANCHER

Denmark 1859–1935

Anna Ancher was born in the fishing village of Skagen on the northern tip of Jutland. She was the daughter of Erik Brøndum, owner of the tavern and hotel that became the focal point of the summer colony of artists who came to paint Skagen with increasing frequency after the mid-1870s.

Between 1875 and 1878 she studied during the winter months in Copenhagen at the drawing academy for women directed by Vilhelm Kyhn, a landscape painter. While her training under Kyhn must have been highly conventional, she must also have been fully aware of the new move toward Realism among the Skagen painters, in particular Michael Ancher, who began visiting Skagen in 1874, and Christian Krohg*, who first arrived in 1879.

In 1880 she married Michael Ancher. The two settled in Skagen, and it was at this time that Anna emerged as a serious artist. In 1882 she travelled to Vienna with her husband. She did not visit Paris until 1888; there she was immediately attracted to the circle of Pierre Puvis de Chavannes and studied drawing at his school for six months. In 1904 she was elected a member of the Copenhagen Academy. [ADG]

2

Lars Gaihede Carving a Stick *1880*
Lars Gaihede snitter en pind
39.0 x 29.0 (15 3/8 x 11 1/2)
Signed lower right: "A.B. 1880"
Skagens Museum

Anna Ancher, née Brøndum, was an exception among the Skagen community of artists in that she was not only an accomplished woman painter, but a native Skagener as well. This painting must have been executed shortly before her marriage to Michael Ancher, since she did not use her maiden initials "A.B." after her wedding in August 1880. It is one of her first mature works and shows no trace of the somewhat clumsy and naive style of such earlier works as her 1878 Return from the Church after a Burial (Skagens Museum).

The subject of the painting is Lars Gaihede, one of Michael Ancher's favorite models. Gaihede was a member of a large Skagen family, and many of his relatives posed for other Skagen painters as well (see Christian Krohg's The Net Mender, cat. no. 54). Anna Ancher's orientation, like that of many Scandinavian artists then working in Skagen, is essentially Naturalistic, avoiding the sentimental and anecdotal qualities of mid-century depictions of peasant life. Using a palette similar to her husband's, Anna studies the model in an intimate close-up view. Her main interest lies in depicting the play of light and the simple, concentrated action of Gaihede. The interior is described with little specificity, and the artist avoids the picturesqueness characteristic of her husband's work.

It was several years before Anna Ancher achieved a fully personal style. She received only sporadic training and surprisingly little encouragement. The Copenhagen critic Karl Madsen, for example, expressed a low opinion of her work. More daunting still was the advice she received from her professor of drawing, Vilhelm Kyhn. As a wedding present, he sent her a set of china accompanied by a note suggesting that she go down to the beach with her painting box and all her painting equipment and set them "to sail the seas, because now, as a married woman she would no longer want to be an artist, but a housewife" (biblio. ref. no. 11, p. 60). [ADG]

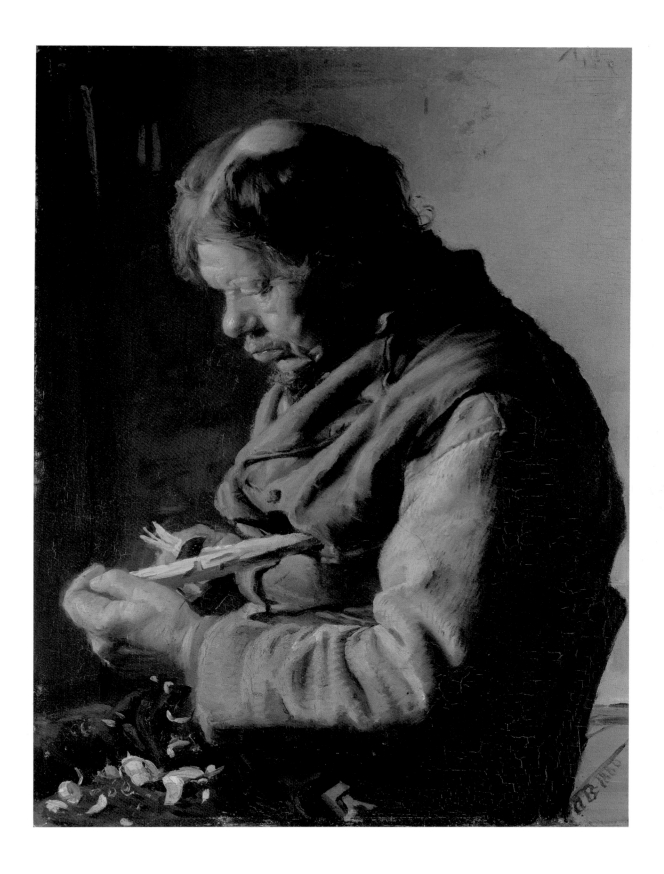

HARRIET BACKER

Norway 1845–1932

Born in 1845 in Holmestrand, a shipping center on the Christianiafjord, Harriet Backer was the second of four daughters. Her parents encouraged her artistic aspirations, and Harriet began drawing lessons at the age of six with Joachim Carlmeyer, a former pupil of Norway's distinguished Romantic landscapist Johan Christian Dahl. In 1857, the family relocated to Christiania, where she attended Johan Fredrik Eckersberg's school from 1861 to 1865, Christian Brun's school from 1867 to 1868, and Knut Bergslien's painting academy from 1872 to 1874. She travelled with her family throughout this period, spending several winters in Berlin and Weimar and the winter of 1870 in Italy, where she devoted herself to copying the old masters.

Backer went to Munich in 1874 and studied briefly with Lambert Linder and, beginning in 1875, with Eilif Peterssen*. In 1878, as younger Norwegian painters were becoming increasingly attracted to French Naturalism, she moved to Paris (along with Hans Heyerdahl and Kitty Kielland*), where she remained for ten years, sharing lodgings with Kielland. She received four large scholarship stipends that enabled her to paint in Brittany as well as in Paris. During her first two winters in Paris she took instruction from Jean Léon Gérôme and Léon Bonnat, and briefly from Jules Bastien-Lepage, rapidly combining her experience of the darker tonalities of Munich colorism with the new tendencies. Backer's 1880 peasant interiors from Brittany are among her earliest works in this new style. She made her debut in the Paris Salon the same year.

In 1889 Backer returned permanently to Norway, spending the summer months painting in the valleys north of Christiania and the rest of the time teaching at her own painting school, which she man-aged until 1912. This school had a great influence on the younger Norwegian painters – Halfdan Egedius* and Harald Sohlberg*, among others, were Backer's pupils.

Backer's own lifetime production was rather small. She worked slowly and continued to paint her richly luminous Norwegian interiors until 1908–09, when she completed her final major series of church interiors from Opdal and Stange. During the last twenty years of her life, Backer concentrated primarily upon still lifes, which she had not undertaken seriously since her years in Munich. [SMN/TS]

3
Blue Interior *1883*
Blått interiør
84.0 x 66.0 (33 x 26)
Signed lower left: "Harriet. Backer./Paris. 1883".
Nasjonalgalleriet, Oslo

Blue Interior, *painted in Paris during the winter of 1883, is a key work in late nineteenth-century Norwegian painting, standing midway between the Naturalism of the 1880s and the mood paintings of the 1890s. In the 1890 Christiania Exhibition, Norwegian* Blaamaleri *triumphed. Blue had become the dominant tone, suppressing dissonances of local color in the search for emotional expression rather than illusionism. Some years earlier, in 1883, Backer's* Blue Interior *had been shown at the Autumn Exhibition in Christiania, where it was a great success in the local art community (R. Heller, "Edvard Munch's 'Night'," Arts, October 1978, p. 80). Both Erik Werenskiold and Andreas Aubert praised its courageous harmony of blue color and blue light. Backer later composed several variations of this quietly knitting woman suffused in light.*

The emancipation of Backer's color had begun in 1881 with her interior Andante *(Stavanger Faste Galleri), initiating a lifelong involvement with the study of daylight pen-*

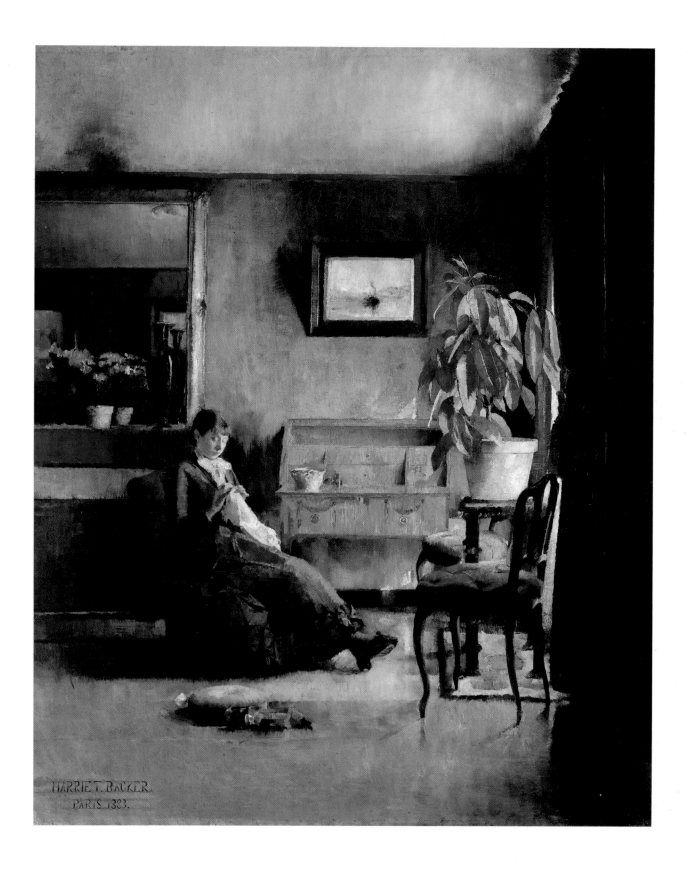

4
By Lamplight *1890*
Ved lampelys
64.7 x 66.5 (40½ x 41⅗)
Rasmus Meyers Samlinger, Bergen

etrating into and defining interior spaces. In Blue Interior
*the play of light animates all matter – the leaves of the
plant, the brilliant red chest, and the seated figure in blue –
although Backer never relinquishes her strong sense of com-
positional structure and design. In her reverent and percep-
tive transformation of a small corner of reality, Backer may
have been stimulated by Alfred Stevens' celebrated inte-
riors. One of Stevens' greatest triumphs had been at the
1878 Paris World Exposition; he exhibited fifteen paintings
that must have come to Backer's attention during her first
year in Paris.*

*In Backer's composition, the window, cut off from our
view, no longer reveals the outside world; instead the light
that it sheds unites the world inside in a coloristically deter-
mined mood of peace, contemplation, and silence. [SMN/
TS]*

*Backer spent the summers of 1886 and '87 involved with the
pioneering Naturalist painters at Christian Skredsvig's*
farm at Fleskum. Deviating from her compatriots' enthrall-
ment with the summer night, she then spent two summers
with Gerhard Munthe* painting sun-filled interiors. In the
financially strained summer of 1890, Backer moved into a
house in Sandvika, just outside Christiania. There she pro-
duced a group of small, masterful canvases, including* By
Lamplight *(a second version is in Oslo, National Gallery).*

*The woman at the center of the composition is a mem-
ber of Backer's familiar repertory of self-absorbed females –
reading, sewing, playing musical instruments – isolated and
enclosed by interior spaces. Her earlier compositions recall
seventeenth-century Dutch interiors in their control and
sensuous treatment of light effects, reflecting Backer's first
passion with Dutch and Flemish art as a student in Berlin:
"Maybe", she wrote, "I had a little Dutch blood in my
veins." (Erling Lone,* Harriet Backer, *Oslo, 1924, p. 8). As
in* Blue Interior *(cat. no. 3), she often painted carefully
nuanced interiors animated by sunlight slanting in through
obliquely viewed windows. Backer's use of a night-time set-
ting, with artificial illumination, adds an interesting dimen-
sion to her subject.*

*By Lamplight is an essay in simplicity. The room's
spare table, chairs, mirror, half-curtains, and especially its
mute, blackened windowpanes, are intended to convey a
mood of silence and suspension. The mystery generated by
the limited range of the artificial light, and by the shadow
cast on the back wall, suggest an affinity with the Belgian
Symbolists. Backer, a lifelong supporter of avant-garde
movements, was most likely familiar with the intimate inte-
riors of James Ensor and Xavier Mellery, and the efforts of
Les XX to include Frits Thaulow and Christian Krohg* in
their exhibitions. Mellery's series* Effet de Lumière *(1880–
83), in which shadows are "the plastic equivalent of silence"
(Francine Legrand,* Symbolism in Belgium, *Brussels, Lacon-
ti, 1972, p. 121), explores, like* By Lamplight, *the mysterious
effects of night on familiar domestic spaces. Perhaps more
than her daylight subjects, Backer's night scenes enhance the
inaccessibility and introspection of her female subjects.*

*During the summer, while continuing to explore light
effects on the spaces in and around her house, Backer
painted the first of her church interiors in Baerum. The tra-
ditional, brightly painted patterning of the old rural church-
es, and the farmers' devotions within, occupied a central
place in her art for the next twenty years. [PGB]*

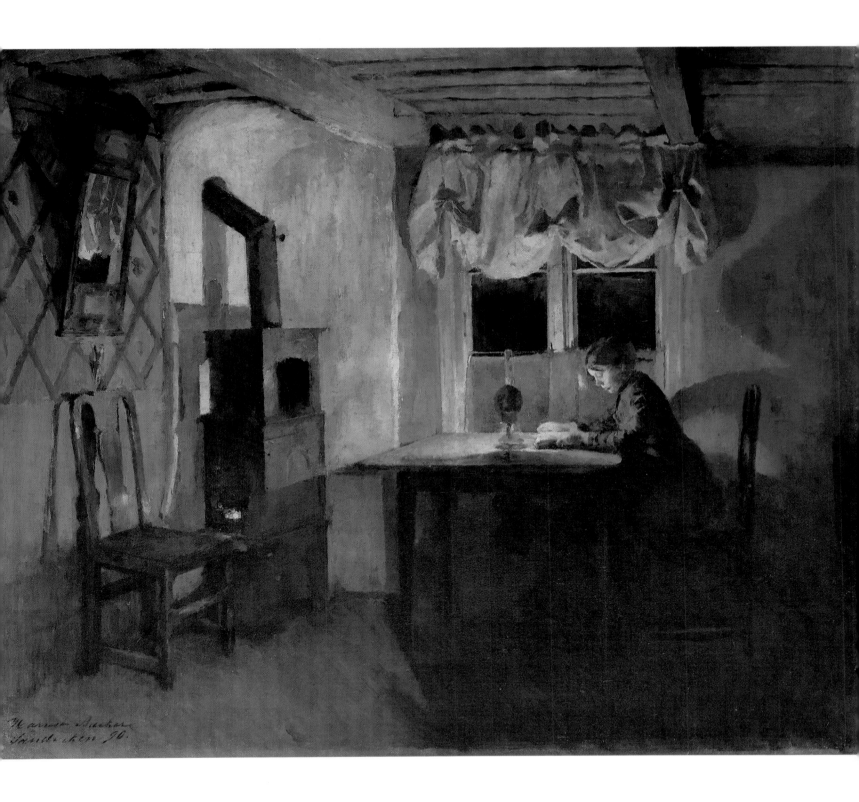

RICHARD BERGH

Sweden 1858–1919

The son of the prominent landscapist Edvard Bergh, Richard Bergh studied at Sweden's Royal Academy of Fine Arts, where his father was a professor, from 1877 to 1881. His early work depicted scenes from Scandinavian history or local legend in a German academic style. From 1881 to 1884 Bergh lived in Paris, where his art was transformed by the influence of Jules Bastien-Lepage and the Impressionists. He showed at the Paris Salon in 1883, '84, '86, '87, and the World's Fair of '89, and established an international reputation as a portraitist. In Paris his style moved toward the emotional and lyrical.

Bergh played an important role as a critic, author, and organizer in the Swedish art world, first in the expatriate community in France and then, in 1885 and '86, as a rebel against the Swedish Royal Academy and as a founding member of the Artists' Union. Bergh was the society's president from 1890 to 1897 and its secretary from 1896 until his death. His efforts for a cooperative association of artists engaged in instruction, politics, and fund raising were modelled on the social art theories of William Morris and John Ruskin.

Bergh wrote extensively on art and was instrumental in defining the so-called National Romantic style in Sweden. Although he admitted to French influence on Scandinavian painting, he believed that Nordic art was independent because it sprang from an affinity with the native landscape. To exploit this "Nordic nature", he moved with Karl Nordström* and Nils Kreuger to the isolated and ancient town of Varberg in western Sweden and formed a new style of landscape painting. After 1900 Bergh's ideas had become widely accepted by the Swedish art establishment. In 1915 he was appointed head of the Nationalmuseum in Stockholm, where he undertook a thorough reorganization of the museum's galleries and administration. [EB/AC/PG]

5

**After the End of a Modelling Session
(Music in the Studio)** *1884*
Efter slutad séance (Musik i ateljen)
145.0 x 200.0 (90⅝ x 125)
Malmö Museum

A critical success at the Salon of 1884, After the End of a Modelling Session *records the intimate aspect of the life of Swedish artists in Paris. Bergh depicts his compatriot, the painter Carl Jaensson (1853–1931), playing the violin in his studio following a session of painting from the nude; Jaensson appears to be examining the progress of his work which stands on the easel while the young model pauses in the midst of dressing to listen. Here, the more passive act of listening is emphasized, evidenced by the prominence of the model. To many artists of the time, music represented the least tangible, most spiritual and consequently most perfect of all the arts.*

*The theme of two figures, one playing a musical instrument while the other listens, occurs elsewhere during these years, notably in the paintings of the Belgian Symbolist artists James Ensor (*Russian Music, *1881, Musées Royaux des Beaux-Arts de Belgique, Brussels) and Ferdinand Khnopff (*Listening to Schumann, *1883, Musées Royaux des Beaux-Arts de Belgique, Brussels). Despite the kinship generated by a shared experience of the music, each person remains psychologically isolated from the other, due to his absorption in a solitary experience.*

This work reflects Bergh's contact with French Naturalism during his Paris years. The casual, contemporary subject matter differs significantly from earlier history paintings such as King Hans and Gustav Wasa *of 1881 (private collection). In addition, Bergh demonstrates his awareness of the vogue for Japanese prints by adopting characteristic pictorial devices including the flattening, simplification and cropping of objects in order to create an emphatic formal pattern.*

Situated in the center foreground, the model constitutes the focal point of the painting. She and the broad expanse of table upon which she sits are quite large compared to the mid- and background elements. An examination of the compositional structure reveals that Bergh adhered to a rigorous geometrical system yielding a "wide-angle" effect. While this does not indicate his dependence on

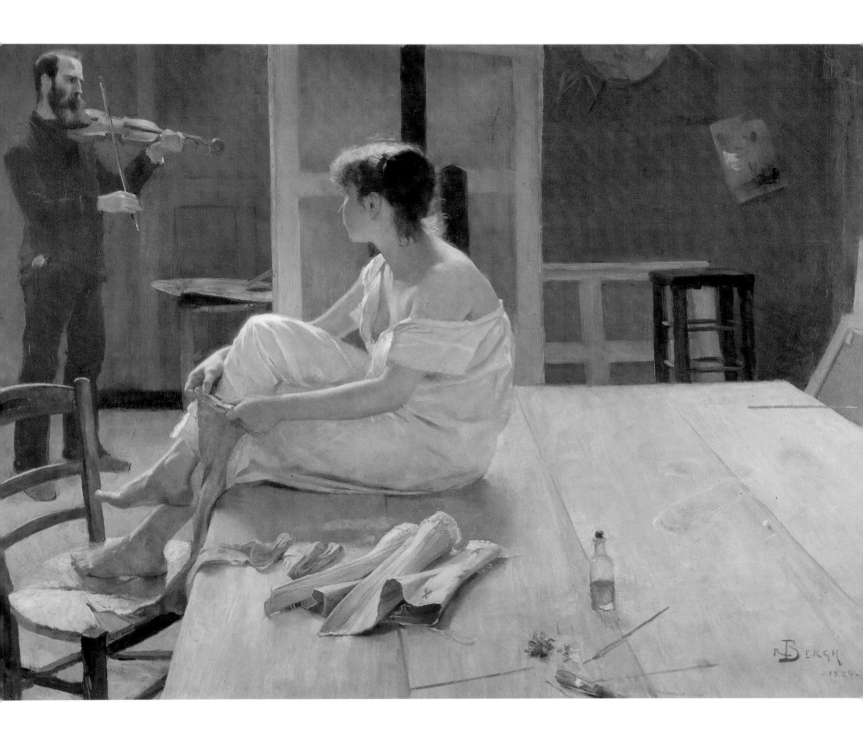

51

photography (since photography avoided such eccentricities), it does suggest a fascination with the inherently expressive possibilities of perspectival constructions, typical of late Realist painters. [MF]

André Brouillet
Charcot's Lecture 1887
L'Hopital Pasteur, Nice.

6
Hypnotic Seance 1887
Hypnotisk séance
153.0 x 195.0 (95⅝ x 121⅞)
Nationalmuseum, Stockholm

The scientific study of the subconscious emerged in France during the 1870s, particularly under the aegis of the famous neurologist Jean–Martin Charcot (1835–1893), whose experiments with hypnotism began in 1878 at the Salpetrière Hospital near Paris. He demystified the phenomenon which, since Friedrich Mesmer's experiments in the late eighteenth century, had been associated with the occult. Charcot gave hypnosis a new dignity and prominence in the medical community. Among the most notable figures who worked with Charcot early in their careers were the Austrian Sigmund Freud and the Swede Axel Munthe.

In Hypnotic Seance, Axel Munthe leans over a somnambulant woman, attempting to cure her before a rapt audience. Munthe was, at the time, the youngest physician ever to have been certified by the French Academy of Science. He became the preferred physician of fashionable foreigners in Paris during the 1880s. He socialized with the Swedish artists at the bistro "Le Coin", and treated their maladies without charge. Ernst Josephson* painted Munthe's portrait (1880, Prins Eugens Waldemarsudde, Stockholm), and Munthe counted August Strindberg* and Carl Larsson* among his closest friends.

Munthe's facility for inducing hypnosis was recognized by many as an unusual gift. His method consisted of speaking softly to a patient and laying a hand gently on the head. Here, Bergh represents the moment after the woman – who wears a white smock over her fashionable dress – has fallen into her trance. Totally relaxed, she slumps against the pillows with her limp arm resting at her side and her unseeing eyes rolled upward. The amazed spectators lean eagerly forward, their tense excitement in marked contrast to the relaxation of the patient and the calm concentration of Munthe. With great sensitivity, Bergh records an event signifying an important medical advance.

The same year Bergh painted Hypnotic Seance, André Brouillet executed Charcot's Lecture. Despite its more dramatic subject matter of a swooning woman, the artist records the scene with a journalistic detachment. Brouillet depicts Charcot's weekly public lecture at which one of a troupe of women, clandestinely trained to display a variety of psychological symptoms on command, would perform. In spite of its similar theme, the theatrical aspect of this work distinguishes it from the more intimate, compassionate painting by Bergh. [MF]

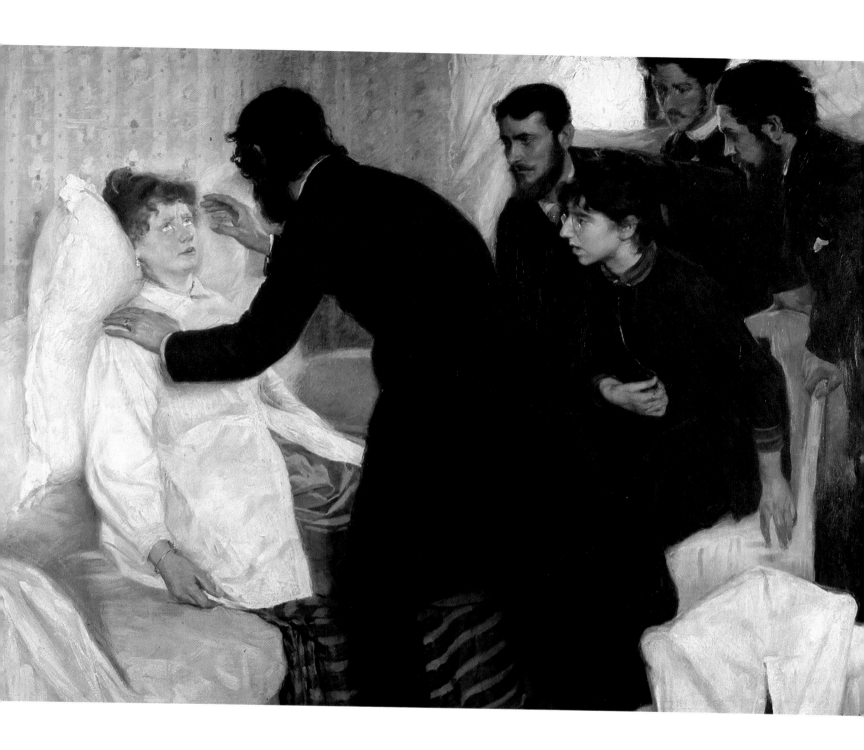

7
Nordic Summer Evening *1899–1900*
Nordisk Sommarkväll
170.0 x 223.5 (67 x 86)
Signed lower left (in monogram):
"RB./1899–1900."
Göteborgs Konstmuseum

Nordic Summer Evening *was begun in Assisi, Italy, in 1899 when the artist made an oil sketch of the singer Karin Pyk. Later that same year he sketched his close friend Prins Eugen* on the second-floor veranda of a house on the island of Lidingö in Sweden. Bergh incorporated both studies into this canvas of 1900. Prins Eugen recalled the day that he posed as a model while he, the painter Oscar Björk, and Bergh discussed the Dreyfus affair in France. "Modelling took some time," wrote Eugen, "but I did some good since Bergh's painting was brilliant." He realized that the picture's contemporary setting represented a breakthrough for his friend. He also sensed that Bergh's trip to Italy allowed the artist to "perceive with greater clarity and naturalism than before" (Prins Eugen,* Breven berätta, *pp. 261, 252).*

In contrast to the overt symbolism of Evening. The Old Woman and Death *(cat. no. 89),* Nordic Summer Evening *relies solely on the mystical power of natural phenomena – light and landscape – to heighten reality. During his stay with Prins Eugen in Italy in 1897 and '98, Bergh apparently developed a new appreciation of the unique Swedish landscape. He believed that Scandinavia's midsummer nights and midwinter scenes triggered primitive emotional responses in its people, much as music may arouse spiritual feelings. Sweden, to his mind, was a new Eden, capable of inspiring poetry and art in those who were willing to seek it. The emotional experience of the Nordic summer evening also included a sexual awakening, suggested here by the self-conscious stance of the woman and the ambiguous psychological tension that pervades the scene.*

The lack of interaction between man and woman and the relationship between figures and landscape are highly reminiscent of Henrik Ibsen's plays. Ibsen often directed characters to observe silently some action or object in an area of the stage away from the audience. He also frequently included a Nordic landscape background seen through a window, as, for example, in the play Ghosts. *[EB/AC/PG]*

NIELS BJERRE

Denmark 1864–1942

Niels Bjerre was born into a family of scholars, musicians, and politicians on his parents' farm near the rural West Jutland town of Nørrelund. Bjerre retained lifelong the native dress and indigenous tongue of West Jutland, and made his central occupation the recording of the landscape and peasant culture of the region.

Bjerre travelled to Copenhagen to study drawing in 1879 and two years later enrolled in Copenhagen's Royal Academy of Fine Arts, where he remained for seven years. His teacher Frederik Vermehren, a painter in the painstaking Naturalist tradition of Christoffer Vilhelm Eckersberg, strongly influenced his development. Having twice failed his final examination, he left the academy without graduating in 1888. The following winter he attended the *plein air*-oriented Artists' Study School established by Peder Severin Krøyer* and Laurits Tuxen (1853–1927).

Beginning in 1892 Bjerre exhibited annually at the radical artists' Free Exhibition. Inspired by seventeenth-century Dutch interior painting, his work consisted of portraits, domestic scenes, and images of religious revival meetings. The greatest of these, *The Prayer Meeting, Harboøre (The Children of God)*, earned him a bronze medal in the 1900 Paris World Exposition.

Joining the Scandinavian pilgrimage to Italy, Bjerre travelled to Florence and Naples with Laurits Andersen Ring* from 1899 to 1901. He travelled to Paris and Auvergne in 1914, the Faroe Islands in 1925–26, and Holland, Belgium, and France in 1931. After 1906 he painted only desolate landscapes and dramatic vistas of his native Jutland. In 1930–31, commissioned by the Ny Carlsberg Foundation, he produced twelve large landscapes for the Lemvig Central Library.

Bjerre pursued literary interests as well as painting. In 1890 he translated Nietzsche's *Thus Spake Zarathustra* into his native tongue. His short stories and essays include *The Fisherman*, published under a pseudonym in 1891, and *The Sacred Congregation*, written in 1892 and published in 1932. [PGB]

8
**The Prayer Meeting, Harboøre
(The Children of God)** *1897*
Bønnemøde, Harboøre (Guds Børn)
82.0 x 106.5 (32¼ x 41⅞)
Signed bottom center: "Harboøre. 1897. Niels Bjerre"
Aarhus Kunstmuseum

Niels Bjerre lived among the peasants he painted, suffering their difficulties and representing them without Romantic idealization. From the time he wrote his essay The Sacred Congregation *in 1892, he repeatedly painted images of the Home Mission evangelical movement in West Jutland. The Home Mission, documented in* The Prayer Meeting *(originally entitled* The Children of God*), incorporated the nationalistic revivalism of clergyman Nicolai Frederick Grundtvig (1783–1872) and the theological existentialism of Søren Kierkegaard (1813–1855). Renouncing the institution of the Church in favor of small evangelical enclaves, the converted, or "Children of God", practised strict Biblicism, observed the Sabbath, and gave up such frivolities as dance and theater, thus separating themselves from the unconverted, or "Children of the Earth."*

The weather-ravaged fishing town of Harboøre, the location of Bjerre's Prayer Meeting, *was deeply affected by the Home Mission. Before the wave of evangelism, it had been a homogeneous community held together by fishing and dairy cooperatives, native customs, and religious worship in the local parish. The Home Mission's prohibition of Sunday fishing and dairy farming dissolved joint ownership of fishing vessels and dairy cooperatives between the "Children of God" and the "Children of the Earth", and increased hardship during an economically depressed period.*

Its social code further fragmented the community, reordering marriage and festival patterns. The local peasants retaliated by excluding the "Children of God" from community meetings and harassing them both verbally and physically.

Earlier in the century, religious evangelism had been the focus of the Düsseldorf-trained painters Christian Dalsgaard and Frederik Vermehren (Bjerre's teacher), who viewed prayer meetings as picturesque manifestations of peasant culture suitable for genre painting. Bjerre, however, had sympathies for the Home Mission, and, acutely aware of the emotional contradictions implicit in religious conversion, recorded The Prayer Meeting with keen psychological insight. His six figures are suspended in individual, self-absorbed reveries that undercut their religious collectivism.

The painting is vitalized by the compositional strategies of Christian Krohg*, whose work Bjerre had admired since the 1888 Northern Agriculture and Art Exhibition in Copenhagen. Vast jumps in scale from the looming foreground figure to the riveting woman at the back activate a nearly isocephalic ordering of figures. The low-angle view of the ceiling and the sidelong depiction of the windows underscore the claustrophobic nature of the room, whose focus is the painted crucifix on the far wall. The subtlety of color and psychological intensity of the scene have often been likened to Vilhelm Hammershøi's Five Portraits (cat. no. 33), painted three years later.

The painting's current title, The Prayer Meeting, Harboøre, defuses Bjerre's message by keeping the religious orientation anonymous and implying group participation. The original title, The Children of God, stresses the pietists' painful alienation from their once-familiar village community. [PGB]

ALBERT EDELFELT

Finland 1854–1905

Albert Edelfelt, an aristocratic Finn of Swedish extraction, began his formal training at the Fine Arts Association in Helsinki at the age of sixteen. After a year he transferred to Helsinki University, where he remained until 1873. He moved to Paris in 1874 and studied intermittently at the École des Beaux-Arts, under Jean Léon Gérôme, until 1878.

A fighter for Realism in Finnish art, Edelfelt influenced the younger generation of Scandinavian artists who studied in Paris – particularly his Finnish compatriot Akseli Gallen-Kallela*. He exhibited in the Paris Salon, the Salon des Champs-Elysées, and the Salon du Champs de Mars throughout the 1880s and ʼ90s, and won a Grand Prix d'Honneur at the 1889 Paris World Exposition.

Enamored of "Norwegianism", Edelfelt believed that the Norwegian writers, painters, and composers whom he met in Paris possessed a cohesive creative spirit. Despite his strong cosmopolitan and Francophilic leanings, he had great hopes for a Finnish national art, and a strain of nationalism appeared in his own work in the late 1880s (for example, *Old Women from Ruokalahti on the Church Hill*, 1887).

National Romanticism grew throughout the 1890s, and Edelfelt incorporated Finnish themes more and more frequently into his work. Russian intervention in Finnish affairs culminated in Tsar Nicholas II's February Manifesto of 1899 in which Finland became subject to Russian imperial legislation. In response, 523,000 Finns and a thousand European intellectuals signed a Pro-Finlandia petition defending Finland's right to self-government. Jean Sibelius composed his tone poem *Finlandia* that same year, and in 1900 Edelfelt, with his international reputation and French connections, persuaded officials of the Paris World Exposition to permit Finland its own pavilion – separate from the Russians with whom the Finns were often exhibited.

Also in 1900 Edelfelt created a series of drawings illustrating the *Tales of Ensign Stål*, patriotic poems by the Finnish poet laureate Johan Ludvig Runeberg. In 1904, the year before his death, the artist executed mural decorations in the old assembly hall at the University of Helsinki. These frescoes, depicting the inauguration of Finland's university in Turku in 1640, were destroyed in World War II. [SRG/SSK]

Albert Edelfelt
Sketch for Luxembourg Garden, 1886
26,0 x 35,0 (10¼ x 13¾)
Ateneumin Taidemuseo, Helsinki

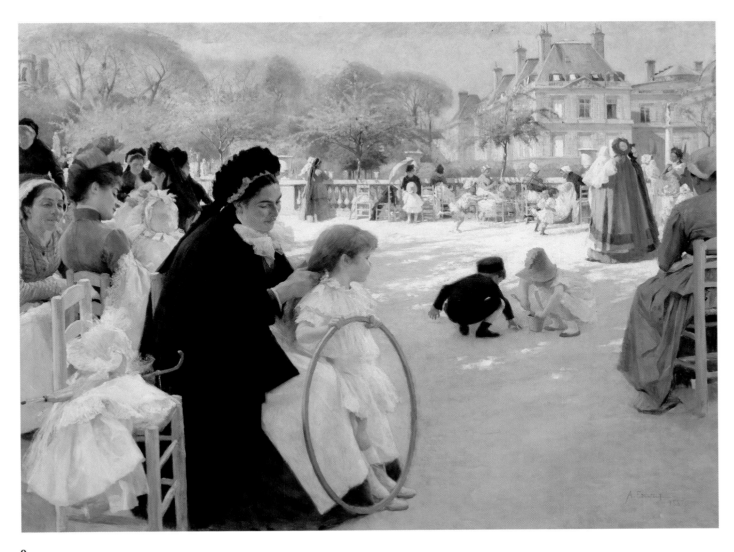

9

Luxembourg Garden *1887*
Pariisin Luxembourgin Puistosta
144.0 x 188.0 (56⅛ x 74)
Ateneumin Taidemuseo, Helsinki

Edelfelt had already achieved considerable success in official art circles by the mid-1880s. He won gold medals at the Salons of 1880 and 1882, and the French government bought his Portrait of Louis Pasteur *(1885, Sorbonne, Paris). This painting represents the synthesis of lessons Edelfelt learned from French* plein-air *Naturalism.*

A maid adjusts the hair of a little girl and young children play in the open space that stretches back toward the barrier surrounding the Luxembourg Palace. The foreground figures in shadow contrast with the ladies and children who promenade in the bright, golden light illuminating *the background. Chalky blues, grays and sand tones dominate this scene of Parisian pleasures.*

Edelfelt replaced the loose, Manet-like application of paint in the penultimate sketch (see illustration) with tighter draftsmanship and a more precise facture in this final version. Like his Finnish compatriots in Paris, Edelfelt was ambivalent about French Impressionism. The artist, friendly with French academic painters including his former teacher Jean Léon Gérôme, perceived Impressionism as a passing trend. He wrote in a letter home: "Tomorrow I will begin on my Luxembourg painting . . . I was at Gérôme's early this morning . . . he spoke a great deal about the Impressionists and the latest fashion in art, and not without bitterness . . . 'to go in for this madness . . . its's pernicious. Take care. Don't let yourself be carried away. What is beautiful will always remain so, and they who only seek to

follow the fashion will more readily become outmoded than those who work simply and honestly.'"

In this work, roughly thirty times the size of the sketch, Edelfelt expanded his composition. The point of view is closer to the Palace, reducing the broad, expansive middle-ground of the sketch to a shorter and more restrained space. *Luxembourg Garden* was completed too late for exhibition in the 1887 Salon, but was shown instead at George Petit's Gallery. Arranged by Claude Monet, Auguste Rodin and Edelfelt, among others, the exhibition also included the Scandinavians Peder Severin Krøyer* and Carl Larsson.* [SRG/SSK]

10
Kaukola Ridge at Sunset *1889*
Kaukolan Harju Auringonlaskun Aikaan
116.0 x 83.0 (45 ⅛ x 32 ⅝)
Signed lower right: "A. Edelfelt"
Ateneumin Taidemuseo, Helsinki

Kaukola Ridge at Sunset *falls at that crucial juncture in Edelfelt's art when he sought to synthesize Parisian sophistication with Finnish nationalism. In the late 1880s and early 1890s Edelfelt painted several works that reflected his change in values. The artist experienced a tremendous pull toward native subjects as early as 1886. He wrote then in a letter to his mother: "I have thought a great deal about making a trip to northern Finland, possibly with Gallén if he will join me. I must see wilder terrain . . . see summer light and real Finnish Finns. Tar boats, wilderness [and] rapids . . . are beginning to take hold of me" (Jukka Ervamaa, "Albert Edelfelt's The View from Kaukola Ridge," Ateneum Taidemuseo Museojulkaisu, vol. 20, 1975–76, p. 44).*

In 1887 Edelfelt travelled to southeastern Finland to illustrate an article for Harper's New Monthly Magazine. *This trip sharpened his sensitivity to the Finnish landscape, and in early summer 1889 he and his wife Ellan de la Chapelle journeyed to Saari in northern Finland, where he painted* Kaukola Ridge at Sunset.

The still body of water that reflects its surrounding landscape is the western part of the sound leading from Lake Kuivajärvi to Lake Pyhäjärvi. The high horizon line and insistent verticality of the picture blend the smooth sound and sky into one unit. Islands and evergreens punctuate the expansive, predominantly gray backdrop. Edelfelt's familiarity with French Naturalism is evident in the subtle, overall luminosity of the work, but the atmosphere is crisper and cooler than in works from his Parisian period (see Luxembourg Garden, *cat. no. 9).*

Kaukola Ridge *was shown in Paris in 1890 at an exhibition arranged by the Société Nationale des Beaux-Arts and was reproduced in the catalogue. The painting was never exhibited in Finland during Edelfelt's own lifetime but beginning in 1893 was known there in reproduction. Finnish art historian Bertel Hintze postulated that the picture might have spawned a new school of National Romantic lake paintings (*Albert Edelfelt, *Porvoo, 1953). Lake scenes painted from particularly high viewpoints were popular in the 1890s and into the early years of the twentieth century in both Finland and Sweden. [SRG/SSK]*

61

11
Särkkä *1894*
63.0 x 91.0 (24¾ x 35⅞)
Signed lower right: "A. Edelfelt/1894"
Ateneumin Taidemuseo, Helsinki

As Karl Nordström does in his Varberg Fort *(cat. no. 84),
Edelfelt here chooses an innately Romantic subject – a
weathered fortress on the sea – and emphasizes its evocative
power with a dramatic use of light and space. Isolated
against the sweep of the water and silhouetted at the edge of
gathering night, the blunt outcropping is heavy with con-
notations of lonely, heroic survival. The structure repre-
sented is the Viapori Fortress in Helsinki Harbor, scene of
an historic surrender to Russian forces in the war of 1808–9.*

*Given the continuing Russian threats to Finnish au-
tonomy in the 1890s, Edelfelt could hardly have chosen this
view without an awareness of its bitter associations. The
National Romantic context helps to explain the rhetorical
sweep of the conception. [SRG/SSK]*

HALFDAN EGEDIUS

Norway 1877–1899

Halfdan Egedius, the son of a railroad accountant named Carl Johnsen, was born in the town of Drammen, thirty miles south of Christiania. Exhibiting a prodigious talent for drawing, he was sent at the age of nine to study under Knut Bergslien (1827–1908).

From 1886 to 1889 Halfdan, who later changed his name from Johnsen to Egedius, attended Bergslien's school of painting in the studio building "Pultosten". There he came to know Christian Krohg's* circle of painters, particularly Thorvald Erichsen, (1868–1938; cat. no. 18), who showed an immediate interest in his work.

In the summer of 1890 Egedius accompanied Erichsen to a farm in the Krøderen district where they practised *plein-air* painting. The next year he enrolled in Christiania's Royal Academy of Drawing and then studied under Erik Werenskiold*, whose interest in native Norwegian topography and customs significantly shaped his artistic outlook. At Werenskiold's prompting, he made a pivotal trip to the remote southern region of Telemark in the summer of 1892. There he met Werenskiold's former student, the painter Thorleiv Stadskleiv (1867–1946), who rapidly became his intimate friend. For the rest of his life, he and Stadskleiv summered in Telemark.

In the summer of 1893, Egedius painted his first masterpiece, *Saturday Evening* (Nasjonalgalleriet, Oslo), a moody, atmospheric landscape that marked the beginning of his tendency toward nature mysticism. The following year, he debuted in the Christiania Autumn Exhibition and, with Harald Sohlberg*, was catapulted to fame as the leader of the Neo-Romantic movement.

After briefly attending Harriet Backer's* school in 1894, Egedius made his sole trip outside of Norway to study in the Copenhagen studio of Kristian Zahrtmann. Upon his return to Telemark in 1895, he painted *Midsummer Dance* (Nasjonalgalleriet, Oslo), the first of his interpretations of indigenous peasant customs. Inspired by Edvard Munch's* psychic Naturalism, he had assumed by 1896 a fully Symbolist aesthetic best exemplified by *Play and Dance* (cat. no. 13).

Egedius executed drawings for Fridtjof Nansen's two-volume history *Farthest North* in 1896, and as a result Gustav Storm engaged the artist to illustrate the *Snorre Sturluson Sagas* the following year. Other artists on the project included Christian Krohg*, Eric Werenskiold*, Eilif Peterssen*, and Gerhard Munthe*. Like Munthe, Egedius interpreted the mythic sagas in an archaizing, supernatural style that vitalized his landscape painting. The Snorre saga illustrations occupied Egedius until his death in 1899 of an acute, degenerative disease. [PGB/TS]

12
The Dreamer 1895
Drømmeren
100.0 x 81.5 (39³/₈ x 32¹/₈)
Signed lower right: "H. Egedius 1895."
Nasjonalgalleriet, Oslo

Egedius painted this brooding portrait of Thorleiv Stadskleiv in the summer of 1895. The setting is Stadskleiv's cabin "Bøstua", which Egedius perceived as his own spiritual center. Earlier, in November 1894, he had written from Christiania: "It is strange how, suddenly in a room where everything is alive, I can sit and think about our sitting-room and our life last summer and fall. It is as if I don't know where I belong" (Halfdan Egedius to Thorleiv

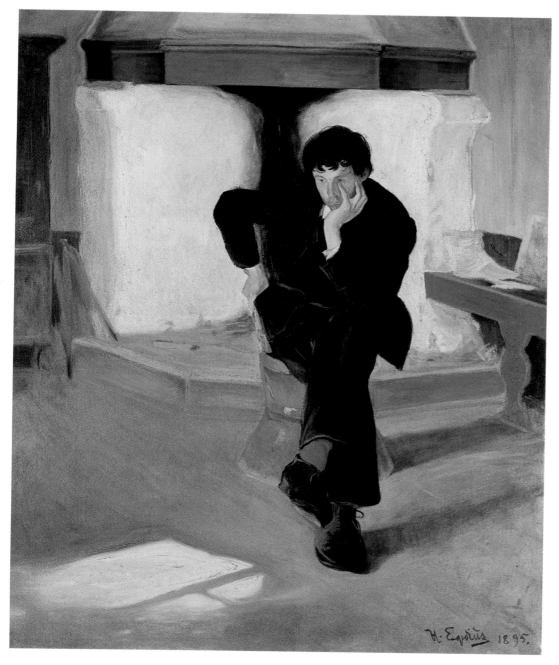

Eilif Peterssen
Portrait of Arne Garborg 1894
133.0 x 106.0 (52⅜ x 41¾)
Nasjonalgalleriet, Oslo
As Magne Malmanger (Professor, University of Oslo) has noted, this introspective portrait of novelist, poet, and journalist Arne Garborg (1851–1924) is strikingly similar in posture and mood to Egedius's *The Dreamer*. Peterssen and Egedius were in close contact during the mid-1890s and it is likely that Egedius was inspired by this portrait, which was painted in 1894 and purchased by the Nasjonalgalleriet the following year.

Stadskleiv, Nov. 15, 1894, in Østvedt, "Egedius og Stadskleiv", p. 194). In a separate letter, he expressed a strong desire to paint Stadskleiv's portrait.

Stadskleiv, a native of Bø, thought himself blessed with peasant "second sight". He frequently had visionary experiences, including a premonition of Egedius's early death. Egedius and Stadskleiv shared a Romantic preoccupation with mysticism and would sit through the night before their white stone fireplace, while Stadskleiv told supernatural tales drawn from local folklore. Their nocturnal sessions often provided ideas for their work. The Dreamer seems to represent the fatigued Stadskleiv at the conclusion of such a session.

The Dreamer echoes the Saturnine figure of Albrecht Dürer's engraving Melancholia I (1514), much celebrated during the nineteenth century for its associations with insanity and death as well as with artistic creativity, clairvoyance, and intuition. In the Romantic tradition of Delacroix's Michelangelo in his Studio (1851; Musée Fabre Montpellier), Egedius draws upon Dürer to represent Stadskleiv as the melancholic artist isolated in his studio. While Delacroix surrounds Michelangelo with the material attributes of his vision, Egedius isolates Stadskleiv, underscoring his inner vision. The enframing fireplace separates the artist from a room that is only obliquely defined through fragmentary furniture and architectural elements. The room is further abstracted through its self-enclosure: the window is only implied by light cast on the floor, removing the scene from any direct contact with nature.

Artists in the 1890s gave the imagination free reign as the Symbolists came to view the inner life of the mind as preeminent over the material world. Egedius wholeheartedly subscribed to this credo and, in portraying the peasant-artist as a self-absorbed visionary, gave prominence to Stadskleiv's mythic, mental life. [PGB/TS]

13

Play and Dance *1896*
Spill og dans
83.0 x 95.5 (32⅝ x 37⅝)
Signed lower right: "H. Egedius/96."
Nasjonalgalleriet, Oslo

Musical theory played a significant role in Romantic and Symbolist aesthetics and was used at the end of the nineteenth century as a justification for dispensing with Naturalistic representation. Music and dance were ideal vehicles for one of Egedius's chief preoccupations, the physical expression of internal mental states. Play and Dance, begun in Telemark during the summer of 1896, exemplifies this interest.

Falling into a long tradition of musician-enchanters in art, the fiddler in Play and Dance has clearly taken possession of the ecstatic dancers in the background. The furious brushwork and theatrical lighting bring to mind Delacroix's portrait of violinist Nicolo Paganini (1830; Phillips Collection, Washington, D.C.), the quintessential Faustian musician whom the critics called unearthly and possessed, and who bewitched audiences with his virtuosity. Telemarkian folklore included the fossegrim, a fiddler inhabiting mills and waterfalls who would exert an uncontrollable power over all who heard him play, the great violinist Ole Bull (1810–1880), Norway's "flaxen-haired Paganini", was said to have learned to play from such a creature. Egedius knew Ernst Josephson's controversial Water Sprite (see no. 49), in which the fossegrim is transformed into the folkloric incarnation of wantonness. The hypnotic gaze and slackened mouth of Egedius's fiddler mirror the water sprite's self-induced ecstasy. His satyr-like features (the painter Thorleiv Stadskleiv was the model) glow from the darkened canvas, demonically distorted in the spectral second head that thrusts out from the fiddler's neck. The multiple depictions of the fiddler's head and violin infuse the scene with a sense of high irrationality.

Per Hesselberg's well-known sculpture Magnetism (1883–84; Göteborgs Konstmuseum) provided a model image of hypnosis as a tool of seduction, a popular notion in the 'eighties and 'nineties. Egedius drew upon this imagery in Play and Dance, fusing it with regional concerns. His fiddler plays the highly ornamented hardanger fiddle native to the region, and the spinning dancers wear Telemarkian festival garb. Telemarkian fiddle music and folk dance greatly interested the Norwegian ethnographers associated with the National Romantic movement of the latter half of the century, and Egedius's mixture of native custom and modernism, resulting in the psychological interpretation of peasant culture, was central to the concurrent Neo-Romantic movement in painting.

Egedius viewed Play and Dance as his most challenging work. Its resolution evaded him, and he lamented on his deathbed in 1899 that the fiddler would remain unfinished. [PGB/TS]

AUGUST EIEBAKKE

Norway 1867–1938

August Eiebakke was born on his parents' farm in Askim in the spring of 1867. An aspiring sculptor, he enrolled in Christiania's Royal Academy of Drawing in 1883. Remaining there on and off until 1889, he developed his technical skills under sculptor Julius Middelthun. The Romantic Naturalism of Erik Werenskiold shaped his early sensibility, and from 1886 to 1888 Eiebakke studied *plein-air* painting under the leading French-trained proponents of Naturalism, Christian Krohg*, Eilif Peterssen*, and Hans Heyerdahl.

Eiebakke debuted at the Christiania Autumn Exhibition in 1887, exhibiting regularly until 1933 and winning critical acclaim in 1891 with *Laying the Table* (cat. no. 14). In January 1892, he entered the Copenhagen studio of Kristian Zahrtmann, wishing to branch out stylistically into a more synthetic realm. He travelled to France, Holland, and Belgium in the following year and then in 1894 trailed the migration of Danish artists to Italy. In the winter of 1895–96 he returned to Italy, where, swayed by the Grundtvigian fundamentalist religious movement, he painted altarpieces and Danish religious motifs akin to the work of Joakim Skovgaard (1856–1933).

In 1897 Eiebakke joined Halfdan Egedius* and Erik Werenskiold* in illustrating Fridtjof Nansen's Arctic Circle chronicles *Farthest North*, which were published concurrently in Norway, Germany, and England. He briefly studied with Zahrtmann the following year, returning to his early Naturalist style.

Eiebakke married Christine Fasting in December 1904, honeymooning in Italy, Denmark, and Germany. In 1910 he began teaching at the Royal Academy of Drawing, where he served as director from 1912 until 1937, when infirmity forced him to retire. He died in Oslo in 1938. [PGB/TS]

14
Laying the Table *1891*
Anretning
93.5 x 120.0 (36¾ x 47¼)
Signed lower left: "August Eiebakke/1891."
Nasjonalgalleriet, Oslo

Laying the Table, *touted by Christian Krohg*, Erik Werenskiold*, and Eilif Peterssen* as the apogee of Naturalism, was a turning point in Eiebakke's career. It was purchased from the 1891 Christiania Autumn Exhibition by the Nasjonalgalleriet and was awarded a gold medal at the 1900 World Exposition in Paris. Eiebakke developed the idea for this four-figure composition, his most ambitious to date, while staying on his parents' farm in the spring of 1891. On May 17 he wrote of his intentions to critic Andreas Aubert, stating his dissatisfaction with banal Realism: "Neither I will [sic] depict poverty with wasted faces and herring and potatoes, nor snobbish people in vulgar interiors, but a scene where well-being and satisfaction are shown as I have known it . . . "*

Eiebakke's family, posed in their Sunday best, modelled for the four figures. The artist reported that his progress was often interrupted throughout the summer because members of his family had to leave their austere oak-lined parlor to work the fields. The painting, which at one time also bore the title* Guests at Home, *records the strict social conventions of a Sunday or holiday visit on a southern Norwegian farm. The "well-being" of the familiar table-setting ritual is tinged with an air of anticipation. The guests awkwardly wait for the table to be set with the cheese, butter, heavy sour cream, and holiday bread that by convention they must refuse several times before being served. Preoccupied with the significance of physiognomy, Eiebakke repeatedly sketched his subjects to master the subtlety of their expressions. In so doing, he captured the tension of the hostess and her guests in their introspective poses, endowing the scene with psychological undercurrents reminiscent of Henrik Ibsen's dramas.*

To our eyes Laying the Table *may be pure Ibsen, but critics of both the Norwegian and French exhibitions viewed the painting as a masterfully rendered tranquil interior. They particularly noted the serene backlighting and rich col-*

oration, and marveled at the luminosity of the linen table-
cloth. The room resonates with both tension and placid sim-
plicity, reflecting Eiebakke's adaptation of the ambiguous
narrative, if not the stylized form, of Symbolist impulses ar-
riving in Norway from Paris and Berlin. [PGB/TS]

PRINS EUGEN

Sweden 1865–1947

Eugen Napoleon Nicholas, Duke of Närke, was the youngest son of King Oscar II of Sweden and Norway, and the brother of the future king, Gustav V. He decided, aged twenty, to become an artist – a sensational decision for a member of the Swedish royal family. He studied in Uppsala from 1885 to 1886 with the *plein-air* landscapist William von Gegerfelt. In 1887 he left for Paris and was taught at various times by Léon Bonnat, Henri Gervex, and Pierre Puvis de Chavannes. Eugen exhibited with the rebellious Artists' Union (whose members included Ernst Josephson* and Richard Bergh*) and shared their progressive views, but could never officially join the organization because of his social position.

Influenced by the work of Max Klinger, Arnold Böcklin, and early nineteenth-century Northern Romantic painting, Prins Eugen specialized in monumentalized landscapes of a decidedly anti-Naturalistic mood. He was encouraged to experiment in fresco painting after a trip to Italy in 1892, and painted large frescoes for the foyer of the Royal Opera House (1898), the hall of the Stockholm North Latin School (1901), the Royal Dramatic Theater (1908), and (in a Cubist-derived style) the City Hall (1922–23).

In 1899 Prins Eugen acquired property at Waldemarsudde on Djurgården island near Stockholm and in the following years built a house there designed by Ferdinand Boberg. As he worked increasingly at Waldemarsudde, he began to concentrate on the nearby urban and harbor vistas. Waldemarsudde became a center of artistic activity as Eugen constructed a large studio, designed decorative objects, and expanded his collection of contemporary Swedish and international art. He exhibited at the Paris World Exposition of 1889 and the Chicago World's Fair of 1893, and visited America in 1912–13 when his work was included in an exhibition of Scandinavian art. [EB/AC/PG]

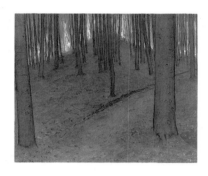

Piet Mondrian
Woods 1898–1900
Boslandschap
Watercolor and gouache on paper
45.5 x 57.0 (17⅞ x 22½)
Gemeentemuseum, The Hague

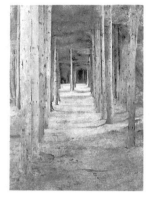

Fernand Khnopff
In the Fosse. Under the Fir Trees 1894
A Fosset. Sous les sapins
65.5 x 44.0 (25¾ x 17⅜)
Galerie Isy Brachot, Brussels and Paris

15
The Forest *1892*
Skogen
150.0 x 100.5 (59 x 39½)
Signed lower right: "Eugen/1892"
Göteborgs Konstmuseum

The year 1892 marked the beginning of Prins Eugen's individual style. Although he continued to sketch out-of-doors, in his finished paintings he sought a more lyrical and studied mood based on rigorously structured compositions and evocative simplification of form. He favored dramatically lit landscapes and depended on the special colors of dawn, sunset, and the Nordic summer night.

Eugen spent the summer and part of the autumn of 1892 at Fjällskäfte in eastern Sweden near Valla Station. He painted the deep forests of the area from several different

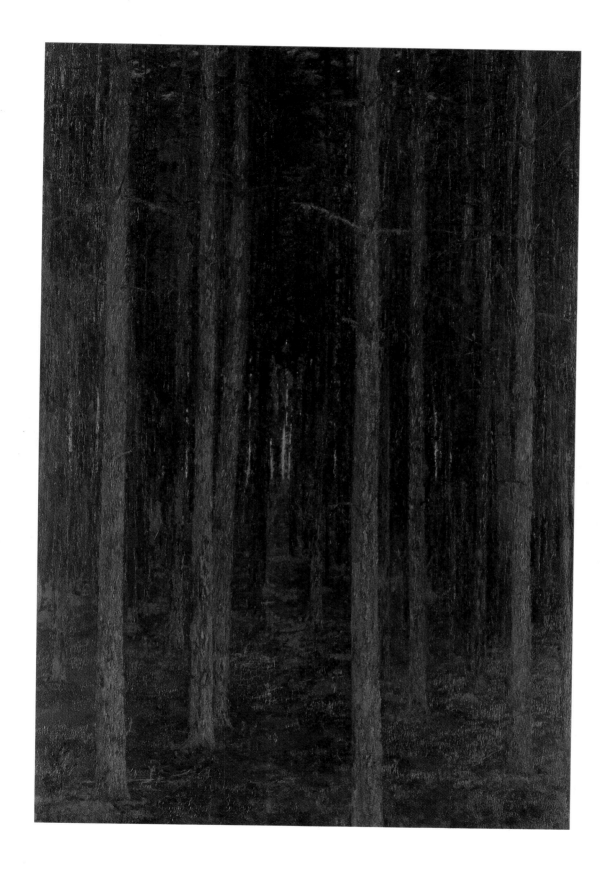

approaches; Forest Clearing *(1892; Prins Eugens Waldemar-sudde, Stockholm), for example, presents a more open, less intimidating image of the woods.* The Forest *was the most abstract of the series and was considered the most important by the artist. For Eugen, the power of primeval nature was a vital source of Nordic identity. Such association of the self and the* folk *with the native landscape was a particularly Northern phenomenon of the nineteenth century, enjoying a revival in Sweden in the 1890s with the style known as National Romanticism.*

Although it never truly departs from reality, the picture is a highly abstract, symmetrical arrangement of texture and vertical line. Upon seeing The Forest *in 1892, Richard Bergh* marvelled: "A pine forest at dusk; a glint of the evening sun between the tall blue trunks which resemble thousands upon thousands of majestic pillars in a boundless church – in nature's own great temple. Over there, the glow of the evening sun – many miles away – resembles a faintly shining choir window with gilt glass, towards which all the pillars, tall and majestic, lead . . . "*

The combination of moody nocturne and insistent Art Nouveau verticality link this painting to a broad spectrum of forest images in international Symbolism of the 1890s and early 1900s and to artists as diverse as Belgium's Fernand Khnopff, the American photographer Edward Steichen, and the young Piet Mondrian. [EB/AC/BF]

16

The Cloud *1896*
Molnet
112.0 x 103.0 (44⅛ x 40½)
Signed lower right: "Eugen/1896"
Prins Eugens Waldemarsudde, Stockholm

Prins Eugen spent his summers in the remote regions of the Scandinavian countryside – first in Norway, then on the island of Tyresö near Stockholm, which provided most of his subjects in the 1880s and '90s. Although he sought direct contact with nature to inspire the contemplative mood of his landscapes, he often began with a graphic design in mind before moving out-of-doors to find a corresponding natural motif. His working method accounts for the abstract quality and the artful symmetry and silhouettes of his landscapes. Such is the case with The Cloud, *a second version of a subject first painted in 1895. The earlier work (Göteborgs Konstmuseum), although highly abstracted, seems like an oil sketch from nature in comparison. The later composition is dominated by a strong sense of two-dimensional design: the elliptical curve of cloud in the upper sky, the serpentine path, the undulations of the hill and tree line. The woods emerge as eerie and suggestive forms of indiscernible mass and volume, in contrast to the specific weight and texture of the large cloud that looms ambiguously beyond. A strange quality of light also cleaves the canvas into a brilliant blue sky set off against a dusk-enshrouded foreground.*

In a scene devoid of human life or literary, historical connotations, Prins Eugen creates a subtly disturbing image by abstract devices alone. His is a pure Symbolist landscape. Unlike Arnold Böcklin or Pierre Puvis de Chavannes, Eugen generates emotions and sensations entirely within the setting, without using supernatural or allegorical elements. The formal reduction of nature and concentrated absence of life recall scenery by Vilhelm Hammershøi (see cat. no. 31), although Eugen relies on more dramatic means to arouse a feeling of the sublime in Nordic nature.

Prins Eugen's account of The Cloud's *conception sheds a revealing light on his subjective working method during these years: "Once I suddenly saw with my inner eye a play of lines and a mass effect that I found pleasing and suggestive. I draw [sic] the lines on a large canvas. The light effect that I needed in the center I first thought to achieve thanks to a sun, but this form proved to be too small. It had to be a large circle and it became a cloud. I was studying cumulus clouds during this period. After I had got a clear idea of the general composition I went out into nature and immediately found a hillside and a group of trees. With a little good will I could divine a path. The whole corresponded to my intentions, or so I thought. Then I worked out my motif quite thoroughly on the spot in front*

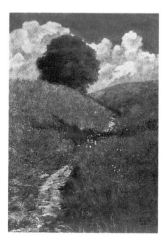

Heinrich Kuehn
A Summer Day 1898
Ein Sommertag
Blue pigment gum-bichromate print
78.7 x 52.6 (31 x 20⅞)
The Metropolitan Museum of Art, New York
The Alfred Stieglitz Collection, 1933
The striking resemblance between Kuehn's photograph and Prins Eugen's *The Cloud* may be due to the two artists' common admiration for the nature lyricism of the German painters (such as Otto Modersohn) who painted at Worpswede in the 1890s.

of nature, but when I came back there the following year I could not recognize the motif any longer, nor could anybody else" (cited in Tidskrift for konstvetenskap 23, 1940/41, p. 102). [EB/AC/PG]

17
Still Water *1901*
Det lugna vattnet
142.0 x 178.0 (55⅞ x 70⅛)
Not signed
Nationalmuseum, Stockholm

Still Water *is one of the last and most intensely lyrical of Prins Eugen's Romantic landscapes. At the end of the century he visited Tyresö less frequently as he involved himself with the building of his home Waldemarsudde and his monumental fresco projects. In August 1901, however, he abandoned his work in the city for a brief retreat to the solitude of Tyresö: "Here it is beautiful and still . . . I work and wander around the hills. However, I am in a big hurry to start work on a large picture: a little round lake, that is, like a pool in the bottom of a kettle, calm and black, untouched by winds that drive the clouds high up in the air"* (Prins Eugen, Breven berätta, *pp. 275–76; letter dated August 15, 1901).*

Once again the artist transformed a motif observed in nature into an arbitrary and forceful composition. Two-thirds of the canvas are devoted to the play of the turbulent sweep of sky, in contrast to the still silhouette of forest and the placid pond below. The symmetry of the composition reinforces the contrary moods. Striated violet clouds flow into a thin line of yellow sunset that creates a luminous glow on the distant horizon. The overview onto the oval pond, flat and black in the foreground, is juxtaposed against the sudden pull of space through the woods in the direction of the rushing clouds and creates an odd sensation. As usual, there is no human presence in the landscape. "I want to people my landscapes myself and I want to reign supreme there," Eugen once wrote. "Oddly enough my landscapes have nearly always peculiar, actually wrong proportions in which a figure would never fit" (Till Prins Eugen, *p. 32).*

Eugen's dramatic use of a seemingly infinite horizon, his precise delineation of the landscape, and his thin brushwork and unnatural colors have more in common with the German school of Romantic landscape than with the Parisian milieu in which he was trained. During the summer of 1901 Eugen also painted The Night Cloud *(Thielska Galleriet, Stockholm), which, like* Still Water, *is a symmetrical composition with a dark, opaque body of water set beneath a stormy sky.* [EB/AC/PG]

LUDVIG FIND

Denmark 1869–1945

Ludvig Find was the son of the theologian and minister Carl Vilhelm Find. He trained first at the Jensen-Egebergs technical school and then at Copenhagen's Royal Academy of Fine Arts, which he entered in 1886. Dissatisfied with the academic curriculum, he left in 1888, and studied with Peder Severin Krøyer* at the Artists' Study School.

Find was introduced to more advanced French painting, including the decorative style of Paul Gauguin, at the French Exhibitions in Copenhagen in 1888 and '89, and soon joined the reaction against Naturalism that occupied the Copenhagen art scene in the 1890s. Although he made his debut at Charlottenborg Palace in 1889, his first impact on the critics came in 1893 with an exhibition at the Kleis Gallery in Copenhagen. A review in the newspaper *Taarnet* cited him as an exemplar of the new Symbolism.

Find exhibited at Charlottenborg until 1896 and was part of the Free Exhibition in Copenhagen in 1897. Following the more insular period of Romantic nationalism of the 1890s, he was one of the first Danish painters to renew contact with current French painting after 1900. He made his reputation as a portrait painter with a particular talent for depicting children. The majority of his work dates from the early twentieth century, and his mature style consists of a loose and bold use of color inspired by Pierre Bonnard and Édouard Vuillard. [EB]

18
Portrait of a Young Man. The Painter Thorvald Erichsen
1897
Portraet av en ung mand. Maleren Thorvald Erichsen
113.0 x 97.5 (44½ x 38¼)
Signed lower left: "Find '97"
Den Hirschsprungske Samling, Copenhagen

Find made his debut in the radical Danish artists' Free Exhibition (Den frie Udstilling) *in 1897 with* Portrait of a Young Man. The Painter Thorvald Erichsen. *The painting was also shown at the Paris World Exposition of 1900 where it won a bronze medallion. It represents a period in Find's career when his affinity with Symbolism was strongest and he had not yet developed the cheerful and painterly style of his maturity. Its subject, Thorvald Erichsen (1868–1938), earned his fame after the turn of the century as a landscapist of a bold and loose colorism inspired by Pierre Bonnard.*

Find depicts the young Erichsen sitting on a birch-wood sofa of Neo-Classical design with patterns of inlaid ebony. Behind him are several photographs of paintings framed together: Taddeo Gaddi's Presentation of the Virgin, *Masaccio's* Expulsion of Adam and Eve, *and Duccio's* Washing of the Feet, *works that Find saw in Florence and Siena in 1893–94. The style of the Italian primitives was emulated by certain Danish painters of the nineties who wished to achieve a simple, pure form of spiritual expression in their own art. Find's use of these images makes the painting a manifesto of sorts, proclaiming the artist's allegiance to the Symbolist movement.*

Erichsen sits stiffly, betraying the self-conscious intensity of a young bohemian artist. The anti-Naturalism of the painting is apparent in comparison to the most famous friendship picture in Danish art, Christen Købke's Frederik Sødring, the Painter *(1832; Den Hirschsprungske Samling, Copenhagen), which is candid, intimate, casual, and warm. By contrast, Find's portrait is proper and distant, a mood best exemplified by Erichsen's hands, the right clenched and held by the left in tense restraint.*

The formality, the somber palette, and the tight brushwork recall the portrait style of Christoffer Vilhelm Eckersberg, the father of Danish Golden Age painting. Find also uses a Neo-Classical sofa almost identical to that depicted by Eckersberg in his portrait of Madam Schmidt *(1818; Den Hirschsprungske Samling, Copenhagen; see Frederiksund, J.F. Willumsens Museum, J.F. Willumsen og den frie Udstillings første år 1891–1899, (1982), p. 44). Find was encouraged by Johan Rohde (1856–1935), a leading figure in the Free Exhibition, to revive earlier Danish painting and* Portrait of a Young Man *is a key painting in Danish art of the nineties. It reveals the desire for universal expression embodied in the Italian primitives, yet betrays a dominant nationalism that rejects French influence and revives indigenous Danish styles. [EB]*

GUSTAF FJAESTAD

Sweden 1868–1948

Gustaf Fjaestad, the son of a shoemaker, began his artistic studies in 1891–92 at the Academy of Fine Arts in Stockholm. Afterwards he trained under Carl Larsson* and with Bruno Liljefors*, whom he assisted on the backgrounds of the large dioramas at the Biological Museum in Djurgården. In 1897 he left the city and settled at Lake Racken, near Arvika, in the province of Värmland (western Sweden). Gradually others moved there as well, and a small artists' community formed around Fjaestad and his wife Kerstin Maria Hellén.

Fjaestad had his first public success in 1898 when he exhibited winter landscapes at the Artists' Union in Stockholm. From that time on his works were highly acclaimed in both Sweden and Europe. His first one-man show was held in 1908 in Stockholm, and his paintings were especially well received in Berlin in 1914 and in London in 1927.

The majority of Fjaestad's paintings depict the winter landscape: views of pristine snow-covered fields or frosted branches. These works were extremely popular and widely disseminated in reproduction. In addition to painting, Fjaestad was involved in almost every aspect of the decorative arts. He designed large tapestries (often executed by his wife), copper and wrought-iron candlesticks, lamps and household utensils, and furniture that has been described as resembling richly sculptured gnarled tree stumps covered with pine needle tufts. [WPM/PG]

19
Freshwater *1905*
Sötvatten
205.0 x 310.0 (80¾ x 122)
Thielska Galleriet, Stockholm

Fjaestad often composed landscapes with an eye toward eventually realizing them in tapestry decorations. The spatially flattened patterns of such canvases were pushed further toward abstraction in the tapestry designs. This work was woven on commission for the home of Ernest Thiel on Djurgården in Stockholm. Its cheery, sunlit decorative scheme contrasts with the subtle, muted harmonies of works such as Running Water.

This tapestry landscape suggests references to international as well as Scandinavian trends at the turn of the century – the decorative projects of Édouard Vuillard and Pierre Bonnard come to mind, for example. Fjaestad's water tapestries – especially the monumental works commissioned for Thiel's salon doors – echo Claude Monet's project for giant wall decorations of water and water lilies, conceived by the early 1900s, but not realized in the Paris Orangerie until 1927. [WPM/PG]

Running Water 1906
Rinnande vatten
Woolen fabric
203.0 x 312.0 (79⅞ x 122⅞)
Signed lower right: "F. 06"
Göteborgs Konstmuseum

Gustav Klimt
Island in the Attersee
circa 1901
100.0 x 100.0 (39⅜ x 39⅜)
Estate of Dr. Otto Kallir,
Courtesy Galerie St. Etienne, New York

20
Winter Evening by a River *1907*
Vinterafton vid en älv
150.0 x 185.0 (59 x 72⅞)
Signed lower right:
"G Fjaestad 1907 Wermland"
Nationalmuseum, Stockholm

The basic character of Fjaestad's work was formed in the 1890s and varied little during his career. Fjaestad's prefer-ence for landscape, and perhaps also some of the Japanese influence evident in this composition, stemmed from his training with Bruno Liljefors (see cat. nos. 66, 67, and 68). But the surface handling of the canvas – subtle, short, dark strokes overlaid as a rhythmic unifying pattern independent of description – seems closer to the 1890s work of Nils Kreuger, who was an admirer of Van Gogh's technique and a member of the Varberg School along with Karl Nord-ström and Richard Bergh*.*

As in the Finn Eero Järnefelt's water scenes (cat. nos. 45, 46) there is a fusion here of naturalist and decorative in-terests. All aspects are naturalistically detailed, but there is an obtrusive sense of pattern in the reflections and in the cropping of the composition. Like his horizonless downward view, Fjaestad's fascination with water's rippling movement is an Art Nouveau tendency embodied in such geographi-cally remote contemporary work as that of Claude Monet and Gustav Klimt (see left). In this particular treatment, a Symbolist tone of meditative contemplation pervades the dark, icy water with a subtle glow of pale lemon light.
[WPM/PG]

80

AKSELI GALLEN-KALLELA

Finland 1865–1931

Born with the Swedish name Axel Gallén, the artist later changed his name to the Finnish-language equivalent Akseli Gallen-Kallela as a gesture of support for the indigenous culture of his nation. His father was a Bank of Finland cashier who later became a lawyer. Axel attended Swedish grammar school in Helsinki and in 1880, at the age of fifteen, decided to become an artist. The following year he began his studies both at the Finnish Fine Arts Association and at Adolph von Becker's private academy in Helsinki. He supported himself in the early 1880s by illustrating pamphlets for the temperance movement.

Taking his painting *Boy with a Crow* (cat. no. 21) along as an example of his work, Gallen-Kallela first went to Paris in 1884 and studied there intermittently until 1890. The young Finn worked first with William Bouguereau and Robert-Fleury at the Academie Julian but soon switched to Fernand Cormon's studio. He began to associate with the colony of Scandinavian artists that included such painters as Albert Edelfelt* and Anders Zorn*.

In 1889, Gallen-Kallela became the first Finnish member of the Societé Nationale des Beaux-Arts. The next year he married Mary Helena Slöör, and the couple honeymooned in the province of Karelia, whose folkloric traditions played an important part in Finnish National Romanticism. Gallen-Kallela was at the center of the National Romantic movement, which reached its climax in the 1890s with the Russian Pan-Slavists' increasingly aggressive attempts to Russify Finland. During this period, he actively pursued themes from the *Kalevala,* the Finnish national epic, eventually creating a linear style accented by self-contained units of local color. Inspiration from *Kalevala* themes sustained him ar-

tistically for the rest of his life.

In 1895, Gallen-Kallela travelled with his family to London where he became interested in the arts and crafts achievements of William Morris. That year also marked his joint exhibition [with Munch*] in Berlin, and the creation of the magazine *Pan,* on whose staff he served along with Munch, the poet and art historian Julius Meier-Graefe, and the painters Anders Zorn, Max Klinger, and James McNeill Whistler. In 1897 he journeyed to Italy to study fresco technique, and in 1899 he used his knowledge of Trecento and Quattrocento murals to create four large frescoes depicting *Kalevala* themes for the Finnish Pavilion at the Paris World Exposition.

In 1902, Wassily Kandinsky invited Gallen-Kallela to exhibit thirty-six works in the Phalanx IV exhibition in Munich. The next year he exhibited with the Secessionists in Vienna, achieving wide acclaim. After exhibiting in the 1908 Salon d'Automne in Paris, he travelled with his family throughout Africa from 1909 to 1911. He exhibited with *Die Brücke* group in Dresden in 1910, and in 1914 the Panama Pacific World Fair in San Francisco requested seventy of his paintings – works which also travelled to New York and Chicago. Always committed to Finnish freedom, he volunteered to fight in the War of Independence of 1918.

In the last decade of his life, Gallen-Kallela's art was exhibited throughout the United States. He and his family visited Mexico in 1923 and the following year they lived in the artists' community in Taos, New Mexico. In 1931, upon returning from a lecture to the Danish-Finnish Society in Copenhagen, Gallen-Kallela contracted pneumonia and died in Stockholm. He was honored with a national hero's funeral. [SRG/SSK]

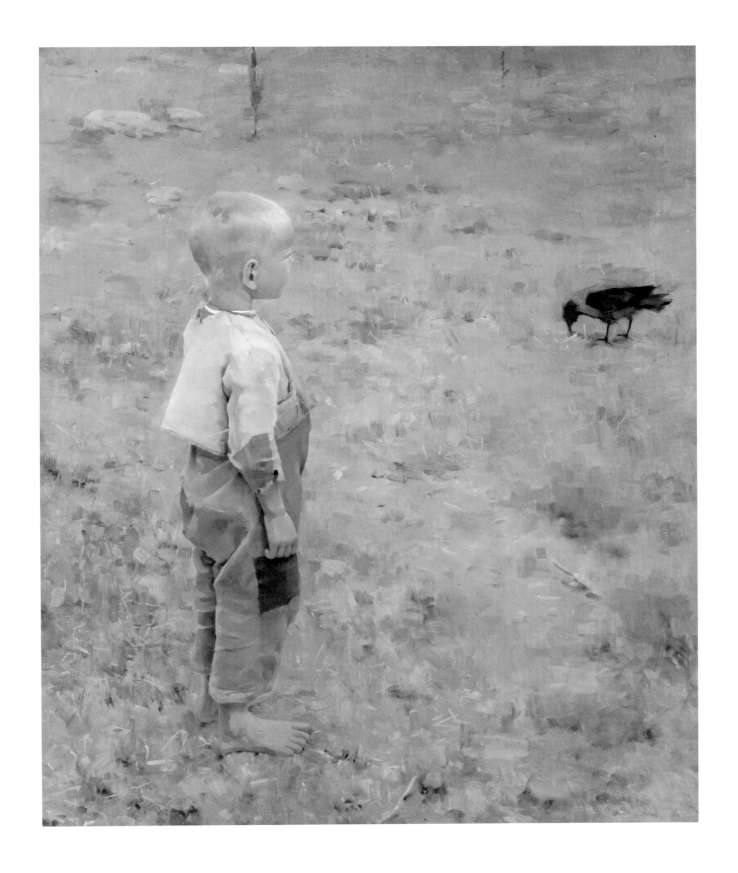

21

Boy with a Crow *1884*
Poika ja Varis
86.5 x 72.5 (34 x 28½)
Not signed
Ateneumin Taidemuseo, Helsinki (Antell Collection)

Bound for Paris in the autumn of 1884, the nineteen-year-old Gallen-Kallela self-consciously rendered Boy with a Crow as a virtuoso "admission ticket" to the Parisian art world. "When I came to Paris with this canvas in 1884," he later wrote in his Kalela Book, "the teachers were amazed at how modern it was, even though I had not seen any of the modern art of the time . . . " Painted that summer, the composition was inspired by a small peasant boy at Sipi farm, where Gallen-Kallela was staying. The boy was told that he could capture a crow by sprinkling salt on its tail, and the artist sketched him as he stalked the bird.

 This quasi-narrative genre scene was directly inspired by the work of Jules Bastien-Lepage (1848–1884), an artist who deeply influenced Finnish painters during the 1880s. Albert Edelfelt*, Finland's "cultural ambassador" to France, had become a strong proponent of Bastien-Lepage while working in Paris in the mid-seventies, and had inspired the younger generation of Finns, including Helene Schjerfbeck* and Ellen Thesleff*, to study under him. The Helsinki studio of the French-trained artist Adolph von Becker, where Gallen-Kallela studied, was also a breeding ground for Bastien-Lepage's plein-air style. Reproductions of Bastien-Lepage's work, such as Pauvre Fauvette (1881; Glasgow Art Gallery and Museum), circulated at von Becker's studio and throughout Helsinki.

 In Boy with a Crow Gallen-Kallela assimilated Bastien-Lepage's characteristic strategy of placing a highly focused figure against a blurred background. He also followed Bastien-Lepage's suggestion of painting a landscape as one sees it from a standing position, thereby avoiding the hackneyed image of a figure monumentally juxtaposed against the sky. The paint handling of the background gradually shifts from dense detail at the bottom of the canvas to longer, thinner strokes above, establishing a slight sense of recession akin to Bastien-Lepage's limited range of focus. Further, Gallen-Kallela shared Bastien-Lepage's technique of visually rooting the peasant to the soil, rendering the boy in the same pigments used for the background, and subtly shifting values of the surrounding grass to reflect the gradation of color from the boy's dark pants to his blond hair. Bruno Liljefors (see cat. nos. 66, 67 and 68) also adapted this technique in creating his mutually reflexive portraits of animals and nature.

 While absorbing Bastien-Lepage's means into his own work, Gallen-Kallela radically extended them. The overall blond tonality of Boy with a Crow, although reflective of Bastien-Lepage's palette, is suppressed into a narrow range. By dispensing altogether with a horizon line, Gallen-Kallela transforms the background into a near-abstract decorative surround resembling the insistent flatness of a tapestry. The ambiguous narrative and peculiar spatial organization of Boy with a Crow set it apart from Gallen-Kallela's other Naturalist paintings of the early eighties, creating an idiosyncratic foreshadowing of his later synthetic style. [PGB/SSK]

22

A Loft at Hoskari, Keuruu *1884*
Luhtikuja, Hoskarin Talo Keuruula
Oil on canvas glued to cardboard
33.5 x 18.0 (13 x 7¼)
Signed lower right (in monogram):
"AG/Aug 84"
Gösta Serlachiusksen Taidesäätiön Kokölmat, Mänttä

Scandinavian artists and intellectuals of the 1880s were keenly interested in humble native architecture. In Sweden the open-air museum Skansen, containing churches, cottages, and farmhouses transported from different parts of the country, was inaugurated in 1891. In Finland numerous artists and architects of the period designed studios in wilderness locations, in the style of indigenous peasant structures (see Studios in the Wilds, Artists' Country Studios at the Turn of the Century, exhibition catalogue, Helsinki: Museum of Finnish Architecture, 1978). Gallen-Kallela's own studio home "Kallela", built in 1894–95 near Lake Ruovesi, was a prominent example. Finnish native architecture also played a significant role in the Neo-Romantic architectural style evolved by Gallen-Kallela's contemporaries Lars Sonck and Eliel Saarinen.

 During his Paris years, Gallen-Kallela returned home every summer to explore Finnish culture, travelling into the wilds in search of the purity and simplicity of the uncorrupted peasant. He painted A Loft at Hoskari, Keuruu in the summer immediately following his first year of study in France.

 In this modest view of native Finnish architecture, dilapidated farm tools lie on the ground, cast in shadow between two rough wood and stone structures. Beyond the alley, a loft stands bathed in sunlight beneath a blue sky. The blondish tones of a new ladder and roof contrast with the older brown and gray wood of the loft and its neighboring structures, and the new ladder is a strong and erect foil to its decaying predecessor lying in the dimly lit debris below.

 This seemingly casual little study shows traditional architecture in a strikingly untraditional fashion. Severely

23

Old Woman and Cat, *1885*
Akka ja kissa
121.0 x 96.5 (75⅝ x 60³/₁₀)
Taidemuseo, Turku

Following his first year in Paris, Gallen returned to Finland during the summer of 1885, with a new appreciation for the indigenous Finnish landscape, inhabitants and architecture. His absorption at first hand of the lessons of French Realism and plein-air Naturalism, in addition to the edifying experience of seeing unfamiliar places, engendered in the young painter a heightened awareness of the special character of his homeland and a desire to describe it. Gallen demonstrated a particular sensitivity to the uniquely limpid quality of Nordic summer daylight in paintings such as Old Woman and Cat.

Realist painters such as Jules Bastien-Lepage and Gustave Courbet initiated a new commitment to the un-idealized facts of rural life. In this work, Gallen pushes this ethic to an extreme of hideous verism undreamed of by his French predecessors. Here a barefoot, elderly woman with outstretched hand seems to seek the attention of a cat which looks past her. The crone's wizened features, swollen feet and tattered clothing indicate Gallen's concern with the specifics of rural life as opposed to its picturesque aspect. Indeed, this painting earned Gallen the title "apostle of ugliness", an appellation shared by other late nineteenth-century Realists such as Wilhelm Leibl.

The fence functions as a barrier between the precisely depicted foreground and the summarily rendered background of field, lake and woods. Furthermore, it marks the division between the constrictive narrative pocket and the sharply contrasting, expansive, rapidly receding landscape beyond. This vista adds a dramatic, expressive dimension to the otherwise prosaic country scene by emphasizing the vast and desolate character of the Finnish countryside, with its gently rolling hills studded with lakes, fields and forests.

Although Gallen creates a successful synthesis of Realism and Naturalism in this painting, the result is far more

cropped, the building elements are composed as a flat pattern of light and shadow, with the central vertical rectangle of the alley rigorously restating the canvas's proportions. The resultant strong linear design and compression of space announce some of Gallen-Kallela's later decorative interests, and tempt one to see here evidence of the artist's contacts with advanced French painting. [SRG/SSK]

24
Démasquée *1888*
Alaston Naismalli ("Démasquée")
65.0 x 55.0 (25 ⅝ x 21 ⅝)
Signed upper right: "Axel Gallén 1888"
Ateneumin Taidemuseo, Helsinki (Antell Collection)

In 1888 Gallen-Kallela wrote home that he was painting a "dirty picture" commissioned by the Finnish collector Herman Frithiof Antell. The work he was referring to was Démasquée, and the year he painted it was a turning point for him. From the depiction of Finnish folk life, seen in Boy with a Crow *(cat. no. 21), he turned to a fascination with French bohemianism, which soon gave way to an abiding interest in Romantic themes from the Finnish Kalevala epic.*

Démasquée contains elements of several of Gallen-Kallela's preoccupations. The careful rendering of the eighteenth-century ryijy-rug reflects his interest in all aspects of the decorative arts, especially Finnish folk weavings and furniture. And the skull, lilies, Buddha, and Japanese fans point toward the more openly Symbolist content of some of his later paintings and stained-glass pieces, while also contributing a chic, cosmopolitan quality to the atmosphere of the work. Essentially, however, Démasquée is aggressively Realist. Gallen-Kallela has represented the model as a model: unglamorous, unidealized, and in an ungainly pose. A sense of artificiality is reinforced by the guitar, which obviously functions as a prop.

An impression of a rather odd lack of resolution is created by this conjunction of Symbolism and Realism. Gallen-Kallela seems to be self-consciously attempting to create a Symbolist work; yet it is so emphatically Realist that one senses something satirical or cynical in the painting. Perhaps the title was chosen for the possibilities of meaning inherent in the word: Démasquer means not only "to unmask" but also "to show one's hand," "to lay the cards on the table."
[WPM/SSK]

conventional than that of the strikingly original Boy with a Crow *of the preceding year. There, the loss of the horizon and the summarily rendered background create decorative flatness which is bolder in its spatial conception than the more prosaic landscape in* Old Woman and Cat. *[MF]*

25
Waterfall at Mäntykoski *1892–94*
Mäntykoski
270.0 x 156.0 (106 1/4 x 61 1/2)
Not signed
Private collection, Helsinki

Although National Romanticism flourished in Finland throughout the 1890s, among cosmopolitan artists like Albert Edelfelt and Gallen-Kallela the concern for indigenous elements was often influenced by broader European developments in painting. A self-conscious reference to folk art and the reduction of forms to flat, often abstract shapes resulted in a highly decorative style which was simultaneously encouraged by Émile Bernard's and Paul Gauguin's Synthetist canvases of the late 1880s and the Norwegian Gerhard Munthe's* tapestries of the 1890s. Gallen-Kallela and his circle, which included Louis Sparre*, experimented with decoration throughout the 1890s and into the 1900s, creating rugs, furniture, and appliqued and embroidered cushions.*

The specific, the symbolic, and the decorative were not always mutually exclusive terms. In the Northern Romantic art of Philipp Otto Runge (1777–1810) "the extremes of the most close-eyed perceptions of nature and [the] most visionary abstract forms and systems [had been] juxtaposed and, at times, combined" (see biblio. ref. no. 12, p. 46). Gallen-Kallela's Waterfall *continued this tradition.*

A critic who viewed this painting in the artist's studio in early 1893 commented on the presence of two allegorical figures beside the fall – a water nymph playing "nature's harp", and a human listener. Although a resident spirit of the woods and waters is common to Nordic folklore, Gallen-Kallela may have drawn specific inspiration for this conception from the Swedish painter Ernst Josephson's highly controversial* Water Sprite *of 1884 (cat. no. 49). Apparently dissatisfied with this form of outmoded allegory, however, he subsequently removed the figures (though the spellbound listener, overpainted, is still discernible at the lower right). To convey the idea of music, he painted instead five golden harp strings extending the entire length of the picture and lying tautly on the surface of the canvas in delicate tension between the specific and the evocative. This device both accentuates the familiar Symbolist analogy between art and music and reinforces the already prominent decorative qualities of the tall, flattened scene. The painted, patterned frame Gallen-Kallela designed for the work further encouraged the tapestry effect.* Waterfall, *virtually contemporary with* Symposium *(cat. no. 26), represents a transitional moment in the artist's development and is a fascinating mixture of Naturalism, Symbolism, and abstraction. [SRG/SSK]*

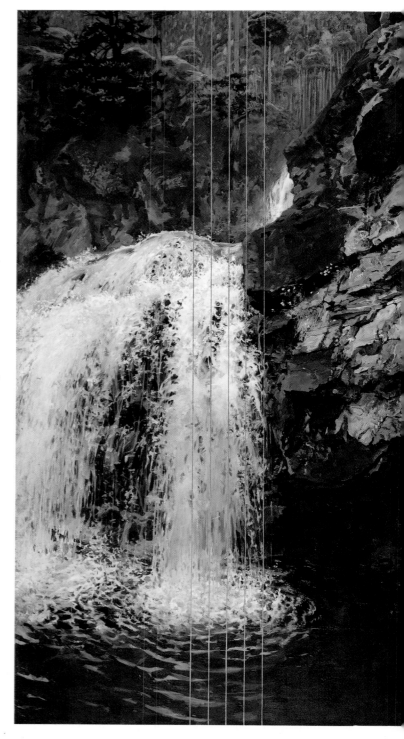

26
Symposium (The Problem) *1894*
Symposion (Probleema)
74.0 x 99.0 (29⅛ x 39)
Signed lower left (in monogram): "AGK"
Private collection, Helsinki

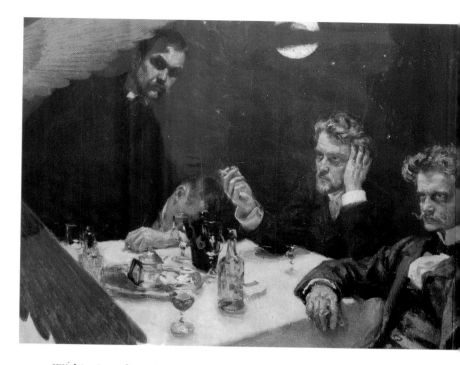

In 1892 a group of Helsinki intellectuals and artists formed Young Finland, a circle devoted to progressive art. The group included many painters with whom Gallen-Kallela had been friendly in Paris and was expanded to include the poets Juhani Aho and Kasimir Eino and the musicians Jean Sibelius and Robert Kajanus. Sibelius, whose work incorporated themes from Finnish folk songs and the Kalevala epic, had patriotic interests particularly parallel to those of Gallen-Kallela.

Symposium (sometimes called Symposion) derives its title from the Greek *symposión*, *drinking together*. The ultimate precedent for intellectual bacchanals like the one shown here is Plato's Symposium, *in which fourth-century-B.C. Athenians gathered nightly to combine drinking and rumination. Gallen-Kallela's updated version of the tradition shows (from left to right) the artist himself, the composer Oskar Merikanto (face down), Kajanus, and Sibelius.*

These bohemians stare across a table laden with empty bottles and half-filled glasses at an apparition, a creature we can only imagine from the two great wings that intrude from the left edge of the canvas. According to family tradition, Gallen-Kallela included in the original sketch a full image of a flayed sphinx, perhaps representing, as sphinxes did elsewhere in European Symbolism, the mysteries of artistic creation. Apparently because the beast was too repulsive, the artist cut down the sketch, and only the suggestive wings were transferred to the final version.

An intermediary oil study for Symposium (see right) shows that the picture strongly suggested caricature in its original conception. Though the sketch contained more obvious symbolic elements – including a naked background figure rising to the heavens, much like Gallen-Kallela's contemporary nude Ad Astra (Private collection, Helsinki) – the final version retains a strong Symbolist flavor in the wings and in the hallucinatory intrusion of the lake landscape background, where the poet Eino saw "a fantastic tree in whose top the free winds of the world play their eternal songs of power" (biblio. ref. no. 33, p. 20). It also retains some of the satirical humor of the sketch, as the elaborate contrivance of the scene and the raffish bleariness of the figures combine to spoof the tone of self-conscious solemnity. The picture was taken seriously when displayed at the 1894 Exhibition of Finnish Artists, causing a memorable scandal and bringing stinging attacks on Gallen-Kallela by his fellow painter Albert Edelfelt* and other critics.

Within Scandinavian art Symposium *falls chronologically almost exactly between Peder Severin Krøyer's* The Artists' Luncheon *of 1883 (cat. no. 62) and Vilhelm Hammershøi's* Five Portraits *of 1901 (cat. no. 33). Both the disjunctions of the picture's style – naturalistically detailed in the foreground, synthetically patterned in the nocturnal landscape background – and its decadent bohemian urbanity make it a midpoint between the hearty, sunlit conviviality of Krøyer's plein-air painters and the private, isolated silence of the artists and intellectuals in Hammershøi's picture. [SRG/SSK]*

Akseli Gallen-Kallela
Sketch for Symposium, A. Gallen-Kallela, Robert Kajanus, Jean Sibelius
1894
58.5 x 56.5 (23 x 22¼)
Gösta Serlakinsksen Taidesäätiön Kokölmat, Mänttä

27

Lemminkäinen's Mother *1897*
Lemminkäisen aiti
85 x 118 (33 ½ x 46 ½)
Atheneumin Taidemuseo, Helsinki (Antell Collection)

During the 1890s, Gallen-Kallela became increasingly interested in heightening public consciousness of a separate Finnish national identity. With this purpose, he began to execute paintings illustrating episodes from the Kalevala, a collection of legends gathered by the philologist Elias Lönnrot earlier in the nineteenth century. Lönnrot visited Karelia and recorded these stories which had passed from generation to generation through oral tradition. They comprise a mythic history of the Finnish people from the Creation until the birth of Christ.

*The Aino myth was the first tale Gallen-Kallela illustrated. Two years later, in 1890, he made his first visit to Karelia in order to provide the second version, a triptych painted at the request of the Finnish government (*The Aino Myth, *1891; Atheneumin Taidemuseo, Helsinki), with a suitably authentic setting.* Lemminkäinen's Mother *is certainly the best known of Gallen-Kallela's Kalevala paintings, which include* The Defense of the Sampo *(1900; Atheneumin Taidemuseo, Helsinki) and* Kullervo Goes to War *(1901; Atheneumin Taidemuseo, Helsinki). It appeared in 1897 at exhibitions in Helsinki and Stockholm, in 1900 at the Paris Universal Exposition and in 1901 at the Vienna Secession.*

Lemminkäinen, one of the epic's principal heroes, travelled to the Tuonela River in search of an answer to the mystery of death. By killing the beautiful swan in the river of the afterlife (analogous to the Styx), he hoped to discover the secret. Unsuccessful in this attempt, the mortal hero lies wounded, attended by his mother. In hope of reviving her dying son, she sends a bee to the sun in order to obtain a healing balm.

In the painting, the mother looks hopefully heavenward as the bee returns with the life-giving, golden rays of the sun. The shadow cast by the hero's bent arm suggests that the courageous hero still possesses some strength. Symbols of death surround the pair – the rose-colored swan, the black river, the blood-red moss covering the rocks and the skulls and bones of Lemminkäinen's failed predecessors. The story represents an allegory of man's eternal quest for the unknowable, the nobility of the search and its certain unfulfillment. For Gallen-Kallela it had a personal significance as well. In a letter to K.A. Tavaststjerna, the artist confessed: "I wonder whether I still dare to tell you that I continue to struggle with the pink swan. If only I would succeed in pulling a single pink feather from its tail, I would give it to Lemminkäinen" (quoted by Salme Sarjas-Korte in Österreichisches Museum, für Angewandte Kunst Wien, Finland 1900, p. 26). Gallen-Kallela's mother modelled for the painting, lending further evidence to the artist's identification with the young hero.

The crisp, linear treatment and intense, unmodulated colors are particularly effective for illustration and derive from Gallen-Kallela's earlier interest in Synthetism and in the lucid outlines of stained-glass, an art he began to practise in 1897. He transforms elements of both reality and fantasy in order to create a consistent and convincing mythic realm. [MF]

28

Landscape under Snow *1902*
Winterbild
76.0 x 144.0 (22^{15}/$_{16}$ x 56^{11}/$_{16}$)
Atheneumin Taidemuseo, Helsinki (Antell Collection)

Gustaf Fjaestad
Winter Moonlight, 1895
100 x 134 cm (62½ x 83¾)
Nationalmuseum, Stockholm

In 1901, Gallen received a commission for a series of monumental paintings to decorate the interior of a mausoleum in Pori, built by the Finnish industrialist Juselius in the memory of his recently deceased eleven-year-old daughter. Gallen was hired by the architect, Josef Stenback, who proposed the victory of death over life as the subject. Having suffered the death of his own daughter six years earlier, Gallen was well suited to undertake this project. In addition, his study of fresco painting in Italy and his work on the 1900 Finnish Pavilion for the Paris World Exposition gave the artist strong technical qualifications for the undertaking.

Gallen included the seasons among the subjects depicted in the mausoleum. He painted Landscape under Snow *as a study for the winter scene, with the undisturbed purity and quietude of the forest in winter serving as a conventional metaphor for death.*

Like Bruno Liljefors, Gallen's image of nature evolved from a concern for its specific incidents, to a broader interest in its cycles and patterns (see cat. no. 68). Although based on Gallen's intimate familiarity with the Finnish wilderness,* Landscape under Snow *has a strong abstract/decorative quality generally characteristic of his works at the turn of the century. This tendency grew from the artist's deepening involvement with the decorative arts – with their traditional demand for clarity and simplicity – and from the example of younger painters such as Gustaf Fjaestad* whose work Gallen could have seen at any number of international and Scandinavian exhibitions. Fjaestad specialized in snow scenes, which he began producing as early as 1895. In them he concentrated on the abstract patterns formed by the blanketing snow and the delicate, almost monochrome tonalities created by the winter light suffusing the forest.*

The snow scenes of both Gallen and Fjaestad had an important influence on the Group of Seven, a circle of Canadian painters who sought an appropriate means of express-

ing their love of the desolate beauty of the Canadian wilderness. Two of the members, Lawren Harris and J.E.H. McDonald, saw paintings by Gallen and Fjaestad at a 1913 exhibition of Scandinavian art held in Buffalo, New York (see Nasgaard, The Mystic North, *chapter 7). [MF]*

93

PEKKA HALONEN

Finland 1865–1933

Halonen's father, a farmer, was an enthusiastic amateur painter, and Pekka often experimented with the older man's paints. At his parents' request he initially attended normal school to become a teacher, but eventually began formal training in art at the age of twenty-one. He attended the Fine Arts Association in Helsinki from 1886 to 1890 and in 1891 went with the Finnish painters Magnus Enckell and Ellen Thesleff* to Paris, where he studied at the Académie Julian for a year. Drawn to the art of Jean François Millet, Camille Corot, and Pierre Puvis de Chavannes, he maintained a Naturalist style, intentionally shying away from Modernism.

The artist returned to Helsinki in the summer of 1892 and travelled east to the province of Karelia. "Karelianism" was the name given to the Finnish National Romantic movement of the 1890s, and pilgrimages to this province were an integral part of the National Romantic painters' mission to find their Finnish roots, for there the old ways of peasant life were preserved. In Karelia Halonen associated with the patriotic painters Albert Edelfelt* and Akseli Gallen-Kallela*.

In 1892–93, the artist experienced a severe religious crisis after reading Leo Tolstoy's writings on practical Christian theology. He returned to Paris in the fall of 1893 and became fascinated by theosophy. In 1894, influenced by the art of Paul Gauguin, he adopted the Synthetist style visible in *Wilderness*. He became interested in fresco painting, especially that of Giotto, and travelled to Italy to study it in 1896–97, around the same time as Gallen-Kallela.

Though deeply patriotic, Halonen never painted themes from the Finnish national epic, the *Kalevala*. His reputation rests on his calm and harmonious vision of Finnish nature, permeated throughout by soft, blondish light. His many winterscapes are especially highly regarded. He exhibited in Stockholm in 1897, with the exhibition of Finnish and Russian artists in 1898, and in the Finnish Pavilion at the 1900 Paris World Exposition. In later life his style became looser and more Impressionistic, akin to that of the late Monet, and he incorporated religious themes into his work. [SRG/SSK]

29
Karelian Playing the Kantele *1892*
Kanteleensoittaja
53.0 x 51.0 (33 ⅛ x 31 ⅞)
Collection of Inger Kokeakiva, Oulu

In 1892, Halonen made his first visit to Karelia. Many believed that the adventures of the Kalevala *actually took place in this remote area of what is now eastern Finland and the northwestern Soviet Union. Protected from extensive knowledge of the outside world by harsh weather conditions and natural barriers, the natives practised customs and arts which had continued with little change for centuries. For those seeking to establish a strong national consciousness, these people, untainted by contact with the rest of Scandinavia and Europe, seemed to present a living record of pure Finnish traditions. In addition to Halonen, Akseli Gallen-Kallela*, the composer Jan Sibelius and the poet Eino Leino drew inspiration from the customs and folklore of Karelia.*

Recording the unpretentious, yet arduous life of the Karelians particularly interested Halonen. Here he depicts an elderly man playing the kantele, a five-stringed harp which the artist's own musically-inclined mother recently had learned to play. The blind man's inward concentration on a familiar song, and his coarse hands, hardened by manual labor, communicate the solitude and simplicity of life in the Finnish wilderness.

In this work, Halonen's conception of music's function and qualities differs markedly from that of Halfdan

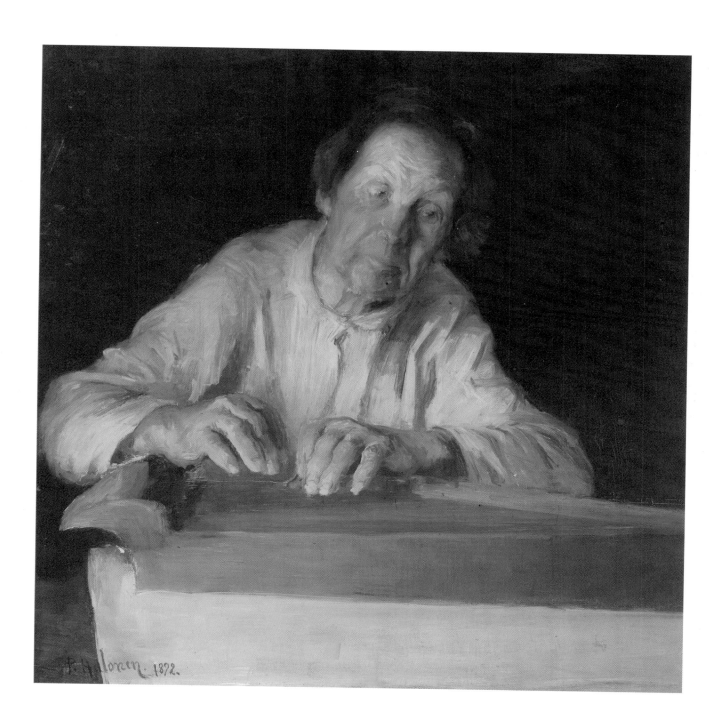

Egedius, who reveals the mysterious power of folk music to incite ecstasy in Play and Dance *(cat. no. 13). To the contrary, Halonen's introspective, quiescent vision emphasizes music's soothing, familiar character. Both Albert Edelfelt* and Eero Jarnefelt*, who like Halonen adhered to a style of modified Naturalism, painted similar subjects in subsequent years. [MF]*

30

Wilderness *1899*
Erämaa
110.0 x 55.5 (43 1/4 x 21 7/8)
Signed lower right: "P. Halonen./1899"
Turun Taidemuseo, Turku

In 1899 Czar Nicholas II issued the February Manifesto, bringing Finland under the dominion of Russian imperial legislation. In a letter to fellow artist Emil Wikström, Pekka Halonen wrote of this challenge: "The Finnish people are tough as Juniper; we can't be beaten by so little . . . the land and the nation will live!" Halonen's comparison of his countrymen with wood was a theme that found frequent expression in the forested landscapes and images of lone trees in Northern Romantic painting. In the Wilderness *canvas, Finland's forest stands as a symbol of nationalist sentiment in a year of crisis.*

Wilderness *may also be viewed as an image of Finland's most important natural resource. The Finnish forest industry developed rapidly in the late nineteenth century as lumber was needed for, among other things, the expanding railway network of Scandinavia. As virgin land was tapped, peasant farmers acquired unprecedented wealth, changed their way of living, and became increasingly dependent on the external market (see John H. Wuorinen,* A History of Finland, *New York, 1965). Eero Järnefelt's* 1893 painting* Burning the Forest Clearing *(Ateneumin Taidemuseo, Helsinki), with its subtitle* Slaves to Money, *apparently refers to this shift. By the late 1890s the undeveloped Finnish forests had thus become a Janus-faced symbol of Finland as not only enduring but also increasingly surrounded and threatened.*

The picture's insistent verticality and radical cropping at the top help to accentuate the height of the trees, transfiguring them into potent and lasting natural forms that continue to grow well beyond our field of vision. The sparsely needled parallel conifers are compressed into a shallow space that further accentuates the image's power and aggressiveness.

At the turn of the century Halonen painted other works in this highly linear and somberly colored style derived from Parisian Synthetism. Winter Day *(1899; reproduced in Ooti Hämäläinen, 1947) is also vertically conceived and cropped at the top like* Wilderness, *and features a tree dominating the shallow space. The format and style of* Wilderness *likewise strongly recall Akseli Gallen-Kallela's** The Woodpecker *of 1893 (Collection of Jörn Donner, Helsinki), and the muted palette is reminiscent of paintings by Pierre Puvis de Chavannes. [SRG/SSK]*

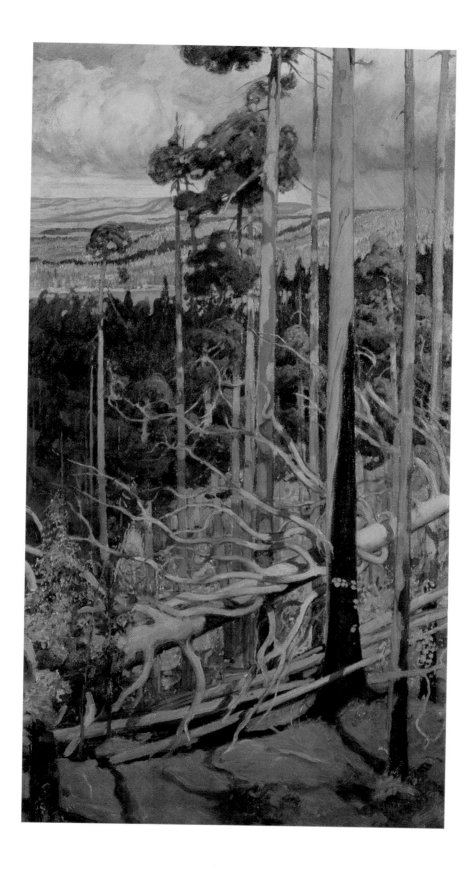

VILHELM HAMMERSHØI

Denmark 1864–1916

Hammershøi was born, the eldest of three children, to Frederikke Rentzmann and the Copenhagen merchant Christian Hammershøi. His biography is void of dramatic event, since he left no written commentary on his art, and he was, by nature, a highly sensitive, private, and stubbornly silent man. (Olsen, "Vilhelm Hammershøi" in Ordrupgaard, 1981, p. 31). In September 1893 he married Ida Ilsted, the sister of the Danish painter Peter Ilsted (1861–1933). The couple remained childless, a condition that undoubtedly contributed to the pervasive stillness, the lack of youth and vigor, so characteristic of Hammershøi's painted interiors. It also left them free to travel. Hammershøi made fourteen trips abroad, including extensive tours of Germany, the Netherlands, Belgium, and Italy, and periods of residence in Paris (October 1891–March 1892), London (October 1897–May 1898), and Rome (October 1902–February 1903).

Although well aware of current European trends, Hammershøi maintained a self-conscious dialogue with the artistic traditions of his homeland. Ironically, he was viewed as the most representative and interesting of Danish painters by foreign critics but suffered from neglect in his native country, save for the invaluable patronage of the Copenhagen dentist Alfred Bramsen. He exhibited at the Paris World Expositions of 1889 and 1900, and in Munich (1891, 1892), St. Petersburg (1897), Berlin (1900, 1904, 1905), London (1907), and Rome (1911). The sophistication and Symbolist tenor of his art appealed to an international audience, and his admirers included Théodore Duret, Sergei Diaghilev, and Rainer Maria Rilke.

Hammershøi began his artistic training in 1878 under the landscape painters Frederik Rohde (1816–1886) and Vilhelm Kyhn (1819–1903). From 1879 to 1884 he studied at Copenhagen's Royal Academy of Fine Arts with C.F. Andersen and H. Grønvold. In 1883 he enrolled concurrently at the Artists' Study School, where, under the tutelage of Peder Severin Krøyer*, he learned to draw from the live model and paint *en plein air* – exercises not offered in the academic curriculum. It was apparent in his student work that his style conformed neither to the exactitude of academic taste, nor to the restless bravura of Krøyer. Instead, the formative influence on his early development was the art of James McNeill Whistler, a debt made explicit in his *Portrait of the Artist's Mother* (1886; private collection), a paraphrase of Whistler's *Arrangement in Black and Gray: The Artist's Mother* (1887; Louvre, Paris). In 1885 he made his debut in Copenhagen's annual Charlottenborg exhibition, the equivalent of the French Salon, with the well-received *Portrait of a Young Woman* (Den Hirschsprungske Samling, Copenhagen). In 1888 and 1890, however, his entries were rejected by the Charlottenborg committee. As a result of these refusals and general dissatisfaction with the academy, Hammershøi and five other artists formed *Den frie Udstilling* (the Free Exhibition) in 1890.

In the nineties Hammershøi experimented briefly with more overt modes of Symbolism. His first programmatic painting, *Artemis* (1894; Statens Museum for Kunst, Copenhagen), was an unsuccessful attempt to incorporate the style of the Italian *primitifs,* who were then enjoying a vogue among the younger Danish painters (see Ludvig Find, cat. no. 18). In *Three Young Women* (1895; Ribe Art Museum) he was inspired by the decorative style of Paul Gauguin. Ultimately these manners were in-

compatible with his innate preference for suggestion and understatement. By the late nineties he consolidated his technique: the enveloping atmosphere, first gleaned from Whistler, developed into a methodical application of short, layered strokes, and was limited to a silvery-gray tonality. At this time, Jan Vermeer's influence appeared, specifically in the *Double Portrait of the Artist and his Wife* (1898; Aarhus Kunstmuseum).

The first decade of the twentieth century marked Hammershøi's maturity and high point. From 1899 to 1909 he lived in an historic Christianshavn house built by the Lord Mayor Mikkel Vibe in 1636. There he painted the interiors that made his reputation. In 1911 he was one of five artists to win a *Grand prix* at the International Exhibition in Rome. His last trip abroad was to London in 1913. Weakened by the death of his mother and by his own serious illness, he painted little after 1914. He died at the age of fifty-one on February 13, 1916. [EB]

31

A Farm at Refsnaes *1900*
Bondegård. Refsnaes
53.0 x 62.0 (20⅞ x 24⅜)
Signed lower right: "V.H."
Davids Samling, Copenhagen

Refsnaes is a peninsula on the west coast of Sjaelland. Its flat landscape is dotted with traditional thatched-roof farmhouses like these depicted by Hammershøi. Such distinctly Danish buildings were a popular subject among turn-of-the-century painters who wished to assert their national heritage – Julius Paulsen (1860–1923) and Laurits Andersen Ring, for example. The motif appears among Hammershøi's earliest works, including* Farmhouse *(1883; private collection) and* Landscape with Farmhouse *(1886; Marie Louise Koch,*

Copenhagen), both of which are rendered in a heavy, generalized manner.

In this mature work, Hammershøi concentrates on the precise articulation of the timid light of winter. The cloudless sky and barren ground form a uniform plane of gray, disturbed solely in the foreground by slices of falling shadow. Utter silence and stillness prevails, except for the pale shaft of smoke that rises, barely discernible, into the gray expanse of sky. The smoke and the open door are the only hints of human presence. Hammershøi betrays an obsessive attention to the rendering of the most minute details and subtle gradations of tone. Even the immateriality of reflected light is captured and ordered into pattern on the window panes. The artist establishes a play between the long line of the roof and the staccato rhythm of the windows along the wall. He guides our eye to the space between the

house and barn, directing us by the arrow of light on the ground, the placement of the two rocks, and the beckoning illumination from around the corner. The finely tuned tenor of the picture creates a gradual, unresolved tension and heightens our awareness of a reality beyond the visible.

The critic Andreas Aubert noted Hammershøi's overt anti-Naturalism as early as 1890 and considered the artist an exponent of the new aesthetic of Decadence (Heller, 1978, p. 81). Hammershøi and Munch* were the only Scandinavians to be singled out by Aubert and were thereby associated with the international coterie of James McNeill Whistler, Pierre Puvis de Chavannes, Arnold Böcklin, Max Klinger, and Gabriel Max. [EB]

32
Dust Motes Dancing in Sunlight *1900*
Støvkornenes dans i solstrålerne
70 x 59 (43¾ x 36⅞)
Not signed
Steen Kristensen, Copenhagen

Images of a solitary woman in an interior, and of stark, empty rooms, dominate Hammershøi's oeuvre during the years he lived in an historic Copenhagen residence at 30 Strandgade. Although the Strandgade house dates from 1636, when it was built by the Lord Mayor Mikkel Vibe, the rooms that Hammershøi occupied on the piano nobile were of late eighteenth-century design. Dust Motes Dancing in Sunlight is one of the first of more than sixty interiors painted in these rooms (Hansen, "The Black and White Colorist," in Ordrupgaard, 1981, p. 14) and is the most celebrated of a series depicting patterns of sunlight in the somber recesses of his home. All is mute and incorporeal; space is defined solely by the vibrating rays of the white light tinged with violet, and by the abstract geometry of the interior design. Six years later, Hammershøi painted an almost identical version, Study of a Sunlit Interior (1906; Davids Samling, Copenhagen), wherein only the time of day, quality of light and location of the pattern cast upon the floor have changed.

Of all the Scandinavian painters of the late nineteenth century, Edvard Munch and Vilhelm Hammershøi were the most noted for their neurasthenic temperaments and for their ability to render their emotional sensitivity through expressive line and color. Both artists favored the light-filled window as a visual symbol and personal vehicle of introspection (see, for example, Munch's Night, cat. no. 70, or Young Woman at the Window, a print of 1894; Schiefler, 1923, no. 5). Hammershøi's use of the motif, however, is more radical than Munch's, for his interior lacks curtains, furniture, or most significantly, a human figure in the act of contemplation. Instead, the viewer becomes lost in the dream-provoking emptiness of the room. Nothing is more ethereal yet more thought-absorbing than the sunlight filtering through the window panes. [EB]

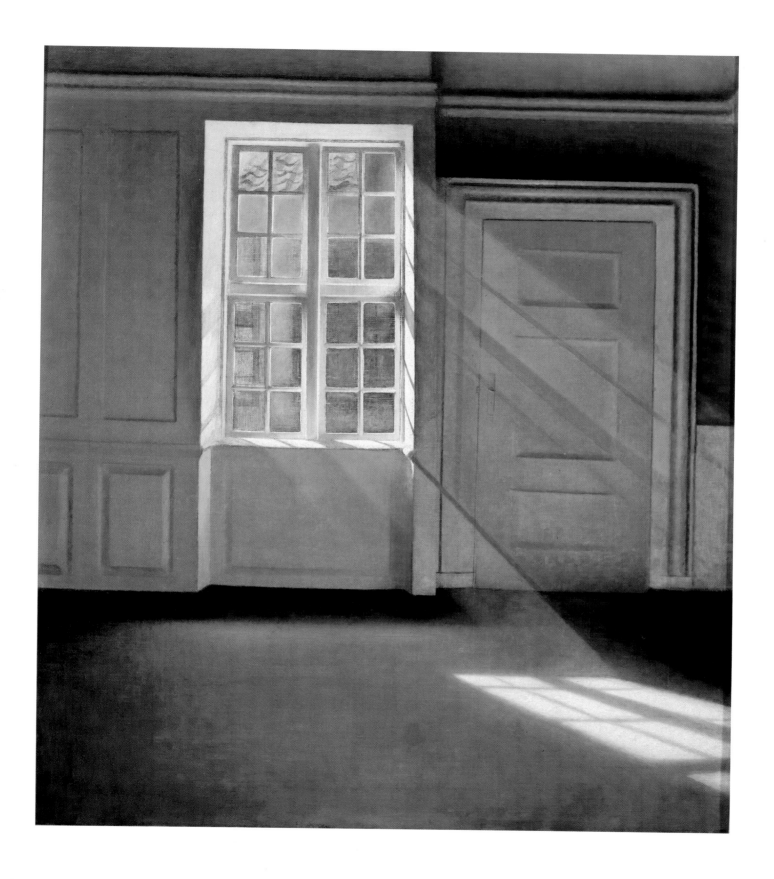

33
Five Portraits *1901*
Fem portraetter
190.0 x 300.0 (74¾ x 118⅛)
Not signed
Thielska Galleriet, Stockholm

Five Portraits *has been called the most forceful painting in Danish art (Wanscher, 1915, p. 407). It portrays five friends of the artist, all supporters of the progressive Free Exhibitions. From the left they are the architect Thorvald Bindesbøll (1846–1908); the artist's brother Svend, (1873–1948), also a painter; the art historian Karl Madsen (1855–1938); and the painters Jens Ferdinand Willumsen (1863–1958) and Carl Holsøe (1863–1935). The five friends are depicted in the evening, in the sitting room of Hammershøi's Copenhagen residence at 30 Strandgade. The veil of brushstrokes and the subdued but infinite values of gray contribute to a sense of mystery, and the silence, the solitude, and the darkness make* Five Portraits *a masterpiece of the Symbolist tradition.*

Hammershøi intended the picture to be a tour de force, *and he did several compositional sketches and individual portrait studies in preparation for the final version (Statens Museum for Kunst, Copenhagen). It is argued that he was influenced by Rembrandt's* Claudius Civilis *(1662; National museum, Stockholm), which he saw in 1897 (Vad, 1957, p. 17). Certainly there is a similarity in the almost supernatural luminosity of the tablecloth, and Rembrandt's subject of an oath of rebellion may have appealed to Hammershøi in his depiction of a group of secessionist artists.* Five Portraits, *however, is devoid of any anecdote or drama. It lacks the bohemian fellowship of Gallen-Kallela's* Symposium *(cat. no. 26) or, as Professor Gert Schiff of the New York University Institute of Fine Arts has noted, the sense of conviviality evoked in such other contemporary group portraits as Lovis Corinth's* The Freemasons *(1889; Stadtische Galerie, Lenbachhaus, Munich). It is a friendship picture unlike any other in the long European tradition of painting comrades gathered round a table.*

Despite attempts to liken the table to a coffin or the position of Svend to that of Judas in depictions of The Last Supper *(Wanscher, 1915, p. 407),* Five Portraits *resists interpretation. The painting's force rests in its ambiguity and impenetrability. Though brought together for a group portrait, the five friends are shown in disparate attitudes, isolated from one another, each lost in private thought. Faced with impervious gazes and preoccupied stares, the viewer feels ill at ease among such inaccessible personalities. There is also something enigmatic in the circumstance of their assembly – a pervasive sobriety that suggests the occasion of a ritual. The stiff, formal attire of the men at back, the central place-*

ment of the attenuated candles, and the delicate glasses set amidst these ponderous forms all add to the intensity of mood. Although the tension is somewhat relieved by the near-comic enormity of Holsøe's feet, his very posture reinforces the sedentariness, the inaction of the group.

The painting was shown in the Free Exhibition of 1902, the Venice Biennale of 1903 and the Berlin Secession exhibition of 1904. In 1904, Hammershøi began a sequel to the work entitled Evening in the Room (Statens Museum for Kunst, Copenhagen), but abandoned it before completion, bitterly disappointed by the failure of a Danish museum to acquire Five Portraits. In the following year, Five Portraits was purchased by the Swedish collector Ernest Thiel at an exhibition in Göteborg. [EB]

34
Christiansborg Palace 1902
Christiansborg Slot
117.0 x 139.0 (73⅛ x 86⅞)
Private Collection

The seat of the Danish Parliament, Christiansborg Palace, was founded in 1167, destroyed by fire and rebuilt several times over the centuries until it evolved its characteristic rococo facade. In this version of 1902, Hammershøi depicts the Marmorbroen, or marble bridge, over the Frederiksholm canal, the ornate sculptural ensemble of the entrance pavilions, and at left, the curved walls of the palace riding-court. Planes of white, wintry light abut sharply with the bulky mass of gray masonry, heightening the play between surface and depth, set off by the closely cropped foreground and oblique angles of the canal walls. Only the warm tones of distant copper rooftops relieve the astringent and melancholic atmosphere of the scene.

Throughout his career, Hammershøi painted historic landmarks of Denmark: the castles of Fredriksborg in Hillerød and Kronborg in Helsingør, and Copenhagen's royal residence, the Amalienborg Palace. As does the Marmorbroen, these buildings stand completely deserted and shrouded in a gentle mist, and are seen from atypical or intimate angles to promote the impression of a mysterious encounter. An unsettling stillness presides over sites formerly alive with human drama, and a sense of nostalgia permeates their walls.

The image of a sleeping or abandoned city had been made famous by the Belgian poet Georges Rodenbach in his 1892 Bruges-la-Morte, and international critics commented on the similarity between Rodenbach and Hammershøi. William Ritter, for example, considered the poet and the painter "sister natures" preoccupied with the theme of silence (Ritter, 1909–10, p. 264). Rodenbach's Bruges had inspired a series of illustrations begun in 1904 by his compatriot Fernand Khnopff, and Hammershøi and Khnopff employed like means: the fragmented view, the melting edges of monumental forms, the concentrated absence of life and movement. Hammershøi's mature versions of the sleeping-city theme date from the early 1900s, and even earlier pictures of farmhouses or the towers of Kronborg castle emanate the same studied quietude. His depiction of historic Danish architecture – for reasons of national pride and interest in monumental form – had its precedent in Danish Golden Age painting. The twilight setting and contemplative mood of Christen Købke's Fredriksborg Castle at Dusk (1835; Den Hirschsprungske Samling, Copenhagen) provided an important example. [EB]

35
The Buildings of the East Asiatic Company 1902
Asiatisk Kompagnies bygninger
158.0 x 166 (98¾ x 103¾)
Private Collection

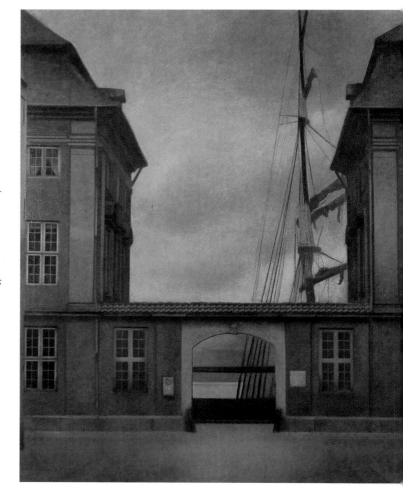

The silence that reigns over Hammershøi's domestic interiors continues in his views of monumental architecture. In addition to painting the historic buildings of Denmark, giving a new and dream-like context to landmarks of both personal and national memory, he repeatedly depicted the less prestigious warehouses of the East Asiatic Company across the street from his home. These commercial buildings are located in Christianshavn, the harbor quarter of Copenhagen built by Christian IV in the early seventeenth century. In 1913, Hammershøi moved to the East Asiatic Company buildings, and lived within the walls of the old trading offices until his death in 1916.

Hammershøi frequently rendered the fog-laden canals of Christianshavn, drawn to the melancholic vistas of aged wharfs and abandoned warehouses, and deserted ships with their masts stripped bare. Typically, his palette is restricted to shades of oyster, silver-gray and pale blue, creating a palpable atmosphere, dank with sea air. The staunchly symmetrical view of The Buildings of the East Asiatic Company *is taken from the end of Skt. Annegade, confronting the gateway of the warehouse at 25 Strandgade. In 1907, Hammershøi painted the same composition in a winter climate (Private Collection).*

Hammershøi's evocative style distinguishes him from the robust naturalism of his compatriot Peder Severin Krøyer, and from the early phase of the Danish Symbolist movement, as represented by the explicit narratives of Jens Ferdinand Willumsen. The critic Emil Hannover called Hammershøi the* "Nordic counterpart to des Esseintes" (Hannover, 1922, p. 346), *the decadent hero of Joris Karl Huysmans's novel* À Rebours *(1884). Although Hammershøi shared themes with the French and Belgian poets, his work also had close ties to an indigenous school of Danish Symbolist literature, and has been compared to that of his friend, the poet Sophus Claussen (1865–1931), whom he visited in Rome in 1902 and 1903 (Finsen in Ordrupgaard, 1981, p. 8). His temperament was also similar to that of the decadent protagonist in* Niels Lyhne, *Jens Peter Jacobsen's novel of 1880. Jacobsen was a strong influence on the German poet Rainer Maria Rilke (see Lydia Baer, "Rilke and Jens Peter Jacobsen,"* Publication of the Modern Language Association of America, *54, no. 3, September 1939, pp. 900–932; no 4, December 1939, pp. 1133–1180), who admired Hammershøi and planned to do a monograph on him (Finsen in Ordrupgaard, 1981; p. 6). Hammershøi, like Rilke, belonged to Jacobsen's "Company of the Melancholy" group of ar-*

tists who have been described as "robust neither in their persons, nor their poetry; poets of dreams and longing, tending towards segregation, loneliness and solitude" (Baer, 1939, p. 903). [EB]

36
Open Doors
(White Doors) *1905*
Åbne døre (Hvide døre)
52.0 x 60.0 (20½ x 23⅝)
Not signed
Davids Samling, Copenhagen

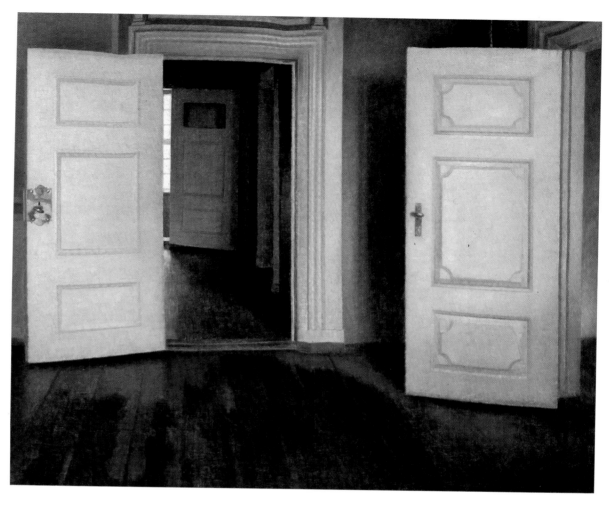

The Scandinavian art historian Poul Vad considered Open Doors (White Doors) *Hammershøi's most important work, an opinion supported by Vad's colleague Jens Thiis, who called it "the essence of his genius". (Vad, 1957, pp. 22–23). It was appropriate that Hammershøi, the isolated artist and introspective man, should find his leitmotif in the inner recesses of his home seen through the veil of his neurasthenic sensibility. The room is filled with the sense of someone's recent departure and the expectation of their return, an "indissoluble tension, a vestige of a complete human drama that still hangs on the walls and the doors" (Thiis quoted by Olsen, "Vilhelm Hammershøi" in Ordrupgaard, 1981, p. 29). The flash of reflection from the brass door handle and the ethereal line of light that falls along the floor convey an impression of transience. Yet time also seems unnaturally suspended. The doors appear to hover slightly, and their frames swell; there is a moment of hesitation before the journey through the open doors, into the hallway, and*

towards the light. The view into a back space was made famous by the seventeenth-century Dutch masters, who used the device to present an informal but intimate glimpse into everyday life. But Hammershøi transforms the motif into a modern metaphor of passage, and the serenity of quiet spaces is replaced by a haunted emptiness.

Open Doors was exhibited during the artist's lifetime in Berlin (1905), London (1907), Rome (1911), and New York (1913), and contributed to his reputation as "the painter of deserted rooms" (Poulsen, 1976, p. 143). He shared this distinction with the Belgian Xavier Mellery (1845–1921), whose series of drawings, L'âme des choses (The Soul of Things), was begun in 1889. Yet Mellery's more theatrical scenes depend on dramatic shadows and the eerie presence of sculptures and plants. Hammershøi's means are less explicit and ultimately more evocative; Open Doors (White Doors) *is a conception without parallel in the art of its time. [EB]*

37
Interior with Punchbowl *1907*
Interior mid punchebolle
64 x 59 (40 x 36⅞)
Signed lower right: "V.H."
Private Collection

In his sequence of interiors at 30 Strandgade, Hammershøi concentrated on the variation of a few chosen corners of his home, rearranging the furniture, shifting the angle of view, or changing the poses of his wife. His devotion to the rooms and objects of his residence parallels similar series by the Belgian artists Georges Le Brun (1873–1914) and Xavier Mellery (1845–1921). For Hammershøi, the interior provides a retreat from modernity and the outside world. It is an inner sanctum of serene classical design, of fine objects filled with memories, and of mahogony furniture imbued with the past. Interior with Punchbowl *is one of the few to include the living greenery of a potted plant, seen here by the wintery light of the window, and it is the only image to bear the artist's empty easel. Although the painting lacks the presence of Hammershøi himself, or even one of his canvases, the easel nonetheless refers to the labors of the artist, and suggests that* Interior with Punchbowl *is a symbolic self-portrait.*

The delicate blue and white Copenhagen porcelain, the piano, and the print of a cityscape above it are featured in several other works by the artist; and the asymmetrical composition here is nearly identical to that of Interior with Empire Furniture *(Private Collection), painted in the same year. The intimate glimpse into the room beyond, as well as the charged meditation upon lowly household objects, betrays the influence of Pieter de Hoogh and Jan Terborch. Hammershøi saw works by the Dutch artists during his pre-1900 trips to Dresden, Amsterdam and London.*

The vacant easel, unseen window and silent instrument seen at back behind the linen tablecloth laid bare, are similar to devices that Jan Vermeer used in creating the sensation of a moment frozen in time. Although the revival of seventeenth-century Dutch masters was prevalent at the turn of the century, Vermeer was viewed as different from the rest and enjoyed a Symbolist interpretation (for an example, see Gustave Vanzype's Vermeer de Delft. Brussels: G. Van Oest and Co., 1908). *Vermeer's canvases produce an emotive resonance rooted in the meticulous observation of the material world, a bridge between Naturalism and Symbolism that Hammershøi would have found congenial to his own aims. Both artists thrive on paradox as a pictorial strategy: "Images of full presence double as evocations of absence and aloneness. Completeness of being resonates with intimations of death and impending loss; an atmosphere of timelessness evokes thoughts of evanescence, of the momentary, of life passing and passing by" (Description of Vermeer by Edward Snow,* A Study of Vermeer. Berkeley: University of California Press, 1979, p. 10). [EB]*

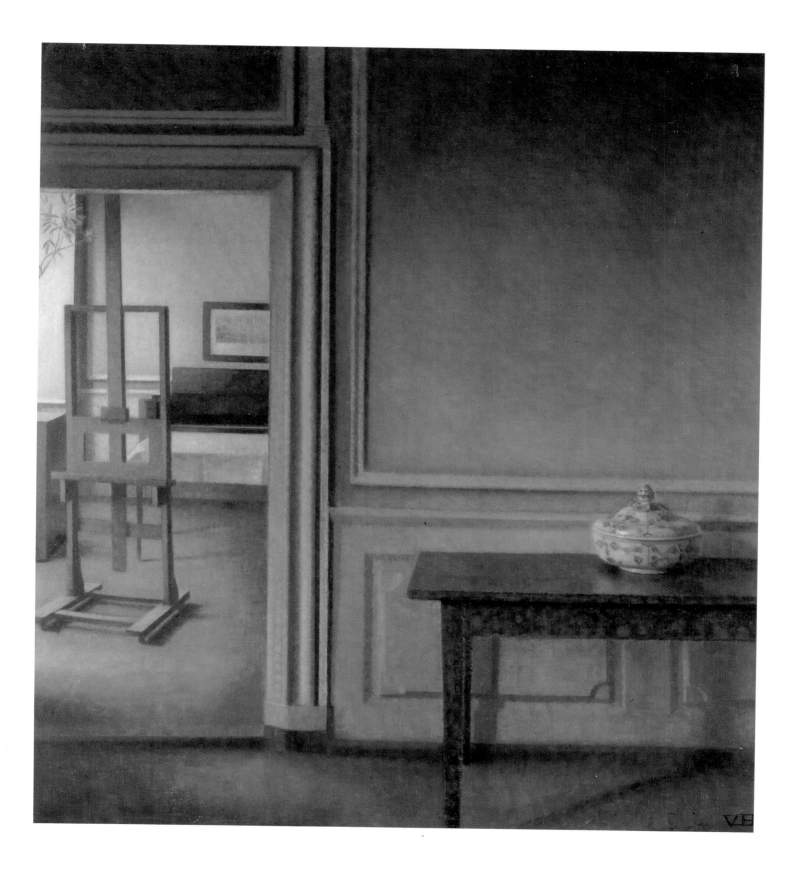

38

Interior with a Seated Woman *1908*
Stue med kvinde siddende på hvid stol
71.0 x 57.5 (28 x 22⅝)
Signed lower left: "V.H."
Aarhus Kunstmuseum

Hammershøi executed a series of sitting or standing figures in combination with the doors of the ante-room depicted in Open Doors *(cat. no. 36). The image here is similar to one painted by the artist in 1900,* Interior with a Woman Seated on a White Chair *(Private Collection). In other versions the woman stands on the threshold of the open door or has progressed to the middle of the back hallway. Typically, she is presented with her back to us, preoccupied by her reading or some undefined activity. Unlike the traditional Romantic figure who longs for freedom by an open window, the woman in Hammershøi's interiors does not resist her enclosure, but becomes immutably ensconced among the objects and furniture that surround her.*

Paintings of domestic interiors have a long history in Danish art, beginning with the Biedermeier scenes of Christoffer Vilhelm Eckersberg (1783–1853) and his pupils. These artists expressed the unpretentious comfort of their bourgeois environments with a clarity of observation and strict architectonic design, vestiges of the classicism that dominated Copenhagen's Royal Academy of Fine Arts at the turn of the nineteenth century. Hammershøi continued this tradition in the composition of his interiors, playing horizontal against vertical, two-dimensional design against spatial illusion. He once commented on his art, "When I choose a motif it is first and foremost the lines that I consider" (Vad, 1957, p. 24). In Interior with a Seated Woman *there is a delight in the repetitive geometry of the wainscoting and door moldings and in the reverberation of rectangles across the picture plane and into space.*

Although a nostalgia for the Danish Golden Age is central to his art, Hammershøi departs from these traditional interiors and from those of his contemporaries Peter Ilsted (1861–1933) and Carl Holsøe (1863–1935). The juxtaposition of an abstract surface geometry with a palpable haze of brushwork gives his work its special tension. The veil of atmosphere creates a continuum informed by spirit, where "not too solid matter shades imperceptibly into a space not truly void" (Robert Goldwater, Symbolism, *New York: Harper and Row, 1979, p. 159). The familial* Gemütlichkeit *and Protestant simplicity so essential to the Biedermeier character are replaced by melancholy, solitude and fragile asceticism. [EB]*

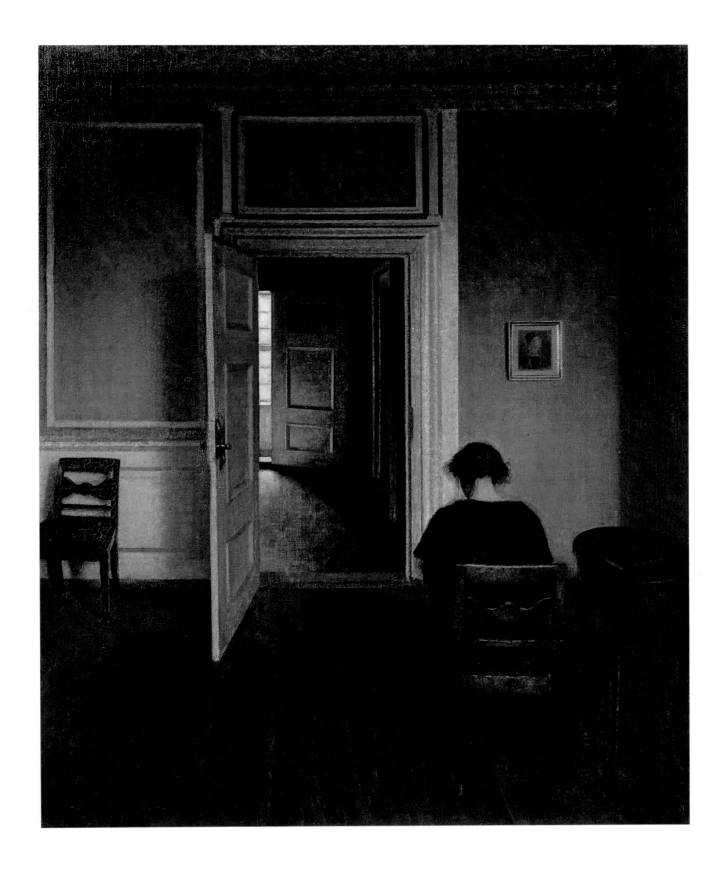

EUGÈNE JANSSON

Sweden 1862–1915

A life-long resident of Stockholm, Eugène Jansson began his artistic training at the city's technical school in 1878 under Edward Perseus (1841–1890). He continued his studies at the Royal Academy of Fine Arts under Georg von Rosen (1843–1923), a noted painter of portraits and historical subjects. His early works include still lifes and portraits of family members.

Becoming acquainted with the radical Swedish painters who had returned from France, Jansson joined the Artists' Union in 1886. He served as secretary of the Union and remained an active member the rest of his life. He was plagued by economic difficulties, ill health, and a progressive loss of hearing.

At the recommendation of Karl Nordström*, the collector Ernest Thiel began to take an interest in Jansson's views of Stockholm in the late 1890s. Thiel bought several paintings and sponsored Jansson's trips to Paris in 1900 and to Italy and Germany the following year.

From 1890 to 1904 Jansson painted city views almost exclusively. In 1905 he turned to male nudes – a change of subject matter that links him with the prevailing interest in vitalism. He was secretive about the change and did not exhibit the new works until 1907. In this last period he also painted portraits and military dances. [RH/PG]

39

Dawn over Riddarfjärden *1899*
Gryning över Riddarfjärden
150.0 x 201.0 (59 x 79⅛)
Signed lower left: "Eugène Jansson/1899"
Prins Eugens Waldemarsudde, Stockholm

Many of Jansson's nocturnal cityscapes of the 1890s represent views from his studio or apartment in the southern part of Stockholm. According to contemporaries, he painted from memory to record the feelings he experienced while watching the quiet city (biblio. ref. no. 100, p. 282). Here the view is from a high vantage point over the dark forms of the Södra hills and the white strand with boathouse and ships, looking across the Riddarfjärden bay which separates the southern and northern parts of the city. In the background the coastline and skyline are rendered summarily but accurately: the reflections in the water conform to reality, as do the relative size and location of the church steeples piercing the sky. At the center is the spire of Riddarholm Church, the largest church in Stockholm.

The fascination with shore lights and their reflections, the high horizon line, and the color harmonies recall the 1870s Nocturnes of James McNeill Whistler, whose work was an important influence upon Swedish and Norwegian "Blue Painting". Edvard Munch was also a major influence on Jansson, and the major exhibition of Munch's work in Stockholm in 1894 stimulated Jansson's development of city views. Works of 1894 that depict part of the site pictured here include more details of the strand, the hills, and the anchored ships. In the Southern Strand of 1896 (Thielska Galleriet, Stockholm) Jansson eliminated much of the detail and absorbed all angularity into the bold, flowing contours that characterize works from the height of his blue period. The directional brushstroke that creates the sense of an energized field is related to works by Van Gogh and the Varberg painters Nils Kreuger and Karl Nordström*. Jansson subsumed their influences into a personal calligraphic touch, employing systems of curly and long, undulating strokes to differentiate sky from water and water from hill. In Dawn over Riddarfjärden he has created a topographically accurate view that conveys an almost hallucinatory mood of beauty and mystery. [RH/PG]*

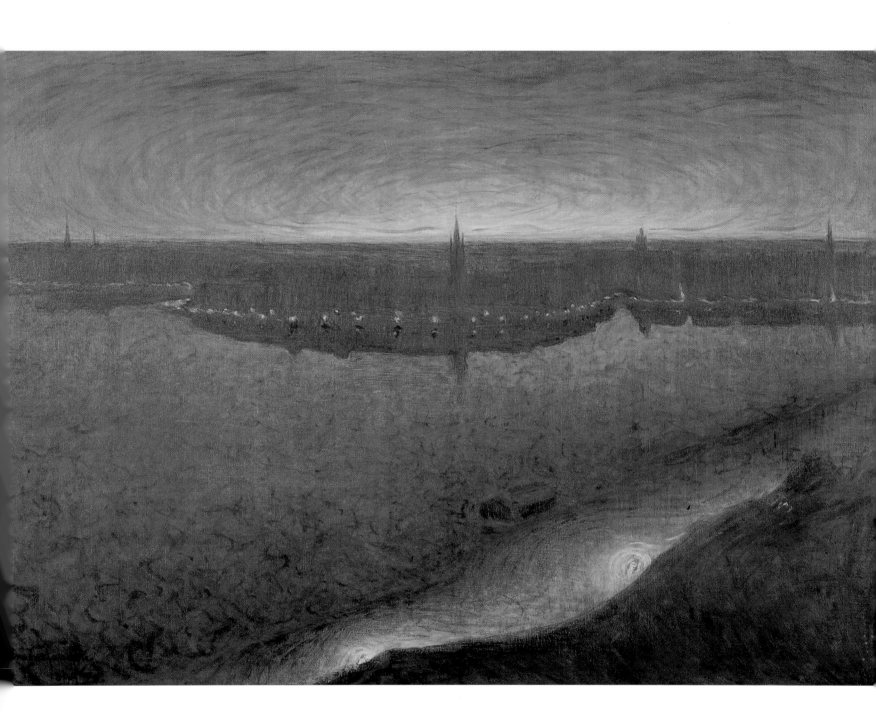

40
The Outskirts of the City *1899*
Stadens Utkant
152.0 x 136.0 (59⅞ x 53½)
Signed lower left: "Eugène Jansson/1899"
Thielska Galleriet, Stockholm

Since his 1890 pastel of the Stockholm street Karlbergsvägen (Näsby, Carl Robert Lamm), Jansson had been interested in portraying the outskirts of Stockholm, where city and country coexist. Another canvas (1899; Thielska Galleriet, Stockholm) shows the same building depicted in The Outskirts of the City *from the opposite side and from a high viewpoint.*

With increasing industrialization, Stockholm grew rapidly in Jansson's lifetime. By the turn of the century, poverty and a severe shortage of housing plagued the city. As a response to this situation, large buildings were constructed on the outskirts to house workers. Jansson shared the radical social ideals of the Artists' Union and participated in various demonstrations in support of workers. At the time he painted The Outskirts of the City, *he was working on the conception of his monumental tribute to the workers' movement, Demonstration Day.*

Despite the absence of humans and the stark architectural style, this view of a new apartment building seems to convey a positive feeling. Seen from a distant low viewpoint that exaggerates its height, the pristine white structure reflects the late-afternoon light and shines between the brilliant, energized sky and the lush, cultivated gardens. Although the scene has a bizarre quality, it nevertheless may be a statement of faith in the future of a social order based upon the ideals of the proletariat.

By paying attention to the indeterminate zone where the city ends, Jansson's picture recalls numerous canvases of the late 1880s by such French Neo-Impressionists as Paul Signac and Charles Angrand. But in giving prominence to the blank modern style of new workers' housing, The Outskirts of the City *has still stronger affinities with the views of Milan's suburbs painted by the Italian Futurist Umberto Boccioni around 1908. Jansson's sense of the romance of the city at night, his socialist leanings, and his active brushwork all suggest an odd, totally coincidental parallel with the early works of the Futurists. [RH/PG]*

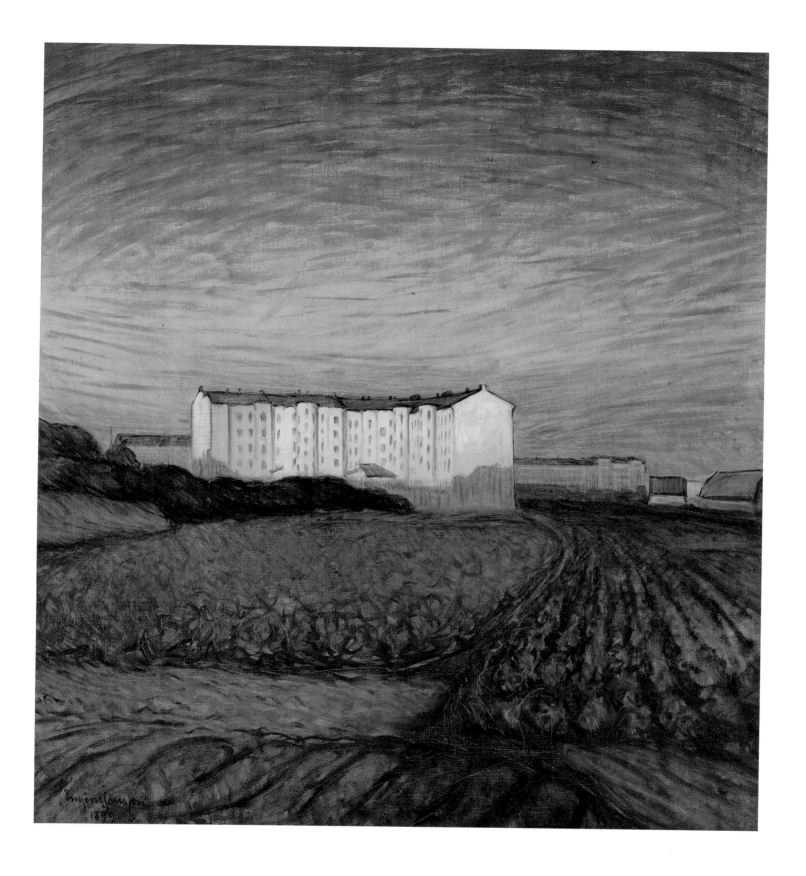

116

41
Self-Portrait *1901*
Jag. Självporträtt
101.0 x 144.0 (39³/₄ x 56³/₄)
Signed lower left: "Eugène Jansson/1901"
Thielska Galleriet, Stockholm

*Here Jansson portrays himself standing before a window –
possibly in his studio or in the apartment he shared with his
mother and brother – overlooking Riddarfjärden Bay and
the lights of Stockholm. The unusual horizontal format for a
half-length portrait, the painter's confrontation with the
viewer, and the window and city view as background recall
Lovis Corinth's Self-Portrait with Skeleton (1896; Städische
Galerie, Lenbachhaus, Munich). It is not known, however,
whether Jansson was aware of Corinth's portrait.*

*Approaching forty, Jansson stares out with a frown
and knit brows as if to express his unhappiness or the seri-
ousness of his work. He has his hands in his pockets and
stands before a bare table. A friend of Jansson attributed
the alienation of this portrait to the artist's illness and the
isolation he then needed in order to do his work (biblio. ref.
no.100, p. 282). Though the face is tightly painted, the sur-
roundings are rendered in the loose manner characteristic of
Jansson's other works of the period. Clearly meant to be
read as a view through a window, the background suggests
four other Jansson canvases. He painted the entire wide
panorama as well as narrow vertical sections of the same
view.*

*Jansson's only other self-portrait (1910; National-
museum, Stockholm; see illustration) offers a telling com-
parison. Both depict the artist not at work, but framed by
the principal subject matter of his art during the period each
was painted: here a nocturnal view of Stockholm, and in the
other, male nudes in a bath house. In neither is the artist
immersed in the world he portrays. Here architecture, table,
and contrasting tonalities separate the figure from the city of
Stockholm. In the bath house self-portrait the artist's clothes
and his lack of contact with the other men mark him as a
non-participant. His striding figure clad in a light tropical
suit and surrounded by athletic, light-drenched bodies re-
flects his interest in vitalistic philosophy. In contrast, here
the slouched, dark-clad figure with hands in pockets expres-
ses the turn-of-the-century introspection of the Decadents.
[RH/PG]*

Eugene Jansson
Self Portrait 1910
Nationalmuseum, Stockholm

42

Hornsgatan at Night *1902*
Hornsgatan nattetid
152.0 x 182.0 (59⅞ x 71⅝)
Signed lower right: "Eugène Jansson/1902"
Nationalmuseum, Stockholm

This is one of two 1902 depictions of Hornsgatan, the main street of the southern part of Stockholm: here a view toward the east; in the other (Thielska Galleriet, Stockholm) a view toward the west.

Adopting the sinuous lines of Edvard Munch and the directional brushstrokes of Vincent Van Gogh, Jansson transformed the dark street into a place of haunting beauty. Reversing the systems used in* Dawn over Riddarfjärden *(cat. no. 39), here he rendered the lower half of the canvas with long, straight strokes and created the sky with his characteristic curling squiggles.*

The row of buildings high upon the bank at the left looms up to form an unsteady balance for the deep void of the night sky. The double row of streetlights leads the eye along the fall and rise of the street, seen from an oblique angle, into the darkness at the end. Lines that radiate from beneath the lamp-post at the left set up conflicting horizontal movements.

Jansson's mastery of the mood and colors of nocturnal Stockholm is paralleled in literature by the novels of Hjalmar Söderberg (1869–1941), whom he may have known through the Swedish collector Ernest Thiel. Söderberg's works evoke the "poetry – of the city streets, waterways, and buildings as they are altered by dim lights and drifting mists and the fluctuations of the seasons" (biblio. ref. no. 83, p. 357). [RH/PG]

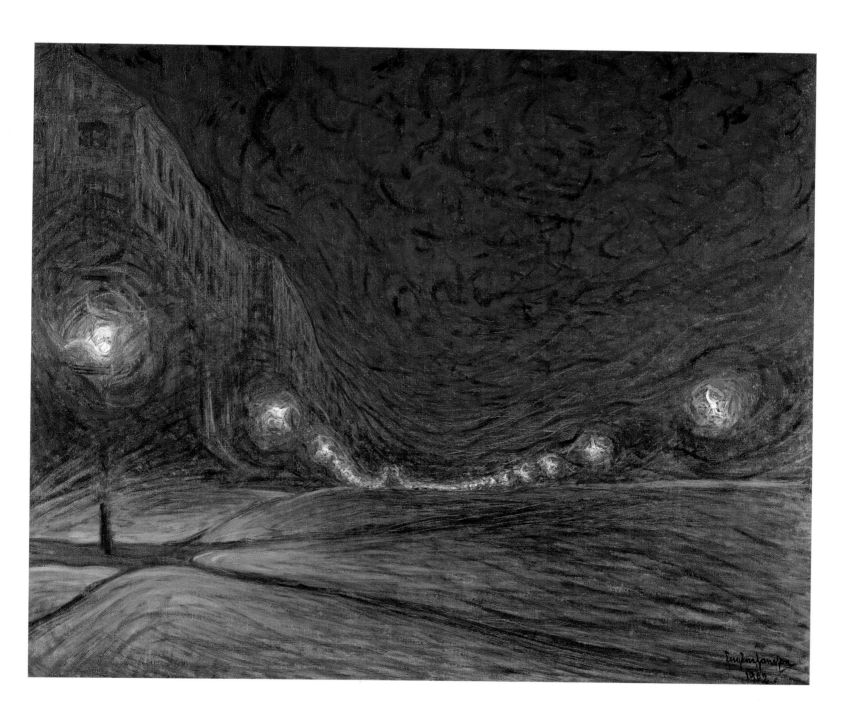

119

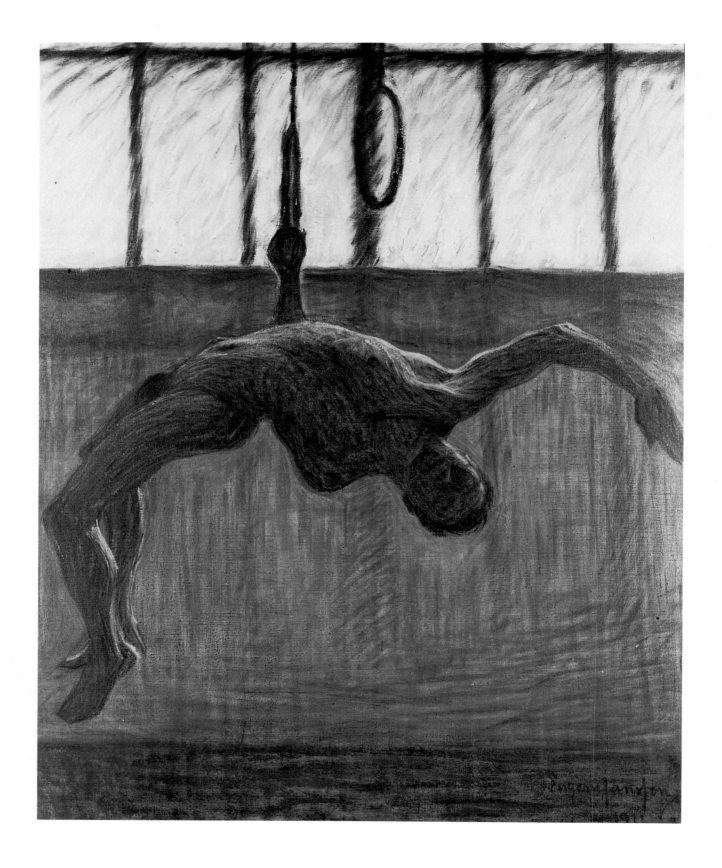

43

Ring Gymnast Number I *1911*
Ringgymnast I
178 x 146 (111¼ x 91¼)
Signed lower right: "Eugen Jansson 1911"
Private Collection

In 1904 Jansson ceased exhibiting and entered into virtual isolation in his Stockholm studio. Three years later he burst upon the artistic scene with a wholly new orientation as a figure painter. Neither Classical nor Idealist in his approach, the work of his last ten years consisted almost exclusively of potent, active, straining male nudes.

Jansson once told Prins Eugen that he always wanted to be a figure painter, but couldn't afford the models' fees. In 1904, Jansson began enlisting volunteer models from the Swedish Navy's cold-water bath houses on the island of Skeppsholmen in Stockholm. From 1911 until his death, he worked in an adjacent, provisional studio, painting gymnasts, divers, and weightlifters. Ring Gymnast Number I is characteristic of this final, remarkable phase of Jansson's work.

Silhouetted against the stark geometry of a fenestrated wall, the young athlete hangs suspended from a gymnastic ring. His body is contorted by the extreme tension of his shoulders and the effort of his upper body to defy gravity. This exploration of torsion recalls the drama of Auguste Rodin's figures from The Gates of Hell (1879–1917), well known to Jansson from his trips to Paris and from their frequent publication in European periodicals. Jansson's sinuous brush strokes, carried over from his 1890s work, give this lone Olympian Narcissus a rawness which the critic Axel Gauffin described as resembling "a living écorché". (New York, Shepherd Gallery, The Swedish Vision, 1985, p. 114).

Jansson's new subject matter, with its homoerotic overtones, reflects the Vitalist philosophy, a positivistic German movement which was gaining currency in Scandinavia. "Open Air Vitalism", incorporating Nietzschian philosophy and the biological theories of Hans Driesch and Ernst Haeckel, had been popularized by the German writer Richard Dehmel (1863–1920), and embraced in Sweden by Jansson's colleague J. A.C. Acke (1859–1924). In the mid-'90s Acke established two art and literary colonies on Stockholm's outer archipelago, where he, like Nietzsche's Zarathustra, urged man to re-encounter nature for spiritual revitalization. Like the numerous advocates of Nacktkultur and sun worship in Germany, he celebrated youth, life and vigor. His paintings, such as Östrasalt (1906; see illustration), fuse the potency of man with the primordial life-giving sun and sea. Acke encouraged Jansson to explore this theme of human perfectability in nature. This new view of a masculine personification of nature was widely held in

Northern Europe in the years after 1900, influencing such artists as Max Beckmann, Thorvald Erichsen, and Edvard Munch*. As Günter Martens suggests, it was an important link between nineteenth-century Symbolism and twentieth-century Expressionism (G. Martens, Vitalismus und Expressionismus, Verlag W. Kohlhammer, Stuttgart, 1971). Interestingly, Edvard Munch was sketching male models at public bath houses and beaches concurrently with Jansson, producing such extraordinary results as Bathing Men (cat. no. 80).

Jansson's relations with young sailors and weightlifters initially repelled Richard Bergh* and Karl Nordström*, and he was temporarily excluded from the Konstnersforbundet's hanging committee. With the 1912 summer exhibition, which coincided with the Stockholm Olympics, Jansson was vindicated and compared to Luca Signorelli. In a community still dedicated to moody landscape painting, the critic Tor Hedberg noted that Jansson's new style signalled "the entry of the male nude into Swedish art" (Claes Moser, Eugène Jansson – The Bath House Period, London, 1983, unpaginated). Jansson returned to this motif in 1912, producing Ring Gymnast II (Wollin, no. 136). [PGB]

J.A.G. Acke
Östrasalt 1906
Claes Moser Collection, Stockholm

KARL GUSTAV JENSEN-HJELL

Norway 1862–1888

Karl Gustav Jensen-Hjell was born Karl Jensen in 1862 and assumed the name Jensen-Hjell in the early 1880s. The son of a restaurant keeper, he was orphaned in his youth.

Jensen-Hjell began his studies at Christiania's Royal Academy of Drawing and then enrolled in Knut Bergslien's school of painting, where he met his lifelong friend Nils Gustav Wentzel*. Around 1882, he joined Christian Krohg's* circle of young artists at the studio building "Pultosten", where he encountered the French-inspired Naturalism that he was to advance. At the urging of Eilif Peterssen*, he went to study in Munich in 1882 and '83. Returning to Norway in 1884, he visited Numedal and there completed *Interior from Numedal* (Nasjonalgalleriet, Oslo), his first submission to the Christiania Autumn Exhibition.

Also in 1884 Jensen-Hjell took his maiden trip to Paris, accompanying Gustav and Kitty Wentzel. A short time later he studied with Frits Thaulow (1847–1906) at Thaulow's "Open-Air Academy" in Modum. Returning to Christiania, he joined the notorious bohemian community whose key figures included writer and political theorist Hans Jaeger, and artists Edvard Munch*, Christian Krohg*, and Kalle Løchen. Munch used the bearded Jensen-Hjell as the model for two paintings emblematic of the Christiania bohemians, the 1884 *Tête-à-Tête* (Munch-museet, Oslo) and the 1885 full-figure *Portrait of Jensen-Hjell* (Private Collection) that scandalized the Autumn Exhibition of that year.

Jensen-Hjell visited Italy and France in 1886, living first in Capri with painter Frits Kolstø (1860–1945), and then in Paris. In the following year he moved to a valley in the Valdres region of Norway, where he began to explore the sweeping vistas of the central Norwegian landscape. At the Autumn Exhibition of 1887 he received his first recognition from the press. Critic Andreas Aubert cited him as an important young Impressionist follower of Krohg in the *Dagbladet* of February 10, 1887, especially praising *Summer Day at Valdres* (Nasjonalgalleriet, Oslo) for its fresh interpretation of the native landscape.

Jensen-Hjell had been suffering from tuberculosis for several years. In 1888 his condition worsened, and on his doctor's advice he moved to Lofthus in the remote Hardanger region of Norway. He died there at the age of twenty-six. [PGB/MM]

44

At the Window 1887
Ved vinduet
73.5 x 99.5 (29 x 39⅛)
Signed lower right: "Xania 87/Karl Hjell."
Nasjonalgalleriet, Oslo

Jensen-Hjell delighted in observing the play of light over intimate interior spaces. At the Window, *painted in 1887 after his return from Italy and France, reflects this preoccupation, which he shared with Nils Gustav Wentzel* and Harriet Backer*.*

The work portrays the painter Kalle Løchen (1865–1893) reading in a corner of his studio. A popular member of the radical Christiania bohemians, Løchen served as a model for Christian Krohg's A Corner of My Studio *of 1884 and Eilif Peterssen's* Portrait of Kalle Løchen *of 1885, both now in the Nasjonalgalleriet, Oslo. His meditative presence in* At the Window *is dominated and ultimately subsumed by the meticulously arranged clutter of his studio. In the tradition of such images of artists as Edgar Degas'* Jacques Joseph Tissot *(1868; Metropolitan Museum of Art, New York), Løchen's surroundings provide the key to his identity, influences, and achievements. His interest in exotica is made clear by the presence of oriental tapestries, por-*

celain, and a Japanese fan, and his decorative concerns are revealed through the painted studio table and still-life arrangements. A copy of Pierre Puvis de Chavannes's The Sacred Grove (1884), the most significant element in the studio, serves as a backdrop for oil sketches representing Løchen's own repertory: seascapes, lamp-lit interiors, portraits, landscapes, and full-figure studies (see A. Th. Dedichen, "Kalle Løchen. Fra åttiårnes kunstnerliv," Kunst og Kultur, 15, 1928).

Puvis de Chavannes's influence was widely felt in Norwegian painting, particularly after the 1884 Paris Salon in which The Sacred Grove was exhibited. The critic Andreas Aubert devoted a laudatory article in the Christiania Aftenposten to Puvis's work that year, equating the decorative rhythms and suppressed tonalities of The Sacred Grove with musical harmonies. Although French critics admired Puvis primarily for his figure painting, young Norwegians like Edvard Munch*, Jensen-Hjell, and Løchen viewed him as the master of the emotionally evocative landscape. As the art historian Marit Lange points out (biblio. ref. no. 67, p. 84), Jensen-Hjell's placement of Løchen halfway between the window to the natural world and The Sacred Grove symbolizes the "two poles" governing the aspirations of the Norwegian Naturalist painters: plein-air Realism and the synthetic world of the imagination.

Løchen's studio also establishes a dialogue between these two poles. Jensen-Hjell leads the viewer on a reductive journey from nature to abstraction, beginning with the uncultivated trees outside the window, moving through the potted plant and ornamental dried weeds behind Løchen, and culminating in the flattened trees of Puvis's The Sacred Grove. Through this conceit Jensen-Hjell demonstrates his belief that although art is born of nature, imagination liberates the artist from the slavish imitation of appearances. This attitude mirrors the central concerns of the Norwegian Naturalist movement of the 1880s. [PGB/MM]

ÁSGRÍMUR JÓNSSON

Iceland 1876–1958

Ásgrímur Jónsson, along with Thórarinn B. Thorláksson*, introduced the modern art movement to the largely rural and sparsely populated country of Iceland. Jónsson was born on a farm in the district of Árnasýsla in southern Iceland, one of the few fertile and habitable areas on the island. He spent his early years as a transient laborer, taking jobs on farms and ships in order to earn a living. In 1897 he decided to become an artist and journeyed to Copenhagen. There he supported himself as a house painter and attended the preliminary drawing classes at the school of Gustav Vermehren (1863–1931). He entered the Danish Royal Academy of Fine Arts in 1900 and studied with, among others, August Jerndorff (1846–1906) and Frederik Vermehren (1823–1910). The curriculum of the academy had long been outmoded, and Jónsson updated and expanded his artistic education through frequent visits to the Danish National Museum. There he was exposed to the art of Vincent Van Gogh, which made an early and distinct impression on the young artist, although he did not adopt a gestural brushstroke and coloristic style until his later years.

Jónsson earned his fame as a landscape painter, the first to establish a distinct Romantic interpretation of the rugged Icelandic countryside. His paintings of native sagas and folk tales, which were later adapted for book illustrations, also reflected his nationalism. Still under the influence of the Copenhagen academy, his style in the first decade of this century was marked by a dry Naturalism. But after a trip to Germany and Italy from 1907 to 1909 and an exposure to Impressionism, his palette and touch lightened significantly. He was also an accomplished watercolorist, and used the medium to develop a greater clarity of color and formal simplicity.

In 1903 Jónsson held a one-man exhibition in Reykjavik, following the precedent set by Thorláksson in 1900. He exhibited regularly at the Charlottenborg palace in Copenhagen from 1904 to 1912, became an honorary member of the Swedish Royal Academy of Fine Arts in 1952, and was the subject of a major retrospective at Listasafn Islands in Reykjavik in 1956. [EB/BN]

45

Tindafjöll *1903–04*
80.0 x 125.5 (31½ x 49⅜)
Signed lower left: "Ásgrímur Jónsson 1903–4"
Listasafn Íslands, Reykjavík

In the summer of 1902 Jónsson left Copenhagen, where he was studying, and returned to Iceland to sketch the native landscape. A study of the glacier of Tindafjöll was the basis for this work, which he began painting in the studio the following year. The canvas is characteristic of his early style and restricted palette.

There was no traditional landscape school in Iceland for Jónsson to look to; instead he learned from the Neo-Romantic style of his Scandinavian contemporaries. The topography of Iceland, with its jagged fissures, lava fields, glaciers, and craters, provided numerous stark and sublime motifs. As in Tindafjöll, *Jónsson often contrasted flat plateaux with soaring mountain peaks. His compositions are frequently symmetrically organized and divided into horizontal bands.*

In this painting there is a sense of monumentality and drama in the sweep of space from the nearby foreground to the luminous, clear sky and distant mountains. The whole is seemingly inaccessible and inimical to human life. The sharp contrasts between foreground and background, dark and light, the soft forms of the lava field and the craggy contours of the mountains effectively suggest the volatile and variegated nature of Iceland's climate and geology. [EB/BN]

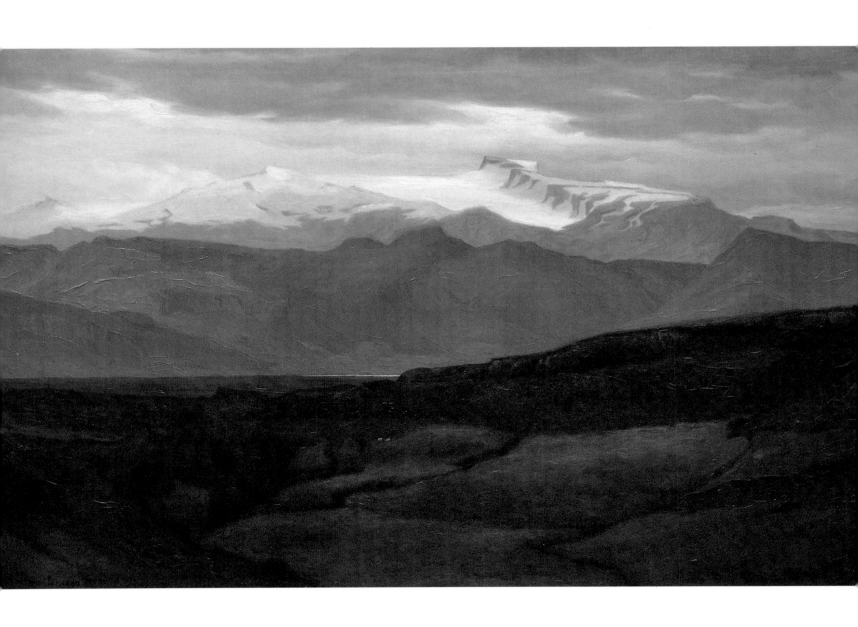

46
Hekla *1909*
150.0 x 290.0 (59 x 114⅛)
Signed lower left: "Ásgrímur J."
Listasafn íslands, Reykjavík

Here Jónsson depicts Mount Hekla rising in the distance above the hills and farms of Árnasýsla, the region where he was born. It is early morning, and both the snow-capped peak of the majestic Hekla and the tiny column of gray smoke from a farmhouse below rise into the cool fresh air of dawn. The view is panoramic, an unusually large and ambitious canvas for the young Jónsson. As a result of his 1908 trip to Berlin, where he saw his first Impressionist paintings, the colors are more luminous than in the earlier Tindafjöll *(cat. no. 51).*

Hekla is a major national and cultural symbol of Iceland. It is one of the highest mountains in Europe, rising 5,110 feet, and is one of the most famous active volcanoes. It was notorious in medieval Catholic Europe as the home of the damned or as the gateway to purgatory, and in local folklore was the traditional gathering place for witches. At the time of Jónsson's painting, Hekla's most recent eruption had occurred in 1845–46 and had decimated the surrounding farms and countryside. Here the houses appear as lonely outposts amidst vast and ungenerous nature. Despite the seeming cool and calm of the panoramic scene, there is an understanding of the mountain's violent history and potential. [EB/BN]

126

ERNST JOSEPHSON

Sweden 1851–1906

Josephson was born into a Stockholm family of Jewish merchants who were deeply involved in Swedish cultural life: one uncle was conductor of the Uppsala Symphony Orchestra and another, Ludwig, was a prominent actor, playwright and director. The death of his father in 1861 left the ten-year-old boy profoundly and permanently scarred, despite the affectionate attention of Uncle Ludwig, who remained Josephson's closest lifelong friend. After an unsuccessful year in the family business, Josephson enrolled in classes at the Royal Academy of Art in 1868, where he followed the rigid and stifling curriculum with great dedication.

In November 1874, Josephson left Sweden to visit major art collections in Copenhagen, Belgium and Germany, before settling in Paris during the spring of 1875 to study with Jean-Léon Gérôme (1824–1904) at the École des Beaux-Arts. The liberal atmosphere of the École, where students were treated as responsible artists capable of choosing an appropriate course of study, invigorated Josephson, who hoped to initiate similar reforms in the repressive Swedish Academy. Josephson spent the summer of 1875 in Sweden. It was to be his last visit until 1881. Upon his return to Paris in the fall of 1875, Josephson contracted syphilis. His slow and painful recovery engendered thoughts of sin, punishment and atonement in his psychologically unstable and religiously-inclined mind.

Thanks to a small scholarship awarded to him by the Swedish Academy, Josephson embarked on a two-year study trip in the spring of 1876. His first six months were spent in Amsterdam, where he engaged in an intensive study of Rembrandt, whom he revered as his artistic father. The subdued and emotional self-expression, penetrating psychological in-sight and rich luminous palette of Rembrandt struck a responsive chord in the young artist. He painted copies of several works including the famous *The Syndics* (Rijksmuseum, Amsterdam). Travelling

47
Jeanette Rubenson *1883*
41 x 32,5 (15¾ x 12³/₁₆)
Signed lower right: "Till Semmy och Jeanette of Ernst Josephson, Dalarö. 83"
Göteborgs Konstmuseum

Josephson spent the summer of 1883 at the summer home of his sister on Dalarö, an island in the Stockholm archipelago. He was in good spirits, having stayed first for a few weeks in Göteborg with his recently-found patron, Pontus Fürstenburg. During his visit, Josephson painted Fürstenburg's portrait, returning in the fall to paint one of his wife, Gothilda.

Jeanette Rubenson is Josephson's best-known and most beautiful portrait of this period. She was the wife of the local police chief and a close friend of the artist's sister. The informality of her pose is appropriate to the relaxed, rural setting. Mrs. Rubenson gazes distractedly to her right as her nimble, bejewelled fingers continue to crochet. The mask-like impassivity of her face and the idiosyncratic cropping of hands and plants reflect Josephson's awareness of Japonist devices and create a paradoxical situation of physical proximity and psychological distance.

The frame of the closed windows, which simultaneously provide a view onto neighboring houses and gardens and act as a barrier between the home and the world, establishes a strict geometrical structure within the painting. The primitive ornamental pattern of embroidery on the dress reinforces this abstract geometry. Within such a restrained format, the vibrant wild flowers on the hat and the vegetal energy of the potted plants combine with the clear, bright colors and shadowless lighting to create a highly charged atmosphere. The fully-bloomed red flower suggests an analogy with the mature, cultivated and spirited sitter whom Josephson describes with a crisply detailed verism. [MF]

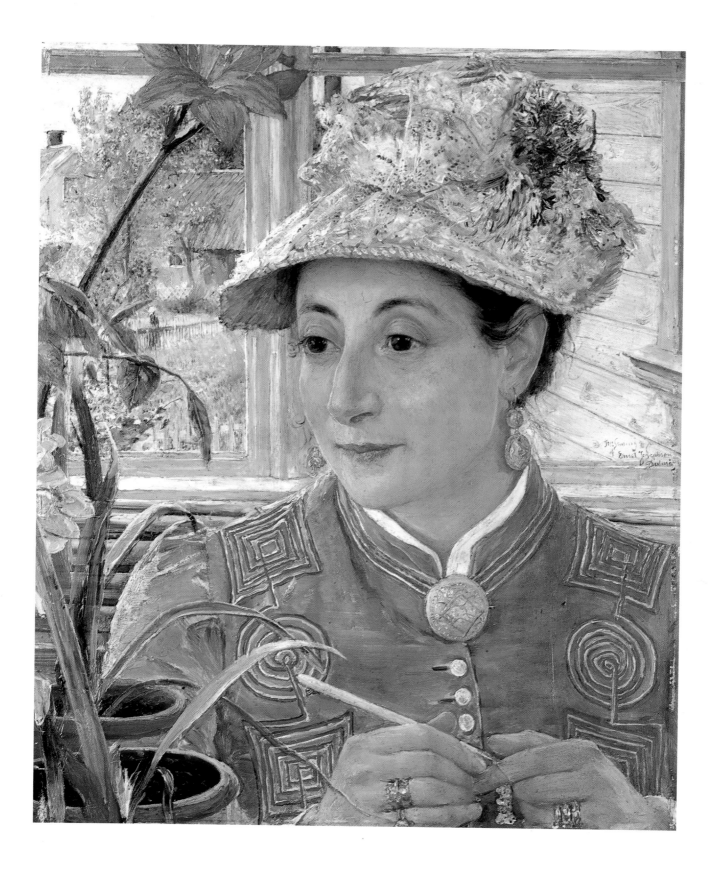

129

through Germany to Italy, where he spent two years, Josephson settled first in Florence and later in Rome. During his Italian sojourn, Josephson suffered prolonged attacks of melancholy and self-pity, alleviated only by the visit of his beloved Uncle Ludwig.

Josephson returned to Paris in 1878 where he shared a studio with a fellow Swedish painter, Hugo Birger (1854–1887), and became involved with the activities of the Swedish artists, who held weekly meetings at the Jesu Syrach café in the Latin Quarter. Through impassioned speeches about political and artistic freedom, he became their *de facto* leader and spokesman. The values of the Realist painter and communard Gustave Courbet (1819–1877) deeply affected Josephson at this time. Like Courbet, Josephson advocated the liberalizing, if not abandonment, of the jury system for official exhibitions; and insisted that one should paint only what one sees, thereby excluding historical and religious themes. Between 1878 and 1880, Josephson painted a series of portraits, primarily of friends. Two of these, *Carl Skånberg* and *Allan Österlind,* were accepted for the 1880 exhibition of the Paris Salon.

A small inheritance left by his mother finally permitted Josephson to make his long-awaited trip to Spain in 1881. Accompanied by Anders Zorn*, Josephson studied not only the paintings of the artists he admired, particularly Velázquez, but also the people who were their subjects. In many of his Spanish paintings Josephson adopted a looser, more spontaneous style. *The Spanish Blacksmiths* (Nationalmuseum, Stockholm), the masterpiece of his Realist style, deftly captures the robust and brutish character of his subjects.

From 1883 to 1886, Josephson divided his time between Paris and Sweden. His lack of success, both financial and critical, was alleviated on the one hand by the generous patronage of Pontus Fürstenburg, and on the other by his fruitful efforts to organize an opposition to the Swedish Academy. In 1885, this resulted in the mounting of the controversial exhibition in Stockholm entitled "From the Banks of the Seine", and in the establishment of the independent Artists' Union. The pleasure and security he enjoyed was short-lived, however. By 1887, he had resigned from the Union, having lost his position of leadership to Richard Bergh*. He had furthermore lost the support of Fürstenburg, whom the scheming Academy had elected to its membership.

Isolated and poverty-stricken, Josephson withdrew into the fantasy world on whose edge he had always teetered. He lived in a hut in Brittany from the winter of 1886–87 until the spring of 1888. In this desolate and desperate time, the Breton peasants' pantheistic mysticism combined with his own delusions to bring on a total mental breakdown. Josephson was coaxed back to Sweden by Österlind, whom, at the time, Josephson believed to be Jesus Christ. After a few unhappy months with his family, he was confined to an Uppsala mental hospital during the winter of 1888–89, where a sympathetic doctor encouraged him to draw. The works of his late years were executed in a highly expressionistic style markedly different from his earlier paintings. Josephson recovered sufficiently to return to Stockholm, where he lived a listless and lonely existence. In 1898, Carl Larsson* raised a meager subscription of two hundred crowns per month, which sustained him until his death from gangrene in 1906. [MF]

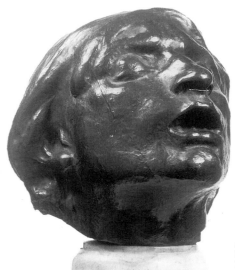

Auguste Rodin
Head of Sorrow 1882
Yale University Art Gallery,
New Haven, Connecticut

48
The Water Sprite *1884*
Strömkarlen
Prins Eugens Waldemarsudde, Stockholm

Josephson's summer 1872 visit to Eggedal, Norway, kindled his interest in the water sprite. With his enchanting fiddle-playing, this mythical creature entices unwary wanderers to a river where they meet their deaths by drowning. Joseph-son's thoughts turned to the water sprite during his early bouts of anxiety and melancholia. To him, the sprite myth symbolized the plight of man flailing about helplessly in a hostile world. His own lack of success in coping psychologi-cally with both critical and financial adversity led to his de-velopment of a persecution complex; like the sprite's victims, Josephson felt himself to be the innocent prey of supra-personal forces.

Josephson worked on the first sketch of this subject during his 1878 visit to Rome and following the unexpected return of Uncle Ludwig to Sweden – a period in which Josephson was plagued by loneliness and self-doubt. During the summer of 1881, on his way to Stockholm after attend-ing the opening of a Scandinavian art exhibition in Göteborg, Josephson stopped briefly in order to sketch the Trollhätten Falls. The Falls, which lie northeast of Göteborg, provide the background to the subsequent three versions. The first of these, executed in tempera and now in the Nationalmuseum, Stockholm, was rejected by the Paris Salon of 1881. Later, Josephson presented it as a gift to his friend Theo van Gogh. Josephson painted the Göteborg ver-sion (Konstmuseum) in Paris during the summer of 1882. This was a difficult summer for him – the Salon refused The Spanish Blacksmiths, *most of his friends had returned to Sweden, and his former fiancée (to whom he was still deeply attached) got married. It therefore seems appropriate that the sprite's head bears a strong resemblance to Auguste Rodin's* Head of Sorrow, *conceived for his masterpiece* The Gates of Hell.

The final version, illustrated here, retains the features of Head of Sorrow. *Although he began this painting in Paris, Josephson soon concluded that he must work at the site of his original inspiration in order to complete the paint-ing satisfactorily. He returned to Eggedal for the summer of 1884, where he hired a young farmer as a model. While Josephson based the setting on his sketches from Trollhätten, he painted the sprite directly from the nude boy sitting out-of-doors during the long hours of sunlight. This practice, ini-tiated by the Impressionists, resulted in greater attention to the effects of sun and light, evidenced here by the colored shadows of the sprite on the water and rocks. Despite the naturalism of figure and setting, the subject is wholly imag-inary and symbolic, anticipating the fantastic and mythical themes of his "insane period". [MF]*

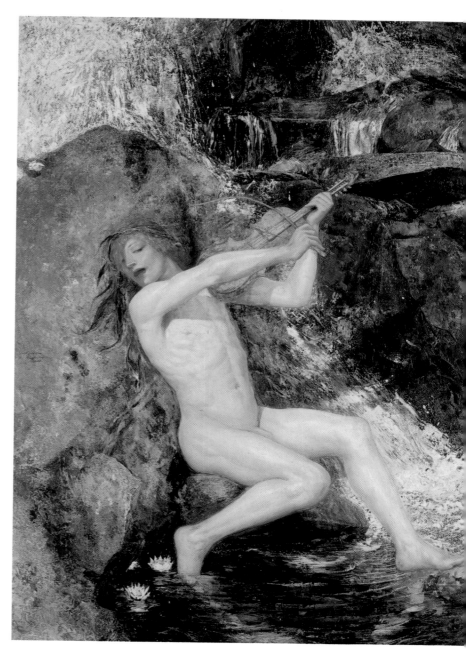

131

49

The Holy Sacrament (The Angel's Sermon) *1889–90*
Det heliga sakramentet (Engelns prediken)
127 x 76 (50 x 29⁷⁄₈)
Nationalmuseum, Stockholm

During his stay in Brittany, Josephson withdrew from the world around him and took refuge in an irrational, imaginative realm. His purpose was to transcend the superficiality of daily life in order to inhabit what he believed to be a realm of eternal cosmic forces. Josephson fell under the influence of Mme. Dupuis, a spiritualist who convinced the vulnerable artist of his psychic gift. He had become interested in the occult sciences following the death of his mother in 1881, at a time when Europe experienced a renewed faith in the power of unseen forces, physical (electricity, radiation) as well as spiritual.

Josephson held séances in Brittany with his companion, Allan Österlind, every evening after dinner. Initially, Josephson summoned the spirits of artists such as Raphael and Michelangelo. Later in his stay and concomitant with his increasing adherence to the teachings of the eighteenth-century mystic Emanuel Swedenborg, Josephson conjured up the spirits of biblical personalities. He eventually became convinced that he was St. Peter, guardian of the gates of heaven and the confessor of all entering souls.

A radical change in Josephson's subject matter and style reflects this detachment from reality. The Holy Sacrament *is a characteristic work of his "insane period", which lasted from 1887 to 1891. Here, a radiant, Christ-like figure performs the miracle of transubstantiation, observed by an ethereal spirit to his left. An angelic figure, hands clasped in prayer, gazes heavenward, while two children, one holding a branch (olive, thorn?), also witness this holy event. The small bird above one child's head may represent the Holy Ghost, or perhaps merely a spectator from the animal kingdom. One cannot confidently make definitive identifications of figures or meanings in paintings of this period.*

Having freed himself from the constraints of conventional subject matter, Josephson evolved a technique appropriate to the personal vision he sought to convey. In this painting, Josephson adopts a highly expressive manner of loose brushstrokes. The visible patches of white ground impart an airy quality which enhances the spiritual subject matter. In addition, Josephson now used color to convey his emotional state rather than the inherent hue of objects. On the evidence of paintings like this, Josephson has been considered an important precursor of Expressionist painting. Indeed, the German Expressionist painter Emil Nolde (1867–1956) purchased several of Josephson's works following their exhibition at the 1909 Berlin Secession. [MF]

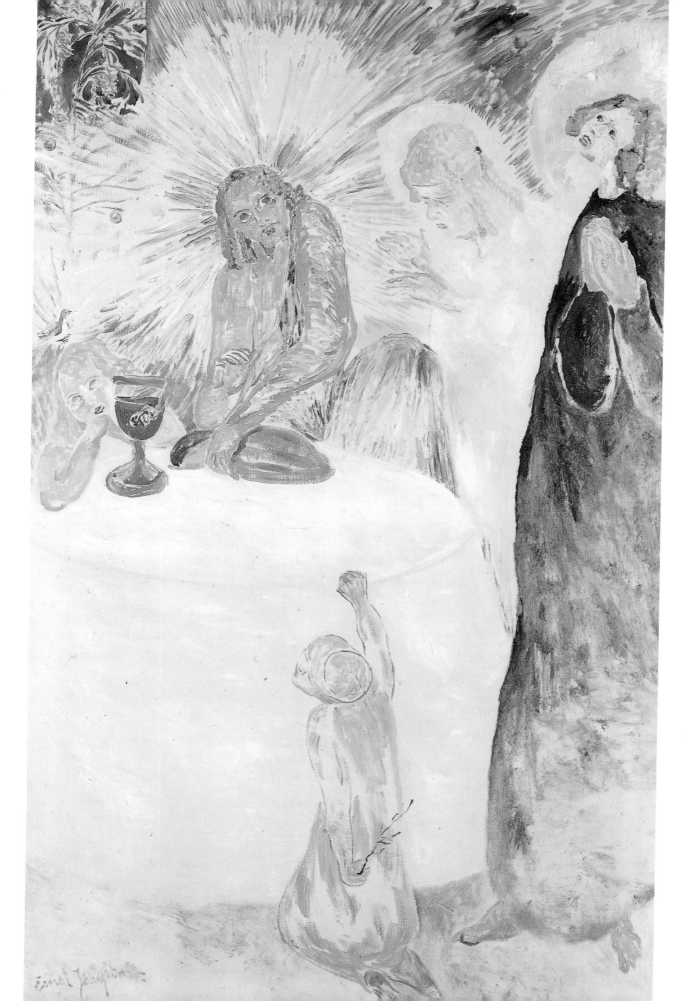

EERO JÄRNEFELT

Finland 1863–1937

Eero Järnefelt came from an old, culturally oriented family. His brother Armas became a distinguished conductor and composer, his brother Arvid a leading writer, and his sister Aino the wife of the composer Jean Sibelius. At eleven Järnefelt began his artistic training in Helsinki at the Finnish Fine Arts Association, remaining there for four years. When he went to the Art Academy in St. Petersburg in 1883, he studied under his uncle, Michail Klodt von Jürgensburg, a *plein-air* painter. From 1886 to 1891 he worked in Paris at the Académie Julian under William Bouguereau and Robert-Fleury. While there he twice received Finnish state stipends. Drawn to *plein-air* painting, he spent the spring of 1888 in Veneux-Nadon (between Barbizon and Fontainebleau) with Scandinavian and French artists. In 1894 the Finnish government subsidized a study trip to Germany and Italy, and again in 1897 he was awarded funds to travel in Italy.

The Russian critic Sergei Diaghilev divided Finnish artists of the end of the nineteenth century into two groups: those with nationalistic approaches and those who followed the aristocrats of the West (biblio. ref. no. 47, p. 29). An exemplar of the latter, Järnefelt nonetheless developed in an atmosphere sympathetic to the Finnish national movement. He lived for several years in the small town of Kuopio amidst a circle of artists and writers who were dedicated to liberal ideas of Realism while at the same time fighting for the Finnish language and education of the masses.

Järnefelt, who married the actress Saimi Pia Swan, became a professor of drawing at the University of Helsinki and an inspector for the Finnish Artists' Association. Among his many awards were gold medals at international art exhibitions in Paris in 1900 and Budapest in 1907. [WPM/SSK]

50
Lefranc, Wine Merchant, Boulevard de Clichy, Paris *1888*
Ranskalainen Viinikapakka
61.0 x 74.0 (24 x 29⅛)
Signed lower left: "Eero Järnefelt/1888"
Ateneumin Taidemuseo, Helsinki

Although Järnefelt shows us two men in a wine shop, the true subject of Lefranc, Wine Merchant *is light. Back lighting, palpable in its intensity at the front of the shop, sharply outlines the standing figure, whose face and hands are illuminated by a match. The red gauze attached to the spiral staircase is also back-lit, intercepting the light from the front and throwing the seated older man's face into shadows. Reflective surfaces such as the polished metal bar are modelled by light, and the light is transmitted through or held by the liquid in the bottle and the glasses on the table.*

Järnefelt's studies at the Académie Julian clearly show up in this work. His preoccupation with the treatment of light in all its variations foreshadows his interest in plein-air painting, which he was to explore later that year at Veneux-Nadon. Lefranc *also reveals his close affinities with Salon Realism of the 1880s. It is specifically allied with the Realism characteristic of many works at the 1888 Salon, where concentration on the rendering of light was also apparent. [WPM/SSK]*

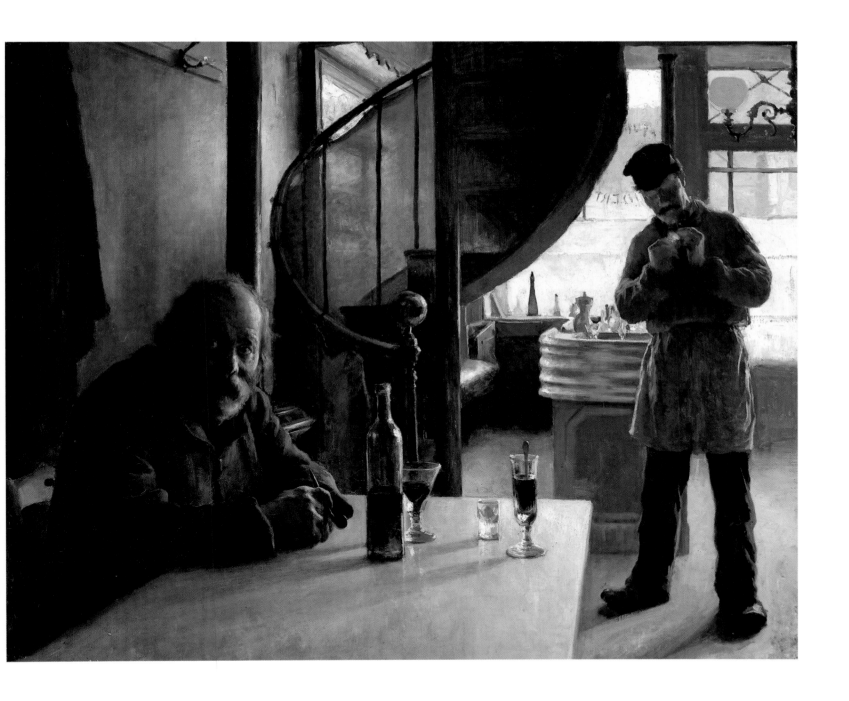

51
Portrait of Professor Johan Philip
Palmén *1890*
Yliopiston Varakansleri J. Ph. Palménin
Muotokuva
116.0 x 84.0 (45 ⅝ x 33 ⅛)
Signed lower left: "Eero Järnefelt./1890".
Ateneumin Taidemuseo, Helsinki

*Järnefelt was a successful and sought-after portrait artist.
He painted the* Portrait of Professor Johan Philip Palmén
*during a summer spent in Finland toward the end of his re-
sidency in Paris. A Finnish scholar and senator, Palmén be-
longed to a milieu much like that of Järnefelt's own family.*

*Palmén is represented in meticulous detail, sternly
confronting the viewer in the attitude of a Scholarly
Napoleon. Much attention is also given to details of the in-
terior, from the Biedermeier furniture to the exotic plants.
Inasmuch as it is a highly detailed depiction of a person in
equally detailed surroundings, the painting appears to reveal
Järnefelt's affinities with Parisian Realism.*

*Yet through this sharp-focus Realism, Järnefelt inten-
sifies the flow of familiar interior decorations into a spatial
conundrum. The logical progression of rooms seen behind
Palmén's right is undermined by the sloping angle of the
floor and decorative geometry of the strip rugs in the hall-
way. This effect compresses the background – into an oddly
shallow space. Adding to the confusion of depth and pattern
are the spider-like forms of the tropical plants.*

*In this portrait Järnefelt reveals both Realist and dec-
orative-abstract sensibilities, creating a dialogue between
pattern and high Realism. Two years later he painted Pal-
mén's portrait again, abandoning the intricacies of this work
for a simpler, more traditional representation with a flat,
grayish background (present location unknown; for a repro-
duction see biblio. ref. no. 41, p. 209). [WPM/SSK]*

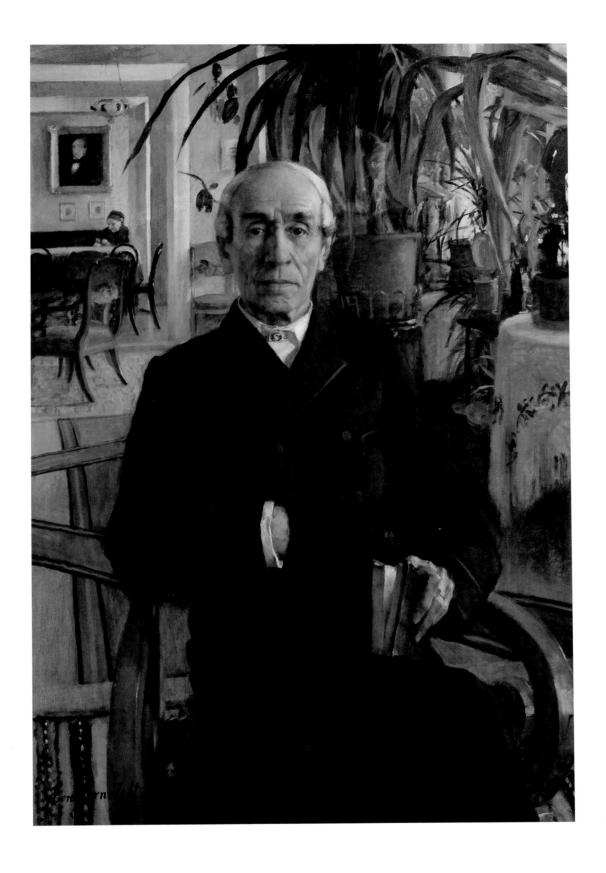

52
Lake Shore with Reeds *1905*
Kaislikkoranta
94.5 x 75.0 (37¼ x 29½)
Signed lower right: "E. Järnefelt/05."
Ateneumin Taidemuseo, Helsinki

Järnefelt expressed his love for Finland in his landscapes. In Lake Shore with Reeds *he conveys what has been described as the intimate and elegiac lyricism of the Finnish country-side.*

Like such comparable works by Albert Edelfelt as* Kaukola Ridge at Sunset *(cat. no. 10), this landscape reso-nates with a mournful Northern atmosphere; in it Järnefelt poetically depicts Scandinavian fall. The odor and dampness of nature's decay are brought out and reinforced by the somber autumnal tonalities and the still water and trees. An empty wicker chair set at the lake's edge signals winter's onset and the desertion of the out-of-doors. This chair, em-phasizing man's necessary retreat, is evocative rather than symbolic. The closing-in of nature is further stressed by the high horizon line and viewpoint. On the whole the work is more wistful and melancholy than it is death-like.*

This painting reveals the influence of Synthetism on Järnefelt's fundamentally naturalistic landscape style. He is highly selective in his use of shapes and cropping. The sim-plified, almost abstract forms of the trees, reeds, and water – represented in restrained and harmonious colors – make this work more a whole than a combination of independent parts. Also contributing to this effect are the overcast twi-light sky, which denies the water's reflective quality, and the matte surface of the entire work. Thus Järnefelt incorpo-rates Synthetist qualities without departing from Natural-ism in terms of either form or mood. [WPM/SSK]

139

KITTY KIELLAND

Norway 1843–1914

Kitty Kielland was born into the leading patrician family of Stavanger in southwestern Norway. She was an essayist about art, morals, and the position of women; her brother Alexander Kielland (1849–1906) was a leading novelist. Although her father opposed her ambition to become a professional artist, in 1873 she left for Karlsruhe to study with the important landscapist Hans Gude (1825–1903). In 1875 she moved to Munich, where she studied with Hermann Baisch (1846–1894) and enjoyed the cultural life of the city in the company of a group of Norwegian artists that included Harriet Backer* and Eilif Peterssen*. She visited Paris in 1877 and settled there in 1879. Sharing lodging with Harriet Backer, Kielland joined a circle of French and Norwegian artist and writers. She first exhibited at the Salon in 1879 and continued to show there frequently, receiving a positive critical response. In 1889 she moved to Christiania, where she lived for the rest of her life.

During the years she lived in Germany and France, Kielland spent much of each summer back in Norway. In 1886 and '87 she summered with Christian Skredsvig*, Gerhard Munthe*, and Eilif Peterssen on the farm of Fleskum near Christiania. The majority of her works depict the calm of the Jaeren plain, south of her native Stavanger. Other landscape subjects include the mountains that border Jaeren, scenes from northern France in the early 1880s, and quiet areas in southeastern Norway in the mid-'80s. [RH/MM]

53
After Sunset *1886*
Efter Solnedgang
80.0 x 115.5 (31 ½ x 45 ½)
Signed lower left: "Kitty L. Kielland/Paris 1886"
Stavanger Faste Galleri

This canvas, the second version of a work executed in 1885 and now at the Royal Palace in Oslo, was painted in Paris. The subject is an old building at Bosvik near the small Norwegian coastal town of Risør where Kielland had spent part of the summer of 1885 with Harriet Backer.*

Kielland viewed the first version of this work as her breakthrough, and the art historian Marit Lange has suggested that the critic Andreas Aubert's praise of the work may have marked it as a turning point in the artist's mind (Lange, p. 72). Aubert had lauded the canvas for using a typical Norwegian subject illuminated by the light of a summer evening to convey a feeling of intensity (Nyt Tidsskrift, 1885, p. 526; cited in biblio, ref. no. 67, p. 72).

Of approximately the same dimensions, the two versions differ only slightly. In the second the hat of the woman is a different shape and color, and her reflection is not so clear as in the earlier work. In general, there is a slight blurring of detail in the second version, resulting in a decreased emphasis on surface texture. The local color is also less strong, giving way to a stronger overall tonality. This version may represent Kielland's desire to place more importance on the mood than on the particulars of the idyllic scene. She had asked Erik Werenskiold to send her a photograph of her 1885 work as an aid in creating a new version to submit to the Salon, and she invited Léon Pelouse (1838–1891), with whom she had studied, to critique the revision. Pelouse lamented that she had gone astray and had begun to paint in the manner of Pierre Puvis de Chavannes (biblio, ref. no. 67, pp. 78–80.) Despite his comments, she exhibited the painting in Göteborg in 1886, in Copenhagen in 1888, and in Paris at the World Exposition of 1889.

This work has been cited as one of the earliest examples of the development of Norwegian landscape painting from Realism to New Romanticism, particularly the simplified depiction of nature and the emphasis upon such typically national subjects as the light summer night. Lange has linked this change in the work of Kielland and Eilif Peterssen with their admiration of the work of Puvis (biblio, ref. no. 67, pp. 79ff). With Peterssen, Kielland initiated the style that would dominate Norwegian painting in the 1890s. [RH/MM]*

CHRISTIAN KROHG

Norway 1852–1925

Krohg was born in Aker, outside Christiania, and in 1870 attended the drawing class of the landscapist Johan Frederik Eckersberg (1822–1870). Following his father's wishes, he studied law and received his degree in 1873. After his father's death in 1874, he studied painting under Hans Gude (1825–1903) and Karl Gussow (1843–1907) in Karlsruhe. In 1875 he followed Gussow to Berlin, where he shared quarters with the German artist Max Klinger (1857–1920) and met the Danish critic Georg Brandes. He visited Skagen in 1879 and again during the summers of 1882, '83, '84, and '88. In Paris in 1881 and '82 he assimilated the influence of Édouard Manet, Jules Bastien-Lepage, and Gustave Caillebotte, and showed in the 1882 Paris Salon. In 1885 he visited Belgium.

Thereafter Krohg spent most of his time in Christiania, where he directed a school of painting together with Hans Heyerdahl (1857–1913) and Erik Werenskiold* (1855–1938). With Hans Jaeger, he was the leader of the Christiania bohemians and for a time editor of their review *Impressionisten*. In 1886 he published his notorious novel of prostitution *Albertine*, which was immediately confiscated. Krohg lived in Copenhagen in 1889–90, went to Berlin and Rügen in 1893, and visited France and Spain in 1898. He returned to Paris for a prolonged stay in 1901 and taught at the Académie Colarossi. From 1889 to 1910 he wrote for the Christiania newspaper *Verdens Gang*, and from 1910 to 1916 for *Tidens Tegn*. In 1909 he became director of the newly founded Academy of Fine Arts in Christiania, a position he held until his death. [ADG/OT]

54
The Net Mender *1879*
Garnbinderen
93.5 x 66.5 (36¾ x 26¼)
Signed upper right: "C. Krohg/79"
Nasjonalgalleriet, Oslo

Krohg visited the artists' community at Skagen in 1879, the year he completed his studies in Berlin. His fellow Norwegian artist Frits Thaulow (1847–1906), who had invited him, was then working at Skagen with a camera lucida, *experimenting with cropped compositions and abrupt spatial juxtapositions. Krohg followed Thaulow's example, and his paintings of that summer – including* The Net Mender *with its raked space – display similar compositions.*

This is the second version of The Net Mender. *The first (location unknown: reproduced in Madsen, 1929, p. 88) was completed in Skagen during the summer of 1879 and was exhibited at the Christiania Art Association on October 4, only a few days after Krohg's return to the Norwegian capital. It was criticized as overly crowded, and Krohg reworked the scene in Christiania that autumn (an intermediate drawing has been preserved in the Kunsthalle, Hamburg). While the changes are minimal, the Christiania version shows a more coherent organization of space and more solidly drawn figures.*

The models are Niels and Ane Gaihede, members of the family that posed for many Skagen painters (see cat. nos. 2 and 57). Their social role is abundantly clear: Niels, too old to continue fishing, is shown mending nets; Ane winds yarn in the background. Their labor, while undramatic, fulfills a specific need in the rural community. Krohg depicts them with an abrupt Realism that owes more to the tradition established in Munich by Wilhelm Leibl (1844–1900) than to Norwegian and Danish precedents. Works like The Net Mender *signalled a decisive break with the conventions of the Düsseldorf school, which had dominated this genre throughout the 1860s and '70s.*

The painting's emphasis on labor stands in contrast to the generally anecdotal scenes of peasant life made popular by the Norwegian painter Adolph Tidemand (1814–1876). While both Tidemand and Krohg shared a sense of na-

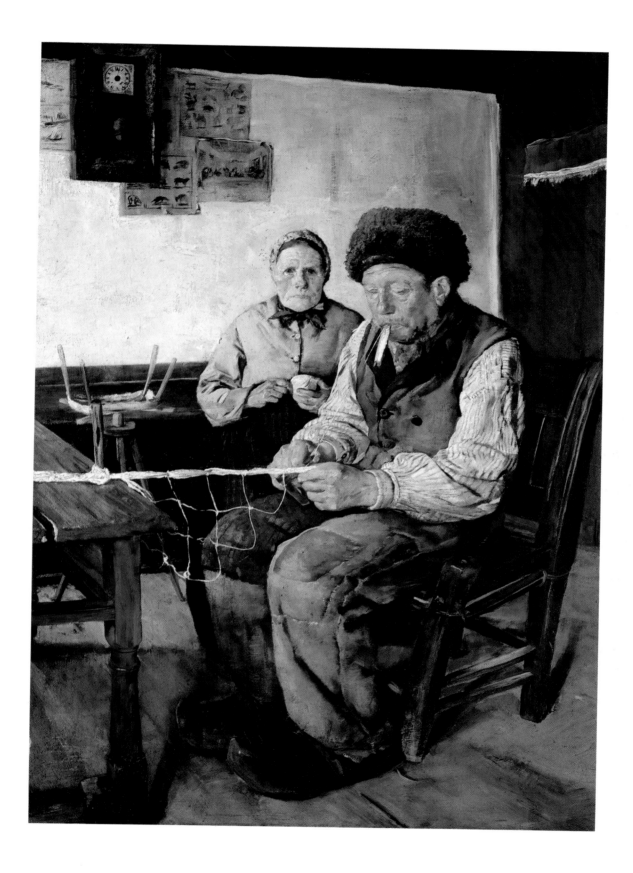

tionalism, documenting the roots of Scandinavian life in peasant culture, there was a major difference in approach. Tidemand's avowed purpose was to preserve the character and mores of Norwegian peasant culture before it was swept away by the Industrial Revolution (Wend von Kalnein. "Der Einfluss Düsseldorfs auf die Malerei ausserhalb Deutschlands," Die Düsseldorfer Malerschule, Kunstmuseum Düsseldorf, 1979, p. 198). Conversely, Krohg acted as a recorder rather than a preservationist. He was concerned first and foremost with depicting the mundane environment and activities of the fisherman and his wife. Where Tidemand would have searched for an interior filled with folk handicrafts, Krohg chronicled the mass-produced prints on the wall: two charts of what seem to be various breeds of animals and a reproduction of da Vinci's Last Supper. He thus minimized the distance between the nineteenth-century viewer and the subject, bringing the heritage of the peasant culture into the immediate present rather than pushing it into a fabled past. [ADG/OT]

55

The Sick Girl *1880–81*
Syk pike
102.0 x 58.0 (40⅛ x 22⅞)
Signed lower right: "C. Krohg"
Nasjonalgalleriet, Oslo

Krohg's Skagen paintings (cat. nos. 54 and 57) represent only one aspect of his career. While he was depicting rural subjects, establishing both his nationalist and Realist sympathies, he also devoted a number of works to urban themes. The Sick Girl *must be considered within this category, for it is a startlingly direct documentation of tuberculosis, which had reached almost epidemic proportions in mid-century Christiania. It was painted during the winter of 1880–81 while Krohg was living in the city, and at least one half-length study survives (Nasjonalgalleriet, Oslo). The child stares out, her skin pasty and her eyes rimmed. Her stark features are thrown into relief by the white of her pillow and gown; the red border on the pale blanket looks almost like a wound across her body. A wilting rose scattering leaves across her lap underlines her imminent death.*

The sick child is a common theme in art. In the nineteenth century the Düsseldorf school frequently used it, and works like Michael Ancher's A Sick Girl *(1882; Den Hirschsprungske Samling, Copenhagen) are representative of the general Scandinavian interpretation of it. These paintings typically show the subject from a picturesque distance, the model languorous and refined by her illness, the overall mood cloyingly sweet. The Norwegian painter Edvard Munch* dismissed the genre and criticized his fellow artists for not showing the true horror of the theme (letter to Jens Thiis, circa 1933; Stang, 1979 p. 60) (see cat. no. 77). Although Munch included Krohg in this criticism, Krohg avoided the standard attitudes of the time by reworking the familiar composition into a head-on engagement.*

This work can be viewed in a personal context as well. While the actual model for this scene is not known, Krohg, like Munch, had seen his sister die of tuberculosis in 1868. He later wrote of her death in the short story "Sister" in the 1906 collection Dissonanster: *"She was still sitting in the rocking chair looking with fatigue in front of her . . . There it was again, this doomed, demanding look in her big eyes." (Oslo, Nasjonalgalleriet, 1981, pp. 69–70.)*

Krohg has pared the scene down to its absolute minimum. He pushes the girl into our space by extreme cropping and forces an uncompromising confrontation with this picture of decay. It was this aspect of the painting that most disturbed contemporary critics. When it was exhibited at the Christiania Art Association, Andreas Aubert wrote in the newspaper Morgenbladet, *"We demand something more to be satisfied, we must see something more of the surroundings" (Oslo, Nasjonalgalleriet, 1981, p. 69). By eliminating such surroundings, however, Krohg had invested the painting with an emotional concentration and physical immediacy unprecedented in his work. These qualities make his art a bridge between the Realist conventions of his contemporaries and the expressive intensity of the next generation exemplified by Munch. [ADG/OT]*

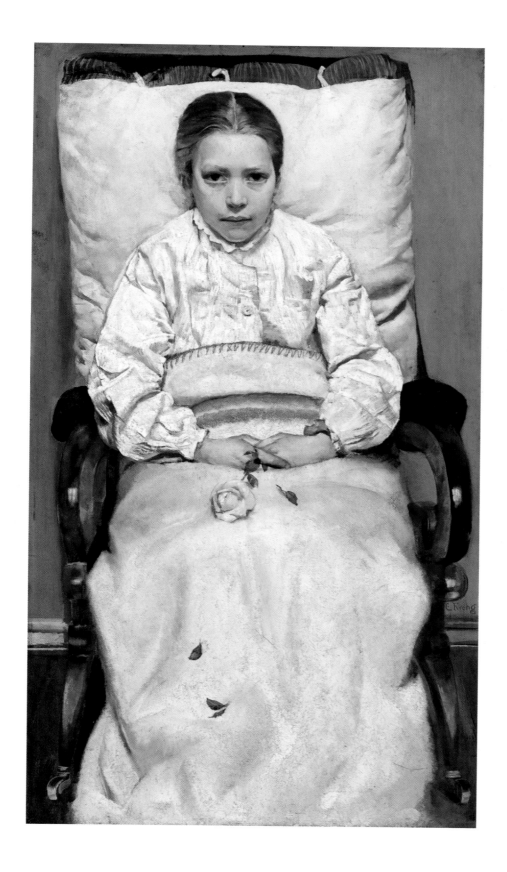

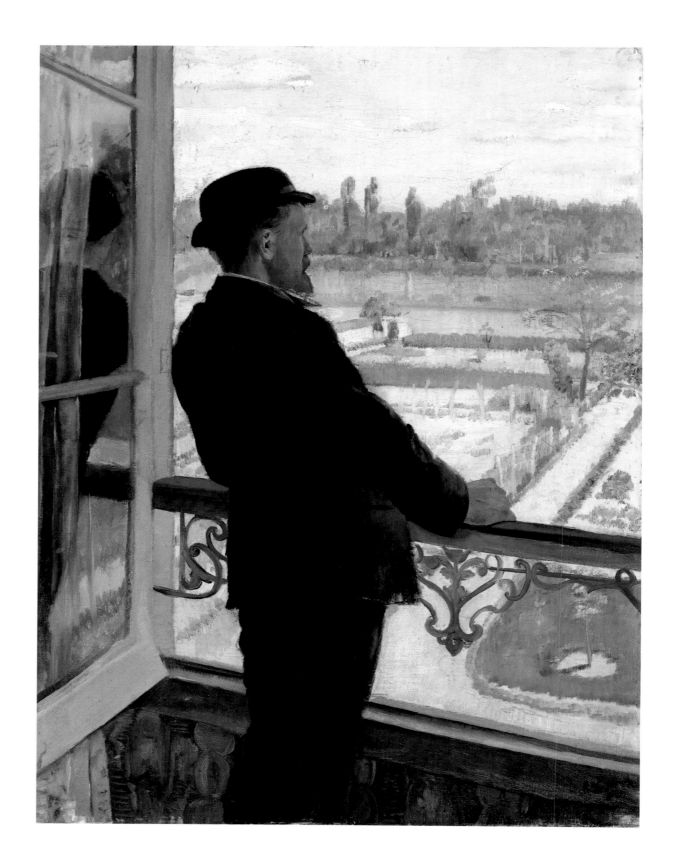

56
Portrait of Karl Nordström *1882*
Den svenske maler Karl Nordström
61.5 x 46.5 (24¼ x 18¼)
Not signed
Nasjonalgalleriet, Oslo

Krohg travelled to Paris in October 1881 and enthusi-
astically visited exhibitions of French art where he studied
the techniques of Jules Bastien-Lepage, Édouard Manet,
and Gustave Caillebotte. In April 1882 he left for Grèz-sur-
Loing, the Scandinavian artists' colony outside Paris, with
his colleagues Christian Skredsvig, Karl Nordström*, and*
Carl Larsson. Krohg and Nordström were especially close*
friends and eagerly shared their ideas about new artistic
trends.

As in Nordström's Garden in Grèz *(cat. no. 83), the*
vista seen through the open window appears to be the
garden of the Pension Laurent, where Nordström stayed
during his Grèz sojourn. Nordström recalled of this portrait:
"We had studied the Impressionists at an exhibition in Paris
and we were filled with the new ideas. Krohg saw me one
day at the open window wearing my blue suit silhouetted
against the garden. He asked me eagerly to stand still in my
pose, fetched a canvas . . . and in a few seconds the work
was in full action" (Oscar Thue, Christian Krohgs portret-
ter, *Oslo, 1971, p. 25).*

The portrait bears a striking structural similarity to
Caillebotte's Homme au Balcon, Boulevard Haussmann
(1880; Private Collection, Switzerland), which was shown
at the 1882 Impressionist exhibition (see Kirk Varnedoe,
1979). Caillebotte had extended the German Romantic tra-
dition of the open window as a metaphor of contrast be-
tween enclosure and escape, but had replaced the wild, un-
tamed Romantic vision of nature with the anonymity of the
metropolis. Krohg's portrait is an intermediary; his bour-
geois garden is a transition between the natural landscape
and Caillebotte's city. [SRG]

57
Sleeping Mother *1883*
Sovende mor
107.5 x 141.8 (42¼ x 55⅛)
Signed lower right: "C. Krohg/Skagen 1883"
Rasmus Meyers Samlinger, Bergen

The mother by her child's cradle was a popular motif in scenes of rural life throughout the nineteenth century. The Düsseldorf painters, both German and Scandinavian, used it, and it was also common in French art. In general, these are scenes of easy sentimentality that illustrate the tradi-

Christian Krohg
Daybreak 1880
Daggry
135.0 x 80.8 (53⅛ x 31¾)
Statens Museum for Kunst, Copenhagen
Weariness by exploitation in the city, as opposed to the exhaustion of the rural *Sleeping Mother,* is the subject of *Daybreak;* this young seamstress has fallen asleep over her chores in the night.

tional role of woman as mother in a cheerful domestic environment. (For a further discussion of this theme in French art see Mari et Femme dans la France rurale traditionnelle, Paris: Musée National des Arts et Traditions Populaires, 1973, pp. 34–36.) In taking it over, Krohg treated the theme with a startling Realism that overthrew many of the standard associations that had attended it.

Sleeping Mother was begun during Krohg's third visit to Skagen in 1883; after several studies, this canvas was completed the following November. The models are Tine Gaihede and her child, and during the initial stages of the composition, Tine's husband, Rasmus Gaihede, was included lying on the bed (biblio, ref. no. 26, pp. 95–96). The palette is uncharacteristically brilliant, perhaps reflecting Krohg's 1881–82 visit to Paris; the rich breadth of color and impasto in areas such as the bedclothing made a strong impression on his student Edvard Munch (see cat. no. 69). Overall, the composition demonstrates the same concerns found in Krohg's earlier Skagen works. The scene is given dramatic impact by abrupt cropping, and the immediate foreground is aggressively punctured by the table on the left, a device also found in The Net Mender (cat. no. 54).

This painting has frequently been compared to Krohg's 1880 Daybreak (see left) which shows a working girl fallen exhausted over her sewing in the morning light. Sleeping Mother, however, is much bolder, as Krohg deliberately stripped it of the sweetness that characterized the scene of the young girl. Tine Gaihede is shown at an awkward angle, closed in by the frame, her back painfully bent and her head buried in the pillow. Similarly, the child is drawn from the least picturesque view, its doll-like head strangely foreshortened. The stained table, the half-eaten porridge that attracts flies, and the intensely crowded interior all convey a sense of squalor.

Krohg uses these details to challenge the conventions of the theme. Instead of presenting a rosy image of domestic harmony, he gives us a sober examination of rural life. The mother is depicted not as a benign and watchful guardian, but as worn out by family chores; her hands barely hold her knitting and the cradle. Krohg used the same approach in many of his paintings: the themes were part of popular traditions, but his Realist treatment of them created potent, contemporary images. [ADG/OT]

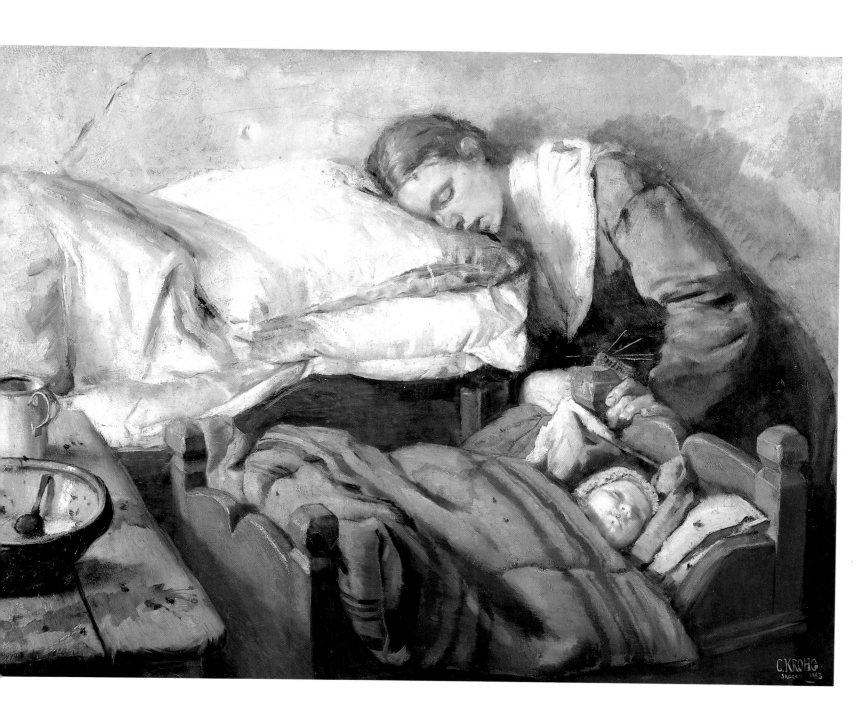

149

58

Portrait of Gerhard Munthe *1885*
Maleren Gerhard Munthe
150.0 x 115.0 (59 x 45 ¼)
Signed lower right: "C. Krohg/85"
Nasjonalgalleriet, Oslo

Krohg's portraits of the 1880s reveal a sensibility different from that seen in his works dealing with social issues, such as The Net Mender *(cat. no. 54) and* The Sick Girl *(cat. no. 55). But these portraits represent another aspect of, rather than a departure from, his interests and artistic style.*

Krohg and Gerhard Munthe (1849–1929) met in 1870 when they were students at Johan Frederik Eckersberg's art school and the Royal Academy of Art in Christiania. Munthe went on to study in Düsseldorf and Munich. In 1883 he settled in Norway, where he wished to define a native school of painting. This interest first led him to Christian Skredsvig's* plein-air circle at Fleskum, and then into a consuming preoccupation with traditional Norwegian design. In the 1890s he led a national crafts revival, based on his studies of folk art. He produced stylized cartoons inspired by Norse sagas, such as* Horse of Hades *(no. 84), some of which were intended for tapestries woven by his wife Sigrun or by professional weavers.*

Krohg and Munthe never became close friends. By all accounts Munthe was far to the right of Krohg's bohemian circle, a witty and exclusive conservative. In this spirited portrait, Krohg has captured these characteristics in Munthe's stance, gesture, and glance.

Manet's influence – seen most strikingly in the use of black – is evident here and dominates in the majority of Krohg's portraits of the 1880s. This work, with its seemingly slick Parisian setting, was actually painted in Copenhagen and depicts the interior of the Grand Café. Amid the dissolution of light and form in the smoky background, the profile of the Norwegian marine painter Reinholdt Boll is visible at the left. [WPM/OT]

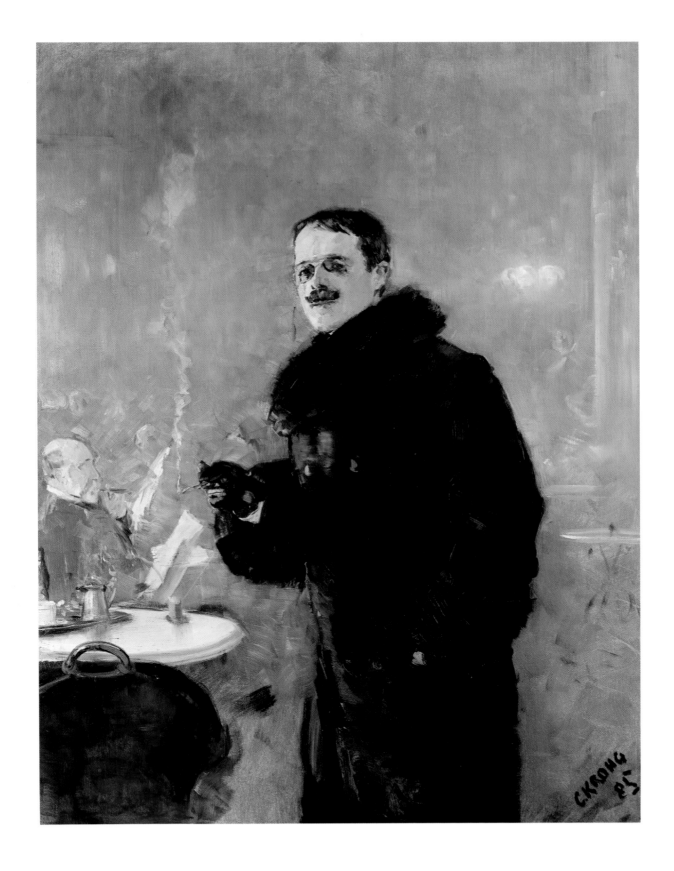

151

59

Albertine in the Police Doctor's Waiting Room, *1886–87*
Albertine i politilegens venteværelse
211.0 x 326.0 (83⅛ x 128¼)
Oslo, Nasjonalgalleriet

While Krohg was studying in Germany, his teacher Carl Gussow directed his attention to socially-engaged art. Radicalized in Berlin under the influence of Max Klinger and Georg Brandes (see cat. no. 94), Krohg returned to Norway in the early 1880s to lead the "socialist" art movement. He belonged to the "Christiania Bohème", a group of artists and writers who joined the anarchist Hans Jaeger to fight for individual liberty and social progress. This circle, inspired by Zola, Marx, and Darwin, extolled the virtues of intellectual and political freedom. They were notorious for their stand on free love and their "vie expérimentale", which included a love triangle between Krohg, Jaeger, and Krohg's future wife. When Jaeger published his self-confessional chronicle, From the Christiania Bohème (1885), it was labelled "obscene" and banned; Jaeger was jailed.

In December of 1886, Christian Krohg published the Jaeger-inspired novel Albertine, which was banned as soon as it appeared. Houses were searched and packages bound for Sweden intercepted. The liberal press lionized Krohg, while the conservative press damned him. The charge of obscenity, reminiscent of that levelled against Jaeger, was debated in a trial that examined not only Krohg's moral turpitude, but the morality of society as a whole. Despite Krohg's brilliant defense speech, carried by the liberal papers, he was found guilty and fined on March 10, 1887. The next day, Albertine in the Police Doctor's Waiting Room went on exhibition in a rented working-class district warehouse. The painting, like the book, caused a sensation.

Albertine is the fatalistic story of a poor, young seamstress who is drawn into a life of prostitution by corrupt police officials. Based on an actual event recounted to Krohg by one of his models, Albertine was an indictment of Christiania's police and its bourgeois citizenry. Prostitution, viewed as a threat to middle-class family life, had been outlawed in Christiania in the early 1880s. At the same time, it had been perceived as a "necessary evil" – a safety valve protecting the virtuous girls of "nice families" – and although proscribed, prostitution became regulated by the police. Krohg was infuriated by this double standard and by the brutal treatment of the destitute girls who were victimized by this system.

In the painting, Albertine, already compromised by a corrupt police official, stands to the left of the painting. She is about to undergo the Police Doctor's degrading physical examination that will hasten her fall into prostitution. Although she stands in the background, she commands the attention of the room's other inhabitants, all prostitutes waiting for their examinations. Only the women standing in the extreme foreground direct their attention away from her. Newly stripped of her innocence, Albertine is on the brink of the experience that will eventually transform her into a seasoned whore akin to the brazenly staring redhead in the foreground. Past, present, and future meet in this image which Kirk Varnedoe interprets as a conflation of the three most compelling scenes in the book: The seduction, the examination, and the ending (Varnedoe, 1979, p. 90).

In 1885, Krohg began Albertine in the Police Doctor's Waiting Room with a clearly defined idea of the motif (Oscar Thue, "Albertine i politilegen's venteværelse", Kunst og Kultur, 1957, v. 40, p. 97–100). Staging and photographing the scene in his studio, he used Christiania prostitutes as his models, while casting himself in the role of policeman (see illustration). He then manipulated the photograph, painting in additional figures. In the final version, after lengthy repainting, Albertine was pushed into the background, her face hidden from our view. With the text's central figure de-emphasized, the painting assumes a casual, "snap-shot" quality (Varnedoe, op. cit.) which enhances its

Christian Krohg
Albertine in the Police Doctor's Waiting Room 1885–86
Photo and oil
Private collection.

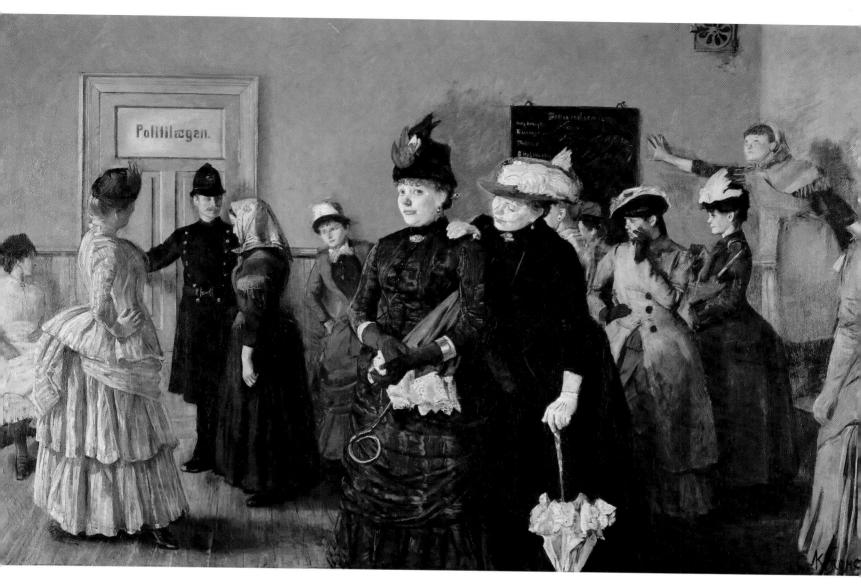

verisimilitude. Edvard Munch*, who always claimed to
have painted the figure to the left of the door, later used this
eccentric narrative strategy in Death in the Sickroom (cat.
no. 75).

Krohg had long been preoccupied with seamstresses as
symbols of oppression (see cat. no. 57), and had produced
Albertine-related paintings as early as 1883 (see Pola
Gauguin, Christian Krohg, Oslo, 1932). The sensation
caused by the final version brought the issue of political art
to the forefront of the Christiania and Scandinavian artistic
community. In his lectures and articles of the later 1880s,
Krohg urged his younger colleagues to paint "truthfully,
piercingly truthfully, unpleasantly truthfully" (Oslo, 1985,
p. 308). In 1889, he painted his second seminal social protest

painting, The Struggle for Existence (Oslo, Nasjonal-
galleriet). Although he blasted the Scandinavian community
for the lack of social content in the 1888 Scandinavian Ex-
hibition in Copenhagen, this tendency had emerged in the
work of L.A. Ring*, Eero Järnefelt*, and Harald Slott-
Møller* (see cat. no. 93).

Albertine in the Police Doctor's Waiting Room, the
most notorious painting of the 1880s generation in Norway,
was purchased from Krohg's studio in 1900, and sold to the
National Gallery in 1907. [PGB]

PEDER SEVERIN KRØYER

Denmark 1851–1909

Peder Severin Krøyer, born in the fishing town of Stavanger, Norway, was the illegitimate son of Ellen Celia Giesdahl. He was brought up in Copenhagen by his uncle, the eminent zoologist Hendrik N. Krøyer. By the age of ten he had proven his artistic talent in scientific illustrations, and in his early teens he entered Copenhagen's Royal Academy of Fine Arts. In 1872 he exhibited several portraits there and was awarded a prize the following year.

Krøyer made his first trip abroad in 1875, visiting Berlin, Munich, Dresden, and the Swiss Tyrol. In 1877, after visits to the Netherlands and Belgium, he entered the Paris studio of Léon Bonnat. Following Bonnat's advice, he visited Madrid in 1878 to see the work of the Spanish masters. In 1879 he went to Brittany and in 1880 to Italy. He returned to Denmark in 1881 after seeing his works in the Paris Salon.

At Michael Ancher's invitation, Krøyer went to Skagen in 1882, establishing a pattern he followed for the rest of his life: he travelled frequently, becoming a true cosmopolitan artist, but always returned to Skagen whenever possible. In 1887 he was named a member of the Danish academy, and in 1889 he was awarded full Danish citizenship and married Marie Triepcke, a former student.

During the 1880s Krøyer established himself as Denmark's foremost *plein-airiste* and also became a portraitist of international repute. He was made a member of the Swedish Royal Academy of Fine Arts in 1899 and was awarded honorary medals at both the 1889 and 1900 Paris World Expositions.

Toward the end of his life Krøyer suffered from the same manic-depressive nervous disorder as his mother, and had attacks which prevented him from working. In 1909 he travelled to Venice to see an exhibition of his work; on his return to Skagen he died. [ADG]

60

Sardine Cannery at Concarneau *1879*
Et sardineri i Concarneau
101.5 x 140.5 (40 x 55¼)
Signed lower right: "S. Krøyer/Concarneau 79"
Statens Museum for Kunst, Copenhagen

This painting of a Concarneau cannery was executed during the fall of 1879 while Krøyer was visiting Brittany. He had just left Paris, where he had been studying for two years under Léon Bonnat. In a letter to the Danish collector Heinrich Hirschsprung dated October 9, 1879, he described this work: "The girls and matrons sit along a long table filled with sardines . . . through some small openings in the roof the sunlight falls and creates a wonderful feeling." In the same letter he said that he wished to paint in the manner of José Ribera and Diego Velázquez, artists whose works he had studied the previous year in Madrid (Mentze, 1980, p. 80).

Both subject matter and style here demonstrate Krøyer's early allegiance to Realism. Concarneau, less than ten miles from Pont-Aven, was then one of Brittany's major port towns, the center for the fishing and canning industry which had rapidly expanded since the beginning of the nineteenth century. By 1877 at least 1,200 boats operated out of the harbor there, and approximately 13,000 people were employed in the process of boiling, salting, canning, and bottling the huge quantities of fish (Fred Orton and Griselda Pollock, "Les Données bretonnantes: La Prairie de la représentation," Art History, Vol. 3, September 1980, p. 324). While Krøyer's painting does not encompass the vast scale of the Concarneau industry, his plunging perspective conveys the ritual assembly-line nature of such work.

Such scenes of industrial life were rare in the work of French artists painting in Brittany at this time. Since the 1850s a number of French artists had come to Brittany to depict scenes of peasant life, rediscovering national roots in

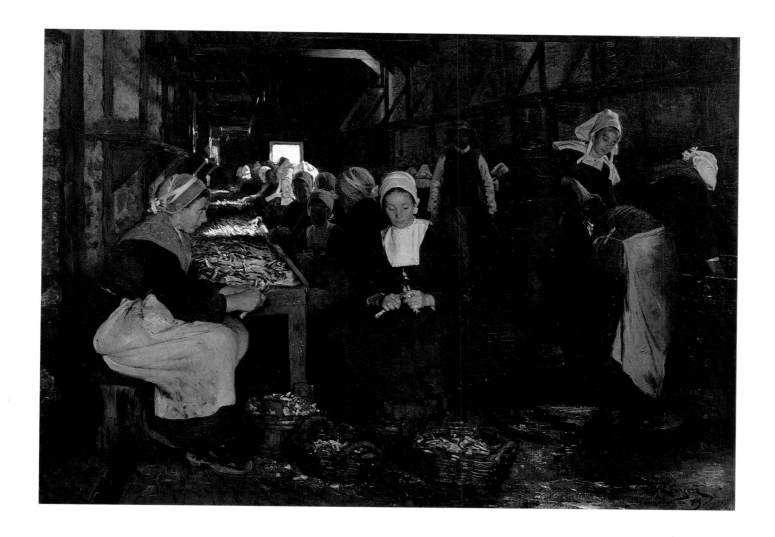

the traditions preserved among the rural populace. These artists, however, concentrated on the religious life of the province, an approach typified by such paintings as François Bonvin's The Poor's Bench: Remembrance of Brittany (1864; Musées d'Alençon) and Jules Breton's The Great Pilgrimage (1868; National Museum of Cuba, Havana). This attitude persisted in the 1880s in the work of both Pascal Dagnan-Bouveret and the Pont-Aven school.

Although Krøyer's Cannery must be viewed as distinct from this French tradition, it falls easily into the same category as paintings by other European Realists. The German Max Liebermann's The Vegetable Peelers (1872; Private Collection, Winterthur) is strikingly similar to Cannery, as are the Dutchman Jozef Israëls' scenes of peasant labor. These artists (among many other Germans, Austrians, and Northern Europeans) had gained attention in France because of the international exhibitions at the 1878 Paris World Exposition, and Krøyer would have been able to see their work during his European travels.

Krøyer's involvement with Realism lasted for several years. In 1880 he depicted another scene of work, The Italian Hatmakers (Den Hirschsprungske Samling, Copenhagen), which was an immediate succès de scandale when exhibited in Paris and Copenhagen. His approach, however, lacks the force of the major Realists, for Cannery is ultimately a tourist's view: the women appear picturesque in their native costume, and the active variety of the figure groupings belies the true monotony of their labor. [ADG]

61

In the Store During a Pause from Fishing *1882*
I købmandens bod, naar der ikke fiskes
79.5 x 109.8 (31 ⅛ x 43 ⅛)
Signed lower left: "S. Krøyer/Skagen 82"
Den Hirschsprungske Samling, Copenhagen

*Krøyer first came to Skagen, the Danish fishing village
turned artists' colony, in the summer of 1882. He had been
invited by fellow painter Michael Ancher, and like many of
Skagen's visiting artists, he stayed at the hotel owned by
Erik Brøndum, the father of Michael's wife Anna Ancher*.
A few days after his arrival Krøyer began this painting.*

 *Everything about the composition emphasizes the dis-
tance between the artist and his subject. The bar fills the
foreground and denies access to the main figure grouping.
The two figures on the viewer's side of the counter are set
off by distance and by cropping, and the only contacts
offered are the glances across the space made by several of
the fishermen. Krøyer maintains what may be called the
"tourist's-eye view" that can also be found in his* Sardine
Cannery at Concarneau *(cat. no. 60). Indeed, the sharp sun-
light, the brownish palette, and the plunging space are all
devices found earlier in* Cannery. *His use of light in the
present scene, however, is far more advanced; here it both
punctuates and unifies space, heralding his move toward the
Naturalism that characterized his work throughout the
1880s.*

 *Michael Ancher was apparently aghast when he heard
that Krøyer had set up easel in the hotel shop, and he wrote
to Krøyer on November 9, "You have painted the shop at
my in-laws. Closer than that you should not go or I shall be
forced to leave town" (Mentze, 1980, p. 104). It is hard to
see what could have caused offense in this picture. On the
other hand, Krøyer's urbane and detached conception fails
completely to render the fisherfolk as either picturesque or
heroic (compare the dramatized grizzliness of Krohg's
Skagen picture* The Net Mender, *cat. no. 54). He chooses a
moment of idleness and depicts the mundane world of their
interaction with commerce instead of isolating their struggle
against the sea. Thus, his first picture at Skagen violates the
more folk-oriented tenor of traditional Skagen imagery by
adopting a cooler, more reportorial stance. [ADG]*

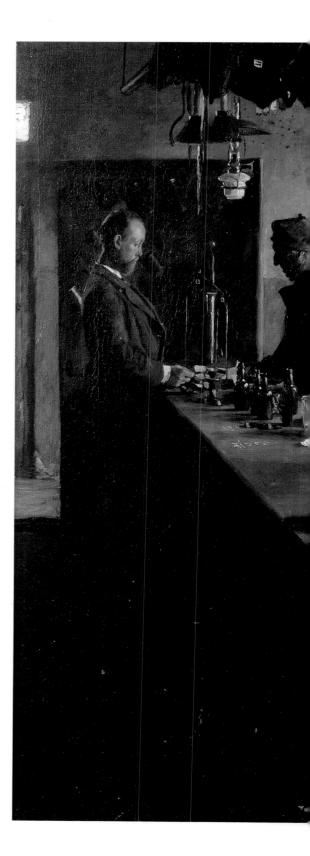

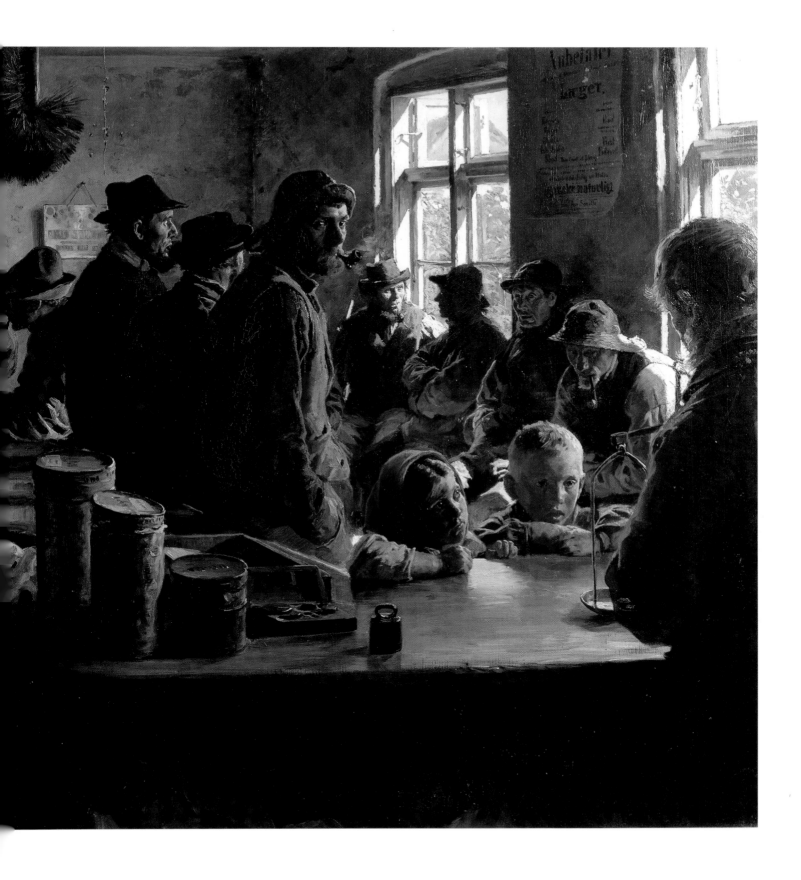

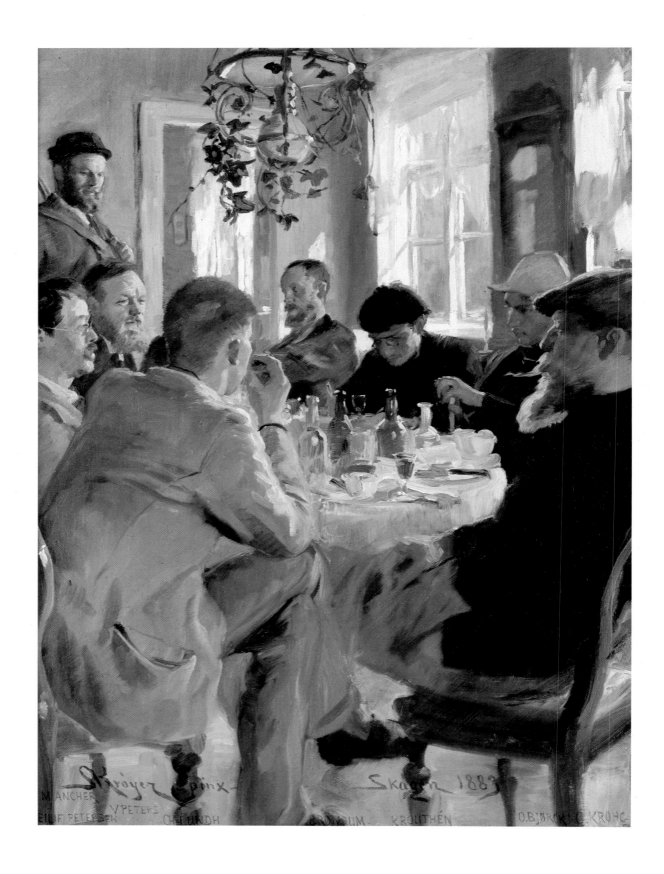

62

The Artists' Luncheon *1883*
Kunstnerfrokost
82.0 x 61.0 (32¼ x 24)
Signed across bottom:
"S. Krøyer pinx. Skagen 1883"
Skagens Museum

During his second visit to Skagen in the summer of 1883, Krøyer painted this celebration of the artists' community there. The figures are identified by the names inscribed at the bottom of the canvas. Clockwise from the left foreground they are Charles Lundh, Eilif Peterssen, Vilhelm Peters, Michael Ancher (standing), Degn Brøndum, Johan Krrouthén, Oscar Björck, and Christian Krohg* (in the right foreground). The setting is the dining room of Erik Brøndum's hotel (see also cat. no. 61).*

Krøyer was particularly attracted to this type of informal group portraiture and did a number of banquet and luncheon themes. He had hit upon this formula with his 1879 Artists' Lunch in Cernay-la-Ville *(Skagens Museum), in which thirteen members of the Breton artists' community are gathered around a broad table. The Skagen* Artists' Luncheon *is, however, a bolder painting in several respects. Krøyer pushes the figures into the immediate foreground, depicting Lundh's back rather than relegating him to one side. The composition is more bluntly cropped, a technique probably learned from Krohg, and the flow of light across the room is handled with a sophistication and a newly vibrant palette that are indebted to contemporary French art.*

This painting holds a special place in the history of the Skagen community. It formed the core of an elaborate decoration for the Brøndum hotel's "Artists' Room", a dining room in which were hung local scenes as well as portraits of all the members of the colony, including painters, writers, and musicians. These were executed by Krøyer and others in an ongoing project. Krøyer initiated the enterprise after the example of a room he had seen at Versailles; ultimately there were eighty-one paintings in the hotel dining room, carefully arranged in a balanced scheme on all four walls. While most of the works were done in the 1880s and early 1890s, the last contribution was made in 1925.

Krøyer painted another Skagen luncheon in 1888, Hip, Hip, Hurrah! *(Göteborgs Konstmuseum). In it he depicted the exuberant moment of a toast, with the artists and their spouses gathered under an arbor in dappled sunlight. Although many of the same artists from* The Artists' Luncheon *were included, a glittering, well-dressed company had replaced the serious gathering of 1883. [ADG]*

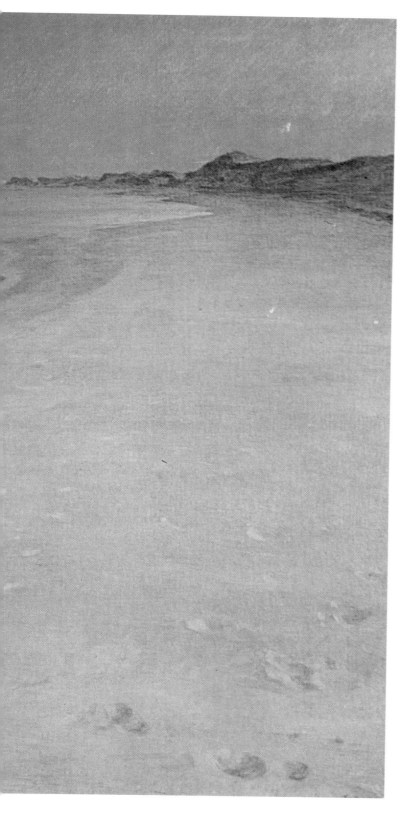

63
Summer Evening on the South Beach at Skagen *1893*
Sommeraften på Skagens sønderstrand
100.0 x 150.0 (39³/₈ x 59)
Signed lower left: "S. Krøyer Skagen 93"
Skagens Museum

Krøyer's Summer Evening on the South Beach at Skagen *is representative of a genre of landscape painting that came into vogue in the late 1880s and early 1890s. Appropriately named "Blue Painting" (biblio. ref. no. 73, pp. 52–64), this genre was distinguished by its seemingly unreal mauve-blue palette and flowing composition. Although it was based primarily on the example of James McNeill Whistler and the French Synthetists, the style was also promoted by the specific atmospheric conditions of Scandinavia.*

In the long Nordic midsummer evenings, the twilight forms what is known as the blue hour, roughly at 10 p.m., when the low sun dissolves the atmosphere into a blue haze. This phenomenon provided a northern equivalent to the misty nocturnes of Whistler's London and the remote light of Pierre Puvis de Chavannes' Arcadia.

Krøyer painted many scenes in this manner, for they satisfied both his need to be a part of the cosmopolitan mainstream and his preference for plein-air painting in Skagen. He painted his first variations on the theme of a woman on the strand in 1891 and continued to rework the composition up until his death in 1909 (Mentze, 1969, p. 207). The models here are his wife Marie Krøyer, a renowned beauty, and the painter Anna Ancher. Krøyer photographed their pose on the beach and later copied it in the studio (the photograph has been preserved in the Skagens Museum). In two small studies for the painting (both in Den Hirschsprungske Samling, Copenhagen) the figures were placed in the distance rather than the middle ground. Here the women dominate the scene, their elegant dresses of summer white draped with an Art Nouveau grace, and their elongated figures drawn with a sinuous delicacy. The scene is a world removed from that of* In the Store During a Pause from Fishing *(cat. no. 61). Many of the Skagen artists followed Krøyer's example, and the rustic images of fisherfolk were supplanted at Skagen by the broad, luminous tones of paintings devoted to mood, nuance, and decoration. [ADG]*

CARL LARSSON

Sweden 1853–1919

Carl Larsson was born into a family of servants and grew up in the slums of Stockholm. With a keen and early desire to become an artist, he entered the Royal Academy of Fine Arts in 1866. In order to support himself and his family during these student years, Larsson worked at a variety of jobs including comic illustration and newspaper reporting. In 1877 he went to Paris, where he stayed for five years. Since the eighteenth century, the French capital had been the principal destination of the most ambitious, aspiring Swedish artists, who travelled there in order to perfect the latest painting style and to establish their reputations.

Larsson initially devoted himself to grand history subjects executed in a late Romantic style. When these efforts failed to gain him admission to the Salon, Larsson changed directions. He moved to Grèz-sur-Loing in 1882, adopted the tenets of *plein-air* Naturalism and began painting with watercolors. There he met and, in 1883, married the fellow Swedish artist Karin Bergoo, who specialized in applied art and eventually provided him with seven children.

The Larssons returned to Sweden in 1885. The following year, Carl began teaching in Göteborg at the Museum's School of Drawing and Painting in addition to working toward the establishment of the opposition Artists' Union. In 1888, he completed three large paintings for Pontus Fürstenburg's Gallery, illustrating Renaissance, Rococco and Modern Art (now in the Göteborg Konstmuseum). These were exhibited at the 1889 Universal Exposition in Paris and established Larsson's reputation as a gifted muralist. In 1891, Larsson exhibited with *Les XX* in Brussels and won the competition for the stairway murals of the Nationalmuseum in Stockholm. To prepare for their execution, he made a pilgrimage to Florence in order to study fresco techniques at first hand, as did many other Scandinavian artists in the mid-1890s including Richard Bergh*, Prins Eugen*, Akseli Gallen-Kallela* and Georg Pauli.

During the 1890s, Larsson began the series of paintings which centered around his family and his country home, Sundborn, where the family moved permanently in 1901. Beginning in 1895 with *My Family*, he published these in small books accompanied by captions which he wrote. These books conveyed a blissful vision of family life at Sundborn which was shattered by the publication of Larsson's confessional autobiography in 1931. [MF]

64
The Old Man and the New Trees. Grèz *1883*
Gubben och nyplanteringen. Grèz
93.0 x 61.0 (58⅛ x 38⅛)
Nationalmuseum, Stockholm

Along with Karl Nordström (cat. no. 83), Richard Bergh* and Christian Krohg*, Larsson formed the core of the Scandinavian artists' colony based in the delightful provincial village of Grèz-sur-Loing, near Paris. It was here that Larsson embarked on a serious study of plein-air Naturalism. His interest in this approach to landscape first emerged in 1877 when he visited Barbizon, the village at the edge of the Fontainebleau Forest most closely associated with the style. There Larsson painted landscapes in oils, a medium he eschewed during his Grèz period.*

The picturesque rural subjects depicted by Larsson, and the flattened compositional structure he occasionally adopted, attest to the pervasive influence of Jules Bastien-Lepage on Scandinavian artists during these years. Larsson's interest now lay more in recording the ordinary activities of village life than in painting pure landscapes. In The Old Man in the Nursery Garden, spring planting occupies the elderly caretaker, as the young children play in the schoolyard. Observing this scene from the opposite bank, Larsson manifests equal concern for capturing the complexities of

water reflections as he does for the subtleties of atmospheric and lighting effects. The delicate silvery tonalities recall the Naturalist paintings of Jean-Baptiste-Camille Corot (1796–1875) whose work Larsson certainly knew.

The subject suggests an analogy between the training of young minds in school and the training of saplings by the gardener in preparation for strong and productive adulthoods. Furthermore, the association of children with springtime coupled with the old man's presence intimates a connection between cycles of nature, of time and of human life. This thematic depth, while unusual for Larsson, may have been inspired by the pastoral visions of the Barbizon painter Jean-François Millet (1814–1875), whose well-known paintings presented such content so compellingly.

This gentle, pastoral vision of rural life, of man living in healthy harmony with his fellows and with nature, constrasted sharply with Larsson's childhood experience of urban poverty. The impact of Grèz on Larsson was significant, as it was here that he was introduced to the beauty and simplicity of country living, a discovery which directed the course of his life. The submission of watercolors painted in Grèz (e.g. In the Kitchen Garden, 1883; Nationalmuseum, Stockholm) to the 1883 Salon won Larsson a gold medal and strengthened his recent commitment to plein-air Naturalism. [MF]

65
In the Corner c. 1895
Skamvrån
Watercolour on paper
32.0 x 43.0 (12⅝ x 17)
Nationalmuseum, Stockholm

In 1889, Larsson's wife inherited a log house at Sundborn in Dalarna, a province best known for its strong folklore and decorative art traditions. Remodelling took place throughout the 1890s. The exterior was panelled and painted and the interior walls and moldings were painted and stencilled. While unusual for the time, highly decorated walls were common in the region's eighteenth-century farmhouses. Larsson designed much of the simple furniture, built by local carpenters, and the women of the family, led by Karin, designed and executed many of Sundborn's woven and embroidered textiles.

Larsson began painting Sundborn subjects around 1895. In Stockholm in 1897 he exhibited the set of paintings issued two years later as a book entitled A Home, which included In the Corner. His purpose in publishing these charming watercolors as small, easily accessible volumes was didactic as well as economic. Larsson sought to promote a style of home decor whose cheerful simplicity had a distinct moral dimension. The rectilinear symmetry of the interiors communicate a sense of domestic order and harmony; the simple designs and clear colors convey an unmistakable sense of honesty; and the traditional motifs and antique fixtures and furniture, a respect for the past.

During the late nineteenth century, artists' homes frequently became an extension of their art. In the 1870s, William Morris (1834–1896), the leader of the English Arts and Crafts Movement, made his Red House near London a showplace for the fabrics, furniture and wallpapers produced by his small company. All articles were meticulously handcrafted with designs often based on medieval precedents. Morris sought to provide a model of honest and enjoyable labor, with the goal of creating a society, based on the medieval guild system, whose collective aspirations would be harmony, happiness and productivity. With similar intentions, the Belgian artist Henry van de Velde designed his own house and its contents in the mid-1890s. His commit-

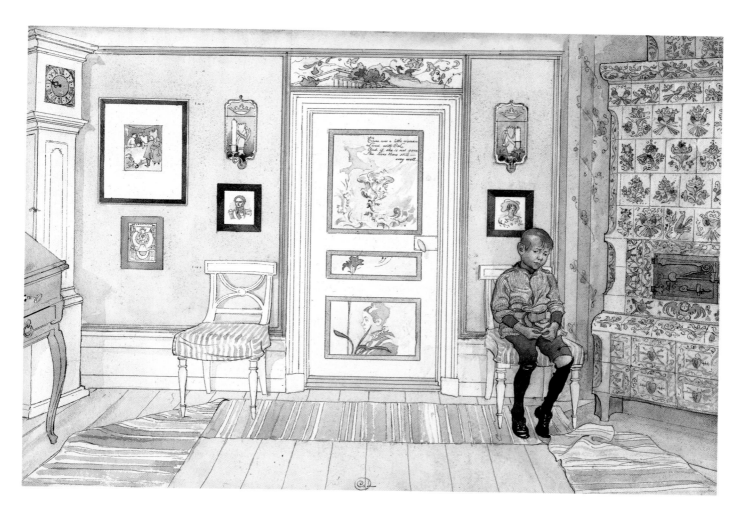

ment to social reform motivated his eventual abandonment of art for design.

Within this home-as-art trend, some artists sought to satisfy escapist tendencies. In Brussels, the dandified painter Ferdinand Khnopff designed an elegant residence containing esoteric symbols and mystical shrines intended solely for private delectation. Larsson's Sundborn lies somewhere between these two conceptions: the model of social reform and the private refuge. In his Sundborn paintings, he celebrated an ideal of cheerful rusticity and the preservation of local

traditions. Larsson's chief concern was familial bliss, not social solidarity.

Most of the Sundborn paintings tell a fictitious story of Larsson family life; this one relates a tale of the punishment and remorse suffered by his son Pontus. The decorative style adopted by Larsson in these works is particularly suited to illustration. His evolution of this style probably evolved from his exposure to English illustrators such as Kate Greenaway, whose intimate scenes of childhood innocence are so close in spirit to his own. [MF]

BRUNO LILJEFORS

Sweden 1860–1939

Liljefors' lifelong activity as a hunter motivated both his close study of animal life and his early decision to become an animal painter. He entered the Royal Academy of Fine Arts in Stockholm in 1879 and was influenced there by his friend Anders Zorn*. In 1882 he studied in Düsseldorf with the animal painter C.F. Deiker and then journeyed to Italy and France. He joined the circle of Swedish artists in Paris and was particularly taken with the light, color, and compositional novelties of Impressionism. He exhibited his work widely with success at the Paris Salons, the 1891 Munich International, the 1893 Chicago World's Fair, and the 1903 St. Louis Louisiana Purchase Exposition.

The banker Ernest Thiel was Liljefors' most important patron, although in 1896 Prins Eugen* of Sweden arranged for a trust fund to allow the artist to work without financial worry. Liljefors eventually purchased the Bullerö archipelago near Stockholm and there studied flocks of migratory birds, which he represented in large, brilliantly colored canvases. His art was based on a scrupulous knowledge of nature, aided from the 1880s onward by photographs he made for preparatory studies. He was also an inveterate caricaturist, a powerful portraitist, and an occasional sculptor of the human figure. [EB/AC/GCB]

66
Dovehawk and Black Grouse *1884*
Duvhök och orrar
143.0 x 203.0 (56¼ x 79⅞)
Signed lower left:
"Bruno Liljefors./Ehrentuna Uppsala/1884."
Nationalmuseum, Stockholm

With Dovehawk and Black Grouse *Bruno Liljefors made his debut at the Paris Salon of 1884. The next year the same painting became his first major work to be shown in Scandinavia, in* From the Banks of the Seine, *an independent exhibition organized by the opponents of Stockholm's Royal Academy of Fine Arts.*

Much of Liljefors' work of the 1880s records the inevitable violence that accompanies the fight for survival in nature. He depicted the predators of the wilderness – eagles, foxes, hawks – as well as civilization's hunters – cats, dogs, and men. Just as frequently he painted the forces of life, such as eagles or foxes feeding their young; and he executed a number of paintings revealing the camouflage of various species. He was an avid caricaturist and studied the characteristic poses, gestures, and facial expressions of birds and game in order to portray accurately the psychology of animals. His interest in the primitive instincts that link humans and animals related to Darwin's theories and the late nineteenth-century phenomenon of psychic naturalism.

Liljefors painted Dovehawk and Black Grouse *in the winter of 1883–84 while living in a farmer's cottage at his ancestral village of Ehrentuna. He later recalled: "Black grouse were unusually plentiful that winter in the meadows close to my hideaway. The wet autumn had caused the oat harvest to sprout and rot where it lay in the fields, attracting huge flocks of these birds. Between meals they encamped among tufts and bushes round the edge of the land. The goshawks came in turn to live off the grouse and the idea for the picture came to me during the many occasions that I was out there hunting."*

Birds that Liljefors shot and mounted served as models for the painting's central scene, arranged like a still life and set within a landscape painted partially out-of-doors. The sharply detailed rendering of the foreground group contributes to the sense of disjuncture from the background, where the snow blurs any suggestion of perspective or depth and the birds are depicted in strict profile. Although Liljefors expressed the desire to record nature with the utmost fidelity, there is an overall decorative patterning and flattening of space here, betraying the influence of Japanese prints he would have seen in Paris a few months before.

[EB/GCB/AC]

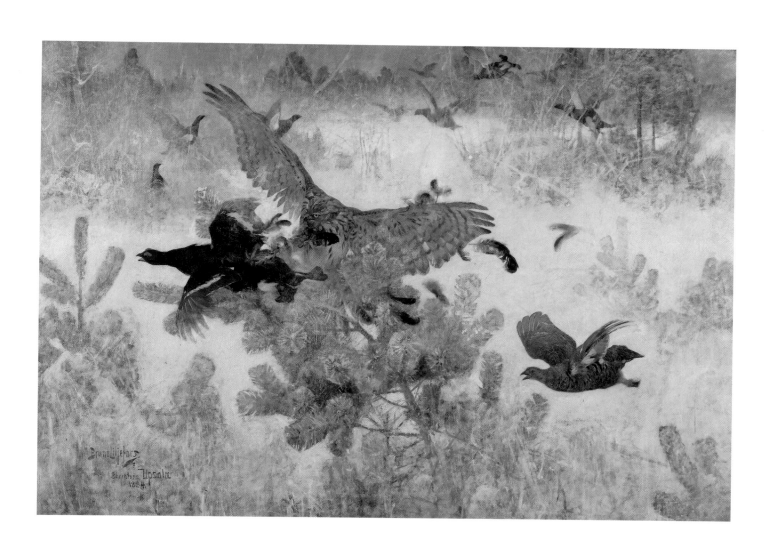

67

Horned Owl Deep in the Forest *1895*
Uven djupt inne i skogen
166.0 x 191.0 (65⅜ x 75¼)
Signed lower left: "Bruno Liljefors. -95"
Göteborgs Konstmuseum

Liljefors was captivated by the figure of the horned owl turned to face the viewer. Beginning with an ink drawing of 1889 (Liljefors Museum, Uppsala), he repeated the motif in this 1895 painting and in an 1896 picture of an owl set against a stark seascape. He also depicted flying horned owls hunting small animals in Flying Owl *(circa 1900; Thielska Galleriet, Stockholm) and devoted two chapters of his book* Det vildas rike, *published in 1934, to the owl's behavior and hunting ability.*

Horned Owl Deep in the Forest *was executed early in 1895 while Liljefors was staying in the small attic of the Hotel National in Copenhagen. It is marked by a spiritual seriousness and psychological intensity characteristic of the Neo-Romantic or National Romantic style then popular in Norway and Sweden. For Liljefors and his critics the owl represented the Nietzschean ideal of the lone, contemplative hunter who is completely at home in the wild, desolate landscape. The owl sits on a ridge close to the picture plane, its feathers nearly indistinguishable from the mesh of dark, partially formed trees in the background. The vibrant forest echoes the brooding mood of the poised bird, an intentional link between macrocosm and microcosm that was characteristic of Liljefors' work of the '90s. Detailed studies of a bird's wing, for example, often served the artist as the basis for the form, texture, and coloring of the surrounding landscape. Individual creature and natural environment were thus inextricably bound in a formal and spiritual unity.*

When this painting was first exhibited, the critics noted a change in Liljefors' style from the 1880s to the 1890s: "From the dainty idylls with small birds and amusing fox families with which he first attracted attention some ten years ago, to Deep in the Forest – *what an intensification and concentration of force, what a scale of moods, from the sounds and thousand colors of day to this representation of night and storm, of chasing clouds and bending spruce tops in which the horned owl sits as the incarnate demon of Nordic nature" (Karl Wåhlin, "Konstutstallninger i Stockholm," Ord och Bild, 1895, p. 3). [EB/BF/AC]*

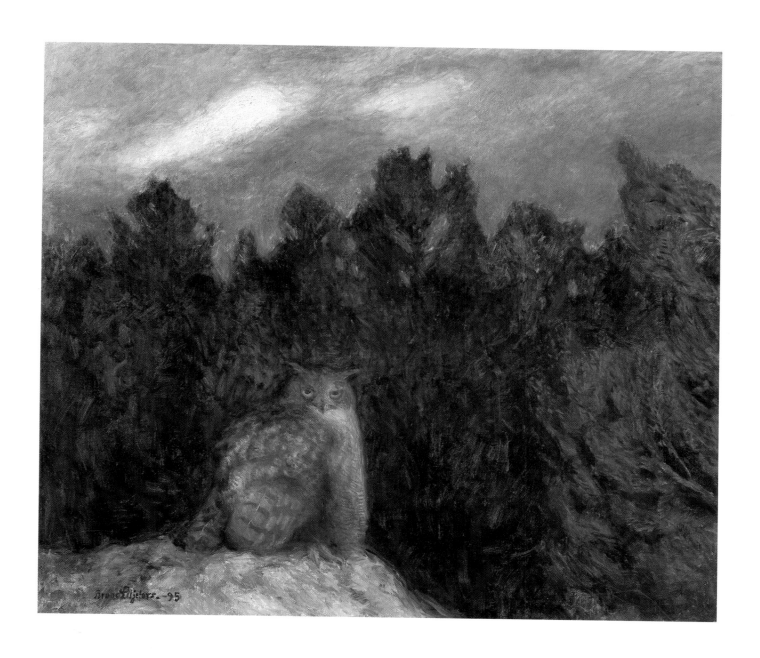

169

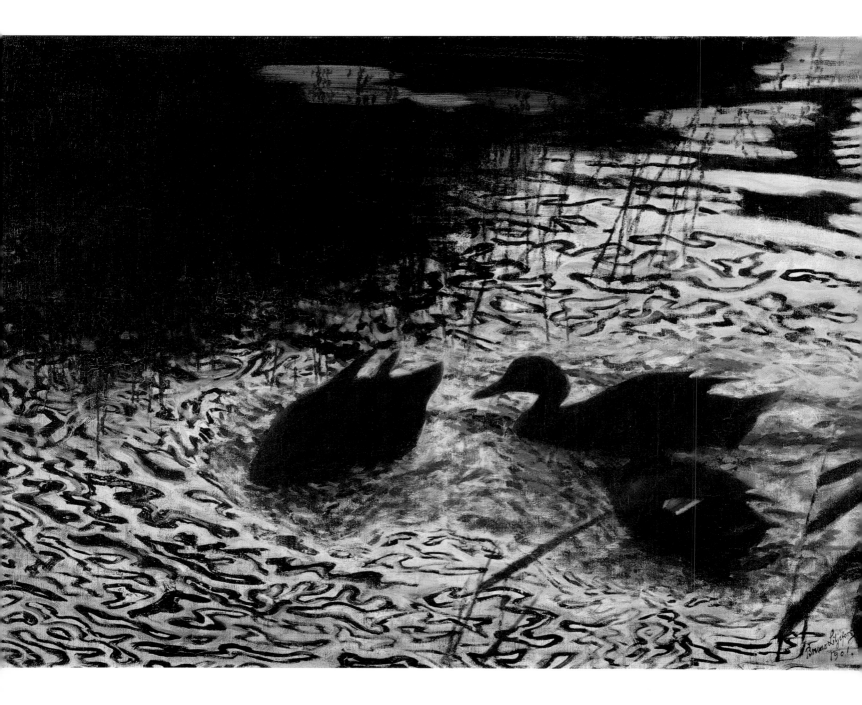

170

68

Evening, Wild Ducks (The "Panther-skin Rug") *1901*
Afton, vildänder ("Panterfällen")
92.0 x 193.0 (57½ x 120⅝)
Thielska Galleriet, Stockholm

*Like the French Impressionist Claude Monet, Liljefors
owned a small boat equipped with an easel; it allowed him
to float quietly in the marshes of the archipelago. After
1900, waterfowl were among his favorite subjects, a prefer-
ence reflecting the increasing amounts of time Liljefors spent
among his islands.* Evening, Wild Ducks *belongs to a group
of drawings and paintings executed around 1900 that took
ducks in their wetlands environment as their subject.*

*As an avid hunter, Liljefors naturally harbored a
keen interest in the habits and habitats of game fowl, but
his concern ran far deeper than that of a mere sportsman.
Liljefors investigated the role of protective coloration, par-
ticularly in birds, under the influence of scientists like Gus-
tav Steffen, a Darwinist whose study* The Significance of
Colors in the Animal and Plant Worlds (Fargernas be-
tydelse i djur- och vaxtvärlden) *was published in 1890. To
Liljefors, this genetically programmed camouflage demon-
strated the inherent will of a species to adapt and survive,
affirming what he believed to be an ancient and immutable
law of nature. In his paintings, Liljefors occasionally applied
this law in reverse: in* Curlew *of 1907 (Nationalmuseum,
Stockholm) the color and pattern of the bird's feathers de-
termine those of the setting.*

The protective quality of darkness is the subject of
Evening, Wild Ducks. *With the onset of twilight, the ducks
become black silhouettes capable of merging invisibly with
the equally inky reeds. In other works of this series, one dis-
cerns only with great difficulty the images of the ducks hid-
den among the reeds. Here, as in all of the paintings in this
group, no predator threatens the peaceful pursuits of the
duck family.*

*The bold linear patterns of this work place Liljefors,
like his younger compatriot Gustaf Fjaestad*, in the decora-
tive tradition of Art Nouveau, popular at the time
throughout Europe. A unified, overall ornamental design
and references to natural forms – especially plants – charac-
terize this style. Its goal, consonant with that of Liljefors,
was to reintegrate man and his creations with the realm of
nature in order to promote an orderly, if not violence-free,
world. The shapes and gold/black color scheme of the ripples
surrounding the ducks suggest the evocative subtitle "The
Panther-skin Rug." [MF]*

171

EDVARD MUNCH

Norway 1863–1944

Edvard Munch, the myth, lives in a hellish world of cataleptics, vampires, and black-shrouded angels of death. Edvard Munch, the man, was born, the second of five children, into one of the foremost intellectual families of Norway in the rural town of Løten in 1863. One year later, Captain Christian Munch, a military physician, moved his family to Christiania, where Munch's mother Laura Catherine Bjølstad and his sister Sophie died of tuberculosis. Munch's younger brother Peter Andreas was to succumb to tuberculosis in 1895.

Munch entered engineering school in 1879, but quickly changed course, enrolling at the Christiania Royal Academy of Drawing in 1881 and concurrently studying art history at the University Library. The conservatism of the academy prompted him and several other young artists to desert in 1882 and move into the studio building "Pultosten" where Christian Krohg* painted. Krohg, just back from his extended stay in Paris, introduced Munch to nationalistic appreciation and mainstreams in current European art. In 1883, Munch debuted at the Christiania Autumn Exhibition and then attended Fritz Thaulow's "Open-Air Academy" in Modum. Thaulow became his strongest supporter, purchasing *Morning* (1884; Rasmus Meyers Samlinger, Bergen) from the 1884 Autumn Exhibition and securing the scholarship that first enabled Munch to visit Paris in 1885.

For the next few years, Munch was immersed in the politically and morally radical circle of Christiania bohemians that included such progressive Norwegians as the writers Hans Jaeger and Jonas Lie and the painters Christian Krohg* and Karl Gustav Jensen-Hjell*. These formative years saw the genesis of his lifelong preoccupations: human biological and psychological patterns.

Munch's initial one-man exhibition was held in April 1889, and was followed by the first of his many summers in Aasgaardstrand on the Christianiafjord. In October he travelled to Paris on a state fellowship, enrolling in Léon Bonnat's studio and visiting the World Exposition and Theo Van Gogh's gallery. Shortly thereafter he received the devastating news of his father's death, which contributed to a physical collapse in 1890. (He suffered another breakdown in 1908.) Returning to Paris on an unprecedented third state scholarship in 1891, he began moving away from his Krohg-inspired Naturalism to a Synthetic art more resonant with inner life.

After his 1892 one-man exhibition in Christiania, the Berlin artists' circle invited Munch to exhibit there. His paintings scandalized the city, and when the exhibition closed within days a group of artists led by Max Liebermann (1847–1935) withdrew from the circle, later forming the Berlin Secession. Although he continued to visit Paris and spend summers in Norway, Munch remained in Berlin and fell in with the bohemian writers and artists who published the periodical *Pan*, including playwright August Strindberg*, poet Stanislaw Przybyszewski (1868–1927), and critic Julius Meier-Graefe (1867–1935). He was also introduced to etching and lithography, which informed his painting. During this period he began to assemble his ambitious, protean ensemble of paintings entitled *The Frieze of Life*. By now a fully Symbolist painter, he exhibited with the Finnish Symbolist Akseli Gallen-Kallela* in 1895.

Munch returned temporarily to Paris in 1896, moving in the circles of Strindberg and the French poet Stéphane Mallarmé, and exhibiting in Samuel Bing's Galerie de l'Art Nouveau. He experimented

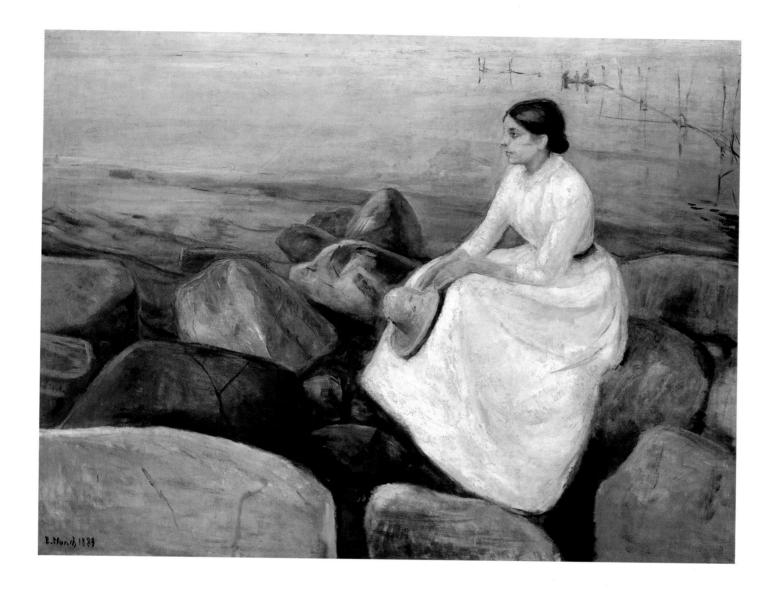

with color lithography and the graphic technique of woodcut, profiting from the pioneering decorative work of Paul Gauguin and Félix Vallotton. He was at the height of his creativity, exploring the psychological potential of color and line.

By the turn of the century Munch was in a state of mental exhaustion, suffering from alcoholism, yet still creatively inspired. In 1902 his "mature" *Frieze of Life* was exhibited at the Berlin Secession. He also designed sets for German and Parisian theater, and in 1911 won the commission for the Oslo University Festival Hall *(Aula)* murals. His work became infused with the bright northern sunlight and muscular health of Norwegian nationalist philosophy.

In 1916, the year his murals were unveiled, Munch purchased his house at Ekely, where he remained for the rest of his life. An internationally recognized artist who had exhibited in virtually every major city in Europe and was revered by the German Expressionist painters, he lived in near isolation, remaining productive until his death in 1944 at the age of eighty. [PGB]

69

Inger on the Beach (Summer Night) *1889*
Inger på Stranden (Sommernatt)
126.4 x 161.7 (49³/₄ x 63⁵/₈)
Signed lower left: "E Munch 1889"
Rasmus Meyers Samlinger, Bergen

Edvard Munch painted Inger on the Beach, *for which his sister Inger modelled, during the first of his many summers in Aasgaardstrand on the Christianiafjord. With its softly undulating coastline, atmospheric blue twilights, and the romance of its nearby Viking burial sites, Aasgaardstrand lured an annual summer coterie of Christiania artists and writers. In the summer of 1889 Hans Heyerdahl (1857–1913) and Christian Krohg* lived in the quaint fishing village and were in daily contact with Munch.*

While Krohg's free brushwork, flattened pictorial space, and attachment to the sea inspired Munch's work that summer, Munch's eradication of any reference to a horizon line and his muted palette of earth tones and silvery blues reflect his interest in Pierre Puvis de Chavannes. In 1884, the critic Andreas Aubert had interpreted Puvis's The Sacred Grove *(1884; Art Museum, Lyon) as a spiritual balance between human emotion and natural environment embodying musical harmony. Munch adapted this notion of a psychological veil extending from nature to enfold its inhabitants to create the iconic image of his sister in the landscape. Although critics attacked the stony silence of Inger when the painting was exhibited at the 1889 Autumn Exhibition in Christiania, it is this aspect of the work, indicating Munch's growing psychological interests, which captivates our imagination.*

As Robert Rosenblum points out (biblio. ref. no. 12, p. 107), Inger *is an adaptation of a persistent motif in Northern Romantic painting, the lone figure in an internal dialogue with nature. Yet rather than actively contemplating the endless expanse of water – as does the woman in Anselm Feuerbach's* Iphigenia *(1862; National Museum, Darmstadt), a widely circulated image of the 1880s –* Inger *is passive and self-absorbed. Munch likens her to the rocks on which she sits, linking her to the earth and sea. In such later works as* Summer Night's Dream (The Voice) *of 1895 (cat. no. 73), the image of a virginal white-clad female on the Aasgaardstrand shore becomes erotically charged.*

In the summer of 1892 Munch radically reinterpreted Inger on the Beach *in* Melancholy (The Yellow Boat) *(Rasmus Meyers Samlinger, Bergen), transforming the fishing boat in the background into the focal point for the anguish radiating from the figure seated in the extreme foreground. Thus transposed into an expressionistic foil, the Aasgaardstrand beach became the setting and unifying element of Munch's* Frieze of Life *paintings of the 1890s.* [PGB]

70

Night (Night at St. Cloud) *1890*
Natt (Natt i St. Cloud)
64.5 x 54.0 (25³/₈ x 21¹/₄)
Signed lower right: "E. Munch"
Nasjonalgalleriet, Oslo

With the aid of a state fellowship Munch left for Paris in October 1889 to study in the atelier of Léon Bonnat. On December 4 he learned of his father's death and was plunged into depression and total self-absorption. Near the end of the month he left the city for the suburb of St. Cloud, where, in the solitude of his apartment, he immersed himself in recollections of the past. He recorded the painful experience of these memories in a diary and in the subjective expression of Night.

The painting is, at once, a representation of the artist deep in thought and an evocation of the melancholic mood produced by his contemplation of the past. Although Night *is autobiographical, Munch's only friend at the time, the Danish poet Emmanuel Goldstein, probably posed for the figure. With his head resting heavily upon his hand, he gazed outside at the evening light and the boats on the Seine. The oppressive blue interior is a metaphor of Munch's psychological insularity, set in direct opposition to the world beyond the window. Forms are generalized and flattened, and the whole composition is enveloped in a hazy, lavender-blue atmosphere. A comparison with Harriet Backer's** Blue Interior *(1883; cat. no. 3) reveals the difference between a Naturalist's descriptive use of color and Munch's emotive exploitation of blue as a symbol of sadness, silence, and death. Munch also referred to the painting as* Symphony in Blue, *attesting to the influence of James McNeill Whistler, who used musical terms in many of his titles. The broad, thin handling of paint and the suggestive abstraction of forms reflect current French trends.*

In a comprehensive article on the painting, Reinhold Heller (1978, pp. 80–105) shows that Night *was a milestone in the development of the Symbolist movement in Scandinavia. When it was first exhibited in the Christiania Autumn Exhibition of 1890, the progressive critic Andreas Aubert aligned it with the new European aesthetic of Decadence: the cultivation of the self and a neurasthenic sensibility.* Night *continued to draw attention from Munch's contemporaries. By 1893 he had orders for four copies, and he repeated the image, in reverse, for an 1895 drypoint and aquatint entitled* Moonlight *(Schiefler, 1923, # 13).* [EB]

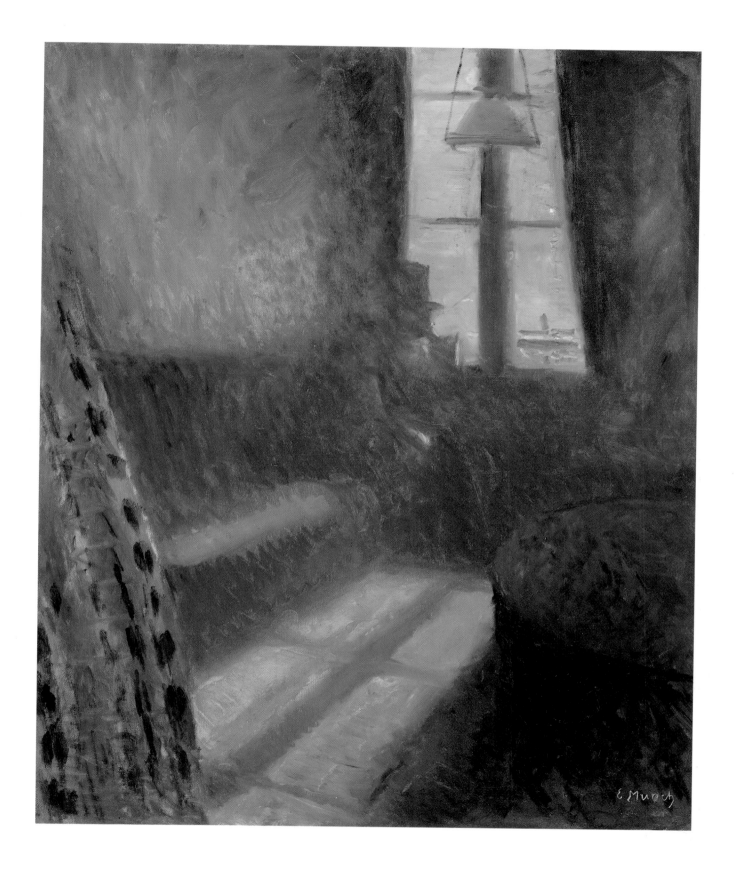

71

A Spring Day on Karl Johan Street *1890*
Vårdag på Karl Johan
80.0 x 100.0 (31½ x 39⅜)
Signed lower left: "E. Munch 91"
Bergen Billedgalleri

A Spring Day on Karl Johan Street, *like* Night *(cat. no. 70),
belongs to a period of experimentation in Munch's career,
1889 to 1892, during which he reacted against his native
training by assimilating current French styles. In* Spring
Day *he uses a Neo-Impressionist technique that he observed
firsthand in Paris, where he could have seen the work of
Georges Seurat at the Salon des Indépendants of March
1890. The quality of space and light and the blurring of
human figures are similar to Vincent Van Gogh's* Boulevard
de Clichy *of 1887 (Rijksmuseum Vincent Van Gogh,
Amsterdam). Munch's division of colors does not conform to
Seurat's strict method, nor is his application of paint consis-
tent across the canvas. Nonetheless, his Pointillism effec-
tively creates the sense of shimmering light on the open
street.*

*Munch painted the picture in May 1890 upon his re-
turn from Paris to Christiania and just before he left to
spend the summer in Aasgaardstrand.* Spring Day *was in-
cluded in the Christiania Autumn Exhibition of 1890,
where Munch assigned to it the highest price among the ten
paintings he exhibited. The signature and incorrect date of
1891 were added by the artist years later, perhaps on the oc-
casion of his 1927 retrospective in Oslo (Boe, 1970, p. 132).*

*Munch depicts the main avenue of Christiania, the of-
ficial promenade for the city's bourgeoisie. It is seen from
Løvebakken, or Lion Hill, the park in front of the Houses
of Parliament, and the view is towards the Royal Palace,
the shimmering monolith at the end of the vista. As early as
1884, with* Afternoon Mood at Olav Reyes Place *(Na-
tionalmuseum, Stockholm), Munch had depicted an over-
view of the city's streets. It was not until 1889, however,
that scenes of street life became a favorite subject of the art-
ist. Here the central figure of a woman with her back to us
and her head obscured by her umbrella commands special
attention. Her stiff pose and hieratic placement, and the*

*somber blue and intense red of her attire, stand out amidst
the random passers-by and the overall light palette of the
canvas.*

*It is possible that the figure, emphasized yet inaccessi-
ble, represents Munch's former lover, Mrs. Heiberg. His St.
Cloud diaries display an obsession with memories of their
meeting on Karl Johan Street, and in a study for the picture
(1890; Munch-Museet, Oslo), an identical figure is watched
by a top-hatted man who leans ominously towards her. This
theme of frustrated desire, loneliness, and anonymity amidst
a crowded street is explicit and more fully developed in* Eve-
ning on Karl Johan Street *(1892; Rasmus Meyers Samlinger,
Bergen). [EB]*

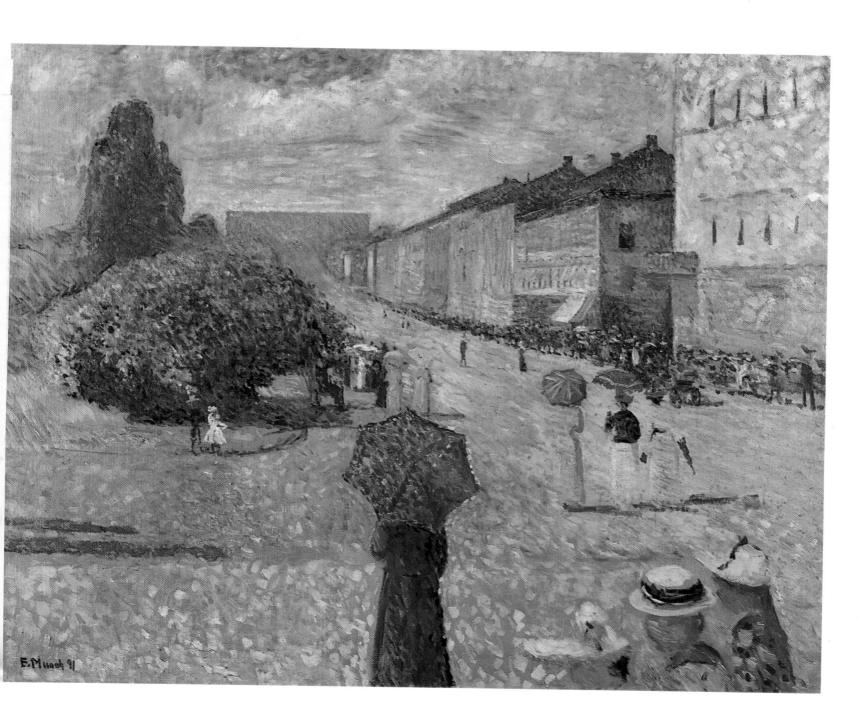

72

Moonlight *1893*
Måneskinn
140.5 x 135.0 (55¼ x 53⅛)
Signed lower right: "E. Munch"
Nasjonalgalleriet, Oslo

In 1893, after spending a frenzied year in the rebellious milieu of Berlin, Munch retired to his summer sanctuary in Aasgaardstrand. That summer, during which he painted Moonlight, *he wrote to the painter Johan Rohde in Copenhagen that he had begun to formulate the* Frieze of Life *– "a picture series . . . the subject will be love and death."*

Several studies for Moonlight *exist, beginning with* Inger in Aasgaardstrand *(Munch-Museet, Oslo), a portrait done in 1891–92. In these studies Munch's sister, dressed in white, stands before a picket fence that penetrates diagonally into the pictorial space. In* Moonlight *the artist takes the diagonal elements of Inger's portrait and makes them parallel to the picture plane. The flattened, rigorous formulation of space, defined by strong horizontal and vertical elements, is the aspect of Munch's attraction to Seurat that survived his 1891 flirtation with Neo-Impressionism. The elegantly flowing Art-Nouveau lines of the tree and the woman's shadow flanking the edge of the house relieve an otherwise rigid composition. Suspended in the midst of the painting, the quasi-devotional woman is shrouded in darkness.*

The female frontal figure plays a significant role in Munch's painting of the mid-nineties. In a style similar to that of the Dane Jens Ferdinand Willumsen, with whom he exhibited in 1892, Munch weaves tension between the woman and her audience into* Moonlight *by giving her a confrontational gaze and depriving her of dramatic gesture. She appears to stare fixedly out of the canvas, yet the suggestion of an arm in the left foreground, perhaps implying the presence of another person, shifts the psychological charge of the composition.*

Since he was working serially during the summer of 1893, Munch may have created Moonlight *and an early version of* Summer Night's Dream (The Voice) *(cat. no. 74)*

as companion pieces, contributing to a personal iconography of female sexuality. He equates the woman's face of Moonlight *with the moon's reflection in the window behind her, defining her through her cyclical, biological identity. Together,* Moonlight *and* Summer Night's Dream *present woman in her sexual relation to man:* Moonlight *is a study of sexual restraint and* Summer Night's Dream *embodies sensual awakening. The two women, respectively the "Widow/Mother" and the "Virgin" (Heller, 1978, p. 79), are fused with Munch's third aspect of woman, the "Whore", into the programmatic* Sphinx (Woman in Three Stages) *of 1894–95 (Rasmus Meyers Samlinger, Bergen) and* The Dance of Life *of 1899 (cat. no. 69).*

The woman in black, radiating light into the surrounding darkness, personifies the Nordic summer night as Munch then perceived it – vaguely sinister and pregnant with mystery. The inscrutable figure in Moonlight *is restated as* Dagny Juell Przybyszewski *(Munch-Museet, Oslo), also of the summer of 1893, and as Inger in* Death in the Sickroom *(see no. 75). [PGB]*

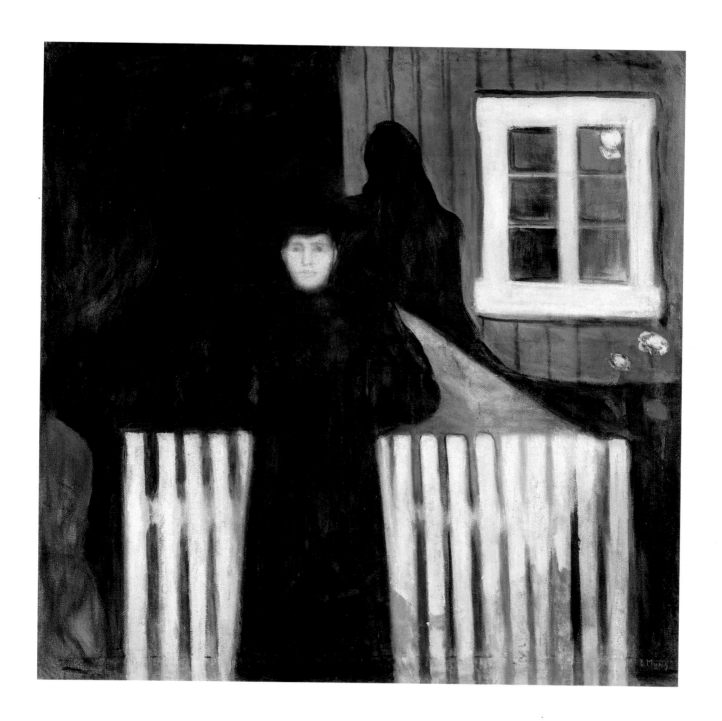

179

73

Summer Night's Dream (The Voice) *1893*
Sommernatt (Stemmen)
96.0 x 118.5 (37³/₄ x 46¹/₂)
Not signed
Munch-Museet, Oslo

In 1893 Munch began the series of paintings entitled The Frieze of Life. *The individual paintings comprised a sequence of psychological states associated with the mysteries of life, love, and death.* Summer Night's Dream *was the first of the* Frieze *paintings, exhibited initially in December 1893 in Christiania in a sequence with* The Kiss, Love and Pain (The Vampyre), Madonna, Jealousy, *and* The Scream *(cat. no. 74), and later in the "mature"* Frieze of Life *at the 1902 Berlin Secession exhibition. This painting and a second version (1893; Museum of Fine Arts, Boston) have carried a number of titles, including* In the Forest *(Stockholm exhibition, 1894),* Evening Star *(Berlin, 1902), and* The Voice.

The setting for Summer Night's Dream *is the mysterious blue twilight of the Aasgaardstrand beach on the Christianiafjord, which Munch saw as a unifying element in* The Frieze of Life *(see cat. no. 79). The painting's title engenders associations with St. Hans' Night, the Nordic celebration heralding the return of summer and light, a moment of revelry and abandonment of social norms. The wooded shores of the Norwegian fjords were traditional meeting places for lovers on St. Hans' Night, while boats bearing celebrants filled the water. As the poet Franz Servaes described the setting in 1894: "Here the sexual will rises stiffly for the first time during a pale moonlit night near the sea, the girl roams among the trees, her hands cramped together behind her, her head tossed back and her eyes staring wide and vampire-like. But the world is a mixture of the misty and the glaring, of sexual fantasy and revulsion" (Heller, 1973, p. 46).*

The theme of Summer Night's Dream *is drawn from Munch's own experience, recalling the moment before his first kiss when he stared into the beckoning eyes of his partner. The expectant pose of the virginal figure is undermined by the threatening force of her sexual yearning. She looms* aggressively in the foreground, demanding a subjective response from her audience: arousal, expectation, or the reaction of Munch and his contemporaries to her – fear and repulsion. This Schopenhauerian interpretation of woman, in which eroticism is inextricably bound with destruction, runs throughout The Frieze of Life *and has been likened to such emblems of the European Decadent movement as Max Klinger's graphic cycle* A Love *(1887).*

The woman in this version of the motif is larger and more boldly executed than in the Boston version, giving her a greater sexual charge. The geometric regularity of the trees and the glimmering shaft of the moon's reflection on the water echo her rigid domination of the canvas. Complementing the otherworldly figure in Moonlight *(cat. no. 72), she is integrated into the taut landscape, sharing in the pulsating, erotic mood of the summer night. [EB/PGB/AC]*

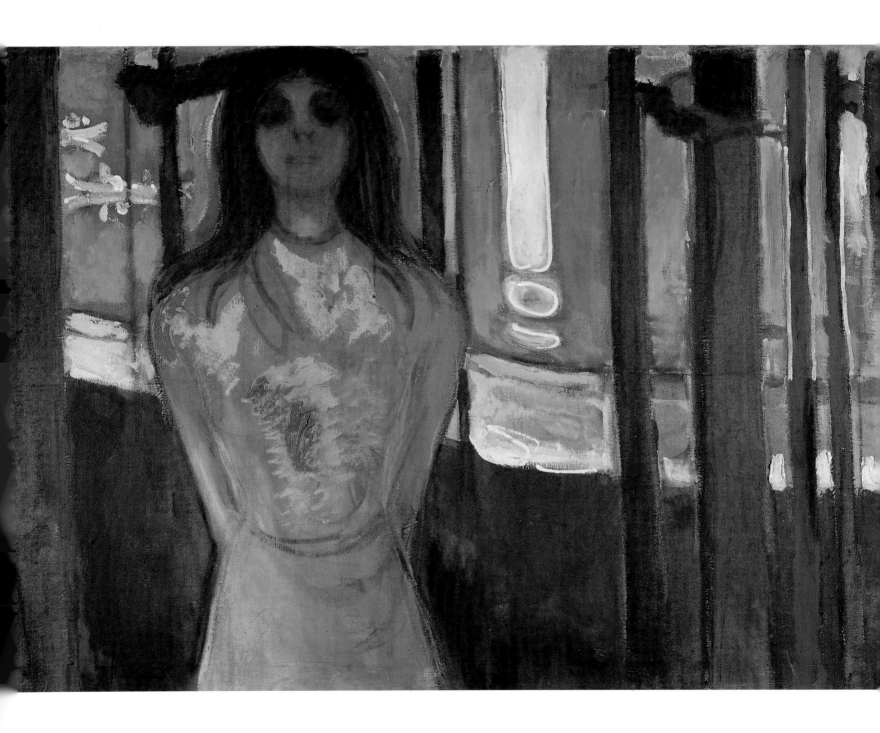

181

74
The Scream *1893*
Skriket
91 x 73.5 (56⁷⁄₈ x 46)
Nasjonalgalleriet, Oslo

The Scream, *a crucial component of* The Frieze of Life, *has become a cultural Rorschach test, symbolizing for each new generation their own particular anxieties: sexual repression, urban alienation, fear of nuclear holocaust, etc. With its prophesy of twentieth-century Expressionism, and Munch's pencilled inscription in its upper register ("Only a madman could have painted this."), it is a source of endless fascination. Typical of the pivotal years 1892–93, it is one of Munch's heroic attempts to communicate his subjective impressions to a wide audience.*

The motif began with a direct experience. Munch recalled:

"I was walking along the road with two friends. The sun set. I felt a tinge of melancholy. Suddenly the sky became a bloody red.

I stopped, leaned against the railing, dead tired. And I looked at the flaming clouds that hung like blood and a sword over the blue-black fjord and city.

My friends walked on. I stood there, trembling with fright. And I felt a loud, unending scream piercing nature."

Christian Skredsvig, travelling with Munch on the Côte d'Azur in 1891, recorded Munch's obsession with this experience:*

"For some time Munch had been wanting to paint the memory of a sunset. Red as blood. No, it actually was *coagulated blood. But not a single other person would see it the same way as he had. He talked himself sick about that sunset and about how it had filled him with great anxiety. He was in despair because the miserable means available to painting were not sufficient." (Christian Skredsvig, 1908,*

quoted in Reinhold Heller, Munch: The Scream, *1973, p. 82).*

Early in 1892 Munch began the process of translating his vision into a series of sketches. They focus on a lone man leaning against the railing of a road overlooking the Oslofjord. Moving away from Munch's initial Naturalist conception, these sketches show a progressively more radical and disjunctive perspective and an increasing emphasis on the figure in the extreme foreground, the equivalent of the artist. Despair *(summer 1982; see illustration) was the first painted version of this motif. Its loose brushwork and reduced, symbolic color scale are indebted to the work of Vincent Van Gogh and Paul Gauguin. As Reinhold Heller notes (ibid., p. 64), the rushing perspective of the road in* Despair *recalls Munch's Neo-Impressionist* Rue Lafayette *(1891; Nasjonalgalleriet, Oslo), which has sources in Gustave Caillebotte's* Homme au Balcon *(1880; Private Collection, France). (See also Kirk Varnedoe and Thomas P. Lee,* Gustave Caillebotte: A Retrospective, *(ex. cat.), Houston, Museum of Fine Arts, 1976–77, pp. 149–50.)* Despair *was exhibited in 1893 as* Mood at Sunset *and* Deranged Mood at Sunset. *Related to such images as* Inger on the Beach (Summer Night) *1889; (cat. no. 69), it revises the German Romantic formula of a lone figure in mystical dialogue with nature.*

In 1893, a shift in emphasis transformed the brooding melancholy of Despair *into the dizzying agitation of* The Scream. *Munch has suddenly turned the foreground figure toward us and stripped him of his top hat, gender, age, and quiet reverie. It is purified into an androgynous, classless, universal emblem of naked fear. The undulating bands of land, water and sky subordinate the figure into an S-curve, depriving it of its human form. Its gaping mouth and lidless eyes recall images of sinners in Hell, from Romanesque sources to Bernini. The face also resembles, as Robert Rosenblum suggests, that of the Peruvian mummy in the Trocadéro which had so preoccupied Gauguin (Robert Rosenblum, "Introduction", Washington, D.C., 1978, p. 8). In an intentional rejection of classical canons of beauty,* The Scream *creates a union of nature's power and human response.*

Despite its radical intensification of natural color, perspective, and form, The Scream *retains distinctive geographical features. Munch originally felt "the scream of nature" while walking along Ljabroveien, the road running along the eastern shore of the Oslofjord between Oslo and Nordstrand. As Arne Eggum has noted, Munch's representation of the fjord and hills of Oslo, and the Royal Palace to the right, corresponds to the view of the city from the stretch of road atop Ekeberg Hill. (personal communication, November, 1984). This hill was a favored spot among nineteenth century landscape painters from which to paint the Oslo-*

Despair
92 x 67
Thiel Gallery, Stockholm

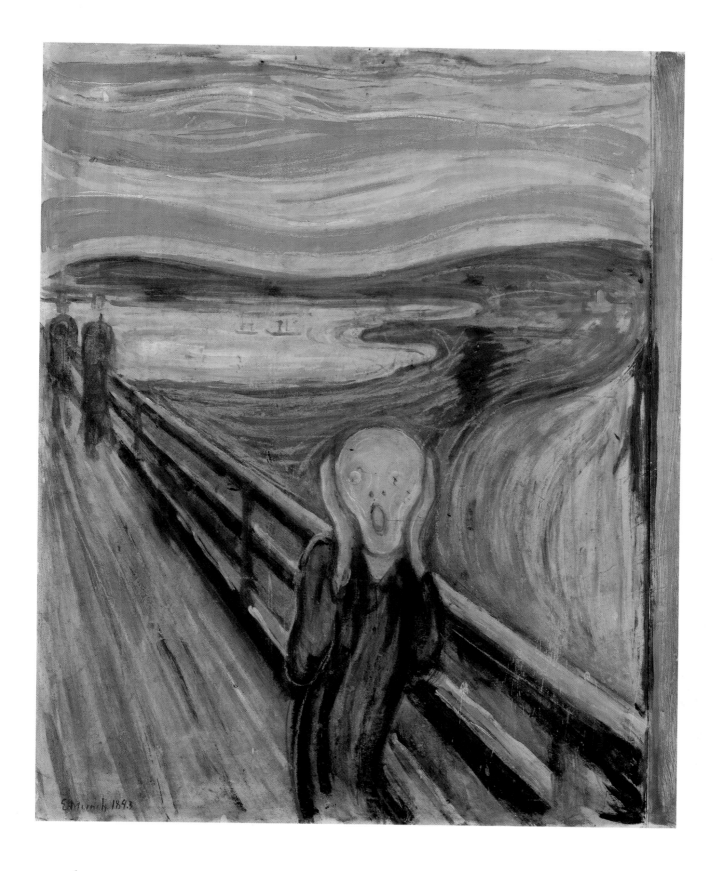

fjord. As Eggum suggests, other aspects of Ekeberg Hill, such as its proximity to Christiania's stock yards and butcher shop district, may have informed the mood of the painting. Many contemporary critics interpreted The Scream as a universal emblem of crushing sexuality. Yet Christiania, with its urban growth pains, and more importantly, with its brutal rejection of Munch's art, is very much present.

The anti-Naturalistic urges expressed in the 1889 "St. Cloud Manifesto" (see cat. no. 70) found realization in The Scream, which became one of Munch's central motifs. He painted several versions of it, and translated it into graphic media. Its liberating symbolic formulations of color and form entered the interrelated themes of Munch's mid-'90s compositions, most notably Anxiety (1894; Munch-Museet, Oslo), in which a tightly packed crowd advances blindly toward the viewer along the same elevated roadway. [PGB]

75

Death in the Sickroom 1893
Døden i sykeværelset
casein on canvas
150 x 167.5 (59 x 65¾)
Oslo, Nasjonalgalleriet

Like The Sick Girl, (cat. no. 77), Death in the Sickroom portrays the death of Munch's sister Sophie, "a link in the memory process where different aspects of the same thing compete." (Washington, D.C., Edvard Munch: Symbols and Images, 1978, p. 175). The members of Munch's family are easily identifiable: Laura is seated in the extreme foreground in the same attitude as in an 1888 painting, Evening (Oslo, Nasjonalgalleriet). Behind her stand Inger and Edvard, Inger's posture recalling an 1892 portrait (Oslo, Nasjonalgalleriet). Andreas leans against a door jamb at the left, and Munch's father and aunt Karen Bjølstad stand to the right. Of the four siblings, only Edvard looks across the room to witness the moment of Sophie's death. Sophie, seated in a wicker chair, is viewed only obliquely, a strategy adapted from Christian Krohg's Albertine in the Police Doctor's Waiting Room (see cat. no. 59). Although Sophie died when Edvard and his siblings were children, he portrays them as they appeared in 1893, suggesting a simul-

taneity of past and present. (Ibid.) Perhaps the vast expanse of floor separating Edvard from the death scene symbolizes the temporal gulf between the event and his reconstruction of it.

In nineteenth-century painting, Death wore many guises: Classical stoicism gave way to the agonized death rattles of the Romantics, Realism's dispassionate recordings (see cat. no. 109), and Symbolism's supernatural personifications (see cat. no. 89). In Death in the Sickroom, Death is marked by Sophie's palpable absence. The six survivors are the metamorphoses of a silent, penetrating grief. Their individual postures of isolation and exhaustion form a composite portrait of helplessness. Several of Munch's contemporaries, including Stanislaw Przybyszewski (see cat. no. 76), recognized the relationship between Munch's emphasis on psychology rather than action, and the plays of Maurice Maeterlinck. While preparing the sketches for this painting, Munch was asked to illustrate Maeterlinck's Pelléas et Mélisande. (Arne Eggum, Edvard Munch, Paintings, Sketches and Studies, 1983, p. 107).

The emptiness of the sickroom reinforces the isolation of its occupants and prefigures Munch's later theatrical set designs (see Zürich, Kunsthaus, Munch und Ibsen, 1976). Its radically tilting floor, suggesting sources in Degas, Van Gogh and Japanese narrative prints, serves as a proscenium stage; its only props are a rumpled bed and a night table supporting a macabre still life with medicine bottles. Relieving the otherwise bare walls is an image of Christ, reminiscent of a print in Munch's childhood home. (Washington, D.C., op. cit. p. 178). The room's lurid interior flattens and silhouettes its inhabitants, who are painted in Munch's bold, simplified Synthetist style. As Reinhold Heller notes, Munch's use of casein – a thin paint mixture which fuses with the supporting canvas – strips the painted surface of all sensuality. In a shared preoccupation with the European Symbolists, Munch's experimentation with non-oil media enables him better to visualize moods and memories, rather than to represent objects. (Heller, 1984, p. 118–19).

Munch first exhibited Death in the Sickroom on December 3, 1893 in Berlin. Here he assembled his first version of the Frieze of Life (see cat. no. 72). Originally entitled A Death, perhaps a homage to Max Klinger's graphic series, A Life (1880), Death in the Sickroom was accompanied by a framed pastel study (Oslo, Munch-Museet). Critics generally received the painting favorably, recognizing it as a product of Munch's introspection. There is a second version of Death in the Sickroom (Oslo, Munch-Museet), along with a large number of sketches and a lithograph of the motif. It was later echoed in The Dead Mother and Child (1894; Oslo, Munch-Museet), and in the many versions of the supernatural At the Deathbed, an exploration of the subjective response of the dying. [PGB]

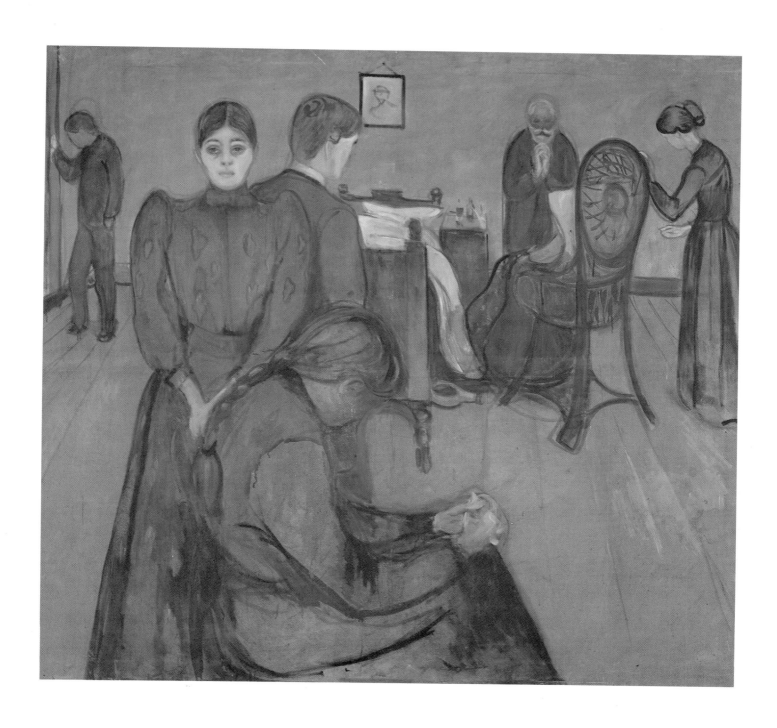

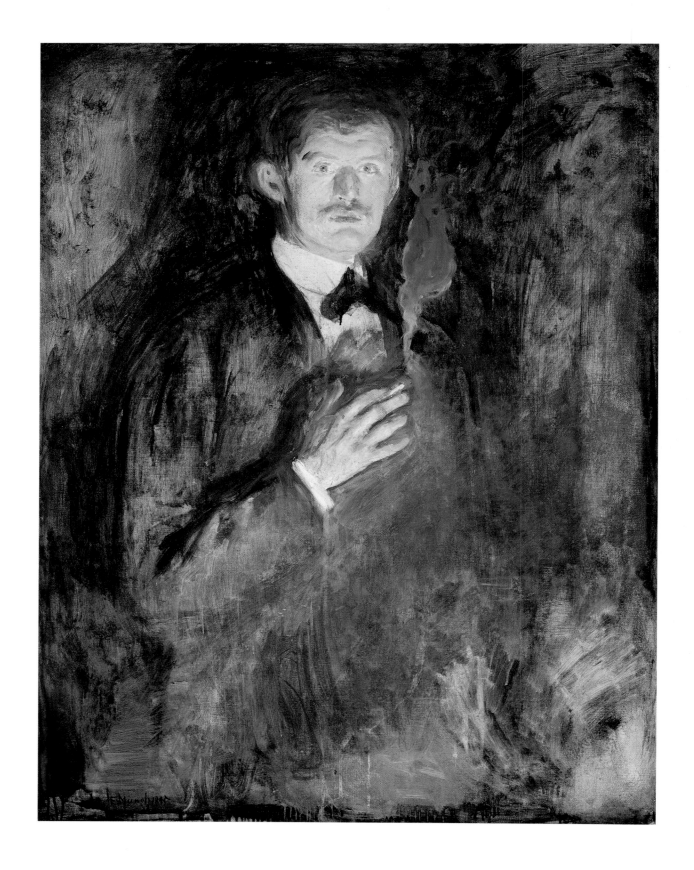

186

76
Self-Portrait with Cigarette *1895*
Selvportrett med sigarett
110.5 x 85.5 (43½ x 33⅛)
Signed lower left: "E. Munch 1895"
Nasjonalgalleriet, Oslo

While fin-de-siècle *Europe experienced an upsurge of spiritualism and occultism, Edvard Munch was living in Berlin, engaged in a cult of "pathological eroticism" with poet Stanislaw Przybyszewski, playwright August Strindberg,* critic Julius Meier-Graefe, and author Richard Dehmel. This group crystallized in 1893, when they convened nightly at* Zum Schwarzen Ferkel (Black Pig) *cafe to discuss Symbolist Paris, the femme fatale, and the newly emerging field of psychology. In a shared spirit of idealism, each member of the "Black Pig" circle fought to express his most fundamental psychic impulses: Przybyszewski in his confessional novels about the sexual unconscious, Strindberg in his experiments in self-induced madness, and Munch in his painting.*

Self-Portrait with Cigarette dates from this impassioned period of self-analysis. Munch's fluid handling of diluted color washes creates a mysterious atmosphere that surrounds and in places absorbs the figure. Echoing the Rembrandt self-portraits he so admired, Munch's face and the hand holding the cigarette are contrasted to the background by theatrical light from below.

Self-Portrait with Cigarette is a portrait of the artist as bohemian. In the radical Christiania of the eighties, which spawned Christian Krohg's Portrait of Gerhard Munthe *(cat. no. 55), Munch developed a typology of bohemianism centering on the cigarette. Beginning with two portraits of Karl Jensen-Hjell* and continuing with portraits of Przybyszewski (1895; Munch-Museet, Oslo) and Henrik Ibsen (1906–10; Munch-Museet, Oslo) and his lithographic* Self-Portrait with Cigarette *of 1908 (Munch-Museet, Oslo), he expanded his personal iconography of the cigarette, increasingly strengthening the expressive quality of smoke.*

Following an 1895 lecture on Munch in Christiania, a student, basing his argument on Self-Portrait with Cigarette, *attacked Munch as being obsessed with mental illness. The debate that ensued contributed to the public's already ingrained view of the artist as mentally unbalanced. The painting remains one of the most riveting images in Munch's prodigious body of self-portraiture. [PGB]*

77

The Sick Girl *1896*
Det syke barn
121.5 x 118.5 (75 $^{15}/_{16}$ x 74 $^{1}/_{16}$)
Göteborgs Konstmuseum

With The Sick Girl, *Munch first broke his bonds with Naturalist doctrine. It was, he said, his most important painting and the source for his subsequent development. Rarely did he rework a motif so frequently: There are six painted versions (1885–86, Oslo, Nasjonalgalleriet; 1896, Göteborgs Konstmuseum; 1907, Stockholm, Thielska Galleriet; 1907, London, Tate Gallery; 1926, Oslo, Munch-Museet; and 1927, Oslo, Munch-Museet; dating: Ragna Stang, p. 59), as well as a number of printed versions. Of this reworking, he wrote: "A painting and a motif that I struggled with for an entire year are not expended in a single picture. If it is of such significance to me, why should I then not paint and vary a motif five times? Just look at what other painters depict over and over again* ad infinitum: *apples, palm trees, church towers, haystacks." (1932 draft of a letter to Jens Thiis, quoted in Heller, 1984 p. 21).*

Christiania, long an artistic backwater, was suddenly alive with new impulses in the early 1880s. In this time of liberation, such artists as Frits Thaulow, Erik Werenskiold, and Christian Krohg* preached the gospel of French Naturalism, and writers such as Hans Jaeger cultivated a bohemian cafe society and advocated free love. Krohg was the spiritual father of Munch's generation, exhorting the younger artists to experiment, break from tradition, and above all, paint realities. One particularly brutal reality was tuberculosis, endemic in the rapidly growing Christiania. Krohg's 1880–81 painting,* The Sick Girl *(cat. no. 55), is his response to this crisis. In this era which Munch labeled "the time of the pillows", Krohg's painting stood out among the cloying images of sick and dying youth which proliferated in Naturalist art. In 1885 Munch also turned to this theme.*

Munch's tragic family history, coupled with his bohemian cultivation of pain, produced a subjective treatment of the motif which was pivotal for his art. The Sick Girl *was initially indebted to Krohg's close-up, almost claustrophobic composition. A backdrop of geometric simplicity framed Munch's models, his aunt Karen Bjølstad and Betzy Nielsen. In order to record his immediate sensations, Munch worked without preliminary sketches, applying his colors in broad, flat areas. As Reinhold Heller suggests, while Munch painted from his models, he was working from the memory of his sister Sophie's death. (Heller, 1984, p. 34). This conflict between his intensely painful memories and the visible scenes before him, presented a crisis in representation: through standard, Naturalist means, his vision was unobtainable. He obsessively attempted to translate his emo-*

tional state into visible form – painting, scoring the surface with a palette knife or brush handle, reworking, reslashing, bruising the surface. By his accounts, he completely reworked The Sick Girl *twenty times in one year. The result was a profoundly moving interpretation of illness. The dying girl and grieving mother dissolve under a densely scratched, heavily impastoed paint layer. As Arne Eggum suggests, the surface was originally overlaid with a delicate web of green lines representing the eyelashes and tears of the observer (Eggum, 1984, p. 45).*

The Sick Girl, *prominently displayed at the 1886 Autumn Exhibition, caused one of the greatest outbursts of indignation in the history of Norwegian art. The critical community was aghast at its lack of finish, and the Naturalist painters, such as Gustav Wentzel*, called it "pretentious rubbish". Even the insightful Andreas Aubert viewed it as a setback in Munch's career, evoking the inevitable comparison between his obsession with perfection and Emile Zola's protagonist in the newly published* L'Oeuvre *(Stang, p. 60). Munch's title,* Study, *a reference to the bourgeois sensibility of his critics, further outraged them. Only Krohg and Jaeger recognized* The Sick Girl's *prophetic quality. Munch had extended the Naturalists' desire to paint material reality, to include psychological reality.*

The virulent criticism of The Sick Girl, *and Munch's sense of failure in depicting the motif, caused him to retreat temporarily from this revolutionary new style. He produced a Naturalist treatment of the theme in 1889, entitled* Spring *(Oslo, Nasjonalgalleriet). An interior setting painted in the manner of Krohg, it includes still-life elements, a sun-brightened window, and a woman knitting, as well as the ailing girl.*

The 1896 version of The Sick Girl, *illustrated here, is Munch's first attempt to rework his original composition. In that year, he approached the theme with the wet, sweeping brush strokes of his* Frieze of Life *imagery, attempting to revive and record his original, painful, inspiration. [PGB]*

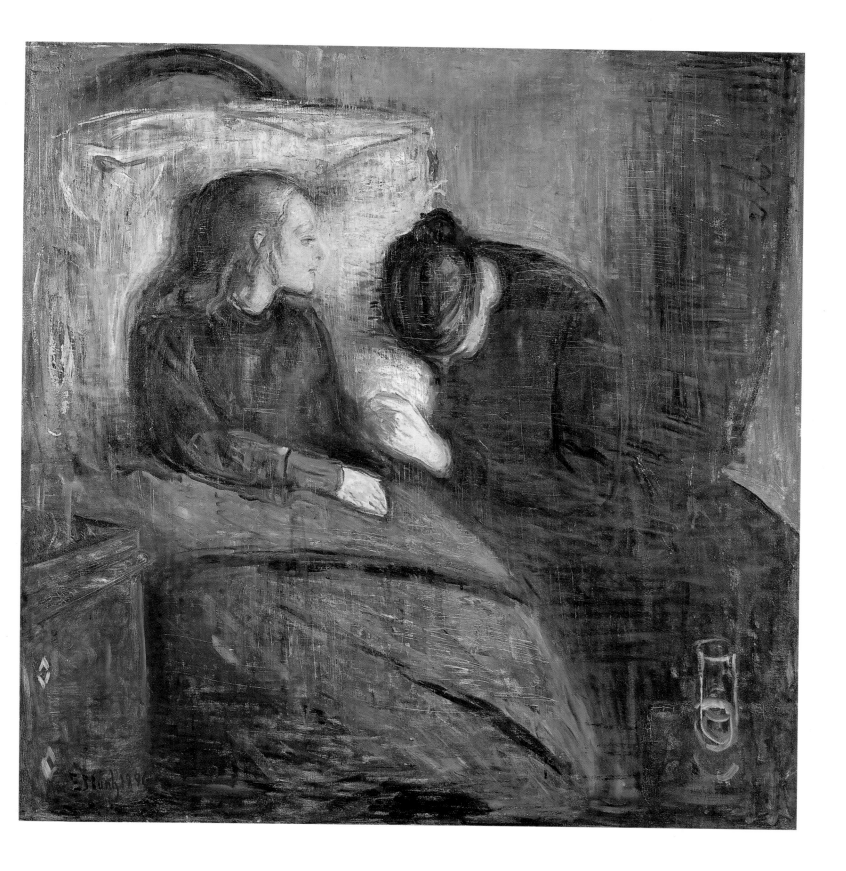

189

78
Melancholy (Laura) *1899*
Melankoli (Laura)
110.0 x 126.0 (43¼ x 49⅝)
Not signed
Munch-Museet, Oslo

Edvard Munch's sister Laura, diagnosed as melancholic while still a girl, suffered bouts of severe depression throughout her life. One such crisis in 1895 inspired the artist to do a series of sketches that became the basis for Melancholy (Laura) in 1899. This painting is a poignant example of his fascination with extreme or aberrant mental conditions. Unlike Halfdan Egedius in The Dreamer (cat. no. 12), he does not resort to the standard Romantic physiognomic typology to evoke melancholia. Rather, ambiguities of space and color act as visual equivalents of Laura's's morbid mental condition.

Laura is the very avatar of psychological isolation, seated unsteadily in a room that is a symphony of spatial ambiguities. The precipitously climbing angles of the floor and foreground tabletop, along with the vertical line describing the juncture of two walls, telescope the pictorial space into one flat, pulsating plane. The spatial organization suggests that Laura is seated at the center of the room, yet the sunlight flooding through the windows hits the wall to her left without casting her shadow. The atmosphere of the room heats the wintry light of the exterior world into an acid yellow as it enters the windows, accentuating the irrationality of Laura's surroundings.

Munch's strategy of "atmospheric realism", which Stanislaw Przybyszewski earlier called his "psychic Naturalism" (1894, p. 103), fuses sitter and environment into a continuous emotional medium. This sensibility has its roots in Édouard Vuillard's Intimist interiors of the early nineties. The art historian Gösta Svenaeus (1968, p. 203ff.) draws a striking comparison between Melancholy and Vuillard's color lithograph Intérieur à la Suspension, which was exhibited and published by the Parisian dealer Ambrois Vollard in 1899 and was the fourth print in Vuillard's suite Paysages et Intérieurs. Vuillard worked on this suite in the studio of August Clot, where Munch pulled his lithographs, and Vuillard's print stimulated Munch's own composition, particularly the tablecloth patterning in the foreground. Munch intensifies the already suggestive design by modelling it after the tinted coronal brain sections which were used to illustrate neurological abnormalities in contemporary medical publications (see example at left). This neuroanatomical allusion functions as a specific exterior reference to Laura's internal mental condition, reinforcing the disorienting effect of the room.

Munch included Melancholy (Laura) in the 1918 Frieze of Life exhibited at Blomqvist's Gallery in Christiania. Although not conceived as a component of the frieze, Melancholy reflects Munch's Symbolist concern with the materialization of invisble impulses, and with psychological, not representational, portraiture. [PGB]

Horizontal section(s) of the cerebrum, displaying the islets of sclerosis in different regions. Plate II of: Jean Martin Charcot, *Lectures on the Diseases of the Nervous System* (The New York Academy of Medicine, 1962), facsimile of the 1881 London edition. Munch and his circle in Berlin hailed neurology and psychology as points of convergence between material science and mysticism. They adopted technical language and medical illustrations of nerve fibers and brain sections as emblems for their Romantic theories of the unconscious.

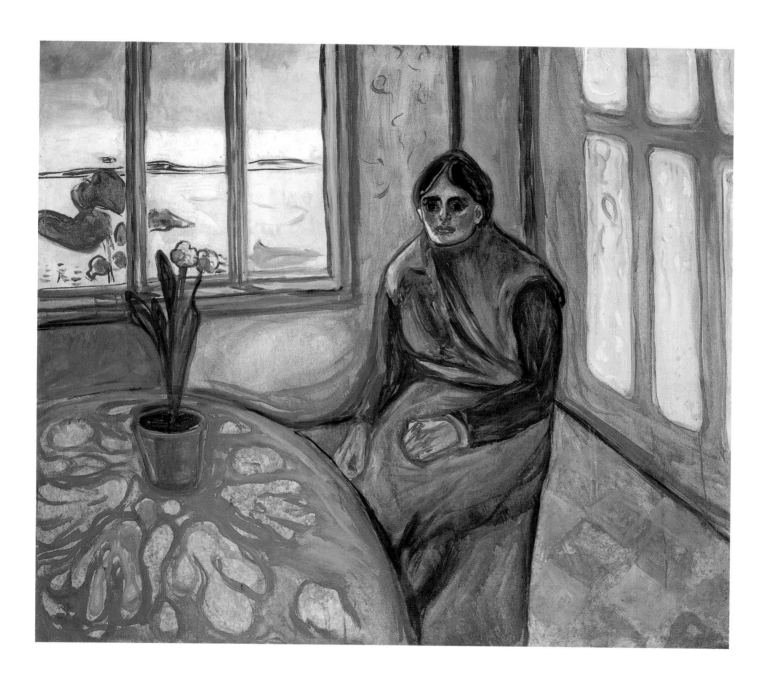

79

The Dance of Life *1899–1900*
Livets dans
124.5 x 190.5 (49¹/₄ x 74³/₄)
Signed lower left: "E. Munch 99."
Upper right: "E. Munch 1900"
Nasjonalgalleriet, Oslo

The Dance of Life, *painted in 1899 and reworked in 1900, was Munch's last major contribution to* The Frieze of Life, *summarizing its subjects into a monumental allegory of human life. Its theme is shared by* Moonlight *(cat. no. 72) and* Summer Night's Dream *(cat. no. 79) and is intimately linked to* Sphinx (Woman in Three Stages) *(1894–95; Rasmus Meyers Samlinger, Bergen).*

The Dance of Life *illustrates the temporal progression of woman's sexuality. At the center of the composition a red-clad female freely dances with a young man whom Munch identified as a priest. To the left stands a virginal figure on the brink of her sexual awakening, and to the right, a haggard woman wearing the black dress of widowhood. The background, in Munch's words, "is a mass of whirling people – fat men biting women on the neck" (Stang, 1977, p. 111) under a mesmerizing full moon reflecting on the water off the Aasgaardstrand shore. The setting for this cycle of anticipation, fulfillment, and desolation is St. Hans' Night (also the painting's original title), the fusion of Nordic religious and secular celebrations marking the summer solstice.*

The Dance of Life *and the whole of the frieze embody the ambitious spirit of* fin-de-siècle *Europe. An urge to create panoramic narrative cycles, reflecting a utopian search for universal truths, came to fruition in such works as Auguste Rodin's* The Gates of Hell *(1880–1917) and Paul Gauguin's* Where do we come from? What are we? Where are we going? *(1897; Museum of Fine Arts, Boston). The strident words of Munch's 1889 St. Cloud manifesto reveal his desire to reinterpret the "sacred" in a post-Christian,*

post-Darwinian era. There Munch said, in terms that directly prefigure the images of The Dance of Life, *that men and women at the moment of sexual union "were not themselves; they were merely one link in the endless chain that joins one generation to the next. People should understand the sacred, awesome truth involved, and they should remove their hats as in church . . ." (Stang, 1977, p. 74). Seeking a foil for Symbolist transpositions of religious imagery, Munch began to explore in 1893 the triptych format that he would later make implicit in* The Dance of Life. *(Heller, 1970, p. 72ff).*

Love and death play central, interdependent roles in Munch's pessimistic theology. In notes of 1898 (Zurich, 1976, p. 13–14) he linked The Dance of Life *with the drawing* The Empty Cross *(1897–99; Munch-Museet, Oslo) and the painting* The Inheritance *(1898; Munch-Museet, Oslo), a sexual reinterpretation of Madonna iconography. Like Henrik Ibsen's play* Ghosts *(1881),* The Inheritance *deals with venereal disease and refers to the legacy of destruction stemming from past sins.*

The Dance of Life *at once underscores the transience of life symbolized by the act of love, and the inevitability of its cyclical repetition.* Dance on the Shore *of 1906 (Munch-Museet, Oslo) repeats the composition, now organized into an actual triptych whose* predella *incorporates motifs from* The Kiss, Sphinx, *and* The Inheritance, *recapitulating, like* The Dance of Life, The Frieze of Life *in an abbreviated format. [PGB]*

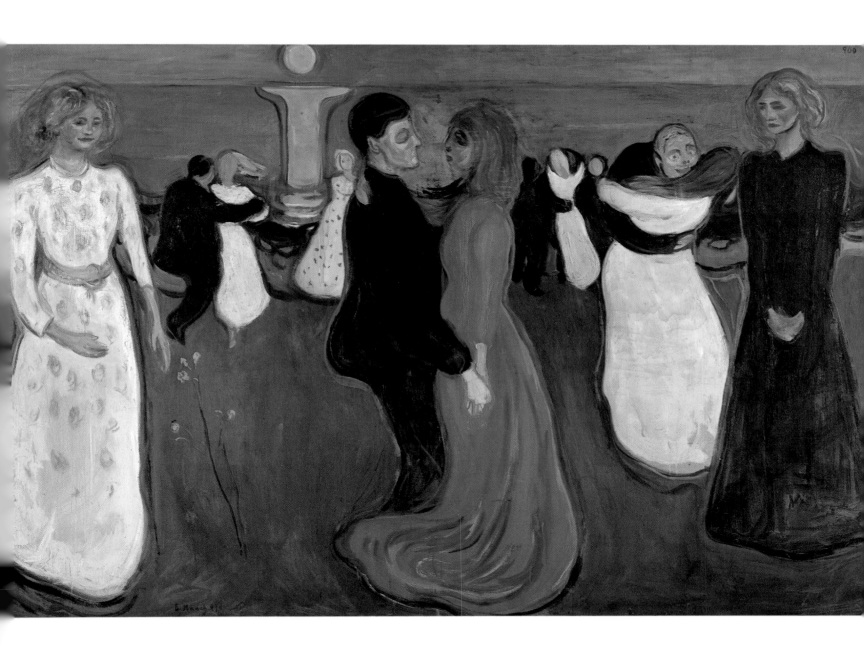

80
Bathing Men *1907–08*
Badende Man
206 x 227 (128¾ x 141⅞)
Ateneumin Taidemuseo, Helsinki

With the new century, Munch's life changed abruptly. He tasted critical success for the first time in Germany, where his exhibition reviews were increasingly reverential. Albert Kollmann, promoter of the Berlin Secession, became Munch's chief supporter, introducing him to the Weimar intellectual community which included architect Henry van de Velde, and the Jugendstil promoter Harry Graf Kessler. Dr. Max Linde published Edvard Munch and the Art of the Future in 1902, and the Dresden artists of Die Brücke hailed Munch as the prophet of the new generation. From Germany, his reputation spread to Vienna and Prague. Despite this recognition, Munch was in crisis. Haunted by a notorious, shattered love affair and by his critical failure in Norway, he lived a nomadic life. His acute alcoholism and general ill health led to periods of delerium and paranoia. In an attempt to stabilize, he began to seek spa cures.

In 1907, Munch settled in Warnemünde, a fishing village on the Baltic coast, which he called a "German Aasgaardstrand". Like Aasgaardstrand, Warnemünde was a popular bathing resort. Munch painted the monumental Bathing Men ca. 150.4 x 150.4 (84 x 84) on Warnemünde's nude beach, using bathing attendants as his models.

Bathing Men is a vivid portrayal of male potency. In this psychologically complex painting, two powerful men

Max Beckmann
Young Men by the Sea 1904–05
Junge Männer am Meer
148 x 235 (92½ x 146⅞)
Weimar, Staatliche Kunstsammlungen

Edward Munch
Self-Portrait on the Beach at Warnemünde
Munch-Museet

walk forward. Their deeply pigmented faces, hands, and genitals contrast the pale skin of their torsos, and their muscles are fully tensed. In the background other male figures traverse the beach and wade into the ocean, their arms ecstatically outstretched. A man's back appears in the lower left, interceding between the viewer and the striding men. The two central figures are made more powerful by the strong, radiating brush strokes that emphasize their volume, in opposition to the insistently flat background. When Munch tried to exhibit this painting in Hamburg in 1907, it was refused on the grounds that it was too radical.

The diverse sources for this image include Cézanne's bathers, Max Liebermann's Bathing Boys (1896–98), the male nudes of Hans von Marées, and the harmonious nature scenes of Munch's Weimar colleague Ludwig von Hoffmann. Trips to Italy around 1900 introduced Munch to the monumental nudes of Michelangelo. E.J. Vehmas suggests an immediate source in the 21-year-old Max Beckmann's Young Men by the Sea (1904–05; see illustration), exhibited in 1906 at the Weimar Deutscher Künstlerbund, and again at Cassirer in Berlin in 1907, noting similarities in theme, format and handling. (E.J. Vehmas, "Edvard Munchin Kylpeviä Miehiä", Ateneumin Taidemuseo. Muscojulkaisu. 9 vousikerta 1–2, 1964, p. 27; see also Barbura C. Buenger, "Beckmann's Beginnings: Junge Männer am Meer", Pantheon 41, March/April 1983, pp. 134–44.)

In 1904 Munch had painted a version of Bathing Men (Oslo, Munch-Museet), probably intended for the Ducal collection in Weimar. Here, nude men stand by the water's edge in the foreground, while youths that have entered the sea appear to be transformed into amphibians as they swim into the background. Sun and sea are the elixirs of life in this neo-Darwinian image, as they are in the 1907–08 Bathing Men. Both versions embody the principles of the German Vitalist movement. Vitalism was fueled by the German obsession with Frederick Nietzsche after his 1889 lapse into insanity. Nietzsche's criticism of modern civilization's inhibitions, belief in human perfectability through struggle, and suggestion of reengagement with nature, captured the imagination of a discontent generation. The Vitalist movement emerged from the blending of Nietzsche with the Darwinian biological theories of Ernst Haeckel (1834–1919), and the Social Darwinism of Georg Simmel (1858–1918).

Vitalism, which celebrated youth, life, and the formative power of man in nature, was manifested by cults of hedonism, sun worship and nudity. Many of Munch's bohemian colleagues from The Black Pig were steeped in Vitalism, including the writer Max Dauthenday (1867–1918), Theosophist-painter Fidus (Hugo Höppener), and especially Richard Dehmel (1863–1920), a key interpreter of Nietzsche. In Northern Europe, many artists such as Eu-

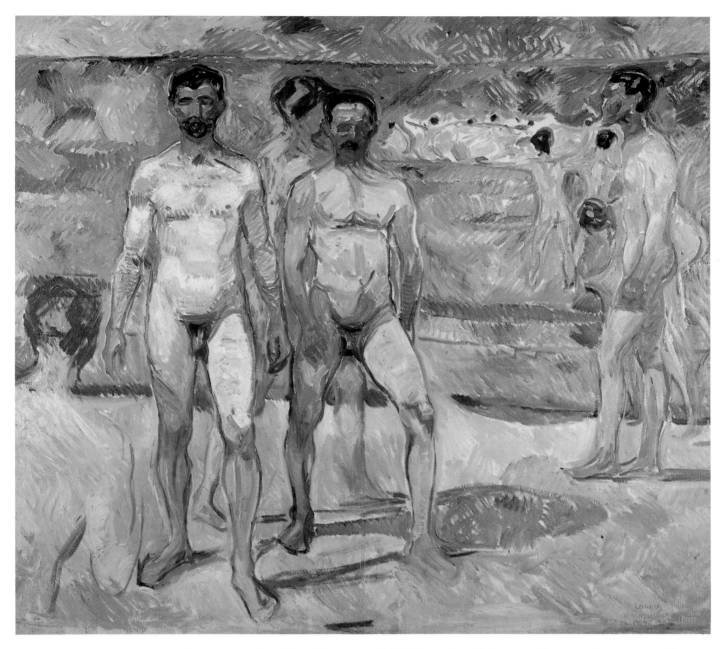

gène Jansson (see cat. no. 43), began to explore this philosophy, replacing the traditional female personification of nature with virile manhood. Vitalist beliefs were shared by Munch's powerful friends and patrons in Weimar, with whom he was in close contact between 1903 and 1907. He must have been particularly receptive to this orientation in 1907 when he was seeking mental and physical renewal.

In 1908 Munch conceived a triptych format for Bathing Men, *appending it with two ancillary paintings, emblems of childhood and old age. When the Ateneum in* Helsinki purchased the central canvas in 1911, Munch painted a second version (1911–12; Oslo, Munch-Museet). Within the traditional Christian triptych format, the bathers form a cycle of life. This central cyclic theme from Munch's 1890s painting (cat. no. 79), once charged with a fatal eroticism, is now translated into a rhythm of waxing and waning male power. Munch continued to explore this life-affirming imagery in his preparatory work for the University of Oslo Aula (Assembly Hall), which preoccupied him throughout the next decade. [PGB]

GERHARD MUNTHE

Norway 1849–1929

Gerhard Munthe (1849–1929), a leading proponent of Naturalistic landscape painting in the 1880s, became Norway's premier theorist and practitioner of decorative art in the 1890s. Born in rural Elverum, Munthe later moved to Christiania where he pursued the standard training of an ambitious landscape painter, first under J.E. Eckersberg, and then under Knut Bergslien and Julius Middelthun. From 1874 to 1877 he painted in Düsseldorf, in association with his relative Ludvig Munthe (1841–1896), a landscape painter in the tradition of J.C. Dahl and Hans Gude. In Munich from 1877–82, Munthe studied Old Master art and continued to paint in the spirit of his uncle.

Munthe returned to Norway in 1882, where, except for short visits to Paris, he remained for the rest of his life. A participant in Christiania's avant-garde cafe culture, he became an associate of Christian Krohg* (see cat. no. 58) and the other important Naturalist theorists of his generation. In 1886, Munthe summered at Fleskum, a farm on the outskirts of Christiania, in the now famous artists' community which included Kitty Kielland*, Erik Werenskiold*, Eilif Peterssen*, Harriet Backer*, and Christian Skredsvig*. Through their constant artistic and intellectual interchange, these artists forged the moody, supernaturally charged style that dominated Norwegian painting for the next decade.

In 1890, Munthe's devotion to Naturalism abruptly shifted to the world of abstract decorative art. Inspired by Norwegian folk art, folk tales and legends, Munthe carefully refined and archaized his style based on his research into Old Norse painting methods, tapestry patterns, and archeological finds. Beginning in the 1890s, Munthe published widely on Norwegian art history and theories of decorative art. His articles were published as a collection, *Minder og Meninger fra 1850-aarene til nu (Memories and Opinions from the 1850s to the Present)*. His "intensification" of nature, filtered through Norwegian motifs and color keys, produced paintings and saga and book illustrations, as well as work in tapestry, metal, and stained glass. His interest in Old Norwegian design culminated in the highly publicized decoration and renovation of Bergen's eleventh-century Haakon's Hall in 1910–16 (destroyed in 1944; sketches remain in the Rasmus Meyers Samlinger, Bergen).

A renowned artist, theorist and designer, Munthe was also a much sought-after book illustrator. Beginning with the 1899 limited edition of the *Snorre Sturlason Sagas*, Munthe illustrated more than six subsequent editions between 1899 and 1934, an edition of J.F. Vindsnes' *Sagas* (1898), *Draumkvaede*, a medieval poem edited by folklorist Molkte Moe (1904), and two editions of Munthe's own *Norwegian Folk Ballads* (1933 and 1943). His interest in craft revivalism and Medieval revivalism place Munthe at the forefront of the Decorative Arts movement at the turn of the century, linking him with the Finnish revivalist Akseli Gallen-Kallela*, and the Danish architect and designer Thorvald Bindesbøll (1846–1908). Munthe died in Oslo in 1929. [PGB]

81
Horse of Hades *1892*
Helhesten
79.0 x 112.5 (49³⁄₈ x 70³⁄₁₀)
Nasjonalgalleriet, Oslo

*Horse of Hades is an imaginative mythological watercolor
illustration, executed in the terse, biting rhythm of Nor-
wegian sagas and the simple colors of Norwegian folk art. It
was exhibited in 1893, the year it was painted, as no. 7 in a
group of eleven cartoons in Christiania's "Black and White
Exhibition". The cartoons, numbered in the order in which
they were composed, represent Munthe's first departures
from Naturalism. The Christiania artistic community was
fascinated by these strong, mythological works: The Na-
tional Gallery purchased eight of them directly from the ex-
hibition, and Jens Thiis applauded this new direction in dec-
orative fantasy art (Bakken, Gerhard Munthes dekorative
kunst, 1946, p. 51).*

*Horse of Hades's blunt, archaized style, although
seemingly at variance with Munthe's earlier Naturalism, is
no more than the realization of his evolving preoccupation
with Norwegian history. The son of a district physician in
Eastern Norway, Munthe inherited the rustic arts and crafts
traditions of the farm. By the 1870s, Munthe had made de-
tailed studies of folk art and ballads. Concurrently, inspiring
Munthe's research, the Christiania Museum of Applied Art
opened, dedicated to the revival of indigenous Norwegian
style. As the "Old Textiles" collection grew, a laboratory
was established to resurrect old weaving techniques and
color recipes. Publications on Viking art, such as S. Müller's
classic Dyrornamentiken i Norden (1880), and on the con-
tents of the newly discovered Tune and Gokstad ship finds,
were in increasing circulation.*

*Munthe's decorative interests were further stimulated
by his summers at Fleskum, where the artists often enter-
tained such distinguished guests as composer Edvard Grieg,
painter Frederik Collett, and art critic Andreas Aubert.
Their evening discussions often led to subjects appropriate
for the stimulation of the group's new art: Old Norwegian
poetry, sagas, and folk tales. Munthe and Aubert frequently
dominated these discussions, focusing on the issue of an indi-
genous Norwegian "color". Munthe longed for a revival of
"the fewest and most natural colors, such as those of the old
tapestries before decadence set in, bringing with it weak-
ened color gradations and the lifelessness that followed"
(ibid., p. 35). This desire to reestablish "muscle" in Nor-
wegian art formed the basis of Aubert's treatise, "The Deco-
rative Color: A Norwegian Color Instinct" (1892). At the
same time, Munthe began his cartoons.*

*Munthe's first direct application of his revivalist lean-
ings was in an 1888 tapestry cartoon for his wife, Sigrun, a*
*weaver. He continued to produce textile cartoons for Frida
Hansen (1855–1935), Norway's leading weaver, in her
newly formed Norsk Aaklaede og Billedvaeveri. A number
of these designs were exhibited in the 1900 International
Exhibition in Paris, drawing critical attention as manifesta-
tions of Norwegian Art Nouveau.*

*Horse of Hades, while linked stylistically with
Munthe's tapestry designs, was intended as a singular com-
position. Its theme is a conflation of images drawn from
Saga literature, which makes scattered references to the un-
derworld. Munthe seems to have relied on heroic quests into
the underworld described in Snorre Sturlason's Sagas – Nor-
way's national "folk book" – first translated into Dano-
Norwegian by Jacob Aall (1830s) and P.A. Munch (1859–
71). The gates of the underworld are invariably guarded by
Hel, Loki's daughter. She is a seeress who is often accom-
panied by wolves. Munthe's inclusion of bears and bats is a
creative contribution to this literary pastiche.*

*Stylistically, too, Munthe creates a pastiche. The over-
all strength of his linework, as well as the individual animal
motifs, are absorbed directly from Old Norse textiles. He
uses strong, stark colors to heighten the drama of the scene,
laying them down in broad, unmodulated areas. Also
heightening the drama of the scene are quotations from such
eclectic sources as Hiroshige's woodcuts and Thorvald Bind-
esbøll's ceramic designs. In color, form, and theme, Horse
of Hades satisfies Munthe's desire to produce a modern
Norwegian art in an appropriate vocabulary. [PGB]*

EJNAR NIELSEN

Denmark 1872–1956

Born in Copenhagen in 1872, Ejnar Nielsen studied at the Danish Royal Academy of Fine Arts from 1889 to 1893, when he made his debut at the spring exhibition in Charlottenborg Palace. He also took classes at Kristian Zahrtmann's school in the spring of 1895 and the winter of 1895–96. Perhaps his most important artistic model, however, was the Danish Symbolist painter Jens Ferdinand Willumsen*.

From 1894 to 1900 Nielsen worked alone in the central Jutland town of Gjern, where he produced some of his most important works. Among them are the 1896 painting *The Sick Child* and the 1897 work *In His Eyes I Saw Death* (both in the Statens Museum for Kunst, Copenhagen), as well as *The Blind Girl* of 1896–98. Nielsen's interest in the pathos and nobility of these simple people continued in his illustrations for the novels *The Old Man's Child* (1900), by Karl Larsen, and *Kirsten's Last Journey* (1901), by Johannes Jensen.

Nielsen made his first trip abroad in 1900. In Paris from 1900 to 1901, stimulated by his earlier contact with Willumsen, he was particularly attracted to the work of the Gauguin-influenced *Nabi* painters and to the art of Pierre Puvis de Chavannes. He married in 1901 and spent 1902 living in Italy – Verona, Venice, Pisa, Milan, and Florence – where he developed an interest in Quattrocento painting (particularly that of Andrea del Castagno), which influenced his art upon his return to Gjern in 1903. During that year he won his first Eckersberg medal for *The Pregnant Woman* (Göteborgs Konstmuseum), which reflects a new, broader, more spiritually concentrated style. Nielsen returned to Italy and France from 1905 to 1911 and made short visits to Brittany in 1908 and Lapland in 1909. He married a second time in 1908.

Nielsen remained based in Gjern until 1927. He became increasingly concerned with large-scale decorative commissions, making studies for a mosaic for the Copenhagen town hall from 1927 to 1930 (a project he never carried out) and painting a mural for the state hall in Portrum from 1932 to 1939. An active and vital presence in the Danish art community until his death, he served on the board of directors of the Royal Academy of Fine Arts from 1914 to 1920 and was a member of the governing body of Den Hirschsprungske Samling from 1925 to 1931. In 1927 he was honored by the Artists' Society with a comprehensive retrospective in Charlottenborg Palace. [SMN]

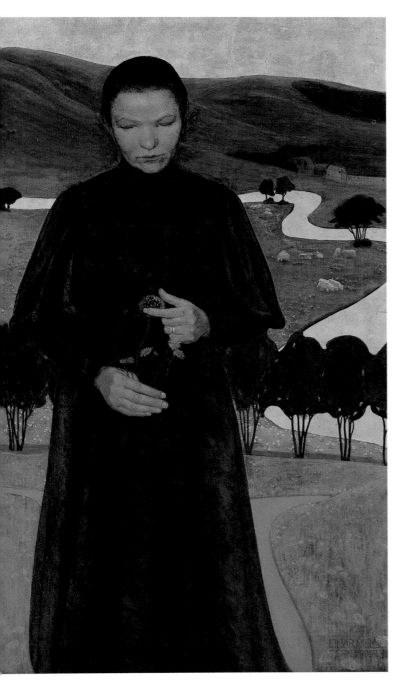

82
The Blind Girl. Gjern *1896 og 98*
Den blinde. Gjern
131.5 x 79.2 (51¾ x 31⅛)
Signed lower right: "Ejnar Nielsen/Gjern 1896–98"
Den Hirschsprungske Samling, Copenhagen

Nielsen's commitment to the truth (an extension of the bitter Realism developed in the 1880s by Jens Ferdinand Willumsen, Johan Rohde, and Harald Slott-Møller*) was united with his Symbolist vision in a series of paintings completed in Gjern from 1894 to 1898. Among them was* The Blind Girl, *whose dominant theme is life as seen under the shadow of death. Nielsen found in the simple people of Jutland a fundamental ennobling perseverance in the face of life's struggles. Like Van Gogh, the Swiss painter Fernand Hodler, and a number of other artists of the 1880s and '90s, he painted the old, the poor, and the sick in his search for a common human destiny.*

The unified tonalities of The Blind Girl *foreshadow Nielsen's attraction to Pierre Puvis de Chavannes. The image may be related to Emmanuel Swedenborg's notion of second sight, a Romantic tradition that flourished in Symbolism, according to which one must lose one's awareness of material surroundings in order to see across great distances of time and space into the soul and divinity. Nielsen has replaced some of the girl's lost visual impressions with experiences gained through touch. She cradles in her hand a dandelion, which, in its state of decay, is the ultimate symbol of evanescence and fragility. The landscape that stretches out behind her becomes the projection of ideal vision liberated from simple sensual perception and connected to a larger reality. [SMN]*

KARL NORDSTRÖM

Sweden 1855–1923

Karl Nordström received his earliest training at the Royal Academy of Fine Arts in Stockholm, where he studied from 1875 to 1878. He left academic art after failing to pass from the introductory course to the advanced level and became a student in E. Perséus' art school. Travelling to Paris in 1881, he lived in the village of Grèz-sur-Loing, southeast of Paris, in 1882 and 1884–86 with fellow countryman Carl Larsson* and the Norwegian painter Christian Krohg*. Having had no success at the Paris Salon, he returned to Stockholm in 1886 and began painting scenes of Swedish nature, particularly winterscapes. In that same year the Artists' Union was founded with Nordström serving as president.

National Romanticism flourished in Sweden throughout the 1890s, and Nordström – spurred by that movement's re-evaluation of the indigenous landscape – developed a deeper and more subjective appreciation of the Swedish countryside in the course of the decade. In 1890 and '91 he executed his first "mood" pictures, in which he sought to capture the somber Swedish twilight. In 1892, he painted the barren, rocky coast of his native district, Bohuslän, and in 1893 he moved to Varberg, where he formed the Varberg school of Swedish Symbolism with Nils Kreuger and Richard Bergh*. He left Varberg in 1895 for Stockholm, dividing his time thereafter between the capital and Bohuslän, and remaining active as leader of the Artists' Union. [SRG/GCB]

83
Garden in Grèz *1884*
Trädgårdsmotiv från Grèz
108.5 x 73.5 (42¾ x 28⅞)
Signed lower left: "Karl Nordström/Grèz 84."
Göteborgs Konstmuseum

Garden in Grèz *falls within Nordström's French period, when he adopted a modified Impressionist technique. The subject is the garden and wall at the Pension Laurent, a hotel in Grèz-sur-Loing in the neighborhood of Fontainebleau. Stone buildings and a wall are seen in the distance across the cool, grassy expanse of garden. Bathed in vaporous white light, the structures dissolve into a myriad of gray, slate, and blue tones. Nordström, more radically Impressionist than most of his Scandinavian compatriots, was criticized by the Swedish press for his shimmering surfaces. His colleague and friend Richard Bergh* wrote of Nordström's Grèz period: "He painted what he found outside the door of the pension where he stayed . . . he studied light effects, discovered the laws of color contrasts, and found that the different objects of nature never appear independent of each other when embraced by the same atmosphere." [SRG/BF]*

201

84
Varberg Fort *1894*
Varbergs fäste
72.5 x 117.5 (45 ⅝ x 73 ⅖)
Göteborgs Konstmuseum

Losing Finland to Russia in 1809 after a 447-year associa-
tion, Sweden was joined from 1814 to 1905 in an ambiguous
and antagonistic union with Norway, which it won from
Denmark. Industrially underdeveloped and socially restric-
tive, Sweden was unable to support the doubling of its
population between 1800 and 1900. The lack of oppor-
tunities spurred emigration to America in numbers that ex-
ceeded those of any other Scandinavian country. Faced with
concern over Russian expansion and Norway's insistent push
for self-determination, Sweden feared for its national sur-
vival. The government responded by attempting to "Ameri-
canize" Sweden through modernization and cultivation of
its rough northern land. The 1890s gave birth to increased
nationalism, and National Romantic art and literature grew
throughout the decade.

The unspoiled Halland province, in which the Var-
berg School flourished from 1893 to 1895, provided a veh-
icle through which Nordström, Nils Kreuger, and Richard
Bergh could express their personal and subjective visions of*
Swedish nature. Forming a nexus between nationalism and
Symbolism, Varberg Fort *depicts a medieval stronghold of*
the Vasas, the ruling family during Sweden's Golden Age of
the sixteenth and seventeenth centuries. Reduced to a series
of abstract forms, the citadel is compressed into a shallow,
two-dimensional space that reflects the influence of
Gauguin, whose work Nordström saw in Copenhagen in
1893. Twilight envelopes the fort – a conception akin to that
of Albert Edelfelt's Särkkä *(cat. no. 11) from the same*
period. In the two views Nordström executed of the fortress,
he celebrated the inherent strength of Sweden. [SRG/GCB]

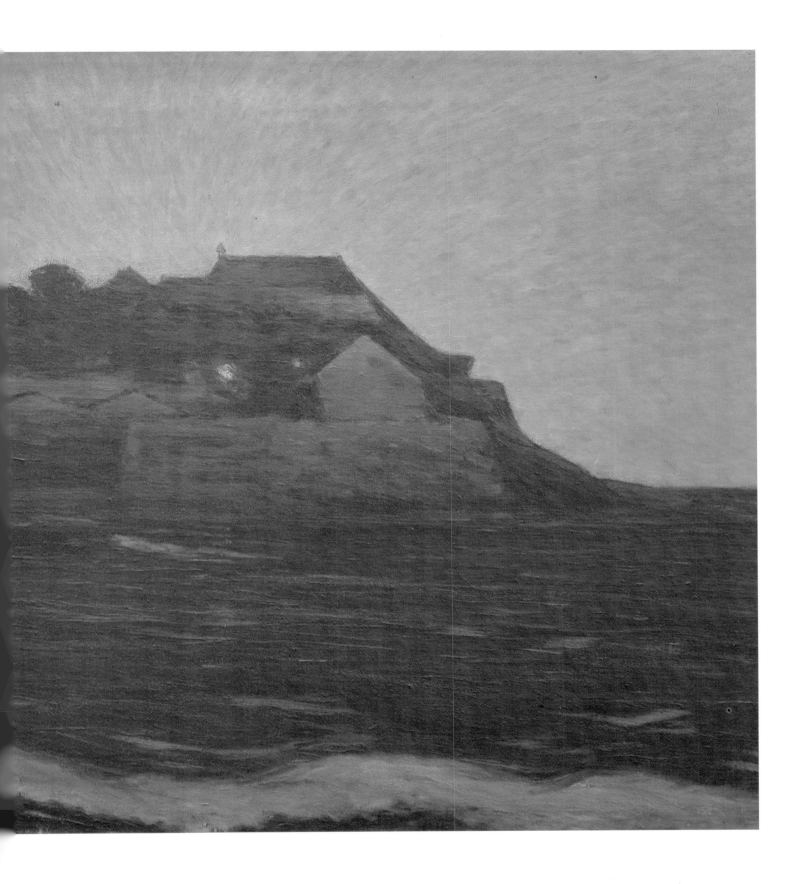

203

EILIF PETERSSEN

Norway 1852–1928

Peterssen began his artistic training in 1869 at Johan Fredrik Eckersberg's painting school in Christiania, and in 1871 he studied at the Danish Royal Academy of Fine Arts in Copenhagen. He spent the next two years in Karlsruhe, where he studied with Hans Gude and Wilhelm Riefstahl. After visiting London and Paris, he moved in 1873 to Munich, where he studied history painting with Wilhelm Diez and came under the influence of Franz von Lenbach. He left the Munich academy in 1874 and won acclaim in 1876 for the painting *Christian II Signing the Death Sentence of Torben Oxe* (Nasjonalgalleriet, Oslo). Returning to Christiania in 1878, he wrote that his success in Munich had made life and art too easy for him.

Peterssen continued to travel widely in Europe, visiting London, Paris, and Venice. From 1879 to 1883 he lived in Rome most of the time but was a frequent summer visitor to the artists' colony in Skagen (see cat. no. 62). In 1883 he settled in Christiania, where he became a member of the Art Association and served on its board from 1885 to 1888 and from 1894 to 1895. He travelled to Normandy and Italy in 1896 and 1897.

Peterssen was a popular teacher and an artist of diverse talents. During the Munich period, history paintings accounted for most of his work. In Italy he began to concentrate on open-air paintings of genre subjects, and from the 1880s on, landscapes and genre made up the major part of his production. Early in the twentieth century he carried out several mural commissions of religious themes. [RH/OT]

85

Meudon Landscape *1884*
Landskap från Meudon
38.5 x 46.5 (15⅛ x 18¼)
Signed lower right: "Eilif Peterssen-Bas Meudon '84"
Nationalmuseum, Stockholm

Peterssen's interest in depicting light effects in a landscape goes back at least as far as his oil sketch The Death of Corfitz Ulfeldt (1873; Nasjonalgalleriet, Oslo), in which he placed the characters at the edge of a forest beneath a lowering sky. In the 1880s his attention turned from historical subjects to pure landscape, often painted outdoors. Although this canvas is dated during the period Peterssen lived in Christiania, he may have painted it on one of his trips to Paris. His inscription indicates that the site is Bas Meudon, the industrial section of Meudon, a suburb west of Paris. Instead of depicting the main tourist attractions of the Forest of Meudon or the Terrace with its renowned Parisian views, he focused from a low viewpoint upon an ordinary fence with a light-filled vista of buildings in the distance.

Occupying much of the composition, the fence both encloses the viewer in the narrow space of the foreground and yields a full view of the buildings beyond. The opening between the two parts of the fence and the stairs that lead back and to the left offer additional "escapes" to the area below. The close-up cropped view and the use of the fence as a decorative screen are related to Akseli Gallen-Kallela's A Loft at Hoskari, Keuruu (cat. no. 22) in that they suggest an attention to the spatial and framing devices of advanced French painting. [RH/OT]*

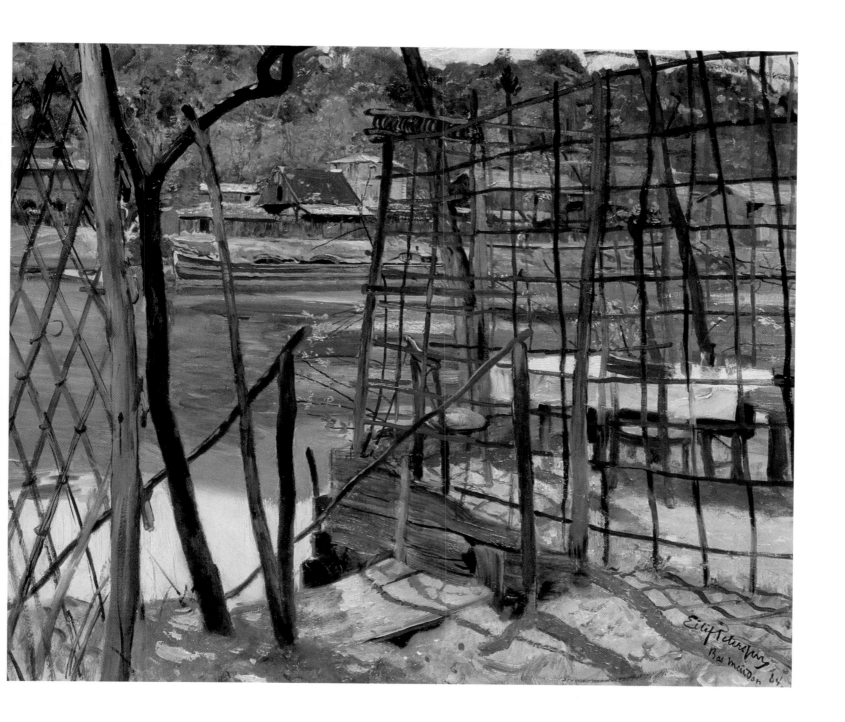

205

86
Summer Night *1886*
Sommernatt
133.0 x 151.0 (52³/₈ x 59¹/₂)
Signed lower left (in monogram): "Eilif P 86"
Nasjonalgalleriet, Oslo

During the summers of 1886 and '87 Peterssen joined Kitty Kielland, Erik Werenskold*, Gerhard Munthe*, and Christian Skredsvig* at the farm of Fleskum near Christiania. Painted in the first summer, this work shares the group's common concern with depicting a mood by means of a relatively naturalistic view of the Norwegian landscape. Peterssen has shown a corner of the lake at Baerum from a high viewpoint in a deceptively casual, "snapshot" composition. The tree at the right, firmly rooted at the shoreline, is cropped by the upper edge of the frame. This device occurs in such earlier Norwegian landscapes as Johan Christian Dahl's* From Praesto *(1814; Nasjonalgalleriet, Oslo).*

The cropped tree extending almost the full height of the work also suggests the influence of Japanese art. Grounded by this strong tree and the almost tangible underbrush of the foreground, the viewer steps comfortably into a realistic scene. However, only a small area of sky is visible at the top center of the work; the rest of the sky and the crescent moon are only reflections in the glassy surface of the lake. This water/sky, filling a large proportion of the canvas, conveys an unsettling, upside-down feeling.

The art historian Marit Lange has stressed the significance of Peterssen's encounter with the art of Pierre Puvis de Chavannes in the Salons of 1884–86. She sees Puvis's The Sacred Grove *(circa 1884; Palais des Arts, Lyon) as the inspiration for Peterssen's new concentration upon bodies of reflecting water and for his use of a high horizon line and a static scene to portray the mood of the Nordic summer night. Peterssen's debt to Puvis is even more evident in* Nocturne *(see right), a work of the following year that adds to the* Summer Night *landscape a languid female nude adapted from Puvis's* Autumn *of 1864 (biblio. ref. no. 67, p. 84–86).*

The later addition of a nude with Symbolist overtones suggests that Summer Night *may have meaning beyond the*

depiction of an idyllic scene from nature.In the literary tradition of treatments of the Scandinavian summer night, there are many examples that include an intimation of death amidst the joy and beauty of the season. In Strindberg's drama Midsummer *(1900), revelers dance amid gravestones on Midsummer night. Edvard Munch* summed up the influence of his paintings on Ibsen's* When We Dead Awaken *(1899) with the statement that the play takes place ". . . all in a light summer's night where life and death walk hand in hand" (quoted in Washington, 1978, p. 244). In Peterssen's beautiful, contemplative painting the fallen birch tree and the vigorous tree at the right may symbolize the cycle of the seasons – decay and regeneration.*

A second version of this canvas (location unknown; reproduced in biblio. ref. no. 67, p. 77) was done in 1886. There are two other versions of Nocturne *(1887; Nasjonalgalleriet, Oslo and 1889; Stavanger Faste Galleri). [RH/ OT]*

Eilif Peterssen
Nocturne 1887
Skogsnymf
200.0 x 250.0
(78³/₄ x 98¹/₂)
Nationalmuseum, Stockholm

LAURITS ANDERSEN RING

Denmark 1854–1933

Laurits Andersen Ring is considered one of the most important visual chroniclers of peasant life in late nineteenth-century Denmark (Madsen, 1946, p. 360). He adopted the surname Ring in 1896 after the village in southern Sjaelland in which he was born. His father Anders Olsen earned a living as a farm laborer and a wheelwright; his mother was descended from generations of serfs. Ring began an apprenticeship to a housepainter in the nearby village of Praestø in 1869. He helped to restore large estate houses, and it was there that he first saw paintings hanging on the walls. From 1873 to 1877 he lived in Copenhagen, attending classes in the winter and supporting himself as a journeyman painter in the spring and summer. He studied for two years at the technical school and in 1875 entered the Royal Academy of Fine Arts, where he spent six semesters in preparatory drawing classes taught by Frederik Vermehren (1823–1910) and J.A. Kittendorf (1820–1902). He left the academy dissatisfied in December 1877.

Ring returned home and taught himself to paint, beginning in the early 1880s with pictures of his friends and family in interiors. He made his debut at Charlottenborg Palace in 1882 with *The Christmas Visitor* (Den Hirschsprungske Samling, Copenhagen). The following year his father died, initiating a decade of economic and personal hardship during which he lived a transient existence, migrating between Copenhagen and smaller villages nearby. Although he attended Peder Severin Krøyer's* school for four months in 1886, the major influences on his Naturalistic style were the French painters Jules Bastien-Lepage and Jean François Raffaelli. One of his few supporters during these years was the critic Karl Madsen, who advocated the nationalistic

subject matter depicted by Ring. They travelled together to France, Belgium, and the Netherlands in 1889. Marriage to Sigfried Kähler in 1896 brought stability to the artist's life and work. His oeuvre is divided according to the periods of residence he spent in various small towns: 1898 to 1902 in Frederiksvaerk, 1902 to 1914 in Baldersbronde, and 1914 to 1933 in Roskilde. Ring outlived his younger wife by ten years and died in St. Jørgensbjerg near Roskilde. [EB]

87

The Lineman *1884*
Jernbanevagten
57.0 x 46.0 (22³⁄₈ x 18¹⁄₈)
Signed lower left: "L.A. Ring/Juni 1884"
Nationalmuseum, Stockholm

Ring rejected the cosmopolitan art center of Copenhagen and dedicated his life to the unbiased recording of the rural environment he knew best. His self-taught style and unclassical draftsmanship were well suited to depict the primitive conditions of peasant life and the lined faces and bent postures of the tillers of the soil. Like his compatriot and literary counterpart, the novelist Henrik Pontoppidan (1857–1928), Ring neither idealized nor was condescending to the peasants, but simply accepted them. Pontoppidan's novels described the "passionless Danish folk with the pale eyes and timid soul" with a Social Realist's eye: "Thus it had always been in Denmark. One generation after the other grew up red-cheeked and clear-eyed, free-minded and strong; one generation after the other has sunk into the grave, broken, bent, always vanquished" (quoted in J.G. Robertson, "Henrik Pontoppidan," The Contemporary Review 117, 1920, p. 377 n. 8).

Ring's subjects included the mundane chores of farm laborers, scenes of families on their way to church, and portraits of the aged and of children born to a harsh existence. In The Lineman, *however, he moves beyond the expression*

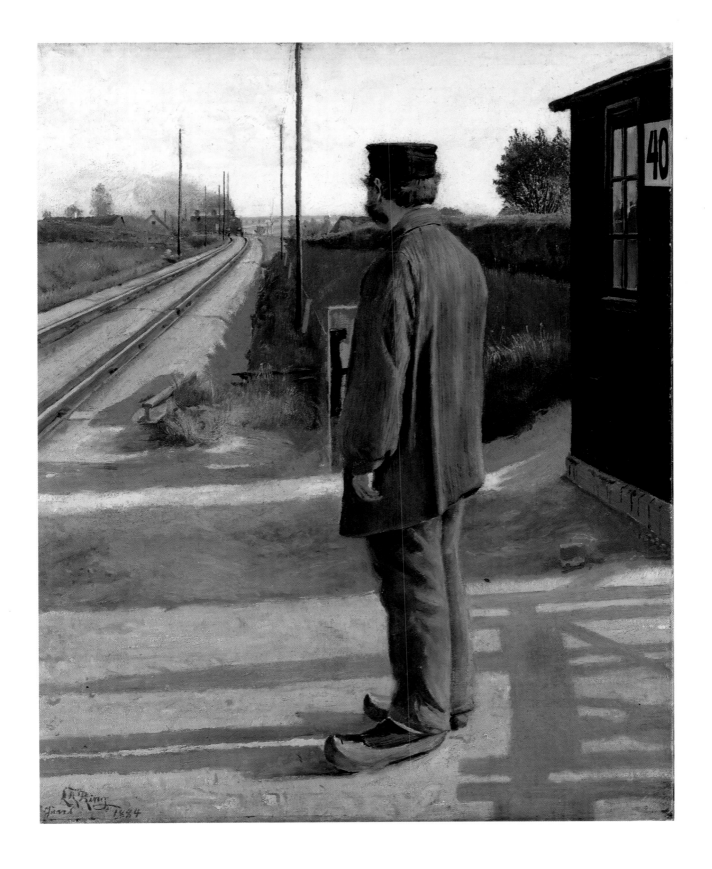

of a simple genre scene to bare an explicit ideological statement. It is one of the few works in which he represents the changes that the onslaught of modernization brought upon the peasants. Industrial expansion usurped both the land and the role of the rural worker, a transformation depicted in this picture of a peasant working as a lineman. The encounter of the common laborer and the oncoming train creates a symbol of the old way of life versus the new, of wooden shoes against iron track. Although the first railroad appeared in Denmark in 1843, it was not until the last third of the nineteenth century that its effects were felt. Modernity exploded into the consciousness of primitive peasants, and centuries of unaltered existence changed overnight. Here Ring portrays the inevitable confrontation of man and machine. In the stooped shoulders of the lineman there is a sense of resignation and defeat. [EB]

88

Young Girl Looking out of a Window 1885
Ung pike som ser ut av et takvindu
33.0 x 29.0
Signed lower left: "L.A. Ring"
Nasjonalgalleriet, Oslo

Having spent the summer in Ragelund with the farmer Lars Ebbesen, Ring returned to Copenhagen in the fall of 1884, to spend the winter as he had the previous year. He studied briefly at the Academy with Julius Exner (1825– 1910). During this period, Ring inhabited a rented attic studio on the Vingaardstraede; it furnished the setting for several paintings, including Young Girl Looking out of a Window.

In this work, a flushed-cheeked girl props open the small attic window in order to catch a glimpse of the street below. The grey tonalities used here by the artist appropriately describe a typically overcast winter day in Copenhagen.

The deliberately eccentric cropping, low perspective and emphatic formal pattern created by the frame of the open window may derive from Ring's knowledge of Japanese prints, his interest in photography or perhaps from his exposure to the works of Edgar Degas (1834–1917). Here Ring sacrifices anecdote for a concern for unusual composition and an off-beat moment, characteristics shared by Degas and evidenced in paintings such as Woman with Dog. *In both instances, the artist focuses on the head of a young woman viewed at close range and from an oblique angle. By purposefully avoiding a frontal view, both Ring and Degas eschew the conventional interest in a subject's features or personality in favor of the expressive possibilities of form alone. [MF]*

Edgar Degas
Woman with Dog ca. 1875–80
Nasjonalgalleriet, Oslo

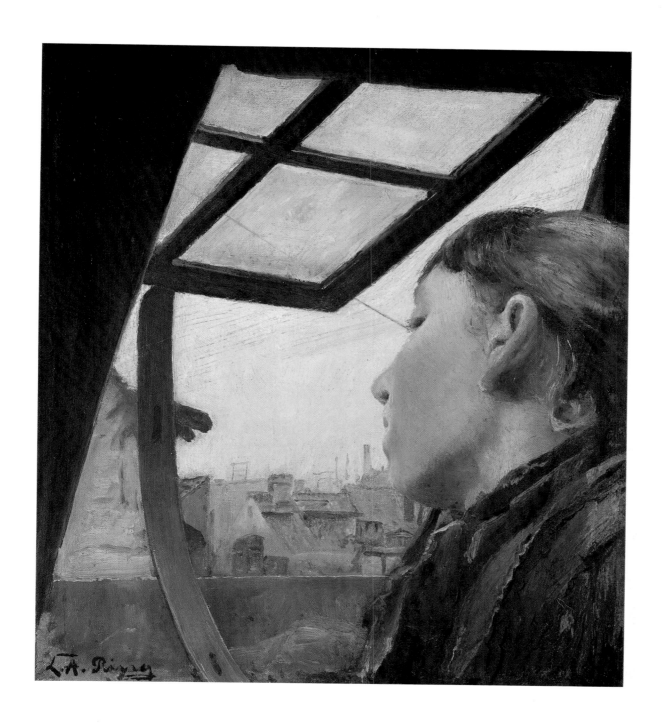

211

89

Evening. The Old Woman and Death *1887*
Aften, den gamle kone og døden
121.0 x 95.0 (47⅛ x 37⅜)
Signed lower left: "L.A. Ring 87"
Statens Museum for Kunst, Copenhagen

*Ring strayed from the path of Naturalism during the years
1887 to 1894. His work was tinged with a melancholy Sym-
bolism prompted by the deaths of his father and brother,
and by economic and personal insecurity. His preoccupation
with death was often manifested in his paintings through
subtle analogies between the transience of human life and
the cycles of nature. In* Evening, *however, he created an ex-
plicit allegory, reviving the Northern medieval tradition of
the Dance of Death in a manner similar to Richard Bergh*
in Death and the Maiden *(1888; Prins Eugens Waldemars-
udde, Stockholm) and Edvard Munch* in* Death at the
Helm *(1893; Munch-Museet, Oslo). Ring depicts an old
peasant woman sitting wearily upon her burdensome load.
The approaching end of her life is implicit in the setting sun,
the infinite expanse of horizon, and the long road that
curves out of sight. Her moment of repose will be cut short
by the ghostly specter of Death, which hovers above her,
brandishing a scythe. The motif of a peasant woman sitting
by the side of the road, surrounded by an evocative land-
scape, but without the figure of Death, was also used by
Munch in his 1888 painting* Evening: Loneliness *(Sigval
Bergesen d.y. Collection, Oslo).*

Prior to Evening *Ring worked exclusively* en plein air
*and with a light-colored palette. He composed this work
however, in the studio, beginning with a study of a skeleton
in the atelier of Peder Severin Krøyer*. The reduced tonal
range and somber coloration reveal the influence of Vilhelm
Hammershøi*, an artist Ring admired greatly and with
whom he felt a particular affinity during this introspective
period (Hertz, 1935, p. 208).*

Ring knew Jean François Millet's The Woodcutter
and Death *(Ny Carlsberg Glyptotek, Copenhagen), a simi-
lar scene of a peasant's liberation from hard labor by the
personification of death. The direct inspiration for Ring's
image of an ethereal yet omnipresent thief, however, was
Henrik Pontoppidan's tale of peasant life and death entitled*
Knokkelmanden, *published in 1887. Like Ring, Pontop-
pidan presents death as "an ominous shadow in an other-
wise straightforward rendering of peasant existence" (Hertz,
1934, p. 208). [EB]*

213

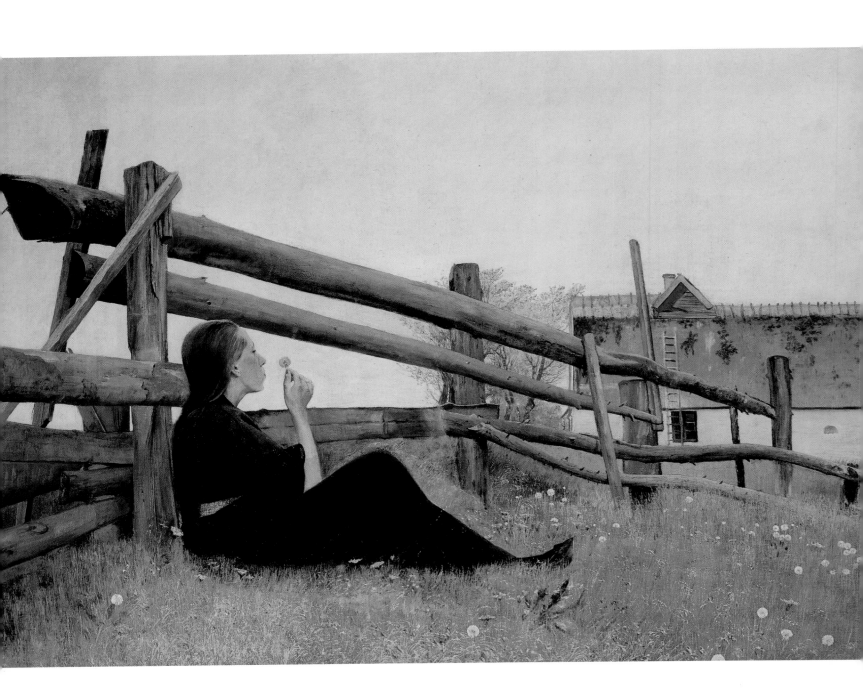

214

90

In the Month of June, *1899*
I juni måned. Pige, der puster
maelkebøttefrø
87.5 x 123.5 cm (35 x 49½)
Nasjonalgalleriet, Oslo

In the fall of 1898, Ring moved to Frederiksvaerk from Ka-rrebaeksminde, where he had been living since his marriage in 1896. This period was filled with domestic bliss (his first child, Ghita, was born in 1899), moderate success (following his first retrospective in 1889 at the Copenhagen Art Asso-ciation) and travel abroad (with his second Italian sojourn in 1899).

Ring's landscapes dating from the turn of the century usually emphasize the broad and fertile plains of the Danish countryside, as in River in Early Summer, Frederiksvaerk (1900; Ordrupgaardsamlingen, Copenhagen); rarely do they contain figures. In this atypical work Ring focuses on a girl reclining against a fence, absorbed in a moment of in-trospection on an early summer's day. Having perhaps made a secret wish, she is about to blow the dandelion seeds from their stem, scattering them across the fallow field.

The artist executed In the Month of June *in his "hard" style, inspired in part by Pieter Brueghel, whose themes and techniques he admired. Concurrently in other works, Ring employed his "loose" style, derived from Natu-ralism and reserved primarily for pure landscapes painted out-of-doors. The practice of working simultaneously in these two styles was characteristic also of the German paint-er Wilhelm Leibl (1844–1900).*

In its subject and mood of peaceful solitude, this work anticipates one of the most popular American paintings, Christina's World *by Andrew Wyeth (1917–). However, the profoundly tragic story of the crippled Christina, com-municated in the painting by a pervasive sense of melan-choly, is absent in Ring's charming, bucolic scene.* [MF]

Andrew Wyeth
Christina's World 1948
The Museum of Modern Art, New York

HELENE SCHJERFBECK

Finland 1862–1946

Helene Schjerfbeck has a unique position in Finnish art. Although ill health ultimately forced her into the life of a recluse, she was nonetheless an important exponent of Scandinavian internationalism and an essential participant in the orientation of Finnish art towards Paris in the 1880s. Born in 1862, Schjerfbeck began her art training at the age of eleven at the Finnish Artists' Association and later continued at Adolph von Becker's private academy from 1877 to 1880. Her work from this period embraced a wide range of subjects, including scenes from Finnish history. Except for this early treatment of historical subjects, however, her art was never again involved with a demonstration of nationalistic values.

In the early 1880s Schjerfbeck won a number of different national fellowships that permitted her to work and study abroad. She was in Paris from 1880 to 1882 and again in 1883 and '84, studying under Léon Bonnat, Jean Léon Gérôme, Gustave Courtois, and Pascal Dagnan-Bouveret. The intervening year, 1882–83, she spent at the academy in St. Petersburg, where she studied under the Russian academician Chistyaku. The most significant influences on her art in the 1880s were Jules Bastien-Lepage and, later, Pierre Puvis de Chavannes. Like many art students of her generation, she was impressed by Bastien-Lepage's entries in the Salons of 1880 and '81, and she studied briefly with him during these years. The free handling and candor of her painting *The Convalesent* (1888; Ateneumin Taidemuseo, Helsinki), which was exhibited at the Paris World Exposition of 1889, attest to this association. In 1889, the year that Puvis de Chavannes broke with the official Salon and founded the Salon du Champs de Mars, Schjerfbeck studied at his atelier and began to explore the principles of reduction and simplification in the creation of an expressive mood.

The 1890s were not very productive for Schjerfbeck. Except for travel to Paris, St. Ives, and Italy in 1889–90, and to Vienna and Italy in 1894, she concentrated her energies on teaching at the Finnish Artists' Association. In 1903 she retired from Helsinki to the rural sanctuary of Hyvinge. The restrained, ascetic color characteristic of her work at the beginning of the century (which was at least partially inspired by Puvis de Chavannes, James McNeill Whistler, and Vilhelm Hammershøi*) gradually became bolder and more luminous. This development is particularly apparent in the remarkable series of self-portraits she produced until her death in 1946. [SMN/SSK]

91
The Seamstress *1903*
Ompelijatar (Tyoelaeisnainen)
95.5 x 84.5 (37⅝ x 33¼)
Signed lower left: "H S 1903"
Ateneumin Taidemuseo, Helsinki

The austere simplicity and linear elegance of The Seamstress *attest to Helene Schjerfbeck's involvement with the Classicizing goals of James NcNeill Whistler, Pierre Puvis de Chavannes, and the Pre-Raphaelites. However, the limited aesthetic of abstract Classicism failed to satisfy Schjerfbeck. Certainly* The Seamstress *is related in means and intent to Whistler's work of the 1870s, particularly such single-figure portraits as* Arrangement in Gray and Black No. I: The Artist's Mother *(1872; Louvre, Paris), which Schjerfbeck would have seen at the Salon of 1883. But the strength and pathos of* The Seamstress, *the subject's more concentrated pose, and the greater angularity of the faceting of facial planes are quite different from Whistler's compartmentalized spatial elegance.*

Schjerfbeck often reworked the same composition into several versions in her search for a reduction of formal means and a concentration of psychological expression. She ultimately confined herself to a narrow range of female subjects at a time when the issues of women's rights, status, and identity were crucial. Although The Seamstress is related to an iconographic tradition in Victorian painting that depicts the appalling condition of female employment, it is neither narrative nor didactic. This isolated woman projects a sense of woman's strength complete within herself. [SMN/SSK]

CHRISTIAN SKREDSVIG

Norway 1854–1924

Christian Skredsvig was born into a farming family in 1854 in rural Modum, the location of Frits Thaulow's "open-air" painting academy. Thaulow first recognized Skredsvig's drawing abilities and sent him to J.C. Eckersberg's school in Christiania in 1869. In the early '70s, Skredsvig studied briefly under the landscape painter Vilhelm Kyhn (1819–1903) in Copenhagen, who suggested that he seek a more cosmopolitan education. Warned against the popular but waning Düsseldorf Academy ("too many Norwegians"), Skredsvig travelled to Paris where he was deeply impressed by French art. Evidently he saw J.F. Millet's *The Angelus* (1855–57; Louvre, Paris), later calling it a forerunner of Norwegian "mood painting". Beset by financial difficulties in Paris, Skredsvig followed Erik Werenskiold* and Eilif Peterssen* to Munich in 1875, where he remained for three years studying under Heinrich Zügel (1850–1941).

In 1879 Skredsvig returned to Paris, circulating among the expatriate Scandinavian artists and writers, particularly the Swedish "Opponents". His first breakthrough was with *La berge du quai des Saints-Pères, Dec. 1879,* exhibited in the 1880 Salon. In the following year, *Une ferme à Venoix (Normandie),* reminiscent of a summer spent at the artists' community at Grèz, received a gold medal at the Salon, and was purchased by the French state. Skredsvig, the first Norwegian to succeed at the Salon, later served as a judge with Frits Thaulow.

In the wake of this achievement, Skredsvig toured Spain, Italy, and Corsica with the Swedish painter Ernst Josephson*. Returning to Paris in 1882, Skredsvig married a fellow Norwegian, Maggie Plahte. Her father, a businessman and patron of the arts, gave his daughter a farm in Fleskum as a wedding present. After the death of their two-year-old daughter in 1885, the Skredsvigs moved from Paris to Fleskum. In the summer of 1886, Skredsvig invited Harriet Backer*, Kitty Kielland*, Erik Werenskiold*, Gerhard Munthe*, and Eilif Peterssen* to live and paint with him, establishing one of the most fertile artistic communities in Norwegian history.

After the other artists dispersed in 1887, Skredsvig remained at Fleskum, producing his greatest work in the late 1880s. He travelled only occasionally, including an 1891 trip to the Côte d'Azur with Edvard Munch*, until he moved north to Eggedal in 1894. There, he produced his series of supernatural watercolor mountain vistas, *Valdres Visa* (Statens Museum for Kunst, Copenhagen). He published his memoires, *Daage og Naetter blandt Kunstnere* in 1908, and two novels, *The Miller's Son* (1912) and *Even's Homecoming* (1916), written in the naive, fresh style of his watercolors.

In the mid-'90s, the farm at Fleskum burned to the ground, taking with it many of Skredsvig's paintings of the 1880s. Skredsvig continued painting and writing until his death in 1924. [PGB]

92

The Willow Flute *1889*
Gutten med Seljefløyten
79.0 x 120.0 (49³/₈ x75)
Nasjonalgalleriet, Oslo

Christian Skredsvig
Sketch for the Willow Flute
20. April 1886
21.5 x 32.5
Private collection

Fleskum became an informal painting collective for the first time in 1886. The common goal of the six artists who summered there was the discovery and establishment of a purely Norwegian school of Naturalism. By day they painted the landscape of rural Baerum. By night they became a remote intellectual "salon", drawing writers, critics, and musicians from Christiania. The artists began to focus on the moody, cobalt blue light of the summer night as an emblem of their homeland, and for a period, their work shared a common "voice".

The Willow Flute *was conceived in April of 1886, just prior to this first communal summer. A gouache sketch, signed and dated "20 April 86" (see illustration), shows a young boy, his back turned toward us, playing a willow flute to the expanse of water before him. He stands on the left side of the painting, on the edge of a riverbank that is covered by spontaneously painted willow branches, bracken and grass – a witness to springtime revitalization. Silhouetted against the sky, he is a picturesque descendent of J.-F. Millet's French peasants, although painted in the rapid brush strokes which Skredsvig had assimilated from Impressionism.*

In its altered version of 1889, The Willow Flute *is a quiet evocation of, and symbol for, the moody Norwegian summer night. The boy now faces us, playing to the stilled water at his feet. Behind him, the edge of a forest-lined lake has moved up the canvas, allowing only a hint of the sky at the horizon line. This was a favorite compositional ploy of Jules Bastien-Lepage, with whom Skredsvig was familiar from his 1881 summer in Grèz. From this tilted perspective, the sky is revealed to us indirectly, through reflections on the water. The framing of this composition was influenced by Eilif Peterssen's* Summer Night, *painted at Fleskum during the summer of 1886, and the 1887 variation,* Nocturne *(see cat. no. 86). Skredsvig adopted Peterssen's palette and high-angled view of the pond in* The Willow Flute, *but replaced the overtly symbolic nude wood nymph in* Nocturne *with a more subtly evocative peasant boy.*

The willow flute, the focus of the painting, is one of the oldest flute types. It is a transverse fipple flute, played by skillful manipulation of its one open end. Carved from a willow bough when the wood is most supple in the early spring, it has traditionally been used throughout rural Scandinavia for communication between farmers, hunters and shepherds. With the growth of urban culture in the nineteenth century, the willow flute became associated with rustic and pastoral society, and valued by ethnomusicologists for its purity. (see Curt Sachs, Geist und Werden der Musikinstrumente, *Hilversum, 1965). From ancient tradition, the flute is associated with fertility and rebirth. Throughout Northern European children's literature and verbal histories, the flute is an instrument of magic, calling forth trolls and water spirits.*

An emblem of the neo-Romantic movement of the 1880s, The Willow Flute *evokes the spiritual life of the rural Norwegian peasantry. The fluting boy stands halfway between Naturalism and Symbolism: recording rustic customs, as in Erik Werenskiold's** On the Plain *(cat. no. 108), as well as communicating with the rhythms and forces of Nature, as in Ernst Josephson's** The Water Sprite *(cat. no. 49). Like the youth in Bjørnstjerne Bjørnson's poem, "Tonen" ("The Melody"), which inspired the painting's theme, Skredsvig's boy yearns for an integration with the summer night:*

219

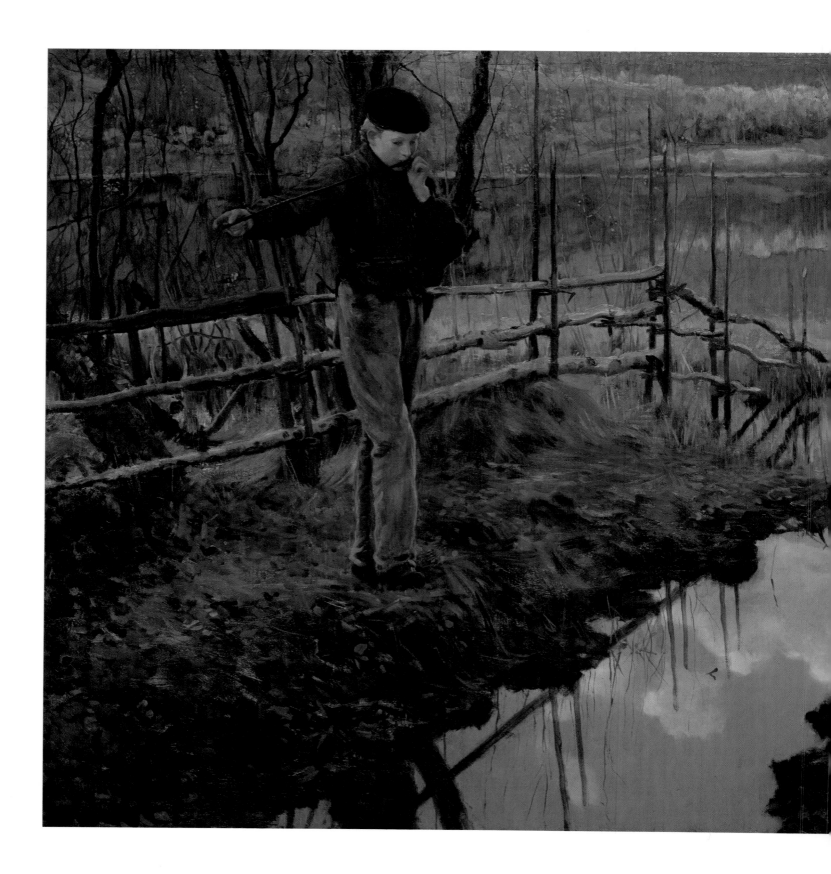

220

"In the woods the lad wandered the whole day long,
 The whole day long;
For there he had heard such a wonderful song,
 Such a wonderful song.

"He made him a flute from a willow-tree,
 From a willow-tree;
And sought if therein lay the melody,
 The melody.

"It came, and it whispered its name to him,
 Its name to him;
But, whispering, died in the forest dim,
 In the forest dim.

"And as he lay sleeping, it stole to him oft,
 Stole to him oft.
In dreams it would lovingly hover aloft,
 Hover aloft.

"But when, joyously listening, he woke from his dream,
 Woke from his dream,
Far off hung the song in the wan moon-beam,
 The wan moon-beam.

"'Oh, Father in Heaven! now take me from hence,
 Take me from hence!
The song it has stolen my heart and sense,
 My heart and sense.'

"But our Father answered: 'It loves thee well,
 It loves thee well,
Tho' it never thine own for an hour may dwell,
 For an hour may dwell.

"'For no other song shalt thou long and pine,
 Long and pine;
But for this one alone, which can never be thine,
 Never be thine.'"

(from Arne. Translation: Walter Low, London 1895)
[PGB]

HARALD SLOTT-MØLLER

Denmark 1864–1937

Harald Slott-Møller, a leader in Danish painting and decorative arts and a founding member of the Free Exhibitions, experienced meteoric success in the 1880s as a Naturalist, only to turn in the 1890s to an idiosyncratic Symbolism that led to the eventual decline of his reputation. This path closely paralleled the career of his influential friend Jens Ferdinand Willumsen*.

Slott-Møller attended Copenhagen's Royal Academy of Fine Arts from 1881 to 1883. Dissatisfied with the academy's conservatism, he entered the Artists' Study School and left three years later as Peder Severin Krøyer's* leading student. The eminent critic Karl Madsen followed his career from his debut at the 1886 exhibition in Charlottenborg Palace. With the unveiling of *The Poor: The Waiting Room of Death* in Copenhagen's Great Northern Exhibition of 1888, he was hailed as the leading Naturalist painter of his generation.

In May of 1888 Slott-Møller married Agnes Rambusch (1862–1937), a fellow artist from Krøyer's school. They travelled to Italy in the winter of 1888–89 and were immediately entranced by Trecento and Quattrocento painting. Harald reacted strongly against Naturalism after 1890, impelled by three factors: the medievalizing tendencies of his wife's painting, the spiritual qualities he perceived in Italian art, and the pilgrimages he made to London in 1896–97, 1899, and 1900 to view the work of Dante Gabriel Rossetti. Further trips to Italy and his association with the Grundtvigian religious movement strengthened his conviction about spiritual, stylized painting. In 1917 he published his theories in *Kunstens Kilder* (*The Sources of Art*; Copenhagen: H. Hagerup Forlag), stating his belief in the sovereign influence of Christianity on art.

In the 1890s Slott-Møller was a sought-after portraitist and a strong proponent of the Neo-Romantic artisans' movement, engaging in bookbinding, wall decoration, jewelry design, ceramics, and furniture decoration. After 1910, the Slott-Møllers isolated themselves personally and artistically, continuing to paint in a Pre-Raphaelite-derived style until their deaths in 1937. [PGB]

93

The Poor: The Waiting Room of Death *1888*
Fattigfolk. I dødens venteværelse
131.0 x 184.5 (51½ x 72⅛)
Signed lower left: "Slott-Møller"
Statens Museum for Kunst, Copenhagen

Harald Slott-Møller painted this gripping and controversial painting as a response to social conditions in Copenhagen. In the late 1880s the peasantry, migrating to the city from their native countryside, confronted unemployment and wretched living conditions in the rapidly expanding Danish capital. Concurrently, Copenhagen became an important center for socialist ideology. Such radical periodicals as Edvard Brandes's Politiken *and Louis Pio's* Socialistiske Blade *were published there, and Brandes's brother Georg preached social commitment from the lecterns of the university (see cat. no. 94).*

By focusing his artistic sensibilities on the urban poor, Slott-Møller was an anomaly in the generation of Naturalist painters trained under Peder Severin Krøyer – a group primarily concerned with rediscovering the people and places of the picturesque Danish countryside. In the late 1880s Erik and Frants Henningsen were among the few urban genre artists working in Denmark, creating anecdotal illustrations for Copenhagen newspapers akin to Jean François Raffaelli's* Les Types de Paris *of 1889. Although influenced by the Henningsens' sentimentalized reportage, Slott-Møller's painting rejects the anecdotal and picturesque in favor of a didactic social Realism fused with morbid symbolic content.* →

222

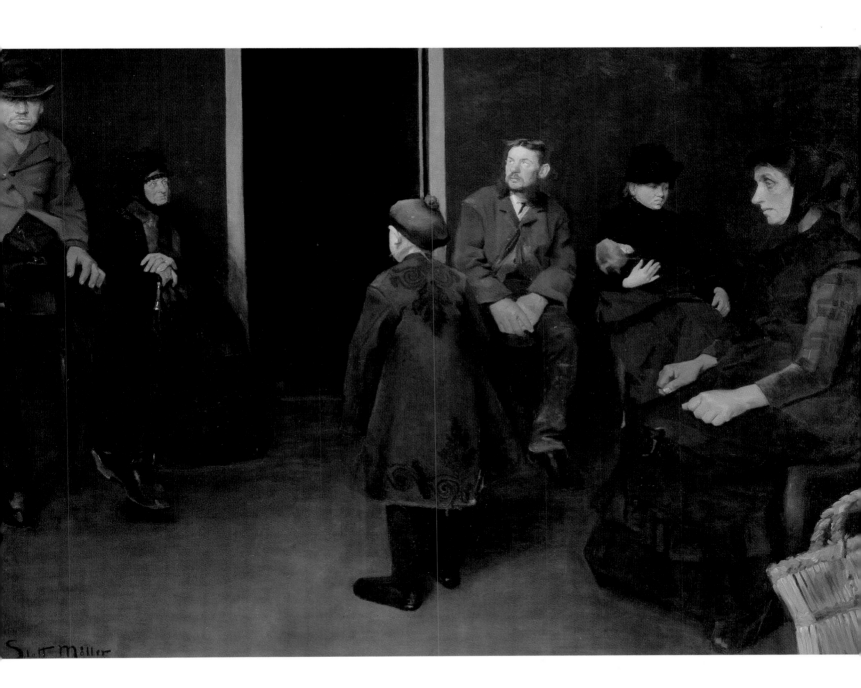

223

→ *In a monumental allegory of urban psychic despair, Slott-Møller portrays a group of indigents passively awaiting death. They are spiritually as well as materially impoverished, stripped of volition and dignity as they sit in an anonymous, stark room in static attitudes of introspection. The door at the center of the composition reveals a figure of Death personifying the aphorism "Death is the poor's only doctor." The figure emerges from impenetrable darkness, beckoning to the ragged boy already responding to his call.*

Slott-Møller seems to have felt that the figure of Death was too literal and evident, and partially painted it out. This symbolic element in The Poor, *related to such images as Jean François Millet's* The Woodcutter and Death *(1859; Ny Carlsberg Glyptotek, Copenhagen) and Laurits Andersen Ring's* Evening. The Old Woman and Death *(cat.*

no. 89), was criticized at the 1888 Great Northern Exhibition. "This memento mori," said one critic, "is completely misplaced and carries with it no more mysticism than a poison label on a pharmacy bottle." (Ny Jord, 1888, p. 383, quoted from Peter Michael Hornung, Skildringer af Bønder, fishere og byproletariat, i perioden fra Realismens gennembrud til tiden omkring Første verdenskrig. *M.A. thesis, University of Copenhagen, 1981).*

*As a combination of Social Realism, psychological alienation, and morbid allegory, this painting stands midway between such urban-critical pictures as Christian Krohg's** Albertine in the Police Doctor's Waiting Room *of 1887 (cat. no. 59) and such fully realized Symbolist images as Edvard Munch's** Death in the Sick Room *of 1893 (cat. no. 75). [PGB/KM]*

94

Georg Brandes at the University of Copenhagen *1890*
Georg Brandes i Københavns Universitet
94.5 x 82.0 (37⅜ x 32¼)
Signed lower left: "Harald Slott-Møller"
Det Kongelige Bibliotek, Copenhagen

Georg Brandes at the University of Copenhagen *was the first and most riveting of Slott-Møller's portraits of leading personalities. As in his psychologically probing 1907 portrait of poet Helge Rode (National Museum, Frederiksborg), he typically painted his sitters in outdoor settings, subsuming them into a symbolic relationship with their landscape. The portrait of the critic Brandes, one of Denmark's foremost intellectuals, places him in his own milieu at the podium of a university lecture hall.*

Slott-Møller began attending Brandes's famous lectures at the university while studying under Peder Severin Krøyer at the Artists' Study School. He was strongly influenced by Brandes's aesthetic, social, and literary theories which were reflected in* The Poor: The Waiting Room of Death *(cat. no 93). Brandes, involved in the Danish artistic community, developed a friendship with Slott-Møller that gave the young artist insight into the scholar's personality.*

Slott-Møller's portrait captures the pathos rather than the greatness of Brandes, who, despite his international reputation, was nonetheless the target of anti-Semitic senti-

ment. Viewed from below, as if by a member of the university audience, he appears vulnerable and is dwarfed by the looming podium and overhead light fixtures. Instead of ennobling Brandes's features, the raking light emphasizes the sensitive furrowing of his brow and the dark recesses under his eyes.

Slott-Møller's portrait of Brandes and Eero Järnefelt's Portrait of Professor Johan Philip Palmén *(cat. no. 45), both of 1890, represent polar opposites within a shared goal of* portrait de milieu – *defining the sitter by his environment. Järnefelt's highly decorative, synthetic style enriches Palmén's portrait through its color, movement, and delightful spatial ambiguities. Slott-Møller, on the other hand, rigorously simplifies his palette and compositional elements to evoke a stark, sympathetic reading of Brandes.*

The reduced, severely ordered composition and high degree of stylization in the Brandes portrait create an interesting parallel to the work of the Parisian artist Félix Vallotton (1865–1925). Slott-Møller's bold use of black paint, especially praised by critic Karl Madsen, was a precursor of Vallotton's paintings and woodcuts of the later nineties. Travelling the same road toward graphic simplicity in 1890, Vallotton would begin a prolific outpouring of woodcuts in 1891, while Slott-Møller turned, in the same year, to Romantic Italian landscape painting, leaving behind the moody palette and simplified means of the Brandes portrait. [PGB]

225

HARALD SOHLBERG

Norway 1869–1935

Harald Sohlberg was born in Christiania, the son of a prosperous fur merchant. In 1885, at his father's request, he was apprenticed to a decorative painter, enrolling in the Royal Academy of Drawing at the same time in order to learn the skills necessary for his new profession. In 1890 he became the private pupil of Sven Jørgensen, an eminent painter of rustic scenes. From the beginning Sohlberg revealed a profound and highly original feeling for landscape. Throughout most of 1891 he worked alone in nature, first at Nittedal, a rural retreat north of the capital, and then during the summer at Østre Gausdal, where with Thorvald Erichsen (see cat. no. 18) he experimented with Pointillism.

In the autumn of 1891 Sohlberg joined a group of young painters, including Halfdan Egedius*, who were working under the supervision of Erik Werenskiold* and Eilif Peterssen*. During this period his feeling for the symbolic power of landscape began to mature. He then studied briefly at Kristian Zahrtmann's school in Copenhagen, returning in late May of 1892 to Christiania, where he remained for the next three years. At this time he attended both the Royal Academy of Drawing and Harriet Backer's* school of painting, and was often in the company of Egedius, Gustav Vigeland, and Ludvig Karsten. In 1894 he exhibited his first major canvas, *Night Glow* (Nasjonalgalleriet, Oslo), at the state exhibition of art, where it made a profound impression on his contemporaries, particularly Jens Thiis. He was subsequently awarded a scholarship to study in Paris in 1895–96 and then at the Beaux-Arts Academy in Weimar, where he concentrated on landscape painting under his compatriot Fridtjof Smith.

Sohlberg married in 1901 and lived with his wife in the mountains of central Norway. There he began his major motif *Winter Night in Rondane* (cat. no. 98). After living in the bleak copper mining town of Røros from 1902 to 1905, he returned to Paris for four months during 1906 and then settled in Kjerringvik, a small village on the Christiania-fjord. In 1910 he moved to Christiania permanently and spent the year 1913–14 completing *Winter Night in Rondane*, which was exhibited at the Norwegian Jubilee Exhibition of 1914 and San Francisco's Panama Pacific Exhibition of 1915, winning gold medals at both. He continued to paint the eastern and central uplands of Norway until his death in 1935. [SMN/MM]

Niels Emil Severin Holm
**View of the
Straits of Messina
from a Country House** 1859
82.0 x 132.0 (32¾ x 52)
*Museum of Fine Arts. Boston
Arthur Gordon Tompkins
Fund*
Painted decades earlier by a little-known Danish artist, this juxtaposition of a just-abandoned domestic terrace and a beckoning Sicilian vista has an uncanny similarity to Sohlberg's *Summer Night*. Representing two sides of the Scandinavian imagination – the opposing lures of Mediterranean sunlight and Nordic evening – these pictures demonstrate the persistence of Romantic viewpoints, and the special intermingling of crisp Realism and poignant moodiness, in Northern painting of the nineteenth century.

95

Summer Night *1899*
Sommernatt
114.0 x 135.5 (44⅞ x 53¼)
Signed lower right: "Sohlberg/1899"
Nasjonalgalleriet, Oslo

Summer Night, *a vast and silent landscape painted from the balcony of a house high on the Nordstrand ridge southeast of Christiania, is the culmination of Sohlberg's aspirations throughout the 1890s. In certain ways it is a restatement of*

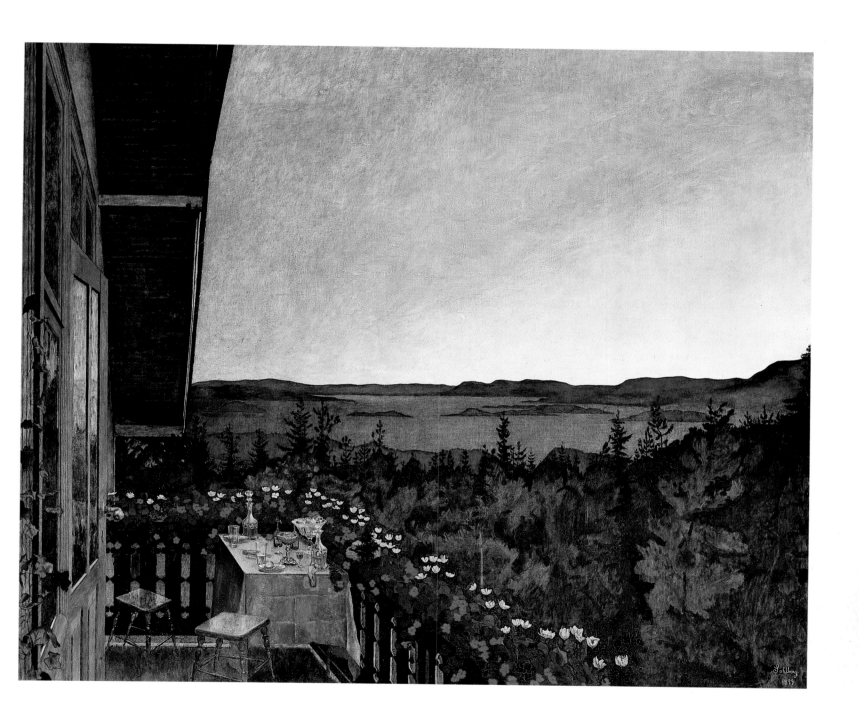

Night Glow *(Nasjonalgalleriet, Oslo)*, the painting with which he made his debut in 1894 and which also depicted the power and intensity of the Nordic summer night. Summer Night *is, however, more complex than any of Sohlberg's earlier works. It is a painting of hidden worlds and unfolding mysteries. The deserted gala table for two is set within a frame of flowers, behind which the opened veranda door reflects the endless panorama of woodland, fjord, island, and hills. The tension between the meticulous foreground detail and the broad washes of the immense landscape beyond reveals the underlying separation between two different realms of experience – the intimate and the transcendental. Sohlberg's dialogue of near versus far (or human versus natural) characterizes a Romantic attitude towards nature and contrasts what August Wilhelm Schlegel called the 'poetry of possession' – the intimate interior – with the 'poetry of desire' – the tempting space outside"* (L. Eitner, "The Open Window and the Storm-Tossed Boat." Art Bulletin, *36, 1955, p. 286).*

Although Summer Night *is devoid of human presence, the table set for two and the abandoned hat and gloves of a woman contribute to an atmosphere of silence in which the presence of the departed lovers still echoes. The painting resounds with the solemnity of a ritual just completed and, in fact, is thought to commemorate the evening of Sohlberg's engagement. The details of the hat and gloves amplify the summer night's palpable sense of mystery as well as its association with love, courtship, and awakening sexuality. Their abandonment suggests both the culmination of the evening and a haunting sense of transience. Such undercurrents of eroticism link* Summer Night *with the personal dream quality of Edvard Munch's work of the early 1890s, particularly* Summer Night's Dream (The Voice) *of 1893 (cat. no. 74). Yet Sohlberg stressed the decorative potential of his subject in a manner quite different from Munch. The thinly laid colors – glowing blues, whites, reds, and blacks – and the severe, compact lines of* Summer Night *recall lustrous enamels or glass mosaics.*

The motif of the terrace was so important to Sohlberg that he began a large oil of the same location in winter. He never completed this other work, however, and only a large oil study exists (Nasjonalgalleriet, Oslo). There are no signs of festivity in the deserted winter scene, and the suggestion of transience, or even death, that is just hinted at in Summer Night *there becomes more overt. [SMN/MM]*

96
Night 1904
Natt
113.0 x 134.0 (44½ x 52¾)
Signed lower right: "Sohlberg/Røros 1904"
Trøndelag Kunstgalleri, Trondheim

In March 1902 Sohlberg and his wife moved to the small Norwegian copper mining town of Røros, high on the mountain plains, where they remained for the next three years. Sohlberg chose Røros because of his desire to paint an industrial setting, a motif that had interested him since 1897–98 when he painted From a Working District in Christiania *(destroyed, but an oil study survives in the Nasjonalgalleriet, Oslo). He found his subject almost immediately in the late-Baroque church that dominated the stark town.*

The Norwegian novelist Johan Falkberget, who was also living in Røros at about this time, described the church's sad and desolate graveyard as a desert of bleak sand, small stones, and rusty crosses. In Night *it is depicted, in Sohlberg's words, as a "frontier between the abodes of the living and the dead." Towering over the countless crosses of the cemetery, the church itself is frontal and strictly centralized, a compositional manipulation altering its actual position. Just behind the church stand rows and rows of humble miners' cottages enveloped by the velvety dusk. The red flowers placed on the freshly dug grave in the foreground are the only bright spots of color – in the artist's words, "a contrast to everything forgotten and decayed." The entire composition is a monument to the generations of hardworking people and their long-forgotten dead.*

When Sohlberg first began working on this painting, he was touched by events that forced him to think about death. In the late fall of 1902 he was called to his mother's deathbed, and soon afterwards news came that his younger brother, Einar, had been killed in the Boer War. Since he had never before experienced the death of anyone close to him, these two losses were especially shocking.

Although Night *developed slowly through various phases, there is only one extant sketch (Nasjonalgalleriet, Oslo). It is such a complicated composition, and Sohlberg generally worked with so many preliminary studies, that it seems reasonable to assume that several others have disappeared or been destroyed. Dated 1903, this one oil sketch appears to have been painted on location and closely resembles the finished work. Another drawing, a photo of which turned up in Sohlberg's papers, also includes all of the elements of the final version except the open grave covered with flowers, which is outlined but not completed (Arne Stenseng,* Harald Sohlberg, *Oslo, 1963, p 84).*

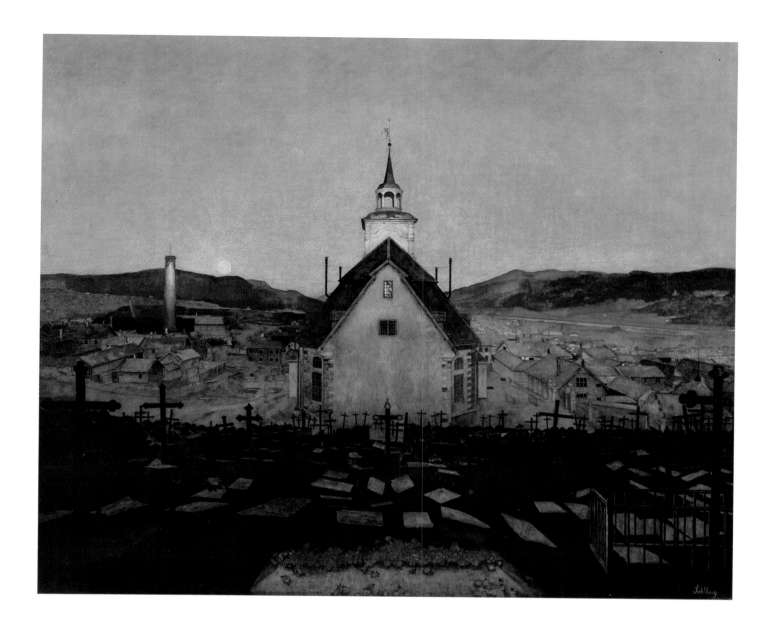

The churchyard was a popular German Romantic motif, and it appears frequently in the work of Caspar David Friedrich (1774–1840), often with the open grave. Similarities between Sohlberg's work and Friedrich's include the tendency towards a symmetrical, centralized distribution of forms with hieratic and pantheistic overtones, as well as tension between intimate and cosmic dimensions. Friedrich had been rediscovered at the turn of the century by the Norwegian art historian and critic Andreas Aubert, whom Sohlberg had come to know in 1895–96 while living in Paris, and with whom he corresponded until 1906 (Stenseng, 1963, p. 218). In studies of Johan Christian Dahl in 1893 and 1894 Aubert had treated Friedrich extensively, and Sohlberg would certainly have seen any number of works by Friedrich during his year in Germany. [SMN/MM]

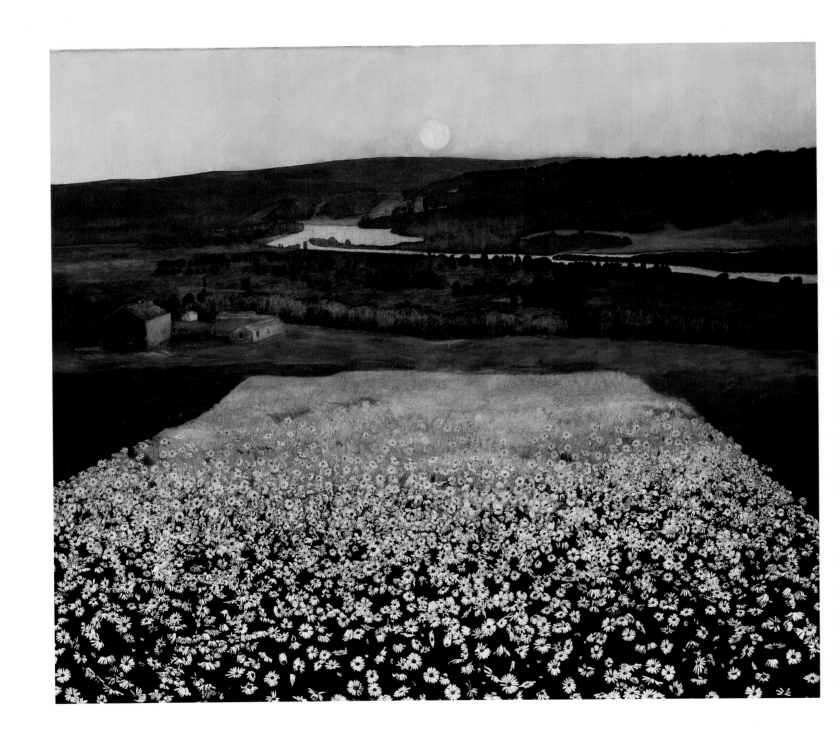

97

Flower Meadow in the North 1905
En blomstereng nordpå
96.0 x 110.0 (37¾ x 43¾)
Signed lower right: "Sohlberg/05"
Nasjonalgalleriet, Oslo

In the summer of 1904 Sohlberg and his wife moved several miles north of Røros to the farm Gullikstad. There Sohlberg painted two of his most important works – Flower Meadow in the North *and* The Highway *(Carsten Lyng, Oslo). Seen together, these paintings form an interesting dialogue about the pastoral beauty of rural life and the insidious onslaught of "progress".* Flower Meadow *is a paean to the untouched landscape of the north country. The only signs of human presence in this immense sea of flowers are the house and barn on the far left, which are submerged in the grandeur of nature.* The Highway *is far more dramatic. The landscape is no longer serene but glows with vivid color and is cut by telephone poles on the desolate road – symbols of the industrialization that had long interested Sohlberg and had prompted his initial work at Røros.*

Flower Meadow *has the jewel-like intensity and magical Realist quality of Sohlberg's earlier canvases. The precise rendering of the daisies in the foreground is extraordinary, as is the abrupt shift to the generalized, softened landscape forms in the distance. This tension reveals the same interpretation of nature previously seen in* Summer Night *(cat. no. 95) and* Night *(cat. no. 96) but without the more obvious symbolic references included in those earlier works. Here nature is enveloped in a hushed, reverent silence. The simplified and symmetrical composition – which Sohlberg also explored in* Night *and is characteristic of his work after 1900 – has distinct religious implications, although there is no longer a church at the center as in* Night.

When Sohlberg ended his immensely productive Røros period and left Gullikstad in November 1905, Flower Meadow, *for which he had made many studies from nature, was not yet completed. He arranged to have the canvas sent to him in France and there finished some of the details. The painting was exhibited in the annual Autumn Exhibition in Christiania in 1906 and received much critical acclaim.*
[SMN/MM]

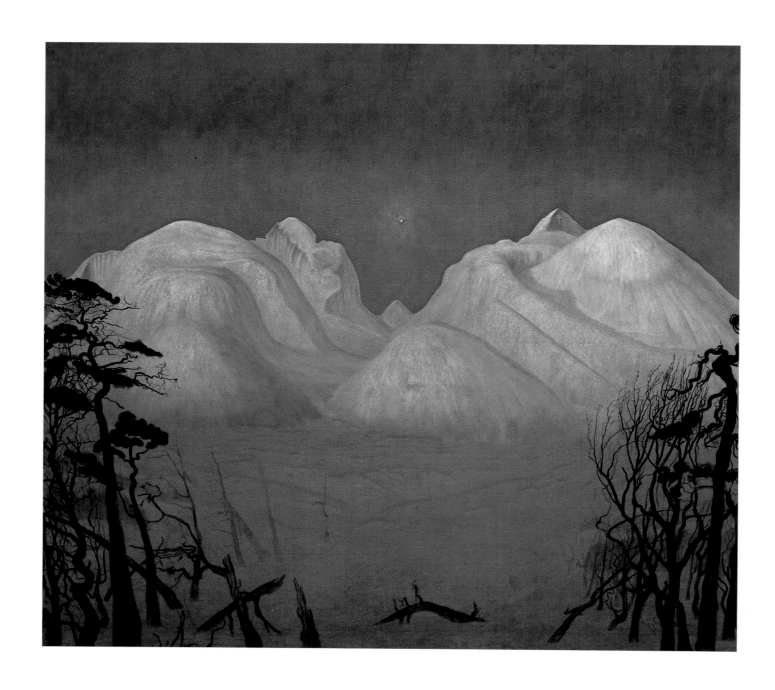

98
Winter Night in Rondane *1914*
Vinternatt i Rondane
160.0 x 180.0 (100 x 112½)
Nasjonalgalleriet, Oslo

Winter Night in Rondane, *vibrating with the icy intensity and stark drama of the remote Norwegian mountains, is Harald Sohlberg's most ambitious painting. A spontaneous decision to join a ski trip late in the winter of 1899 led him to his first confrontation with the Rondane mountains. At first sight, Sohlberg began a fourteen-year fascination with the motif, producing nine finished versions of Rondane, and a large body of sketches.*

His most concentrated on-site study was in the winter of 1900–1901, when he sat night after night, painting by the light of an acetylene torch and battling the cold to prevent his watercolors, and his hands, from freezing. The most important product of this first period is in Bergen (1901; Hilmar Reksten Collection). His wife fell ill during a 1902 trip to Rondane, and the Sohlbergs left the mountains for Røros. Returning to Rondane in 1911, Sohlberg began his final version, which he completed in his studio in time for the 1914 Norwegian Jubilee exhibition.

In a 1914 letter to the Oslo Nasjonalgalleriet purchasing committee, Sohlberg traced the development of the motif from a Naturalistic to a Symbolist interpretation. He initially saw a stately mountain range with a "peaceful" scattering of apple trees standing before it, suggesting a "mild and elegiac composition". As he worked on site however, he began to receive powerful impulses, leading to the mystical revelation he described in a letter of 1915:

"The longer I stood gazing at the scene the more I seemed to feel what a solitary and pitiful atom I was in an endless universe. I grew uneasy . . . it was as if I had suddenly awakened in a new, unimagined, and inexplicable world.

"The deep, long moor where I stood was bathed in a half light and mysterious shadow. I saw deformed, gnarled, and overturned trees, muted expressions of inconceivably strong forces of nature, of the night and rage of storms. Now all lay calm and still, the quietness of death. I could hear my own quick breathing.

"Before me in the far distance rose a range of mountains, beautiful and majestic in the moonlight, like petrified giants. The scene was the grandest and most full of fantastic quiet that I have ever witnessed.

"Above the white contours of a northern winter stretched the endless vault of heaven, twinkling with myriads of stars. It was like a service in a vast cathedral." (R. Nasgaard, The Mystic North, *1984, p. 110).*

To express the heroic quality of this revelation, he broke with his initial representational approach to the mountains (which at one point included skiers in the foreground), gradually working his composition into the rigidly symmetrical mass of mountain- and blasted tree-forms revolving around the central star. Other stars, once scattered across the sky, were gathered into constellations. The color, always reflecting a moody night palette, was refined to a pulsating field of blue, and applied with Sohlberg's characteristically fastidious, precise brushwork. As in Flower Meadow in the North *(cat. no. 97), he contrasted the simplified forms of the background against the detailed, rapid rhythm of the foreground – an essay in the opposition between the permanent and the transitory; the unobtainable peaks and the land below. The whole secret of his painting, he wrote, was in this opposition (ibid., p. 111), echoing the words of the early nineteenth-century Romantics Friedrich Leopold Novalis (1772–1801) and Wilhelm Heinrich Wackenroder (1773–1798).*

Like so many other members of his generation, Sohlberg looked back on the Northern Romantic tradition to help him formulate his ideas about nature mysticism and indigenous national values. Although he always contended that the cross at the top of the right-hand peak of Winter Night in Rondane *was a natural formation, its prominence, particularly in relation to the pivotal central star, clearly indicates a mystical intent. Leif Østby writes that Sohlberg's "Rondane is our Fujiyama; the only, holy, cross-marked mountain in Norwegian art." (Østby, 1936, unpaginated). To project the image of a "soaring cathedral", Sohlberg drew upon such images as C.D. Friedrich's* The Cross in the Mountains *(1808; Staatliche Kunstsamlungen, Gemaldegallerie Neue Meister, Dresden), which caused such a sensation at its 1808 exhibition. Neither Andreas Aubert's critical writings about Friedrich, nor the 1906 Friedrich exhibition in Berlin, could have escaped Sohlberg's attention. The use of this traditional Christian symbol was a convenient way for the Norwegian artist to transform the landscape into an icon.*

While mountain peaks were canonical subjects of the Norwegian Romantics J.C. Dahl and Thomas Fearnley, only Peder Balke (1804–1887) continued to explore this motif beyond mid-century. The renewed interest in indigenous Norwegian values of the mid-'90s revitalized this imagery, first in J.F. Willumsen's * Jotunheimen *(cat. no. 115) and Sohlberg's Rondane, and then in the work of Nikolai Astrup (1880–1928), Ferdinand Hodler, and in Edvard Munch's Nietzschian* The Human Mountain *(ca. 1906 and after). [PGB]*

LOUIS SPARRE

Finland 1863–1964

Count Louis Sparre was born at the Villa Teresita in Gravellona, Italy, of a Swedish father and an Italian mother. In 1875 he was sent to school in Sweden. Although he had originally intended to become an architect, after a year at Stockholm's Royal Academy of Fine Arts (1886–87) he went to study painting at the Académie Julian in Paris. There he met Paul Sérusier, Pierre Bonnard, and Maurice Denis, as well as a number of Scandinavian artists. One in particular, the Finn Akseli Gallen-Kallela* (then known as Axel Gallén), became a close friend and strongly influenced the direction of his work.

Sparre studied in Paris until the summer of 1889, when he travelled with Gallen-Kallela to Visuvesi and Keuruu in the backwoods border region of Finland called Karelia. He returned to Karelia the following year, joining Gallen-Kallela and his wife Mary Slöör on their honeymoon. In exploring both sides of the Finnish-Russian border, the three studied Karelian customs, utensils, and costumes. Sparre later wrote and illustrated a book about these trips entitled *Bland Kalevalafolket ättlingar* (1930, Porvoo).

In 1891 Finland became Sparre's adopted homeland. Settling close to Helsinki, in Porvoo, he married Eva Mannerheim, a bookbinding designer and the sister of the Finnish soldier and statesman Baron Carl Gustaf Emil von Mannerheim. The couple collaborated on such projects as an edition of Johan Ludvig Runeberg's *The Elk Hunters* (1892), for which Eva designed the leather binding and Louis provided the etchings. During Sparre's years in Finland, painting became secondary to him, as he became increasingly involved with decorative arts. He shared with Gallen-Kallela a passion for Finnish folk art, and together they worked to create a fine art based on these traditions.

In 1896 Sparre travelled in the Netherlands, Belgium, France, and England. The English Arts and Crafts Movement, especially William Morris's ideas on functional aesthetics, had a great effect on him, and in London he visited such centers of decorative arts as Liberty's. The following year he established the Iris workshop in Porvoo, with the stated intention of producing beautiful and functional furnishings in modernized versions of traditional Finnish designs.

In 1898 Sparre persuaded A.W. Finch, an important advocate of the Arts and Crafts Movement, to run the ceramics department at Iris. Finch, who had abandoned painting in 1890 to devote himself to decorative arts and was a founder of the Belgian group *Les Vingt*, provided the workshop with a more international element.

The establishment of Iris was pivotal to the development of both Finnish and Scandinavian decorative arts and design in the twentieth century. At the Paris World Exposition of 1900, the Finnish Pavilion included an Iris room that contained ceramics made by Finch and furniture designed by Sparre and Gallen-Kallela after traditional national forms and decorations. Critics praised Sparre's productions for combining naturalism and "honesty" with international elements and styles. Years later a French minister offered France's aid to Sparre's brother-in-law Baron von Mannerheim during the campaign for Finnish independence from Russia, explaining that he had been so profoundly impressed by the pavilion of 1900 that he had never forgotten Finland.

Like William Morris, Sparre never created for "the people" and never gave much thought to expense. By 1902 Iris was in such financial difficulties that it had to be closed. Although Sparre continued to design furniture and decorative objects until his

departure for Sweden in 1908, he devoted himself primarily to painting for the rest of his long life. [WPM/SSK]

99

First Snow *1891*
Ensi Lumi
90.0 x 111.0 (35 ½ x 43 ¼)
Signed lower left: "Louis Sparre/1891"
Ateneumin Taidemuseo, Helsinki

First Snow *was painted at Rimmi Farm in Ruovesi, on the shore of Lake Helvetinjärvi. The painting originally included a male figure outside the window and was entitled* Dinner. *Sparre's alterations to the scene, perhaps made in response to criticisms by his fellow Finnish artist Albert Edelfelt*, signaled his reorientation from Realist preoccupations toward a greater concern with mood and inner life.*

The scene appears to have been initially conceived, like Sparre's early paintings of the border area of Karelia, as a quasi-documentary study of the crafts and customs of the Finnish peasantry. However, in eliminating the more legible narrative of the first version, and in concentrating on the foreboding of winter's onset, Sparre focused not on external aspects of the culture but on the psychological resonances of life lived close to the rhythms of nature.

At the beginning of the long winter, in an oppressively dark interior, the family members are shown not huddled together for mutual support and security, but withdrawn into separate cells of stunned silence. The subject of death in nature's cycle, the breakdown of interpersonal communication, and the concentration on the alienating privacy of instinctual inner states mark First Snow *as a departure from the more straightforward enthusiasm with which Sparre and his countryman Akseli Gallen-Kallela* first approached rural life.* [WPM/SSK]

AUGUST STRINDBERG

Sweden 1849–1912

Best known for his writings, August Strindberg earnestly pursued two other vocations throughout his life: scientific research and art. His scientific activities were not taken seriously at the time, nor has any posthumous reassessment challenged this initial judgement. Strindberg's artistic efforts are however a different matter. Although he met with little critical or financial success, Strindberg exhibited publicly on several occasions. After decades of neglect following his death, the paintings have recently attracted the attention of scholars. Many now view Strindberg not as an inept, zealous amateur, but as an innovative genius, whose works seem prophetic in light of the development of American Abstract Expressionist painting in the 1950s.

Strindberg, the third of seven children, was born in Stockholm to Carl Oscar Strindberg, a shipping agent, and his wife Ulrika, née Norling. He entered Uppsala University in 1867, where he studied medicine and embarked on his stormy literary career. While details of his life appear frequently in his letters and autobiographical plays and novels, facts are often difficult to separate from fiction. Strindberg integrated experienced events with imagined incidents (e.g. unfaithfulness of his wives, persecution by the public), a habit of mind which provided a constant source of misery to those around him.

Strindberg's first known oil painting, *Ruin based on Castle Tulborn in Scotland where Mary Stuart was Imprisoned* (*Ruin efter slottet Tulborn i Skottland der Maria Stuart var fengslet*, Private Collection), was painted in February 1872. Since the fall of 1870 he had demonstrated an interest in drawing and had amused his friends with his aptitude for caricature. Strindberg often turned to painting in moments of stress. This was the case in the fall of 1872. Strindberg had spent the summer in a rented house on Kymmendö in the Swedish archipelago writing *Master Olof*, which he hoped would establish his reputation as a promising new playwright. He received occasional negative reports, and the Royal Theater finally rejected the play in November.

Strindberg took up his brush again in 1874, the year he made his debut as an art critic. He especially favored the young rebels who would form the Artists' Union and wrote reviews and articles supportive of them until he abandoned criticism in 1883. Strindberg's own works from this period show the influence of Per Ekström (1844–1935), a proponent of French Naturalism, particularly in their sensitive rendering of moonlight.

In the fall of 1883, Strindberg, along with his first wife, Siri von Essen, and their two daughters, left for Grèz-sur-Loing – beginning what would be for him fifteen years of transience. Over the next few years, he associated with the Scandinavian colony in Paris and concentrated on his writing.

Strindberg returned to Stockholm in the spring of 1891. Separated from his family (divorce was imminent), he turned his attention to painting. He accompanied Ekström on frequent sketching expeditions and spent the summer alone in his beloved archipelago. Strindberg's feeling for nature, as for all else, was intense, hallucinatory at times. Like the English Romantic painter Joseph Mallord William Turner (1775–1851), Strindberg maintained that one should paint nature, not from sight, but from memory. The objective was not truth to nature, but fidelity to one's unique perception of it. Strindberg adopted a method similar to Turner's; he explored the island by day and drew by night. It was also during this time, in the new summer colony of the Op-

ponents on Dalarö, that Strindberg learned to sculpt. The plasters that survive include a portrait bust of Hanna Palme and a genre peice entitled *The Weeping Boy (Den gråtande gossen)*.

Strindberg painted a group of about thirty works while staying in the archipelago during the summer of 1892 and tried unsuccessfully to sell several at an exhibition held that fall in Stockholm. During this period, he devoted himself to painting and the pursuit of Frida Uhl, whom he married in April 1893. He and his new friends Edvard Munch* and Stanislaw Przybyszewski formed the core of an artistic circle which frequented the cafe *Zum Schwarzen Ferkel*. With his marriage to Frida disintegrating, Strindberg left for Paris in the summer of 1894. Although channelling his creative energy into useless scientific experiments, Strindberg maintained contact with the art world and met Paul Gauguin (1848–1903), whom he saw almost daily for several months.

In February 1897, Strindberg returned to Sweden, where he remained, with brief absences, until his death. With unabated energy, Strindberg's last years were spent assuring the publication of his collected writings, re-establishing a close relationship with the children of his first marriage, and actively supporting socialism. [MF]

Joseph Mallord
William Turner
Snow Storm 1842
Tate Gallery,
London

August Strindberg
The Night of Jealousy 1893
The Strindberg Museum, Stockholm

237

100
The Night of Jealousy 1893
Svartsjukans natt
41.0 x 32.0 (25⅝ x 20)
The Strindberg Museum, Stockholm

Strindberg presented The Night of Jealousy *to the twenty-one-year-old Frida Uhl as an engagement present upon her return in late March from a visit to her parents in Vienna. The subject of the painting relates not to his fiancée, but rather to Dagny Juell, a Norwegian music student, whose blithe spirit and espousal of free love captivated the regulars of Zum Schwarzen Ferkel. Her first romance in the group had been with Edvard Munch*, who was replaced by Strindberg during Frida's absence from Berlin. Dagny ultimately married Przybyszewski, a commitment which did not hinder her amorous intrigues.*

Although Strindberg was just as fickle as Dagny, he was highly critical of her behavior. In this painting, Strindberg expresses his passionate feelings for her. It bears a close resemblance to the seascapes Strindberg executed in 1892 and was painted purely from his over-wrought imagination. In this sea-borne tempest one sees neither horizon, nor ship, nor any stable point of reference. Strindberg had long been fascinated by the vastness and power of the sea, and thought often and longingly of the archipelago, his spiritual home. His concern with describing marine conditions emerges in his writings as well, particularly in The People of Hemsö *(1886) and* In the Outer Skerries *(1890).*

The painting is signed "from the painter (the Symbolist) August Strindberg". In his characteristically egomaniacal manner, Strindberg viewed himself as the originator of Symbolism in painting. Nonetheless, he did not adopt a consciously Symbolist technique. Strindberg's method consisted in an initial haphazard application of oil paint with a palette knife, whose configuration would suggest the composition; he surrendered his hand to subconscious forces.

Strindberg's seascapes have often been compared to Turner's, which he could have seen in great numbers during his May 1893 honeymoon in London. While both men are best remembered for their turbulent seascapes, the unfailing sense of structure and deeply resonant luminosity, ever-present in Turner's "vortex" compositions, are rarely found in the works of Strindberg. [MF]

101
Coastal Landscape 1903
Kustlandskap
77.0 x 55.0 (48⅛ x 34⅜)
Nationalmuseum, Stockholm

In October 1903, Strindberg began a series of tranquil seascapes, first in a vertical format, as seen here, and later in a horizontal format. These were inspired by his daily morning walks from his apartment on Karlavägen to Djurgården, a park island nearby. Strindberg's return to Stockholm and his residence at this address for seven years express the relative success and serenity he enjoyed in his last decade. October was a somewhat melancholy month for Strindberg: he was estranged from his third wife, the twenty-five-year-old actress Harriet Bosse, and their child; and an Austrian philosopher and fellow misogynist whom Strindberg greatly admired, Otto Weininger, committed suicide.

Strindberg presented this painting along with his 1901 Ocean Sunset (Sol går ned uti hav) *as a gift to Harriet, with whom he remained infatuated, even after their 1904 divorce. The low horizon and broad expanse of sky endow this painting with a stability and quiescence seldom found in earlier works.* Coastal Landscape *is the work of a highly responsive artist who, in his autumnal years, has discovered the sea, not simply as a force of destruction but also as a source of consolation. [MF]*

ELLEN THESLEFF

Finland 1869–1954

In Finland during the latter decades of the nineteenth century, women artists could pursue their careers without the strictures that were still prevalent, for example, in the French academic system. As a result, Ellen Thesleff's career began like that of most Finnish artists of her generation. Her earliest instruction was at Adolph von Becker's academy from 1885 to 1887, followed by two years of study at the Finnish Artists' Association. Dissatisfaction with the limits of academic training led her to private instruction at the art school of Gunnar Berndtson (1854–1895), where from 1889 to 1891 she was introduced to the principles of French Naturalism and *plein-air* painting that Berndtson had assimilated in Paris during the 1880s.

Thesleff studied in Paris at the Académie Colarossi under Gustave Courtois and Pascal Dagnan-Bouveret from 1891 to 1893. As early as 1892, in the painting *Thyra Elizabeta* (Private Collection, Helsinki), she began to gravitate towards Symbolism, perhaps under the influence of the Finnish painter Magnus Enckell (1870–1925), who seems to have been the spiritual leader of the young generation of Finnish-Swedish artists then in Paris. Parisian mysticism, particularly the ideas of Sâr Péladan and Édouard Schuré, were of great importance to her at this time. She admired the murals of Pierre Puvis de Chavannes, Leonardo da Vinci, and Sandro Botticelli, and the black and gray tonality of Eugène Carrière, in her development of a monumental decorative style which, like that of her countrywoman Helene Schjerfbeck*, was not in the service of National Romanticism.

In 1894 Thesleff travelled to Italy, which she would later refer to as her spiritual homeland, and to which she returned frequently throughout the early twentieth century. Influenced by the Swiss painter Arnold Böcklin and by the work of the Quattrocento Florentine masters, her art developed a refined color lyricism. Although she began to introduce greater color contrast and freedom into her landscapes after 1910, her portraits retained the ascetic tonality, the values of balance and permanence, that she had embraced in the 1890s when Symbolism first led her to a harmonious Classicism. [SMN/SSK]

102

Spring Night *1894*
Maisema, Kevätyö
38.0 x 46.5 (15 x 18¼)
Signed lower left: "E.T./94"
Ateneumin Taidemuseo, Helsinki

Spring Night, *a small landscape painted near the artist's summer house in rural Finland, was shown at the 1894 Exhibition of Finnish Artists, which introduced Symbolism to the Finnish public and also included Akseli Gallen-Kallela's* Symposium *(cat. no. 26). Painted after Thesleff's years in Paris under the influence of James McNeill Whistler, Pierre Puvis de Chavannes, and French Symbolism,* Spring Night *begins to move from the description of a fragment of nature to an overall evocation of mood.*

As in Kitty Kielland's After Sunset *(cat. no. 53), the treatment of landscape has become more synthetic and less a transparent depiction of reality. Motivated by a feeling of great intimacy with nature, Thesleff renews the spirit of Romanticism with her personal expression of the mood of awakening spring. The silvery gray harmonies of the quiet and deserted landscape resonate with mysterious light, against which the dark tree branches form a screen of delicate, yet emphatic verticals connecting foreground and background.*

The subtle nuances of tone and form and the use of an evening motif were common in the idealistic mood landscapes of the 1890s in Finland. A similar type of lyrical landscape painting, based on a yearning to be close to the land, occurred throughout Northern Europe at this time, particularly in the German artists' colonies in Worpswede and Munich. [SMN]

242

103
Violin Player *1896*
Viulunsoittajatar
40.0 x 43.0 (15¾ x 17)
Signed lower right: "E. Thesleff 96"
Ateneumin Taidemuseo, Helsinki

The Mediterranean idealism embraced by Sâr Péladan in his reviews of the Paris Salons in the 1880s and in his creation of the Rose + Croix Salon *in 1892 called for "beauty, nobility, and lyricism." In response to this Classicizing impulse in French Symbolism, Ellen Thesleff painted* Violin Player *in 1896, two years after her first journey to Italy. As did her contemporaries Pekka Halonen* and Magnus Enckell, Thesleff often used the motif of the violin player during this period, particularly in her portraits of her sisters. This motif recalls the Symbolist notion of correspondence between the visual arts and music. The image of a woman lost in the music of her violin also suggests the later nineteenth-century association between sound and the inner consciousness.*

The Violin Player *is closest to the Intimist themes and soft modelling of Eugène Carrière. By the end of the 1880s Carrière had evolved from Naturalism and was focusing his attention on monochromatic mists. His reintroduction of* sfumato *drew praise from critics and created a sense of mystery in the dissolution of form which greatly appealed to the younger generation of Finnish painters. Although Thesleff renounced color in* Violin Player, *the refined contours of the figure still emerge from the shadowed and generalized ground in a manner reminiscent of Carrière's belief that art should reflect, through the harmony of lines and colors, a more elevated spiritual reality. [SMN/SSK]*

THÓRARINN B. THORLÁKSSON

Iceland 1867–1924

Thórarinn B. Thorláksson, who became his country's pioneering artist, lived in northern Iceland until he moved to Reykjavik in 1885. There he studied bookbinding and from 1887 to 1895 served as head of a bookbinding factory. Though professional painters were unknown in Iceland at that time, he attended drawing classes with Thóra Pétersdóttir Thoroddsen and in 1895 travelled to Copenhagen to begin studies at the Danish Royal Academy of Fine Arts. He later left the academy to study in the private school of Harald Foss (1843–1922), a landscapist who worked in the tradition of Danish painting of the 1840s. Upon his return to Reykjavik in 1900, he had his initial showing, the first exhibition by an Icelandic artist ever held in Iceland.

In 1903 Thorláksson married Sigrídur Snaebjörnsdóttir. He began to teach drawing in 1904 at the newly founded technical school and served as headmaster from 1916 to 1923. From 1912 on he also owned a book and stationery shop. Meantime he was active in promoting his art and the art of his countrymen, both at home and abroad. In November 1910 he and Ásgrímur Jónsson* participated in an exhibition at Blomqvist's in Christiania: Thorláksson showed eighteen works; Jónsson, fourteen. With Matthías Thórdarsson, the director of Iceland's National Museum, Thorláksson founded the Art Association (Listvinafélag) in Reykjavik in 1916. He was also instrumental in the establishment of Listvinahús, the first exhibition hall in Iceland. Although the still Icelandic landscape provided him with subject matter for the majority of his works, he painted interior scenes, still lifes, and portraits as well. [RH/BN]

104
Woman at a Window *1899*
Kona vid glugga
61.0 x 61.0 (24 x 24)
Not signed
Mrs. Laufey Snaevarr, Reykjavik

Part of a long tradition of views of an artist working by a window, this canvas is both a study of a particular artist and a statement about the practice of art. Although the sitter has not been identified, her highly individualized features suggest that the painting must be a portrait. Thorláksson places the young woman in an environment that is not only believable but also one that allows him to create an academic "presentation piece" – a demonstration of his own artistic abilities and an inventory of the arts of drawing, sculpture, and architecture.

Thorláksson skillfully portrays delicate effects of backlighting and the interposition of atmosphere. He includes the human figure, landscape elements, still life, and drapery, and depicts the varied textures of skin, hair, wood, paper, leaves, cloth, and crockery. There is also opposition between interior and exterior: the warm tones of the room versus the grayed tones of the snowy world outside; the green, cultivated ivy versus the gray branches of the trees beginning to bud. The woman's soft features are silhouetted against the light and are contrasted with the cast of a satyr hung casually upon the window frame. (Copied in academic drawing classes to teach representation of light and shade, plaster casts of sculpture were common artists' tools.)

The picture bears the strong imprint of Danish art in its air of bourgeois domestic well-being and contrasts sharply with Thorláksson's landscape work in Iceland. [RH/BN]

105
Thingvellir *1900*
57.5 x 81.5 (22⅝ x 32)
Signed and dated bottom left corner
Listasafn Íslands, Reykjavik

Painted in 1900, this view of the grassy lava plain of Thingvellir was shown the same year in Thorláksson's exhibition in Reykjavik (see review, "Myndasýning," Ísafold, December 19, 1900, p. 311). Here Thorláksson employed the structures of Danish painting he had learned under Harald Foss, who had been a pupil of Vilhelm Kyhn (1819–1903) and had worked with Peter Christian Skovgaard (1817–1875). The diagonal body of water receding into space and the relatively flat plain with a row of hills in the background would seem to indicate that he had absorbed the conventions of Skovgaard's paintings of the Jutland landscape. However, the suppression of detail, the moody lighting effects, and the boxlike church and parsonage seem quite removed from both the Danish landscape tradition and from Thorláksson's own minutely rendered interior scenes. These elements may have their sources in his early work and in the native Icelandic amateur style of Jon Helgason (1866–1942) or Thorsteinn Gudmundsson (1817–?).

Thorláksson painted this site many times from different viewpoints. In this depiction the dim lighting, the virtual dissolution of the background hills in atmosphere, and the stillness of the two Icelandic horses impart a mystical quality to the rather ordinary landscape. Approximately thirty miles from Reykjavik, the Thingvellir lava plain is of paramount importance in Icelandic history. In the year 930, chieftains of each local assembly or thing gathered there to adopt a uniform code of law and to establish a national assembly or Althing. For the next four hundred years – until Iceland was annexed first by Norway, then by Denmark – the Althing convened at Thingvellir for two weeks each June.

Thorláksson's interest in Thingvellir as a subject for his painting unites him with the contemporary nationalistic concerns of other Scandinavian artists. During the nineteenth century Iceland's position as a colony began to change. Early in the century the original Althing, then defunct, had become a symbol of Iceland's Golden Age and its lost independence (Ólafur Grímsson; quoted in biblio, ref. no. 55, p. 20). In response to petitions by the Icelanders, the king of Denmark in 1874 granted a constitution, sharing his power to govern Iceland with the reinstated Althing. Thereafter, part of each annual session of the Althing was devoted to consideration of constitutional revisions that would permit Iceland even greater independence. Revisions were passed by both chambers in 1885, '86, '93, and '94, but were vetoed by the Danish king (biblio ref. no. 51 p. 426). Thorláksson surely would have known that the site he chose in 1900 was associated with this struggle and that it was the birthplace of the world's oldest parliament. [RH/BN]

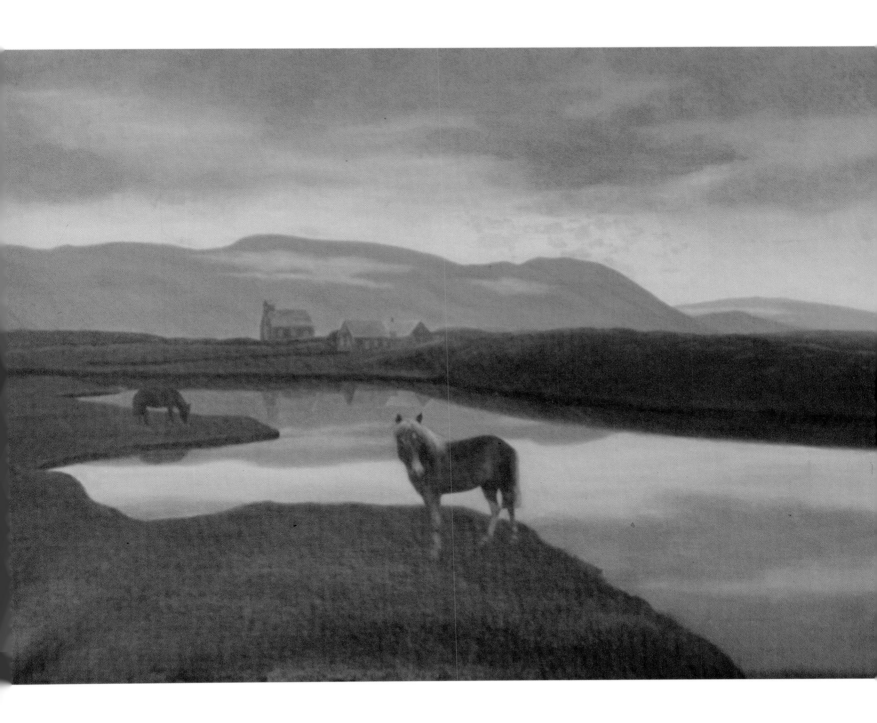

248

106
Eyjafjalla Glacier *1903*
Eyjafjallajökull
93.0 x 120.0 (36⅝ x 47¼)
Signed and dated bottom left corner
Hilmar Gardars, Seltjarnarnesi

*The major part of Thorláksson's oeuvre is devoted to calm
meditation upon the variety and mystery of the Icelandic
landscape – its volcanoes, glaciers, fjords, meadows, lava
fields, and "lunar" plateau lands. He experimented with
different viewpoints, depicting the landscape directly from
eye level, from behind a screen of vegetation, or from an al-
most bird's-eye view.*

*In this painting he portrays the Eyjafjalla glacier in
southern Iceland from the vantage point of a high mountain
ridge looking across a valley. The spectator is set down upon
a shelf of rough lava-formed clumps of earth covered with
grass. At the center of the green expanse, a wedge-shaped
area of smoother ground forms a path that leads to the right
and down the side of the cliff. Opposed to the lush fore-
ground is the barrenness of the mountain in the back-
ground. Though the picture is convincing as a topographical
description, Thorláksson has also suffused the mountain
with atmosphere, endowing it with a velvety surface and
emphasizing the ragged shapes that form the border of the
glacier. [RH/BN]*

NILS GUSTAV WENTZEL

Norway 1859–1920

Nils Gustav Wentzel was recognized as one of the most gifted Naturalist painters of his generation. In 1880, when the conservative Christiania Art Association rejected Wentzel's first submission, his defenders Erik Werenskiold* and Frits Thaulow organized the Norwegian artists' rebellion that led to the first annual Artists' Autumn Exhibition in 1882.

Wentzel was born into a long and venerable line of craftsmen. His father was a carpenter, and for several generations the Wentzels had been glassblowers. Gustav, assuming a bricklayer's apprenticeship in 1875, hoped eventually to become an architect. A sudden change of heart in 1879 led to his enrollment in Knut Bergslien's studio and the Royal Academy of Drawing, where he developed the detailed interior genre painting that established his reputation.

Wentzel took his first trip to Paris in the spring of 1883, later attending Thaulow's "Open Air" academy in Modum. In the autumn he settled into the bohemian milieu of sculptor Rolf Skjeft's Christiania studio, where the young generation of Norwegian Naturalists, including Edvard Munch* and critic Andreas Aubert, congregated.

Wentzel returned to Paris in the following year, studying under William Bouguereau and at the Académie Julian. He made a third trip to the French capital on a government grant in 1888, and the following May, while studying there under Alfred Roll and Léon Bonnat, he married Christiane Marie (Kitty) Baetzmann.

Back in Norway in 1890 Wentzel was swept into the Neo-Romantic movement, shifting his vision from interior genre to Whistlerian landscape painting. With the exception of two extended periods of travel – to Germany, Italy, and France in 1901–02, and to Germany in 1910–11 – he and his wife isolated themselves in the remote southern districts of Telemark and Hardanger, where Wentzel had first travelled in 1880. To offset his poverty during these years, he mass-produced second-rate snow scenes, leading to a decline in his reputation. He moved to Lom, near Vågå, in 1911 and died there nine years later. [PGB/OT]

107
Breakfast I *1882*
Frokost I
100.5 x 137.5 (39½ x 54⅛)
Signed lower right: "N. Gustav Wentzel/Kristiania 1882"
Nasjonalgalleriet, Oslo

Wentzel painted Breakfast I *during the one-year interval between his formal study in Christiania and his initial trip to Paris. Recording a Christiania working-class interior with the scrupulous eye of an ethnographer, he organized the space into a continuous suite of still-life arrangements. He utilized a Balzacian narrative method of atmospheric Realism, the rich accretion of mundane details, to define the interior environment and its inhabitants. It has been suggested that the setting is his parents' home.*

Wentzel's orchestration of two rooms filled with characteristic detail reflects his interest in seventeenth-century Dutch interiors. The window shade in the far room, decorated with an image of Our Savior's Church in Christiania, allows light to filter through the window while impeding access to the outside. Within this comforting enclosure, the figures are intent upon their mealtime preoccupations: the woman cuts bread, the child eats, and the husband retires to the adjacent room, his back partially visi-

All of the objects in this tight interior, painted in a German academic style, speak of daily use by the family: the beaten copper kettle, the rumpled daybed, the worn bathrobe, and the child's coat and hat. The room, once

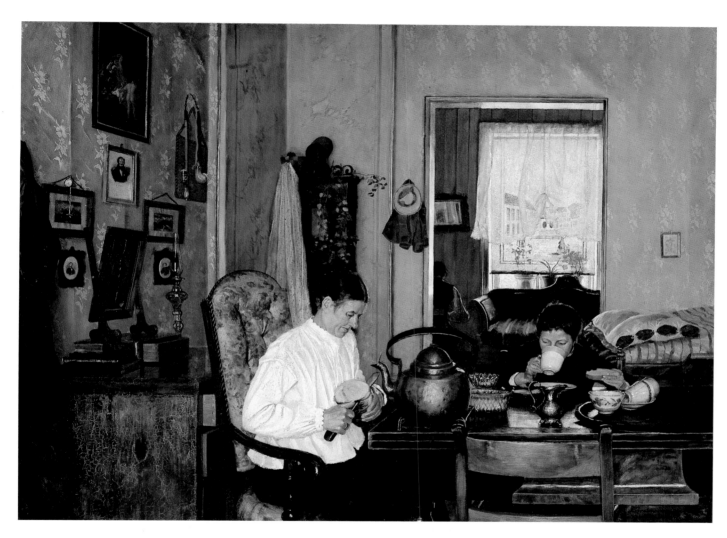

well appointed with elegant lavender-and-gilt wallpaper and mahogany furniture, now suffers from neglect. The portrait and landscape paintings surrounding the cracked mirror to the left have become convenient resting places for the man's pipes and pocket watch, rather than objects of aesthetic value.

Breakfast I *was the pinnacle of Wentzel's early Realist style. After his second trip to Paris he painted* Breakfast II, originally entitled Morning Mood *(1885; Nasjonalgalleriet, Oslo), a recapitulation of the earlier composition. Rather than defining the environment through its details, he celebrated the nuances of light, suggesting the influence of James McNeill Whistler and Claude Monet. The Impressionist-inspired second version earned him a second-class medal in the Paris World Exposition of 1900.* [PGB/OT]

ERIK THEODOR WERENSKIOLD

Norway 1855–1938

Erik Theodor Werenskiold was born into a culturally and politically aware family in 1855 in Eidskog. The fourth of six children, Werenskiold first learned to draw from his mother while studying with a tutor at Kongsvinger Fort where his family moved in 1859. He began his academic studies aged fourteen in Christiania, enrolling in the Royal Drawing Academy four years later under Christian Brun, Julius Middelthun, and Axel Ender. In 1875 Werenskiold met Adolph Tidemand, by then an "old master", who advised him to travel to Munich.

In April of 1876 Werenskiold moved to Munich, enrolling in the classes of Ludvig Løfftz (1845–1910) and in October, of Ludvig von Lindenschmit (1809–1893). In the following two years he met the folklorist P. Christen Asbjørnsen and began his lifelong involvement with fairytale illustration. In 1879 he published his first book of illustrations, *Norske Folke- og Huldre Eventyr i Udvalg*, long considered the first reliable pictorial representation of Norwegian folk life. In the same year he saw the French exhibition in Munich, proclaiming to his comrades that Munich was dead, and enjoining them to travel to Paris.

Following a lengthy sojourn in Switzerland, Werenskiold moved in 1881 to Paris, where he met the dealer Theo van Gogh, and developed close friendships with the Scandinavian writers and painters living in France. He divided his next four years between Paris and Norway, returning again in 1888 to study with Léon Bonnat. Werenskiold spent the summer and early fall of 1886 with Harriet Backer*, Kitty Kielland*, Eilif Peterssen*, Gerhard Munthe*, and Christian Skredsvig* at Skredsvig's farm at Fleskum.

Throughout the early years of the '80s, Werenskiold led the progressive artists' struggle against the oppressively conservative Kunstforeningen in Christiania, organizing the artists' strike, with Christian Krohg* and Frits Thaulow, that resulted in the collectivist activities of the Kunstnerforbundet and the establishment of the important annual Autumn Exhibitions in 1882. He later published a chronicle of these heroic years of struggle, entitled *Kunst. Kamp. Kultur.* (1917, Christiania).

Beginning with the Asbjørnsen illustrations, Werenskiold produced a prodigious body of folk- and fairytale illustrations, including *Children's Adventure Stories* (1884–85) in collaboration with Theodor Kittelsen (1857–1914), Jonas Lie's *Familien på Gilje* (1883), and *Snorre Sturlason's Sagas* with Gerhard Munthe* and Christian Krohg* (1899). In 1895, Frits Thaulow put him in touch with Sergei Diaghilev, the legendary organizer of the Ballets Russes, who travelled to Norway in 1897 to meet him. Internationally, Werenskiold was viewed as the quintessential Norwegian artist, and Diaghilev was anxious to have him organize a Scandinavian painting exhibition in St. Petersburg.

After the turn of the century, Werenskiold travelled widely. An introduction to Cézanne's painting in Paris in 1906 stimulated his experimentation with new techniques and forms. In 1908 he pulled his first etchings, and in 1918, his first lithographs. Erik Werenskiold died in Oslo in 1938, still regarded by younger Norwegian artists as a vital force in their community. [PGB]

108
On the Plain *1883*
På sletten
81 x 100 (50⅛ x 62½)
Göteborgs Konstmuseum

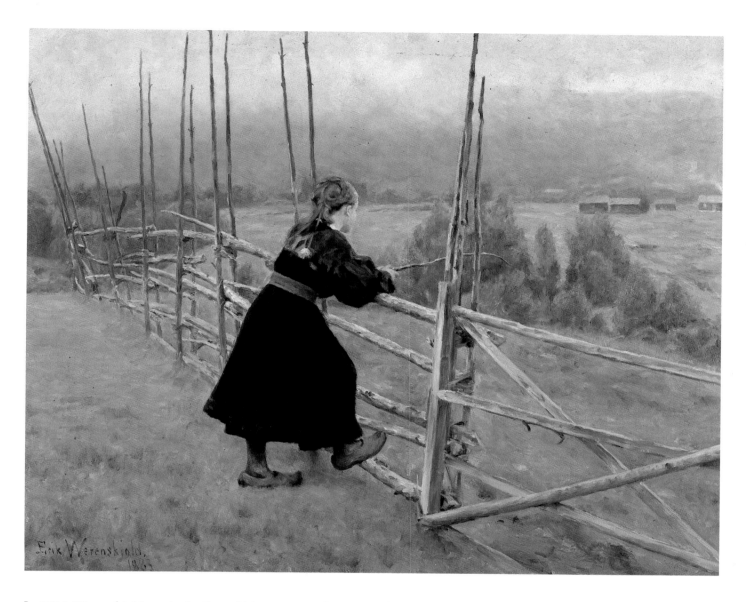

In 1874, Werenskiold made the first of his many "study" trips into the Norwegian mountains. During his years abroad, he invariably returned to the mountains for renewal and inspiration. He and his family arrived home from Paris on June 17, 1883, and settled in Gvarv, in Telemark, one month later. His wife's uncle, a local district magistrate, arranged for the Werenskiolds to move into a neighbor's farm, Lindhem (Leif Østby, in Erik Werenskiold 1855–1938, ex. cat., 1985, p. 34). There, he painted some of his best known compositions, including two nearly identical versions of On the Plain (Göteborg; and Private Collection, Norway).

The idea for the painting evidently stems from Werenskiold's Munich period: a notebook from the Scan-dinavian Society in Munich (Oslo, Nasjonalgalleriet) includes a sketch for a girl standing beside a skigard (the diagonally slatted rustic fence used throughout Norway) (ibid.). The work of Adolph Tidemand (1814–1876), the Romantic chronicler of Norwegian rustic culture, was the starting point for this image. Tidemand favored the mountains of Telemark, a region believed to be culturally pure by contemporary ethnologists. As Asbjørnsen and Moe documented and preserved the rich oral traditions of this region, Tidemand created such picturesque peasant dramas as By the Deathbed (1860; Oslo, Nasjonalgalleriet), replete with all the material trappings of rustic culture. Werenskiold rejected Tidemand's anecdotal approach, instead exploring the tenor of farm life – its moods and psychological character.

We view the Telemarkian girl in On the Plain *from behind as she leans against the fence. She participates in nature's dreamy mood suggested by the fog-shrouded hills. Viewed close-up and painted in the muted tones of the artists' colony at Grèz-sur-Loing, she is the Norwegian cousin of Jules Bastien-Lepage's French peasants.*

The model, most likely one of the Lindhem daughters, is dressed in the bunad *(native costume) of her region in Telemark. The* bunad, *which differs in style from region to region in Norway, is used only on festive occasions, such as weddings or christenings. Each of its details is strictly governed to communicate region, marital status, etc. With the growth of the folk dance movement and general interest in native culture in the late nineteenth century, the interest in* bunads *grew. Considered the last link with the development of native dress, local antique* bunads *were copied and reconstructed by special committees. In part, Tidemand's resurrection of these costumes in the 1840s and '50s inspired this movement. Tidemand copied antique costumes to give his paintings authenticity. Werenskiold used the* bunad, *as well as the* skigard, *to give the daydreamer, poised on the brink of adolescence, geographic specificity.*

Like Christian Skredsvig's The Willow Flute *(cat. no. 92),* On the Plain *became an icon of the 1880s, and was immediately popular in Norway and abroad. It was exhibited at the 1883 Paris Salon, at which the French critics praised Werenskiold's exquisite rendering of light and atmospheric effects.* On the Plain *was also exhibited at the 1884 World Exposition in Brussels, and in 1886, in Copenhagen. A drawing after the painting was published in the* Gazette des Beaux-Arts *(Paris, 1885),* Norden *(Copenhagen, 1886–87), and* Skilling Magazin *(Christiania, 1888). The drawing in* Norden *inspired Jonas Lie's poem, "I Taage" ("In Fog").*

In 1885, Werenskiold painted his best-known version of this motif, with two figures, which was exhibited at the second Autumn Exhibition under the title, September. *The Oslo National Gallery's purchase of the painting the following year honored Werenskiold as the third artist of the Naturalist movement, after Frits Thaulow and Eilif Peterssen*, to enter its permanent collection.* [PGB]

109

Peasant Burial *1883–85*
En bondebegravelse
102.5 x 150.5 (64 x 94)
Nasjonalgalleriet, Oslo

Werenskiold began Peasant Burial *during the summer of 1883. A more ambitious composition than* On the Plain, Peasant Burial *was completed over the following two summers at Lindhem. A large number of studies, including carefully rendered portraits of each of the models, are associated with the painting. Like* On the Plain, *the motif fuses Norwegian and French influences, echoing Werenskiold's early preoccupation with the picturesque Norwegian genre painter Adolph Tidemand. Werenskiold's French "conversion" at the 1879 exhibition in Munich drew him to Paris, and to his new idols, Gustave Courbet and Édouard Manet. Returning to Norway and creating* Peasant Burial, *Werenskiold declared his affinity with the French Realists, and his intention to "paint the everyday".*

Courbet's Burial at Ornans *(1849; Louvre, Paris; see illustration) directly inspired* Peasant Burial. *Werenskiold avoids Courbet's radical pictorial strategies – the reduction of aerial perspective and foreshortening, disjunction between fore- and background, and sense of psychological isolation – instead depicting a carefully observed landscape panorama. Like Courbet, Werenskiold believed death to be a natural rather than a transcendental experience, and adopted his unrhetorical, unsentimental rendering of the funeral scene. Werenskiold reduces the number of participants from Courbet's community portrait of his hometown, Ornans, and strips them of their sober Dutch and Spanish references by placing them in bright daylight.*

Because no clergyman is available, the local schoolmaster reads the funeral oration in Peasant Burial. *His audience, dressed in their well-worn Sunday finery, listen with varying degrees of absorption. Blinking in the light of the powerful midday sun, the rustic Norwegians express no overt sorrow. Their stoicism and acceptance of death are seemingly the result of brutalizing farm life in the moun-*

Gustave Courbet
Burial at Ornans 1849
31.4x66.5
Paris, Louvre

tains. The inevitable cycle of birth and death is symbolized by their range of ages, and by the undramatic growth of foliage on the crosses in the background graveyard. Werenskiold, a master portraitist, carefully records the postures and idiosyncracies of his models, including the young boy's unconscious emulation of his father's stance.

Peasant Burial *was intended as a tour-de-force landscape painting, rendered entirely in situ, as well as an eth-* nographic study and a paeon to native values. The French critical community applauded the painting at the 1889 Universal Exposition, for its brilliant rendering of landscape and atmospheric effects, and for its genuineness. Peasant Burial *was purchased by the Oslo National Gallery directly from the 1885 Autumn Exhibition, where it was immediately regarded as Werenskiold's masterpiece. [PGB]*

CARL WILHELMSON

Sweden 1866–1928

Carl Wilhelmson was born in Fiskebäckskil, a fishing village in the Bohuslän region on the Swedish coast. In 1875 his family was reduced to poverty when his sea-captain father drowned. At the age of fifteen, he moved to Göteborg, a prosperous port, where he worked as a lithographer and later entered the Valand art school, studying under Berndt Lindholm (1841–1914) and Carl Larsson* (1853–1919).

In 1890, Wilhelmson moved to Paris, where he stayed for five years and supported himself by working as a mechanical draftsman. He was particularly impressed by the work of Paul Gauguin and Georges Seurat, and he took classes in the studios of Jules Lefebvre, Tony Robert-Fleury, and Benjamin Constant. He returned to Sweden every summer during these years, and in 1896 settled in Göteborg. From 1897 to 1910 he taught at Valand.

Although Wilhelmson's themes were predominently Scandinavian, he made study trips to Spain in 1910, 1913, and 1921, and visited England in 1924. In 1910 he moved to Stockholm, where in 1912 he opened his own school of painting. He became a professor at Stockholm's Royal Academy of Fine Arts in 1925 and was named a member in 1928. He died in Göteborg. [ADG/GCB]

110

Scene from the Swedish West Coast *1898*
Vid västkusten
41.5 x 33.0 (26 x 20⅝)
Göteborgs Konstmuseum

Too poor to pay for adult models, Wilhelmson relied primarily on children and on women who could afford the time to sit for him. His sister posed for this painting, executed during the summer of 1898 in Fiskebäckskil, where he lived with her and their mother. Wilhelmson devoted his early efforts to interior scenes of domestic activity and prayer; this represents one of his first plein-air paintings of an idle figure. While studying at the Académie Julian in Paris, Wilhelmson learned the principles of this Impressionist method. His purpose here was not merely to record visual sensations, but to evoke a mood expressive of the earnest and unpretentious coastal life.

Tastefully dressed, the woman seems out of place in such humble surroundings. Her pensive gaze, barely visible beneath the wide brim of her fashionable hat, indicates that her thoughts have drifted away from the book now lying in her lap. She adopts the conventional pose of someone absorbed in contemplation: leaning forward, her chin rests unselfconsciously on her hand, while her elbow rests on her thigh. By placing the figure off-center, Wilhelmson establishes a strong contrast between the woman seated in shadow and the expansive, sunny landscape, where fishermens' cottages appear on the far bank of a calm and shimmering sea. The tranquility of the water emphasizes the disturbing psychological attitude communicated by the figure's posture and mien. This is intensified by the odd cropping, which draws the viewer into an almost uncomfortable physical proximity to the incognizant sitter. Within this moody scene of Symbolist interiority, Wilhelmson conveys an impression of the slow pace of life in Fiskebäckskil and the dependence of its inhabitants on the sea. [MF]

111
Fisherwomen Returning from Church *1899*
Fiskarkvinnor på väg från kyrkan
137.0 x 90.0 (51⅛ x 35½)
Nationalmuseum, Stockholm

Upon returning to Göteborg in 1896, Wilhelmson concerned himself almost exclusively with portraying life among the inhabitants of his native Bohuslän. Such subjects first appeared in Wilhelmson's works painted in Fiskebäckskil during the summer of 1892. He harbored a profound respect for tradition and a love for the unaffected manners of these hardworking people. This may have been reinforced in Paris by his exposure to the work of Paul Gauguin (1848–1903), who made several trips to Brittany during the late 1880s and early 1890s in order to observe and to record the ways of the deeply religious and unsophisticated peasants. Peasant piety was a popular subject among artists in the nineteenth century. In addition to Gauguin, Jules Breton (1827–1906), Fritz von Uhde (1848–1911) and Wilhelm Leibl (1844–1900) recorded rural religious practices.

Attracted by the renowned piety and simplicity of the natives, Wilhelmson spent the summer of 1893 painting in Brittany. Both Wilhelmson and Gauguin were among those artists drawn to these provincials because they seemed to enjoy a more secure, authentic existence, one determined by the eternal rhythms of nature, rather than the spasmodic progress of industrialization. While many painters, such as Gauguin, appreciated the peasants from an outsider's perspective, Wilhelmson shared the values and customs of his subjects.

Wilhelmson initially concentrated on portraiture and leisure activities such as a Sunday walk (Sunday Afternoon, 1900, Thielska Galleriet, Stockholm) or an informal gathering of young men and women (June Afternoon, 1902, Göteborgs Konstmuseum). Later, Wilhelmson also undertook labor themes including plowing (Spring Work, 1908; Statens Museum for Kunst, Copenhagen) and fishing (Mackerel Fishing, 1919, Private Collection).

By arranging the figures as a processional frieze, Wilhelmson amplifies the solemnity of the scene. Their serious expressions and coarse clothing, as well as the rustic cottages in the background, further attest to the rugged simplicity of Swedish coastal life. Wilhelmson often equates the honest labor and unaffected manners of rural folk with the manifestation of a deeply-felt spirituality. [MF]

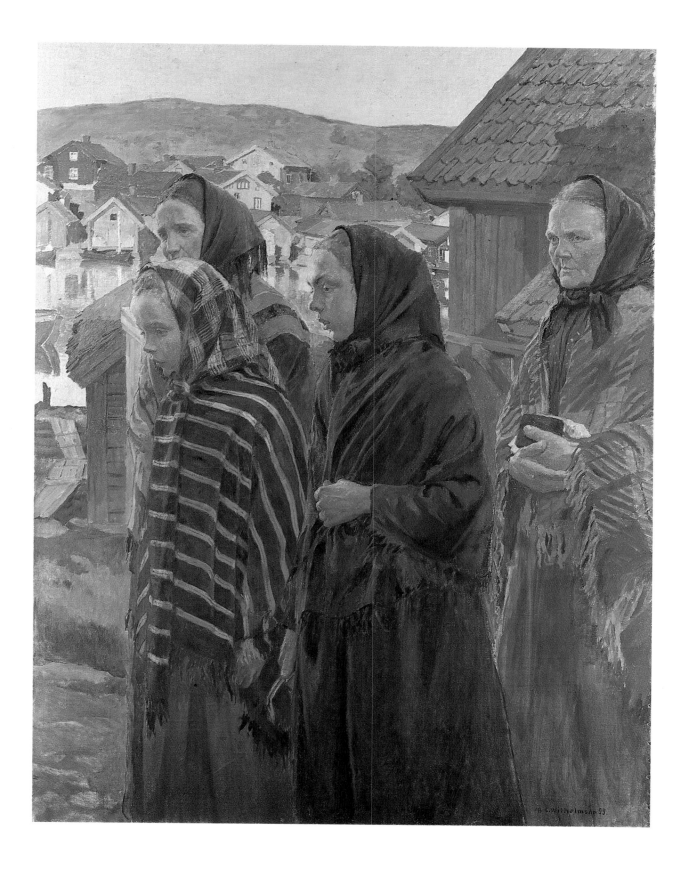

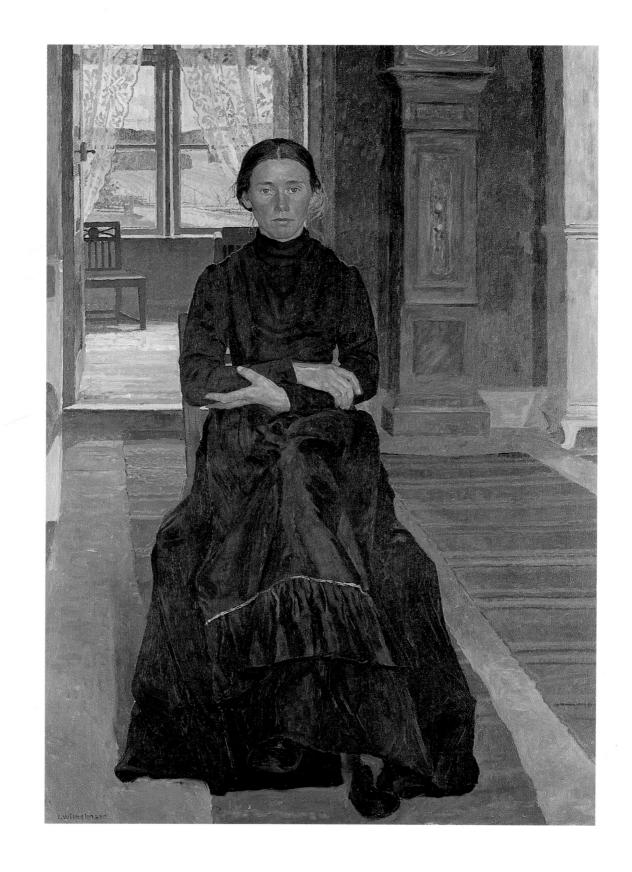

112
The Daughter on the Farm *1902*
Gärdens Dotter
130.0 x 90.0 (51 ⅛ x 35 ½)
Signed lower left: "C. Wilhelmson"
Göteborgs Konstmuseum

In the summer of 1902 Wilhelmson was the guest of his student Anna Sahlström on her family's farm at Torsby in the Swedish province of Värmland. There he painted The Daughter on the Farm *with Anna as his model. Wilhelmson's painting encompasses a way of life and pays homage to the prosperous farming class. In the background, he opens the view out to the fields, stressing the dependence of this society on the land. Anna is shown wearing the dignified black of Sunday dress. The surrounding interior is not poor, but it conveys an austerity echoed by Anna's rigid pose. Indeed, both woman and environment appear to embody a puritanical ethos of work and moral rectitude.*

From his earliest years in Göteborg, Wilhelmson had been concerned with scenes of local interest. During his stay in Paris he had, like many of his contemporaries, been attracted to Brittany. On his return to Sweden, he devoted a large part of his oeuvre to fishermen, farmers, and peasants, converting these themes into nationalistic icons.

Anna's exceptionally large and expressive hands – seemingly too powerful for her brittle frame – are pointedly crossed and inactive. The posture is static but not relaxed; her eyes fail to meet the viewer's, despite the fact that she stares forward fixedly. Self-consciously posed, physically prominent, and meticulously detailed, this young woman is still psychically distant and wears an ambiguous expression. Strongly individualized, her portrait is, as the title indicates, a type-image – an appreciation of a way of life and a frame of mind. [ADG/BF]

JENS FERDINAND WILLUMSEN

Denmark 1863–1958

Willumsen began his studies at the Copenhagen Academy in 1881. After a short time, he abandoned the study of architecture for painting, and made his official debut at the Charlottenburg Salon of 1883. Stifled by the training offered by the Academy, Willumsen left in 1885 in order to study with Lauritz Tuxen (1853–1927) and Peder Severin Krøyer*, who had established a free art school in opposition to the Academy in 1882. The great French Exhibition held in Copenhagen in 1888 provided Willumsen's first direct exposure to contemporary currents in French painting and prompted his first trip abroad. Willumsen spent November 1888–March 1889 in Paris, and made a two-month sojourn to Spain before returning briefly to Copenhagen. That same year the Charlottenburg rejected his *Wedding of the King's Son* (1888; J.F. Willumsen Museum, Frederikssund), provoking Willumsen's unbroken vow never again to exhibit at the Danish Salon.

Willumsen worked mainly in France during the early 1890s, and spent the summer of 1890 at Pont-Aven in Brittany, where he evolved his distinctive Synthetist/Symbolist style. In addition, he met Paul Gauguin, whom he saw periodically both in France and in Copenhagen. This decade was Willumsen's most active. He exhibited with the Salon des Indépendants in 1891 and experimented with a variety of media including wood carving (under the influence of Gauguin), terracotta and stone sculpture, poster design and architecture. In 1891, he designed the Free Exhibition Hall, where he and other artists seeking to escape the oppressive standards of the Charlottenburg showed their work. In 1893, the artist began plans for his ambitious multimedia "Great Relief," not realized until the late 1920s. The relief's monumental scale and universal subject matter – aspects of human existence – relates it to similar grandiose *fin-de-siècle* projects by Edvard Munch* (*The Frieze of Life*) and Auguste Rodin (*The Gates of Hell*).

In 1893, Willumsen visited the United States in order to attend the Chicago World Exposition, where several of his works were exhibited. From this point on, he travelled extensively on the continent and made a second U.S. trip in 1900. Willumsen settled on the Côte d'Azur in 1920. He was extremely prolific after 1910, laboring in willful ignorance of current artistic developments and instead focusing inward on personal expression and on the old masters. In the twentieth century Willumsen created his most bizarre and critically unappreciated works in social and artistic isolation. [MF]

Edgar Degas
A Woman Ironing ca. 1874
Metropolitan Museum of Art, New York. The H.O. Havemeyer Collection, bequest of Mrs. H.O. Havemeyer, 29.100.46.

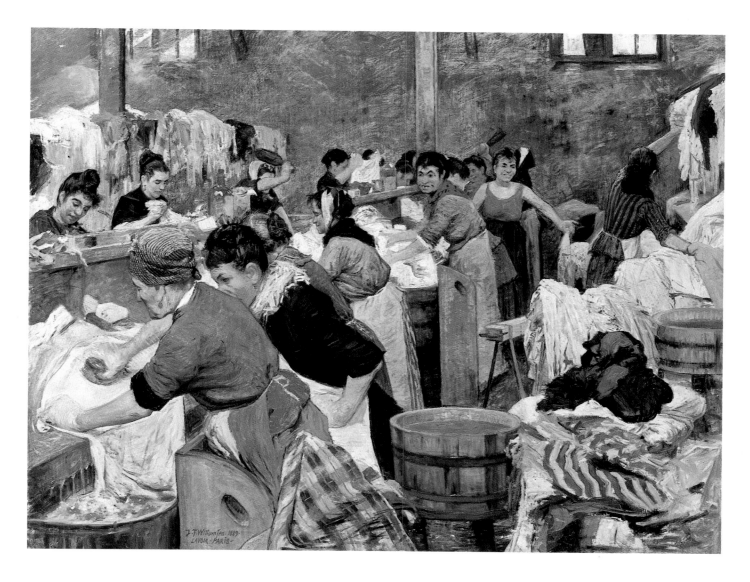

113
In a French Laundry *1889*
I en Fransk Tvättinrättning
102.0 x 130.0 (40⅛ x 51⅛)
Göteborgs Konstmuseum

Stimulated by the wide variety of styles and subjects to which he was exposed in Paris, and most of all by the city's dynamism, Willumsen rejected his academic training, eschewed formal study and began painting scenes of modern life upon his arrival in the French capital. His greatest influence at this time was Jean-François Raffaëlli (1850–1924), whose urban, working-class themes intrigued the Dane. Willumsen spent much of December 1888 at the Luxem-

bourg Museum copying Raffaëlli's At the Bronze Foundry *(1886; Musée des Beaux-Arts, Lyon).*

Between December 1888 and his departure for Spain in April 1889, Willumsen executed several Realist works similar to Raffaëlli's in both subject and style, including In a French Laundry. *In search of cheaper living quarters, Willumsen moved to Montmartre in late December and concentrated on neighborhood scenes such as this. A group of dreary, wooden shacks near the construction site of Sacré Coeur contained the bustling activity and amiable banter of the laundresses whom Willumsen records at work. He depicts a large group of figures, few young or beautiful, engaged in a variety of activities such as washing, sorting, drying and pressing. In the crisp winter air, all details, near and far, are rendered with equal clarity.*

This factory-like setting contrasts with the intimate scenes of Edgar Degas, the best-known painter of laundresses. Beginning in the 1870s, Degas began an almost scientific study of laundresses (as he did of various other female professionals including milliners and ballet dancers). He focused on single figures at close range, in steamy environments and often bathed in intense summer light. The sensual nature of Degas's laundresses are the antithesis of the toothless, haggard workers of Willumsen, whose ugliness borders on caricature. Their energetic pace contrasts dramatically with the studied movement of Degas's often solitary women. Furthermore, Willumsen's concern with the activity of a place necessitated a far more dynamic, aggressive technique than did Degas's concern with describing physical presence and routinized movements.

When exhibited in Copenhagen in October 1889, this and Willumsen's other new Realist works received unfavorable reviews. One of the most outspoken critics was Karl Madsen, who expressed indignation at what he claimed was Willumsen's shameless plagiarism of Raffaëlli (Nasgaard, Willumsen, p. 82). He failed to notice obvious differences such as Willumsen's interest in rapid movement and his bold technique, characteristics not shared by Raffaëlli. Madsen had no sympathy for the young artist who turned to the French Realists in an effort to free himself from rigid academic precepts, an inevitable step in the evolution of Willumsen's personal style. [MF]

114

Jotunheimen *1893–4*
Oil, painted zinc, and enameled copper
150 x 277 (59 x 109)
Signed lower left: "J.F. Willumsen 1893"
J.F. Willumsens Museum, Frederikssund

Jotunheimen *is a symbolic interpretation of Norway's highest and most dramatic mountain peaks. Begun in 1893 and completed in the next year, it marks a turning point in Willumsen's career. Disaffected from his association with Gauguin, and stinging from charges of insanity levelled by his critics, Willumsen travelled to Norway in the summer of 1893. There he spent several months painting in the mountains and then went to Christiania where he held a one-man exhibition at Abels Kunsthandel. He had executed his first mountain studies in the Swiss Alps in 1891, but felt them to be lacking. In* Jotunheimen, *he tasted the sublime: "The clouds drifted away and I found myself at the edge of an abyss, looking over a mountainous landscape in the far north, grim and harsh, covered by eternal snow and ice, a world uninhabitable for human beings." (R. Nasgaard,* The Mystic North, *1983, p. 21).*

Willumsen's approach to the motif was abstract from the beginning. Recalling the flat, decorative rhythms of Japanese prints and Old Norse tapestries, his initial sketches pit the flowing accretions of snow on rock against the hard-edged mosaic reflections below. The final version is a refinement of this first inspiration. His colors, limited to stark grays and earth tones, are applied in sharply defined zones, in the manner of his Parisian Synthetist work. Conceived as a pictorial equivalent for Willumsen's emotional response to Jotunheimen, *it is a "condensation" of many views rather than a topographic likeness.*

Mountain landscapes had rarely been painted in Norway since the romantic period (see cat. no. 90). Roald Nasgaard suggests that Félix Vallotton's woodcuts, "Hautes Alpes" (1892), exhibited at the 1892 Rose + Croix Salon, may have inspired Jotunheimen. *(Nasgaard, Willumsen, p. 25). Willumsen's crystalline reflections on the lake surface are seemingly without formal precedents. They prefigure Gustaf Fjaestad's* shifting, abstract water patterns, and even Synthetic Cubism's playful juxtaposition of flattened*

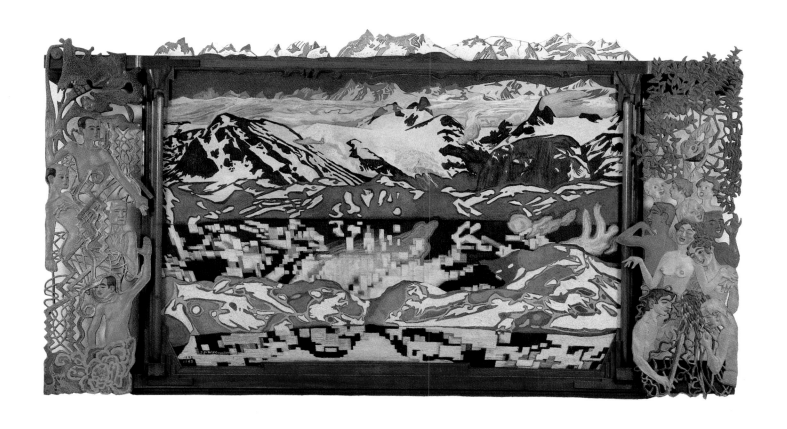

115

After the Storm I *1905*
Tempera on canvas
155.5 x 150.0 (97¹⁄₅ x 93³⁄₄)
Oslo, Nasjonalgalleriet

forms, and they parallel some of Gerhard Munthe's* experi-mental design work.

Willumsen intended Jotunheimen to be a purely deco-rative composition, resonant with the strength and moral superiority of the north. As he completed the painting, he felt that its meaning was not adaquately expressed by the landscape, and he constructed the allegorical frame. He ex-hibited Jotunheimen *without the frame in the 1893 Salon du Champs-de-Mars, and with the frame in the 1895 exhibi-tion of* Den Frie, *accompanied by the following explanation:* "The figures on the left of the relief represent those who steadfastly seek through learning and reason the link be-tween the infinitely great and the infinitely small. The in-finitely great is symbolized by a stellar nebula, the infinitely small by microbes. The figure below is inspired; the figure above is convinced of the true outcome of his researches.

The right side of the relief is in contrast to the left and represents the purposeless; below are two men, one of whom is weaving a net which the other is as quickly unravelling; in the center a group of those who are indifferent; above a figure representing chimeric dreams." *(quoted in Nasgaard, ibid., p. 21).*

Merete Bodelsen links this programmatic faith in the moral efficacy of work to the writings of the Scottish essayist and historian Thomas Carlyle (1795–1881), citing many points in common with his protagonist in Sartor Resartus *(ibid., p. 24). The narrative frame, an attempt to explicate the painting's meaning, has sources in Max Klinger's graphic work of the 1880s, and parallels in Edvard Munch's* frame *for* Metabolism *(1894–5/1918, Munch Museum, Oslo). The picture and frame ensemble scandalized the Free Exhibition of 1895: Willumsen's symbolism was considered obscure and his figural imagery, bizarre. Yet with* Jotunheimen, *Willumsen had begun to see the limitations of his earlier Synthetist curvilinearity, and attempted to invent a new style for his new subject matter, or, as he wrote in 1891, a new language suitable for a new century. [PGB]*

Willumsen conceived After the Storm I *at Le Pouldu, in Brittany, during the summer of 1904. Initially inspired by a Beethoven symphony, he executed a watercolor study of the jagged sun-scorched coastline which became the basis for this evocation of nature gone awry. In the final version, the sun plays impartial witness to the wake of a violent storm. Foaming breakers rock the wrecked hull of a ship while, overhead, the last of the storm clouds evaporate. In the foreground, a woman runs blindly across the sand. Her rhetorical gesture of grief belays her horror at the betrayal of the life-giving sun and sea. A young boy runs behind her, but in her despair, she ignores his wanting gesture – another emblem of nature's turmoil. Both figures are dramatically back-lit by the blazing sunlight which heats the colors of air and water into a blistering intensity.*

As Roald Nasgaard points out, After the Storm I *is the first instance of a northern artist in the Symbolist de-cades depicting the sun's disk (R. Nasgaard,* The Mystic North, *p. 99). Northern landscapes were largely moonlit evocations of the elusive "nature spirit". But with the new century, a new sensibility was emerging. A vast ascending sun is the hub of Edvard Munch's* University of Oslo Aula *(Assembly Hall) decorations (1909–1916). While Munch's sun burns with vitality – the source of potency and life – Willumsen's embodies nature's destructive powers. It scorches and blinds the foreground figures. They are helpless victims of its primordial power, a reversal of the Vitalist tendencies of post-1900 Scandinavian nature philosophy (see cat. nos. 43 and 80).*

When After the Storm I *was exhibited at the 1911 Oslo Kunstnerforbundet exhibition, National Gallery direc-tor Jens Thiis recognized the painting's success in conveying anguish, but objected to its theatricality. After some debate in which Harriet Backer* championed Willumsen's cause, the National Gallery purchased the monumental canvas in 1913. Three years later, Willumsen painted* Fear of Nature *(After the Storm II, J.F. Willumsens Museum, Frederiks-sund). The second version is more elemental. The boy and the shipwreck, traditional narrative components, are omit-ted in favor of an intensification of color and brush work. This version has left Willumsen's Synthetist-inspired land-scapes behind, and is closer in execution to Edvard Munch's expressionist sketches for the Aula Sun. [PGB]*

266

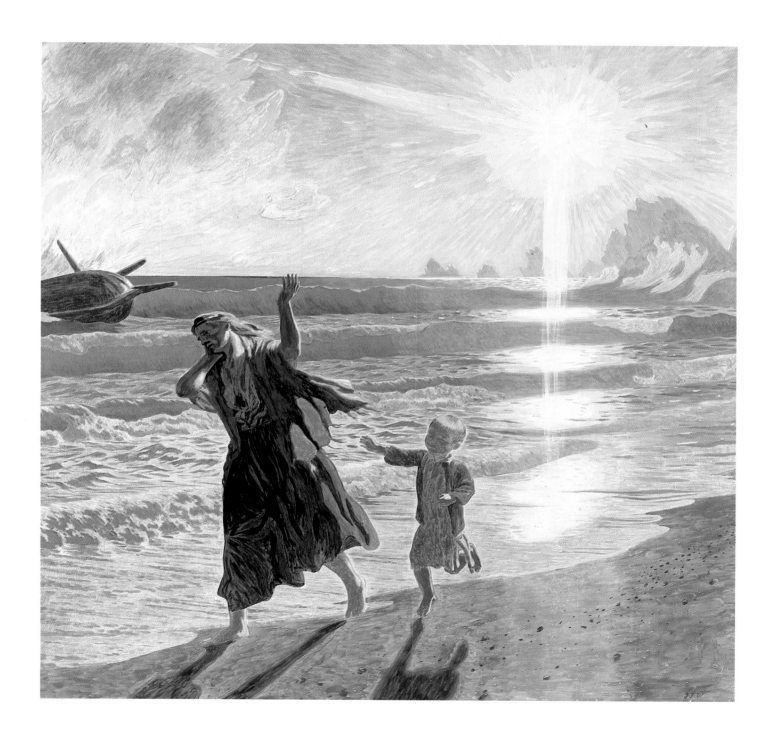

ANDERS ZORN

Sweden 1860–1920

Zorn spent his childhood in Mora on the farm of his impoverished grandparents. From 1875 to 1881 he attended the Royal Academy of Fine Arts in Stockholm, where he pursued an eccentric course of study, and, inspired by the watercolors of Egron Lundgren (1815–1875), concentrated upon developing his watercolor style. In 1881–82 he toured London, Paris, and Spain – the first of countless trips he made to foreign countries in order to seek new subjects and lighting effects as well as contact with the art of the old masters. From 1882 to 1888 he lived mainly in London and achieved some success as a portrait painter.

Zorn married Emma Lamm in 1885, and the two spent the winter of 1887–88 with James McNeill Whistler and Helene Schjerfbeck* in the artists' colony of St. Ives. At about this time, he began seriously to devote himself to oil painting. In 1888 the couple settled in Paris, and he became part of an influential artists' circle that included Antonin Proust, Albert Besnard, and Auguste Rodin. His studio on the Boulevard de Clichy also became a gathering place for other Scandinavians, including Christian Krohg*, Albert Edelfelt*, and Akseli Gallen-Kallela*. In this period Zorn experimented with Impressionist ideas and carefully studied the brushwork of Edouard Manet.

In 1896 Zorn moved back to his native Mora. When not travelling, he and his wife involved themselves directly in the community and studied and collected indigenous art. Internationally successful, he continued to execute oils, watercolors, etchings, and sculpture. The subjects of his mature works (excluding etchings) are mainly portraits, nudes, and genre subjects in roughly equal proportions. [RH/GCB]

116
Our Daily Bread *1886*
Vårt dagliga bröd
watercolor
68.0 x 102.0 (42½ x 63¾)
Nationalmuseum, Stockholm

In 1886, the Nationalmuseum in Stockholm commissioned Zorn to paint a Swedish subject for its collection. In view of the fact that he had spent little time in Sweden during the early 1880s – having resided in London and subsequently having taken an extended honeymoon through the German and Austro-Hungarian Empires and as far as Constantinople – the request may seem unwarranted, yet the young artist had already achieved great popular acclaim in his native country.

Zorn returned to Mora with his wife in July 1888. In addition to completing a series of etchings of the Turkish capital, he immersed himself in the study of rural life and costume, a subject which had fascinated him during his recent stay in Transylvania. His affinity for such peasant subjects and his esteem for Jules Bastien-Lepage may have developed during his London sojourn, with his exposure to Bastien-Lepage's English followers George Clausen (1852–1944) and William Stott (1857–1900), the latter of whom spent summers at Grèz-sur-Loing.

This watercolor, for which Zorn made numerous detail studies, depicts his grandmother preparing a meal in a broad ditch for his relatives laboring in the field beyond. The artist harbored an intense concern for precision of detail and authenticity of setting; here the cook and harvesters wear traditional costumes and work in the family fields. Zorn's interest in the folk art and dress of his native Dalarna inspired his extensive and varied collection of such objects.

With the high horizon and steep recession, Zorn directs the viewer's attention to the solitary old woman seated in the foreground, whose weather-beaten features and stooped posture betray the hardship of a life so inextricably bound to the land.

The title refers to the "Lord's Prayer," thereby suggesting a religious dimension to this ostensibly genre scene.

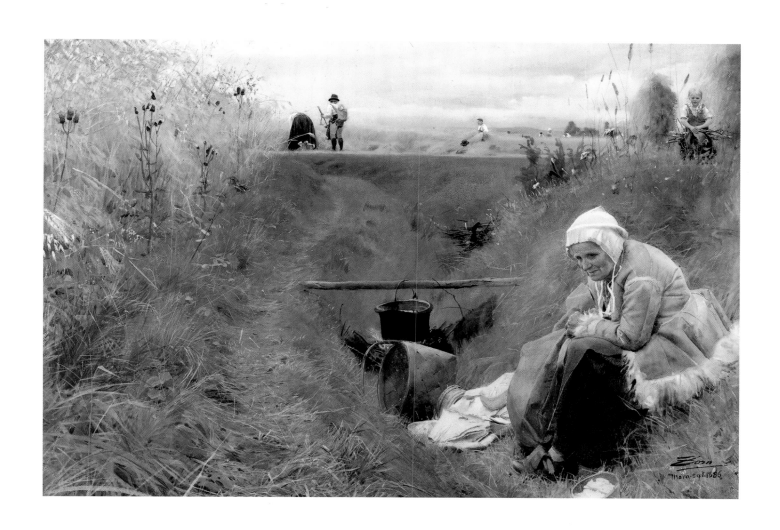

Like Jean-François Millet (1814–1875), Zorn celebrates the biblical virtues of peasant existence. In For Our Daily Bread (1925; former collection of Ella Odquist), Carl Wilhelmson* similarly seeks to enlarge the significance of the pious, resigned and unaffected character of provincial life in Sweden by introducing the popular prayer. [MF]

Édouard Vuillard
The Ferryman 1897
Le Passeur
Oil on board
54.6 x 74.9 (2½ x 29½)
Musée Orsay, Paris

117
Midnight *1891*
Midnatt
69.0 x 102.5 (27⅛ x 40⅜)
Signed lower right: "Zorn/Mora 91/Midnatt"
Zornmuseet, Mora

Zorn painted this view of a woman rowing on Sweden's Lake Siljan during the last week of June 1891 while on a visit from Paris to Mora. He exhibited it that fall at the Stockholm exhibition of the Artists' Union, of which he was a member from 1886 to 1903, and in Paris at the 1892 Champs de Mars Salon.

 Throughout his career Zorn was absorbed with problems posed by different kinds of lighting. He first depicted the light summer night, a favorite theme of nineteenth-century Scandinavian artists, in To the Dance *(1880; Ebildslätt, Orust). In keeping with the associations carried by the Scandinavian summer night, the apparent solitude of the woman in* Midnight *and the viewer's close confrontation with her unreadable expression give the action and its setting an air of mystery.*

 By 1891 the motif of a figure in a boat which is "cropped" by the picture plane had become common in European painting and in Zorn's work. He first used it in 1883 in the etching Mary on the Thames, *which may have derived from James Tissot's painting* Young Woman in a Boat *(1870; reproduced in M.J. Wentworth,* James Tissot: Catalogue Raisonné of His Prints, *Minneapolis Institute of Arts, 1978) or from Tissot's etching* The Thames *of 1879 (Lawrence, p. 35). Zorn's* Midnight *may, in turn, have inspired the cropped boat, the backward glance, and the moody light of Édouard Vuillard's* The Ferryman *(see illustration). Both works convey a scarcely definable sense of foreboding. [RH/GCB]*

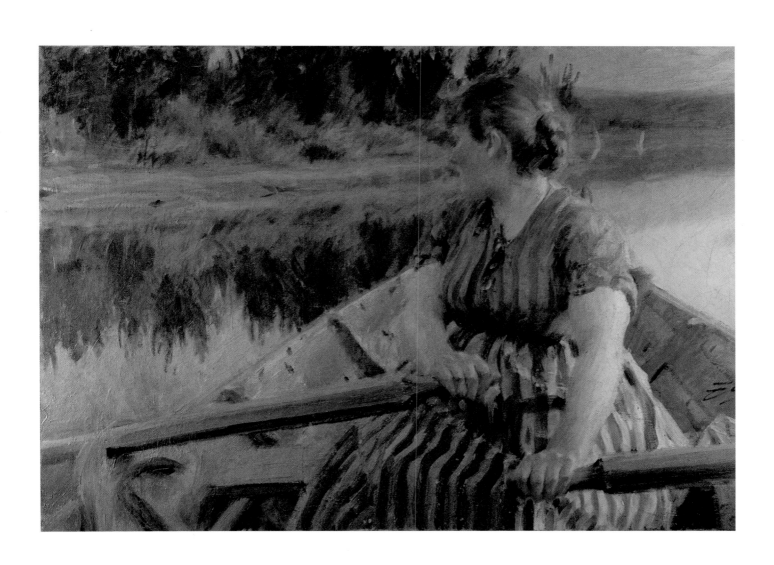

271

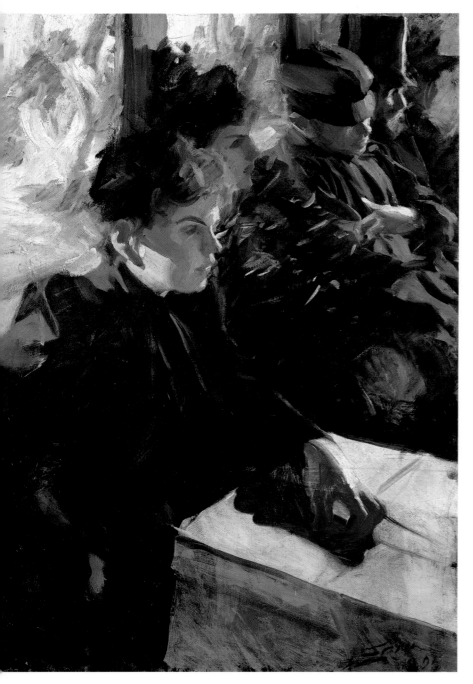

118
The Omnibus I *1891*
100 x 66 (62¼ x 41¼)
Nationalmuseum, Stockholm

During the late 1880s and early 1890s, Zorn spent much of his time in Paris, where he specialized in portraiture. These were successful years for the artist: in 1890 he participated in a group show at Galerie Georges Petit which included Auguste Rodin, Alfred Sisley and Albert Edelfelt, and in 1891 Durand-Ruel exhibited a selection of his etchings.*

On an 1890 visit to Hamburg, Zorn painted a series of brewery scenes in which he concentrated on crowded interiors for the first time. This study prepared him for works such as Omnibus I, whose subject and technique ally him to Impressionism. Here Zorn focuses on the expressionless mien of a young Parisian woman clutching the ties of her large package as she sits in a city bus. The solitary repose of the introspective passengers contrasts dramatically with the bustling activity of the street seen through the bus window. Such private experience in public places was a quintessential Impressionist theme explored earlier in the paintings of Pierre-Auguste Renoir (1841–1919) and Edouard Manet (1832–83).

The complex figural composition and lighting, with extremes of raking sunlight and deep, colored shadows, challenged the Swede's technical abilities and manifest his interest in the empirical concerns of the Impressionists. Like them, Zorn adopted a technique which effectively communicated the fast pace of Parisian life. Zorn's fascination with contemporary, urban street life and his broad, virtuoso brushwork relates him to late Impressionist artists such as Giovanni Boldini (1842–1931).

The American collector Isabella Stewart Gardener purchased a second version of this work, Omnibus II (1892; Isabella Stewart Gardner Museum, Boston) from Zorn, whom she met during his 1893 trip to the United States to attend the Chicago World Exposition. Mrs. Gardner was deeply impressed by the artist, who visited her in Venice the following year in order to paint her portrait. [MF]

119
Self-Portrait *1896*
Självporträtt
117.0 x 94.0 (46 x 37)
Signed lower right: "Zorn/1896"
Nationalmuseum, Stockholm

Painted during the last winter Zorn lived in Paris and first shown at the 1896 Champ de Mars Salon, this self-portrait was the result of months of experimentation. Preliminary drawings show the model much closer to the artist; Zorn repainted the canvas several times before finally moving her into the shadowy background. The broad, loose brushwork and attention to solid form reveal Zorn's study of Rembrandt, Hals, and the French Impressionists, and the influence of his German artist friend Max Liebermann. Zorn was noted for executing paintings using a sober color scale limited to white, ochre, vermilion, and ivory black – the four colors used to paint this canvas and the ones represented on his palette in the picture.

Armed with palette, pigments, brushes, and cigarette, and attired in the dashing artist's costume of smock and ascot with stickpin, Zorn takes a break from painting. He generally employed professional models for his paintings of nudes, and they would entertain him by singing as he worked. The model here is an Italian woman with long red hair, which Zorn described as covering her like a winter cloak (letter to I.S. Gardner, paraphrased in Lawrence, p. 68).

Though the compositions vary among Zorn's portraits of artists and their models – other examples include etchings of Augustus Saint-Gaudens and Albert Besnard – each makes clear that the artist is in the position of power. Here, Zorn's bulky figure fills fully one-third of the image, and he confronts the viewer as bright daylight illuminates his smock. The smaller figure of the model, wrapped in her hair, slouches in a chair pushed into the dim corner. The darkness between the two and the pattern of the parquet boards tilting down toward the artist's corner create a psychological distance and tension. This work provides a sharp contrast to the oblique view of the ageing Vilhelm Hammershøi in his Self-Portrait of 1911 (Statens Museum for Kunst, Copenhagen). Zorn's down-to-earth physicality also opposes the vaporous, otherworldly depiction of Munch's Self-Portrait with Cigarette (cat. no 76). [RH]

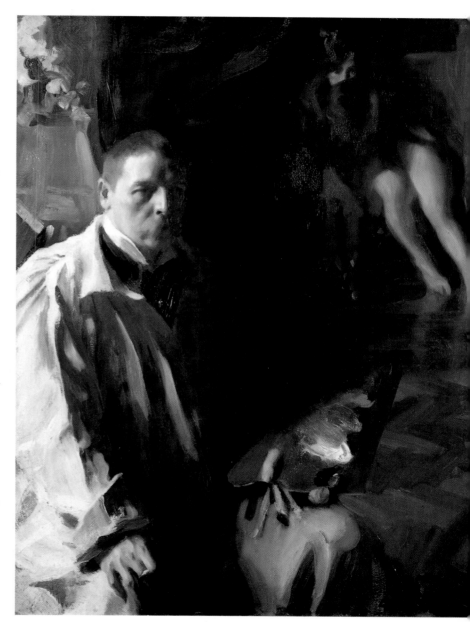

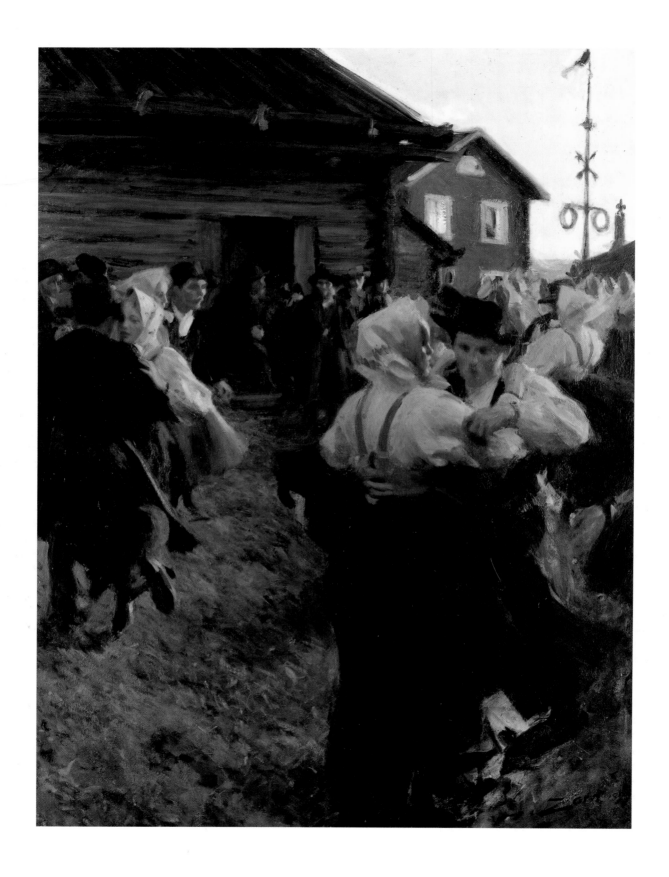

120

Midsummer Dance *1897*
Midsommardans
140.0 x 98.0 (55⅛ x 38⅝)
Signed lower right: "Zorn 1897"
Nationalmuseum, Stockholm

In 1896, the summer after Zorn's return to his native Swedish province of Dalarna, Prins Eugen attended the local Midsummer festival and suggested that Zorn paint the subject. His first response was a rapid oil sketch in a horizontal format (Zorn Museum, Mora); the following year he executed this version, which was awarded the Medal of Honor for painting at the 1900 World Exposition in Paris. On commission from the American industrialist Charles Deering, he*

The painting is part of a rich tradition in Scandinavian art and literature of treatments of the Midsummer festival. Celebrated on or around June 23 – one of the longest days of the year – Midsummer was a major holiday in Norway and Sweden. It was especially popular in rural areas where people flocked to the villages to dance around the maypoles in the bewitching light of the summer night. Ibsen (St. John's Night, 1852) and Strindberg (Midsummer, 1900) used the Midsummer festival as the setting for their works dealing with nationalism. Among the Swedish painters who depicted the festival earlier in the century was J. W. Wallander (1821–1888), whom Zorn admired for his rural scenes. Wallander's and other mid-century artists' paintings of the subject usually presented a detached view of many figures dancing across a stage-like space. Careful attention was given to details of costume, architecture, and foliage. Zorn, too, was fascinated by native peasant costume, and he respected local variations to the extent of refusing to paint a model in garb from outside her native district. However, he was more concerned with conveying the extraordinary light and mood of the celebration than with recording intricate embroidery or the individual leaves of the maypole decorations. His broad handling of paint may result in a suppression of such details, but the placement of the main couple invites the viewer's participation in the dance. With vastly different aims, Edvard Munch later used the Midsummer*

tival as a point of departure for The Dance of Life *(cat. no. 79), in which flattened figures symbolize the eternal cycle of life and love.*

With increasing industrialization and the displacement of the population to the cities, there was a concern in the 1890s for the preservation of the vanishing peasant culture. Zorn's friend and fellow Dalarnan, Erik Axel Karlfeldt, was the major representative of this trend in poetry. The province of Dalarna came to be known as the area which had preserved most carefully a traditional Swedish way of life (biblio. ref. no. 83, p. 616). Zorn's own deeply rooted interest in his native culture extended to support, encouragement, and manipulation of the local arts and folk events. Apparently the custom of setting up a maypole had lapsed in his area, and he persuaded the villagers to erect one for the 1896 celebration. In addition to collecting native silver, glass, tapestries, and paintings, he and his wife organized handicrafts classes and other activities for the young people of the area. The lead couple depicted in Midsummer Dance *are said to be the winners of a dance contest sponsored by him (Boëthius, 1949, p. 122).*

Zorn's most ambitious endeavor was the collection of antique Swedish buildings like the ones seen in the upper left-hand corner here. He was eventually able to create the hamlet of Gopsmor – a rural version of the Skansen architectural museum near Stockholm. In light of such extraordinary devotion to his heritage, it is easy to understand why he later said of this painting, "I consider this to be the work that contains the whole of my innermost feelings" (quoted in Boëthius, 1949, p. 354). [RH]

FOOTNOTES

1. See Selma Jónsdóttir, "Art in Iceland at the Turn of the Century," in K. Varnedoe, ed. *Northern Light: Realism and Symbolism in Scandinavian Painting, 1880–1910* (Brooklyn, N.Y.: The Brooklyn Museum, 1982), pp. 57–59.

 One of the most fervent admireres of Iceland's society and literature was the English poet and artist William Morris. Deeply affected by Icelandic sagas, he travelled in Iceland and brought back reports of the virtues of the nation. See *Journals of Travel in Iceland 1871–1873*, Vol. 8 of William Morris, *The Collected Works of William Morris* (London: Longmans Green & Co., 1911).

2. On the Scandinavian artists abroad, see Salme Sarajas-Korte, "The Scandinavian Artists' Colony in France", in Varnedoe, ed. *Northern Light*, pp. 60–66; also Bo Lindwall, "Artistic Revolution in Nordic Countries", *Northern Light*, pp. 35–42.

3. See Lindwall, "Artistic Revolution in Nordic Countries," loc. cit.

4. Ibid.

5. See Tone Skedsmo, "Patronage and Patrimony," in *Northern Light*, pp. 43–51.

6. See Jónsdóttir, "Art in Iceland at the Turn of the Century," loc. cit.

7. See Emily Braun, "Scandinavian Painting and the French Critics," in *Northern Light*, pp. 67–74.

8. One of the most consequential manifestations of this anti-modern tenor is the rise of the *volkisch* ideology in Germany. For an excellent account of this phenomenon, see George F. Mosse, *The Crisis of German Ideology* (New York: Schocken, 1981).

9. The *Kalevala* epic was first assembled in definitive written form by the Finnish scholar Lönnrott in his thesis of 1827. For an English translation see Francis Peabody Magoun, Jr., *The Old Kalevala and Certain Antecedents* (Cambridge:

Harvard University Press, 1969). On the larger question of the modern phenomenon of the mythifying of a national past, see Eric Hobsbawm and Terence Ranger, eds. *The Invention of Tradition* (Cambridge: Cambridge University Press, 1983).

10. On the importance of summer night celebrations as rallying points for a new idea of the collective state, and for a clear delineation of the sinister manipulation of this kind of festival, see George F. Mosse, *The Nationalization of the Masses* (New York: New American Library, 1977); and George F. Mosse, *Nazi Culture* (New York: Schocken, 1981).

11. A direct connection between Scandinavian art and Arts-and-Crafts currents in Belgium and England exists by virtue of Akseli Gallen-Kallela's contacts with England and A.W. Finch's participation in Louis Sparre's Iris Workshop (see pp. 108 and 220). Scandinavian painting also had a direct and significant impact on German and Russian art of the late nineteenth and early twentieth centuries. Although Edvard Munch's importance for the German Expressionists has generally been recognized, we are only beginning to acknowledge the interchange that took place between such Scandinavian artists as Gallen-Kallela and early modern figures like Sergei Diaghilev and Wassily Kandinsky. See Peg Weiss, *Kandinsky in Munich: The Formative Years* (Princeton: Princeton University Press, 1979), pp. 65–67; and Peg Weiss, *Kandinsky in Munich 1896–1914* (New York: Solomon R. Guggenheim Museum, 1982), pp. 47–48.

12. For a broader analysis of this phenomenon of "outsider" response to modern currents, see Marshall Berman's remarks on "The Modernism of Underdevelopment," in his *All That is Solid Melts into Air* (New York: Simon and Schuster, 1982).

13. Kirk Varnedoe, "Caillebotte's Space" in *Gustave Caillebotte: A Retrospective Exhibition* (Houston: Houston Museum of Fine Arts, 1976), pp. 69–71 and 149–150; and "Christian Krohg and Edvard Munch," *Arts Magazine*, April 1979.

14. See "Émile Zola" in Georg Brandes, *Menschen und Werke, Essays von Georg Brandes* (Frankfurt: Literarische Anstalt, Rutten und Loening, 1900). The essay was originally written in 1887. See especially the analysis of Zola's *La faute de l'abbé Mouret*, pp. 244 ff.

15. For a rich description of the *vie expérimentale*, see Reinhold Heller, "Love as a Series of Paintings" in *Edvard Munch: Symbols and Images* (Washington: National Gallery of Art, 1978), pp. 87–111 and especially pp. 92–95.

16. On Munch and psychic Naturalism, see Heller, "Love as a Series of Paintings," loc. cit.; and Carla Lathe, "Edvard Munch and the Concept of Psychic Naturalism," *Gazette des Beaux-Arts* (March 1979); also Wladyslawa Jaworska, "Edvard Munch and Stanislaw Przybyszewski," *Apollo* (October 1974); and ultimately Stanislaw Przybyszewski, "Psychicher Naturalismus," *Die Neue Deutsches Rundschau,* vol. 5, no. 1 (1894).

17. My thanks to Björn Fredlund, Director of the Göteborg Art Gallery, and to Ulf Linde, Director of the Thiel Gallery in Stockholm, for pointing out to me the singular interest of Liljefors' work, and for explaining to me the theoretical bases of these paintings. Liljefors' interest in building an art entirely of nature imagery is not merely a personal quirk, but a special manifestation of anti-urban currents of his time. In 1886, in his autobiographical memoir *Son of a Servant,* August Strindberg wrote: "When a man has discovered society to be an institution based on error and injustice, when he perceives that, in exchange for petty advantages society suppresses too forcibly every natural impulse and desire, when he has seen through the illusion that he is a demigod and a child of God, and regards himself more as a kind of animal – then he flees from society, which is built on the assumption of the divine origin of man, and takes refuge with nature. Here he feels in his proper environment as an animal, sees himself as a detail in the picture, and beholds his origin – the earth and the meadow . . . And in our time, when all things are seen from the scientific point of view, a lonely hour with nature, where we can see the whole evolution – history in living pictures, can be the only substitute for divine worship." *(Son of a Servant,* Claud Field trans., New York: G.P. Putnam & Sons, 1913, pp. 197–198) Liljefors' relation to the broader picture of animal imagery in nineteenth-century art and literature is taken up by Bo Lindwall and Lindorm Liljefors in *Bruno Liljefors* (Stockholm, 1960) and by Allan Elenius in his *Bruno Liljefors* (Stockholm: Bokförlaget Carming, 1981).

18. The intervening link between Liljefors and Marc is the Swiss animal painter Jean Bloe Niestlé, whose work, much admired by Marc, is remarkably close to Liljefors'. See Frederick S. Levine, *The Apocalyptic Vision* (New York: Harper and Row, 1975), pp. 34–39; and *Der Blaue Reiter* (Munich: Stadtische Galerie in Lenbachhaus München, 1970), pp. 134–137. Niestlé's work of *circa* 1905, however, is less advanced stylistically than Liljefors' more broadly handled and boldly colored works of the same period. Marc could have seen such later works by Liljefors in sources like the article "Bruno Liljefors" in *Zeitschrift für Bildende Kunst,* no. 16 (1905), pp. 116–121. Two 1905 paintings were there reproduced full-page in color (facing p. 116 and facing p. 132). On the relation of Marc's paintings of animals to human imagery, see Johannes Langner, "Iphigenie als Hund" in *Franz Marc 1880–1916* (Munich: Prestel Verlag, 1980); and the response by Donald Gordon, "Marc and Friedrich Again: Expressionism as Departure from Romanticism, " *Source,* no. 1 (Fall 1981).

The speculation on the subjective life of animals and its relation to human thought was not simply Romantic fantasy, but also a central issue of psychological study in the period preceding World War I. Imaginative projection into the subjective impressions of test animals was a key approach to the study of the mind – and an approach then under attack from Pavlov's insistence on the sole and independent validity of observable response. See Jeffrey A. Gray, *Ivan Pavlov* (New York: Penguin, 1981), pp. 28–30.

19. I obviously here steal a simplified generalization from a vastly complicated field. For an introduction to relevant ideas of the history and philosophy of scientific change, see Thomas Kuhn, *The Structure of Scientific Revolutions,* 2nd ed. (Chicago: The University of Chicago Press, 1970); and Frederick Suppe (ed.), *The Structure of Scientific Theories,* 2nd ed. (Chicago: University of Illinois Press, 1979).

20. The key text relevant to the reevaluation of Northern art of the nineteenth century is Robert Rosenblum's *Modern Painting and the Northern Romantic Tradition* (New York: Harper and Row, 1975). In many senses Scandinavian painting of the late nineteenth century can be seen as providing a "missing link" between the early nineteenth-century German Romantics and the early twentieth-century German Expressionists. The issues which I feel now need more recognition and investigation are those of the links between artistic imagery and political thought within this Northern tradition. Although the coincidence of psychological and social implications in Scandinavian Symbolism is only another episode in the dialogue between Romantic ideas of the individual and the nation-state, the particular forms and motivations of National Romanticism that underlie Nordic art of the late nineteenth and early twentieth centuries seem particularly fraught with implications for modern politics.

SELECTED BIBLIOGRAPHY

GENERAL

1) Brussels, Musées Royaux des Beaux-Arts, *Le Symbolisme en Europe* (Rotterdam, Brussels, Paris, 1976).

2) Buffalo, Albright Art Gallery, *Exhibition of Contemporary Scandinavian Art*, by Christian Brinton (1913).

3) T.K. Dersy, *History of Scandinavia* (Minneapolis: University of Minnesota Press, 1979).

4) Mirian C. Donnelly, "The Arts and Crafts in the Scandinavian Countries," Abstract of paper given at 24th annual meeting of the Society of Architectural Historians, *Journal of the Society of Architectural Historians*, XXX (1971), p. 245.

5) Düsseldorf, Kunstmuseum, *Düsseldorf und der Norden* (1976).

6) Jean Jacques Fol, *Les pays nordiques aux XIXe et XXe siècles.* (Paris: Presses universitaire de France, 1978)

7) Carl Laurin, Emil Hannover, Jens Thiis, *Scandinavian Art* (New York: The American-Scandinavian Foundation 1922).

8) Bo Lindwall and Nils Gösta Sandblad, *Bildkonsten i Norden.* Vol. 3: *Nordiskt Friluftsmåleri, Nordiskt Sekelskifte* (Stockholm: Bokförlaget Prisma, 1972).

9) Roald Nasgaard, *The Mystic North. Symbolist Landscape Painting in Northern Europe and North America 1890–1940.* (Toronto: University of Toronto Press, 1984).

10) Oslo, Nasjonalgalleriet. *1880-årene i nordisk maleri,* (ex. cat., Oslo, 1985).

11) Inga Rockswold Platou. "The Art Colony at Skagen, Its Contribution to Scandinavian Art" (Ph.D. diss., University of Minnesota 1968).

12) Robert Rosenblum, *Modern Painting and the Northern Romantic Tradition: Friedrich to Rothko* (New York: Harper and Row, 1975).

13) Margaretha Rossholm, *Sagan i Nordisk Sekelskifteskonst, en motivhistorisk och ideologisk undersökning* (Stockholm: K.L. Beckmans Tryckerier, 1974).

14) Ulrich Thieme and Felix Becker, *Allgemeines Lexikon der Bildenden Künstler* (Leipzig, 1907–1950).

15) O.G. Turville-Petre, *Myth and Religion in the North* (New York, 1964).

16) Henri Usselmann, "Complexité et Importance des Contacts des Peintres Nordiques avec L'impressionisme" (Ph.D. diss., The University of Gothenburg, 1979).

17) Kirk Varnedoe, *Northern Light: Realism and Symbolism in Scandinavian Painting 1880–1910.* (ex. cat., Washington, D.C.; Brooklyn, and Minneapolis, 1982; Göteborg, 1983).

18) John H. Wuorinen, "Scandinavia and the Rise of Modern National Consciousness" in *Nationalism and Internationalism,* essays inscribed to Carlton J.H. Hayes (New York, 1950).

DENMARK

19) Margaretha Balle-Petersen, "The Holy Danes: Some Aspects of a Study of Religious Groups," *Ethnologia Scandinavica: A Journal for Nordic Identity* (Lund, June 1981).

20) Copenhagen, Statens Museum for Kunst, *Vor Hundert Jahren: Dänemark und Deutschland 1864–1900. Gegner und Nachbarn.* (1981).

21) *Dansk Biografisk Leksikon,* first edition (Copenhagen: J.H. Schultz 1932–1946).

22) *Dansk Kunsthistorie,* Vol. 1–5 (Copenhagen: Politikens Forlag, 1972–1975).

23) Emil Hannover, *Dänische Kunst des 19. Jahrhunderts* (Leipzig: E.A. Seeman, 1907).

24) Herman Madsen, *200 Danske Malere og Deres Waerker* (Copenhagen: Aage Pioras Forlag, 1943).

25) Karl Madsen, *Kunstens Historie i Danmark* (Copenhagen: Alfred Jacobsen, 1901–1907).

26) ———, *Skagens Maleri og Skagens Museum* (Copenhagen: Gyldendalske Boghandel Nordisk Forlag, 1929).

27) Stewart Oakley, *A Short History of Denmark* (New

28) Paris, Maison du Danemark, *Les Peintres de Skagen 1870–1920,* by Knud Voss (1980).

29) Vagn Poulsen, *Danish Painting and Sculpture,* (Copenhagen: Det Danske Selskab, 1976).

30) B. Scavenius, *Fremsyn-snaeversyn. Dansk dagbladskunstkritikk 1880–1901.* (Copenhagen, 1983).

31) Skagens Museum, *Illustrerte Katalog* (1981).

32) Erik Zahle, *Danmarks Malerkunst fra Middelalder til Nutid,* third edition (Copenhagen, 1947).

Anna Ancher
Margrethe Loerges, *Portrait of Anna Ancher* (Copenhagen: Hernov, 1978).
Also Bibliography refs: 11, 20, 26, 28, 31.

Niels Bjerre
Dansk Biografisk Leksikon, Vol. 2, revised edition (Copenhagen, 1979).
Leo Swane, "Niels Bjerre", in *Vor Tids Kunst*, No. 19 (Copenhagen, 1935).
Also Bibliography refs: 14, 19, 24, 29.

Ludvig Find
Bibliography refs: 21, 24.

Vilhelm Hammershøi
Alfred Bramsen, "Weltkunst. Der dänische maler Vilhelm Hammershøi," *Zeitschrift für bildende kunst*, N.F. 16 (1905), pp. 176–189.
Alfred Bramsen and Sophus Michaëlis, *Vilhelm Hammershøi, Kunstneren og hans Vaerk* (Copenhagen and Christiania, 1918).
Copenhagen, Ordrupgaard Collection, *Vilhelm Hammershøi*. Essays by Hanne Finsen, Thorkild Hansen, Harald Olsen. Catalogue by Hanne Finsen and Inge Vibeke Raaschou-Nielsen (1981).
Julius Elias, "Vilhelm Hammershøi", *Kunst und Künstler* 14 (1915–1916), pp. 403–408.
Hanne Finsen, *Vilhelm Hammershøi*, (ex. cat., New York, Wildenstein and Co., Washington, D.C., The Phillips Collection, 1983).
H., "Aus der Neunten Austellung der Berliner Secession," *Kunst und Kunstler* 2 (1903–1904), pp. 402–403, 405.
Ulf Linde, "Vilhelm Hammershøi: Fem porträtt," *Thielska Galleriet Katalog* (Stockholm, 1979), pp. 50–51.
William Ritter, "Vilhelm Hammershøi", *L'art et les artistes* 10 (1909–1910), pp. 264–268.
Poul Vad, *Vilhelm Hammershøi*, Kunst i Danmark (Copenhagen, 1957).
Vilhelm Wanscher, "Vilhelm Hammershøi", *Ord och Bild* 18 (1915), pp. 401–411.
Also Bibliography refs: 23, 24, 29.

Peder Severin Krøyer
V. Justrau, *P.S. Krøyer* (Copenhagen: G.E.C. Gads Forlag, 1922).
Ernst Mentze, *P.S. Krøyer: Kunstner af stort format – med braendte vinger* (Copenhagen: Det Schønbergske Forlag, 1980).
Also Bibliography refs: 11, 20, 26, 28, 31, 73.

Laurits Andersen Ring
H.C. Christensen, *Fortegnelse over Malerier og Studerier af L.A. Ring i Aarene 1880–1910.* (Copenhagen, 1910).
Odrupgaard. *L.A. Ring*, 1984. (Essay by Eske K. Mathiesen).
Peter Hertz, *Maleren L.A. Ring* (Copenhagen, 1935).
Cai M. Woel, "L.A. Ring et Levnedsrids", *Dansk Kunst* II (Copenhagen: Arthur Jensens Forlag, 1937).
Also Bibliography refs: 21, 24, 25.

Harald Slott-Møller
V. Jastrau, "Harald Slott-Møller og Agnes Slott-Møller", *Små Kunstbøger*, No. 23 (Copenhagen, 1934).
Marcus de Rubris, "Artisti contemporanei: Harald Slott-Møller", *Emporium* 4, Vol. 58 (Bergamo, 1923).
Also Bibliography refs: 14, 20, 21, 24.

J.F. Willumsen
Merete Bodelsen, *Willumsen i Halvfemsernes Paris.* (Copenhagen, 1957).
Frederikssund, J.F. Willumsens Museum, *J.F. Willumsen og den frie udstillings første år 1891–1898.* (1982).
Nasgaard, Roald. "Willumsen and Symbolist Art 1888–1910". (Ph. D. dissertation, New York University, 1973).
Schultz, Sigurd. *J.F. Willumsen.* (Copenhagen, 1967).

FINLAND
33) Brussels, Palais des Beaux-Arts, *Finlande 1900; Peinture, Architecture, Arts Décoratifs* (1974).
34) Eino Jutikkala and Kauko Pirinen, *A History of Finland*, revised edition, trans. by Paul Sjöblom (New York, 1974).
35) Alf Krohn, ed. *Art in Finland: Survey of a Century* (Helsinki, 1953).
36) W.R. Mead, "Kalevala and the Rise of Finnish Nationality", *Folklore*, vol. 73 (Winter 1962), pp. 217–229.
37) Onni Okkonen, *Finnish Art* (Helsinki, 1946).
38) Oslo, National Gallery, *Finsk Malerkunst*, by Olli Vallkonen (1980).
39) Österreichisches Museum für Angewandte Kunst Wien. *Finland 1900. Finnischer Jugendstil* (1973).
40) Ringbom, Sexton. *Konsten i Finland.* (Helsinki, 1978).
41) Hans Rosenhagen, "Finnländische Maler", *Die Kunst für Alle*, vol. 19, (1903–1904), pp. 206–213.
42) S. Saarikivi, K. Niilonen, H. Ekelund, *Art in Finland*, fifth edition (Helsinki, 1964).
43) Salme Sarajas-Korte, *Suomen varhaissymbolism i ja sen lähtet* (Helsinki: Otava, n.d.).

44) _____, *Vid Symbolisens käller, Den tidiga symbolismen i Finland 1890–1895* (Helsinki: Pietarsaari, 1981).

45) John Boulton Smith, *Modern Finnish Painting and Graphic Art* (London, 1970).

46) _____, "Painting and Sculpture" in *Finland, Construction and Creation*, H. Kallas and S. Nickels, ed. (London, New York, Helsinki, 1968).

47) _____, *The Golden Age of Finnish Art* (Helsinki, 1975). Stockholm, National Museum, *Målarinnor från Finland, Seitsemän Suomalaista Taiteilijaa*, 1981.

48) J.J. Tikkanen, "Die Kunst in Finland". *Die Graphischen Künste*, XXIX (1906).

49) B. Zilliacus, *Finnish Designers* (Helsinki, 1954).

Albert Edelfelt

Albert Edelfelt, Små Konstbocker, no. 12 (Lund, 1911).

Albert Edelfelt, *Liv och arbete.* (Helsinki, 1921)

B. Edelfelt, *Ur Albert Edelfelts brev 1–3.* (Helsinki, 1917, 1921, 1926).

Jukka Ervamaa, "Albert Edelfelt's *The View from Kaukola Ridge*", *Ateneumin Taidemuseo Museojulkaisu*, vol. 20 (1975–76), pp. 42–49 (English translation).

B. Hintze, *Albert Edelfelt.* (three volumes; Helsinki, 1942–44).

Salme Sarajas-Korte, "The Norwegian Influence in Finland in the early 1890s", *Ateneumin Taidemuseo Museojulkaisu*, vol. 21 (1977–78), pp. 45–48 (English translation).

Akseli Gallen-Kallela

Akseli Gallen-Kallela, *Boken om Gallen-Kallela.* (Helsinki, 1932; new edition, 1948).

Paul Kraemer, "Axel Gallen, Finnlands Grosser Maler", *Die Kunst für Alle*, vol. 23, (December 1917), pp. 77–80.

Niilonen, K., ed., *Kalet–Wilderness Studio and Home* (Keuruu, 1966).

Onni Okkonen, ed., *A. Gallen-Kallela Drawings* (Porvoosa, 1947).

Onni Okkonen, *Akseli Gallen-Kallelan Taidetta* (with an English summary), (Porvoosa, 1948).

Marc Treib, "Gallen-Kallela: A Portrait of the Artist as Architect", *Architectural Association Quarterly*, vol. 7, no. 3 (July/September, 1975), pp. 3–13.

Also Bibliography ref: 16.

Pekka Halonen

Outi Hämäläinen, ed., *Pekka Halonen*, (with an English summary) (Porvoosa, 1947).

Eero Järnefelt

Stockholm, Nationalmuseum, *Finskt 1900* (1971).

L. Wennervirta, *Eero Järnefelt ja hänen ai Kansa 1863–1937*, (Helsinki, 1950).

Also Bibliography refs: 14, 35, 37, 41, 42, 47, 48.

Helene Schjerfbeck

H. Ahtela, *Helene Schjerfbeck. Kampppailu Kauneudesta* (Porvoo, 1951).

Eilif and Hanna Appelberg, *Helene Schjerfbeck. En biografisk konhivteckning* (Helsinki, 1949).

Gotthard Johansson, *Helene Schjerfbecks konst* (Stockholm, 1940).

Helene Schjerfbeck, (Lübeck (ex. cat.), 1969).

Louis Sparre

Paivi Huuhtanen, "Louis Sparren suomalaisromanttiset maalaukset vv. 1889–1895", unpublished university study (Helsinki University, 1970).

Eva Mannerheim-Sparre, *Konstnärsliv Sparre-Minnen* (Helsinki, 1951). (Finnish: *Taiteilijaelämää*).

Also Bibliography refs: 14, 35, 42, 47, 48.

Ellen Thesleff

L. Bäcksbacka, *Ellen Thesleff* (Helsinki, 1955).

Ellen Thesleff, (Helsinki (ex. cat.) 1969).

ICELAND

50) Bjørn Th. Bjørnsson, *íslenzk myndlist á 19. og 20. Öld* (Reykjavik: Helgafell, 1964).

51) Knut Gjerset, *History of Iceland* (New York: The Macmillan Co., 1924).

52) Georg Gretor, *Islands Kultur und seine junge Malerei* (Jena: Eugen Diederichs, 1928).

53) *íslenzk myndlist*, ed. Kristján Fridriksson (Reykjavik, 1943).

54) Oslo, Kunstnernes Hus, *Den offisielle islandske Kunstutstilling* (1951).

55) Richard F. Tomasson, *Iceland – The First New Society* (Minneapolis: University of Minnesota Press, 1980).

56) Waterville, Colby College Art Museum, *Icelandic Art*, by Selma Jónsdóttir (1965).

Ásgrímur Jónsson

Ásgrímur Jónsson, text by Tómas Gudmundsson, Second edition, with new pictures (Reykjavik, 1962).

Ásgrímur Jónsson, text by Gunnlaugur Scheving (Reykjavik, 1949).

Ásgrímur Jónsson, Myndir og minningar, text by Tómas Gudmundsson (Reykjavik, 1956).

Ásgrímur og Thjodsögurnar, text by Einar Ólafur Sveinsson (Reykjavik, 1959).
Also Bibliography refs: 50, 53.

Thórarinn B. Thorláksson
Selma Jónsdóttir, *Oplysningsforbundenes kunsttillaeg* (Copenhagen, 1973).
Valtýr Pétursson, *Thórarinn B. Thorláksson* (Reykjavik, 1982).
Reykjavik, National Gallery of Iceland, *Thórarinn B. Thorláksson,* by Selma Jónsdóttir (1967).
Also Bibliography refs: 50, 53, 56.

NORWAY
57) Henning Alsvik, Leif Østby, and Reidar Revold, *Norges billedkunst i det nittende og tyvende århundrede,* 2 volumes (Oslo: Gyldendal, 1951–1953).
58) Jan Askeland, *Norsk Malerkunst.* (Oslo: Cappelen, 1981).
59) Jan Askeland, *Norwegian Painting: A Survey* (Oslo: Tanum, 1971).
60) Andreas Aubert, *Die Norwegische Malerei im XIX Jahrhundert* (Leipzig: Klinkhardt and Biermann, 1910).
61) _____, *Norsk kultur og norsk Kunst,* (Christiania, 1917).
62) Harald Beyer, *Nietzche og Norden* (Universitetet i Bergen, årsbok, 1958), Historisk-antikvarisk rekke.
63) Andreas Elviken, "Genesis of Norwegian Nationalism", *Journal of Modern History,* vol. 3, no. 3 (1931), pp. 365–391.
64) Oscar Falnes, *National Romanticism in Norway* (New York, 1933).
65) Eduard Gudenrath, *Norwegische Maler von J.C. Dahl bis E. Munch* (Berlin, 1943).
66) Anne M. Hasund Langballe, *Bibliography of Norwegian Art History* (Oslo: Universitetsforlag, 1976).
67) Marit Ingeborg Lange, "Fra den Hellige Lund til Fleskum, Kitty L. Kielland og den nordiske sommernatt", *Kunst og Kultur* 60, h. 2 (1977).
68) Sima Lieberman, *The Industrialization of Norway 1800–1920* (Oslo: Universitetsforlag, 1970).
69) Madison, Elvehjem Museum of Art, *The Art of Norway 1750–1914* (1978).
70) Newcastle-Upon-Tyne, Laing Gallery, *Norwegian Romantic Landscape 1820–1920,* by John Boulton Smith, (1976).
71) *Norges Kunsthistorie,* (Oslo: Gyldendal Norsk Forlag, 1981–1982) Vols. 1–7.
72) *Norsk Kunstnerleksikon,* 1–4. (Oslo, 1982–6).
73) Leif Østby, *Fra Naturalisme til Nyromantikk: 1888–1895* (Oslo: Gyldendal Norsk Forlag, 1934).

74) John Boulton Smith, "Romantic Landscape Painters of Norway 1814–1914", *Apollo,* no. 104 (August 1976), pp. 114–119.
75) Håkon Stenstadvold, *Norske malerier gjennom hundre år* (Oslo: Dreyers Forlag, 1943).
76) Jens Thiis, *Norske Malere og billedhuggere* (Bergen, 1907).
77) A. Wickstrøm, *Kvinner ved staffeliet,* (Oslo, 1983).
78) Sigurd Willoch, *Kunstforeningen i Oslo, 1836–1936* (Oslo: Blix Forlag, 1936).

Harriet Backer
R. Bowman, "The Art of Harriet Backer", *Scanorama* (Oct.–Nov., 1978).
Kristian Haug, "Norway's Great Woman Artist", *American Scandinavian Review* (1925), pp. 735–740.
Else Christie Kielland, *Harriet Backer 1845–1932* (Oslo, 1958).
Erling Lone, *Harriet Backer* (Oslo, 1924).
Oslo, Nasjonalgalleriet. *Katalog over norsk malerkunst* (Oslo, 1968), no. 68–92, pp. 20–26.
Norske Mesterverke i Nasjonalgalleriet (Oslo, 1981), pp. 59–62.
Also Bibliography refs: 71, 77.

Halfdan Egedius
W. Halfvorsen, *Halfdan Egedius* (Christiania, Copenhagen, 1914).
Kitty Kielland, "Halfdan Egedius", *Samtiden* 10 (1899).
Øistein Parmann, *Halfdan Egedius. Liv og verk.* (Oslo: Dreyer, 1979).
Halfdan Egedius, Liv og Verk (Oslo, 1979).
Einar Østvedt, "Egedius og Stadskleiv. Vennskap og Telemarks-kunst", *Kunst og Kultur* 23 (1937).
_____, "Halfdan Egedius. Et vennskap og en korrespondanse", *På gamle stier* (Oslo, 1944).
Also Bibliography refs: 13, 14, 69, 71.

August Eiebakke
August Eiebakke to Andreas Aubert, May 17, 1891, University Library, Oslo.
Julius Lange. "Norsk, Svensk, Dansk Figurmaleri, Indtryk og Overvejelser", *Tilskueren: maanedsskrift for literatur* (1892).
Oslo, Kunstforening, *August Eiebakke,* by Kristian Haug (1939).
Also Bibliography refs: 14, 74, 75.

Karl Gustav Jensen-Hjell
Simon Thorbjørnsen, "Glemte Kunstnere", *Kunst og Kultur* (1933).
Also Bibliography refs: 57, 67, 75.

Kitty Kielland
Gabriel Schanche Hidle, *Profiler og paletter i Rogalands kunst* (Stavanger, 1965).
Stavanger, Stavanger kunstforening, *Kitty L. Kielland. Minneutstilling* (1976).
Also Bibliography refs: 57, 67, 69, 75, 77.

Christian Krohg
Pola Gauguin, *Christian Krohg* (Oslo, Gyldendal, 1932).
Christian Krohg, *Kampen for Tilvarelsen* (Oslo-Gyldendalske Boghandel Nordisk Forlag, 1920).
Oslo, Nasjonalgalleriet, *Christian Krohg 1852–1925: Norske Mesterverker i Nasjonalgalleriet*, by Oscar Thue (1981).
Leif Østby, *Norges billedkunst i det nittende og tyvende århundre*, Vol. I (Oslo: Gyldendal Norsk Forlag, 1951).
Oscar Thue, *Christian Krohg* (Oslo: Gyldendal Norsk Forlag, 1962).
————, "Christian Krohg-studier", *Kunst og Kultur*, LXIII (1965), pp. 193–197.
Kirk Varnedoe, "Christian Krohg and Edvard Munch", *Arts* 53 (April 1979), pp. 88–99.
Also Bibliography refs: 11, 26, 28, 31, 73, 10.

Edvard Munch
Henning Bock and Günter Busch, ed. *Edvard Munch. Probleme- Forschungen- Thesen.* (Munich: Prestel, 1973).
Ray Asbjørn Boe, "Edvard Munch: His Life and Work from 1880–1920" (Ph.D. diss., New York University Institute of Fine Arts, 1970).
Das Werk des Edvard Munch (Berlin: Fischer, 1894). Essays by Stanislaw Przybyszewski, Willi Pastor, Franz Servaes, and Julius Meier-Graefe.
Henri Dorra, "Munch, Gauguin, and Norwegian Painters in Paris", *Gazette des Beaux-Arts* (November 1976).
Arne Eggum, *Edvard Munch. Malerier, skisser og studier.* (Oslo, 1983. English version, 1983. Swedish version, Stockholm, 1985).
Reinhold Heller, *Edvard Munch, His Life and Work.* (Chicago: University of Chicago Press, 1984).
————, "*Edvard Munch's Night*, the Aesthetics of Decadence, and the Content of Biography", *Arts*. Vol. 53, No. 2 (October 1978).
————, *Edvard Munch: The Scream* (London: Penguin Books, 1973).
————, "The Iconography of Edvard Munch's *Sphinx*", *Artforum*, Vol. 9, No. 2 (October 1970).
Houston, Sarah Campbell Blaffer Gallery, *Edvard Munch*, by Peter W. Guenther (1976).
Wladyslawa Jaworska, "Edvard Munch and Stanislaw Przybyszewski", *Apollo* 100, No. 152 (October 1974).
Johan Henrik Langaard and Reidar Revold, *Edvard Munch: Fra År til År, A Year by Year Record of Edvard Munch's Life* (Oslo: Aschehoug and Co., 1961).
Carla Lathe, "The Group 'Zum Schwarzen Ferkel', A Study in Early Modernism" (Ph.D. diss., University of East Anglia, 1972).
Gustav Schiefler, *Edvard Munchs Graphische Kunst* (Dresden, 1923).
Ragna Stang, *Edvard Munch, The Man and his Work*, trans. Geoffrey Culverwell (New York: Abbeville Press, 1979).
Gösta Svenæus, *Edvard Munch. Das Universum der Melancholie* (Lund, 1968).
Gösta Svenæus, *Edvard Munch. In männlichen Gehirn* (Lund, 1973).
Washington, National Gallery of Art, *Edvard Munch, Symbols and Images* (1978).
Zurich, Kunsthaus, *Munch und Ibsen*, by Pål Hougen, (1976).
Also Bibliography refs: 9, 10, 12, 13.

Gerhard Munthe
Hilmar Bakken, *Gerhard Munthes Dekorative Kunst.* (Oslo, 1946).
Gerhard Munthe, *Minder og Meninger fra 1850-aarene til nu.* (Christiania, 1919).

Ejnar Nielsen
Bibliography refs: 2, 13.

Eilif Peterssen
Kristian Haug, "The Art of Eilif Peterssen", *The American-Scandinavian Review* XIII, no. 9 (September 1925), pp. 524–531.
Håkon Stenstadvold, *Idekamp og stilskifte i norsk malerkunst 1900–1919* (Oslo: F. Bruns Bokhandels Forlag, 1946).
Also Bibliography refs: 9, 10, 57, 67, 69, 76.

Christian Skredsvig
Harald Aars, "På Fleskum i Baerum 1886. Fra sommernatten til folkevisen.", *Kunst og Kultur* 28 (1942).
Francis Bull, "Christian Skredsvig og Fleskumkolonien", *Kunst og Kultur* 48 (1965), p. 91–102.
Torleiv Kronen, *Christian Skredsvig. Liv og diktung.* (Oslo, 1939).
Christian Skredsvig, *Dage og Naetter blandt Kunstnere.* (Christiania and Copenhagen: 1908; revised 1943).

Harald Sohlberg
Harald Aars, "Harald Sohlberg", *Kunst og Kultur,* IV (1913–1914), pp. 232–236.
Leif Østby, *Harald Sohlberg* (Oslo, 1936).
Arne Stenseng, *Harald Sohlberg. En kunstner utenfor allfarvei* (Oslo, 1963).
———, "Harald Sohlberg", *Norsk Biografisk Leksikon,* vol. XIV (1962), pp. 127–133.
Also Bibliography refs: 2, 9, 57, 60.

Nils Gustav Wentzel
Hakon Kongsrud, "Gustav Wentzel 1859–1937", *Årbok for Gudbrandsdalen* (October 1959).
Oscar Thue, "Gustav Wentzel, Dagen derpå 1883", *Trondhjems kunstforenings Årbok* (1962).
Kitty Wentzel, *Gustav Wentzel* (Oslo, 1956).
Sigurd Willoch, "Gustav Wentzel", *Kunst og Kultur* (Oslo, 1927).
Also Bibliography refs: 69, 75, 76.

Erik Werenskiold
Erik Werenskiold 1855–1938. (ex. cat. Modum: Modums Blaafarvevaerk, 1985).
Kunst og Kultur. Werenskiold Edition. Essays by H.E. Kinck, C.W. Schnitler, Henrik Sørensen, Walther Halvorsen, Jens Thiis (Christiania: 1915).
Leif Østby, *Erik Werenskiold, Kunst i Skolen.* (Oslo, 1956).
Leif Østby, *Erik Werenskiold. Tegninger og akvareller.* (Oslo, 1977).

SWEDEN
79) Sven Alfons, Bo Lindwall, and Ragnar Josephson, *Svensk konstkrönika under 100 år* (Stockholm: Natur och Kultur, 1944).
80) Ingvar Anderson, *A History of Sweden* (New York: Praeger, 1956).
81) The Brooklyn Museum, *The Swedish Art Exhibition,* by Christian Brinton (1916).
82) Donald R. Floyd, "Attitudes Toward Nature in Swedish Folklore" (PhD. diss., University of California, Berkeley, 1976).
83) Alrik Gustafson, *A History of Swedish Literature* (Minneapolis: University of Minnesota Press, 1961).
84) P. de Lespinase, *Art et Esthetique: La peinture suédoise contemporaine* (Paris: Alcan, 1928).
85) Oscar Levertin, *Svensk konst och svensk natur* (Stockholm: Albert Bonniers Forlag, 1918).
86) Brita Linde, *Ernest Thiel och hans konstgalleri* (Stockholm 1969).

87) London, Royal Academy of Art, *Exhibition of Works by Swedish Artists 1880–1900,* by Axel Gauffin (Stockholm: P.A. Norstedt 1924).
88) Viggio Loos, *Friluftsmåleriets genombrott i svensk konst 1860–1885.* (Stockholm: 1945).
89) Claes Moser, et. al. *Swedish Realism and Symbolism.* (ex. cat., Stockholm: 1983).
90) New York, Shepherd Gallery. *The Swedish Vision, Landscape and Figurative Painting 1885–1920.* (ex. cat. 1985).
91) Georg Nordensvan, *Svensk Konst och Svenska Konstnärer i nittonde Århundradet.* volume 2: Från Karl XV till Sekelslutet (Stockholm: Albert Bonniers Förlag, 1928).
92) G. Pareli, *La Peinture decorative en Suéde de la fin du 19e siècle* (Stockholm: Bonnier Förlag, 1933).
93) Sven Sandström, *Konsten i Sverige: Det sena 1800-talets bildkonst och miljökonst* (Stockholm: Almqvist & Wiksell Förlag, 1975).
94) Larry Emil Scott, "Pre-Raphaelitism and the Swedish 1890s" (Ph.D. diss., University of Washington, 1973).
95) Herbert Sjöberg, *Konstnärskolonin vid Racken.* (Arvika: NWTs Förlag, 1976).
96) Stockholm and Gothenburg, *Från Seinens strand: Illustrerad Katalog* (Stockholm: Looström, 1885).
97) Stockholm, National Museum, *Konstnärsförbundet 1891–1920,* by Sixten Strömbom and Bo Wennberg (1948).
98) ———, *Opponenterna av 1885,* by Sixten Strömbom (1945).
99) ———, *Svenskt Måleri from realism till expressionism* (Nationalmusei Utställningskataloger 84, 1942).
100) Sixten Strömbom, *Nationalromantik och radikalism: Konstnärsförbundets historia 1891–1920* (Stockholm: Albert Bonniers Förlag, 1965).
101) Erik Wettergren, *The Modern Decorative Arts of Sweden,* trans. T. Palm (Malmö, 1926).
102) Nils G. Wollin, *Modern Swedish Arts and Crafts* (New York, 1931).

Björn Ahlgrensson
Arvika Konstförening, *Björn Ahlgrensson* (1979).
Also Bibliography ref: 93.

Richard Bergh
Richard Bergh, *Efterlämnade skrifter om konst och annat,* (Stockholm, 1921).
———, "En intervju med mig själf", *Ord och Bild* 3 (1894), p. 280–281.
Axel Gauffin, "Till minnet av Richard Bergh", *Studiekamraten* (1959), p. 12–23.

Tor Hedberg, *Richard Bergh. En studie* (Stockholm, 1903).

Gunhild Osterman, *Richard Bergh och Nationalmuseum. Några dokument.* (Lund, 1958).

Birgitta Rapp, *Richard Bergh konstnär och kulturpolitiker 1890–1915* (Stockholm: Rabén och Sjögren, 1978). Includes English summary.

Stockholm, National Museum, "Richard Bergh 1858–1919. Minnesutställning i Akademin för de fria konsterna", by Axel Gauffin, 1949.

Erik Wettergren, "Richard Berghs konst", *Nationalmusei Årsbok* 1 (Stockholm, 1919), pp. 25–42.

Prins Eugen

Prins Eugen, *Breven berätta (1886–1913),* (Stockholm: P.A. Norstedt, 1942).

Axel Gauffin, *Konstnären Prins Eugen* (Stockholm: P.A. Norstedt, 1915; 2nd ed. 1947).

————, "The Landscape Paintings of Prince Eugen of Sweden", *The International Sudio* 45 (January 1912), pp. 173–185.

Tor Hedberg, "Prins Eugen", *Kunst og Kultur* 14 (1927), pp. 1–12.

Gotthard Johansson, "Prins Eugen som Stockholmsskildrare", *Samfundet Sankt Eriks Årsbok* (1947), p. 9–20.

Gustaf Lindgren, ed., *En bok om Prins Eugen* (Uppsala: J.A. Lindblad, 1948).

————, *Prince Eugen's Waldemarsudde. A Guide* (Stockholm, 1949).

————, *Waldemarsuddes konstsamling, konstverk förvärvade under åren 1889–1939* (Stockholm: P.A. Norstedt, 1939).

E.L. Nyblom, "Prince and Painter: Prince Eugen of Sweden", *The Studio* 91 (1926), pp. 36–37.

Georg Pauli, *Eugen: Målningar, Akvareller, Teckningar* (Stockholm: A. Bonnier, 1925).

Gunnar M. Silfverstolpe, *Prins Eugens konst* (Stockholm: Nordisk Rotogravyr, 1935).

Gustaf Fjaestad

Agneta Fjaestad, *Gustav och Maja Fjaestad – ett konstnärpar* (Karlstad, 1981).

Also bibliography refs: 14, 90.

Eugène Jansson

K. Fåhraeus, "Eugène Jansson", *Ord och Bild* (1915), pp. 467–480.

Tor Hedberg. *Tre Svenska målargenier: Eugène Jansson, Herman Norrman. Sager-Nelson* (Stockholm: Albert Bonniers Förlag, 1923).

Carl G. Laurin, *Stockholm through Artists Eyes*, 2nd ed. (Stockholm: P.A. Norstedt & Söners Förlag, 1930).

Claes Moser, *Eugène Jansson. The Bath-house Period.* (ex. cat., Julian Hartnoll Gallery, London: 1983).

Nils G. Wollin, *Eugène Janssons måleri* (Stockholm: P.A. Norstedt & Söner, 1920).

Also Bibliography refs: 14, 100, 90.

Ernst Josephson

Erik Blomberg, *Ernst Josephsons konst.* (Stockholm: Kungl. Boktryckeriet P.A. Norstedt & Söner, 1956).

Ingrit Jacobsson, *Näckenmotivet hos Ernst Josephson. Ett tema med variationer* (Gothenburg: Elanders Boktryckeri Aktiebolag, 1946).

Ernst Josephson, *Svarta rosor och gula* (Stockholm: C & E. Gernandts Förlags Aktiebolag, 1901).

Portland Art Association. *Drawings and Paintings by Ernst Josephson.* catalogue essay by Erik Blomberg (1964).

Karl Wåhlin, *Ernst Josephson 1851–1906. En minnesteckning.* (Stockholm: Kungl. Hofboktryckeriet, 1911).

Carl Larsson

Sven Alfons, *Carl Larsson, Skildrad av honom själv.* (Stockholm, 1952).

Sarah Faunce, et. al. *Carl Larsson.* (ex. cat. The Brooklyn Museum, New York: Holt, Rinehart and Winston, 1982).

Georg Nordensvan, *Carl Larsson 1–2.* (Stockholm, 1920–1).

Bruno Liljefors

Allan Ellenius, *Bruno Liljefors* (Uppsala: Bokförlaget Carmina, 1981).

Tor Hedberg, *Bruno Liljefors, en studie* (Stockholm: Aktie bolaget, 1902).

————, "Bruno Liljefors, a Swedish Painter of Animals", *The International Studio* 42 (1910), pp. 119–128.

Martha Hill, "Liljefors of Sweden, The Peerless Eye", *Audubon* 80, No. 5 (September 1978).

Leningrad, Hermitage and Gothenburg, Konstmuseum, *Anders Zorn, Bruno Liljefors* (1967).

Bruno Liljefors, *Det vildas rike* (Stockholm: A Bonnier, 1934).

Bo Lindwall and Lindorm Liljefors, *Bruno Liljefors* (Stockholm: Rabén och Sjögren, 1960).

Ernst Malmberg, *Larsson, Liljefors, Zorn: En Återblick* (Stockholm: P.A. Norstedt, 1919).

K.A. Russow, *Bruno Liljefors, an appreciation*, trans. A. Poignant (Stockholm: C.E. Fritze, 1929).

Karl Nordström
Tor Hedberg, *Karl Nordström, en studie* (Stockholm, 1905).
Torsten Svedfelt, *Karl Nordströms konst* (Stockholm, 1939).
Also bibliography refs: 9, 10, 79, 84, 87, 90.

August Strindberg
Reidar Dittmann, *Eros and Psyche: Strindberg and Munch in the 1890s* (Ann Arbor: University Microfilms Press, 1982).
Torsten Matte Schmidt, ed. *Strindbergs maleri.* (Malmö, 1972).
Göran Soderström, *Strindberg och bildkonsten.* (Stockholm, 1972).

Carl Wilhelmson
Gothenburg, Konstmuseum, *Carl Wilhelmson västkustmålaren*, catalogue essay by Eric Jonsson (1974).
Axel L. Rondahl, *Carl Wilhelmson.* (Stockholm: Kungl. Boktryckeriet P.A. Norstedt & Söner, 1938).

Anders Zorn
Karl Asplund, *Anders Zorn, His Life and Work* (London: "The Studio", Ltd., 1921).

Gerda Boëthius, *Anders Zorn, An International Swedish Artist. His Life and Work* (Stockholm: Nordisk Rotogravyr, 1954).
_____, *Zorn: Swedish Painter and World Traveller*, trans. Albert Read (Stockholm: Rabén and Sjögren, 1961).
_____, *Zorn: Tecknaren, målaren, etsaren, skulptören* (Stockholm: Nordisk Rotogravyr, 1949).
Loys Delteil, *Anders Zorn*, Le Peintre-Graveur Illustré, vol. 4 (Paris: Chez l'Auteur, 1909).
Erik Forssman, *Tecknaren Anders Zorn* (Stockholm: Natur och Kultur, 1959).
_____, *Zorn i Mora* (Stockholm: Alberg Bonniers Förlag, 1960).
Freiburg, Städtische Museen, *Anders Zorn 1860–1920*, by Erik Forssman (1976).
Lawrence, Spencer Museum of Art, The University of Kansas, *The Prints of Anders Zorn*, by Elizabeth Broun (1979).
Paris, Galeries Durand-Ruel, *Exposition Anders Zorn*, (1906).
Stockholm, National Museum, *Anders Zorn: Akvareller och teckningar från Zorns samlingar*, by Gerda Boëthius, (1939).
_____, *Anders Zorn, 1860 Minneutställning 1960*, by Bo Wennberg (1960).

ADDENDUM
While the present book has been in preparation, the following exhibition catalogues, with essays by diverse Scandinavian authors and other European colleagues, have made important contributions to the literature on later nineteenth and early twentieth century Scandinavian painting:

Oslo, Nasjonalgalleriet. *1880-årene in Nordisk Maleri.* August–October, 1985. Exhibition subsequently at Stockholm, Nationalmuseum; Helsinki, Amos Anderssons Konstmuseum; and Copenhagen, Statens Museum for Kunst. Essays by K. Berg, S. Ringbom, B. Lindwall, O. Thue, H. Westergaard.

London, Hayward Gallery (Arts Council of Great Britain). *Dreams of a Summer Night.* July–October, 1986. Essays by J. House, K. Berg, S. Sarajas-Korte, M. Klinge, G. Broberg

Dusseldorf, Kunstmuseum. *Im Lichte des Nordens.* October, 1986 – February, 1987. Essays by U. Schneede, K. Berg, S. Sarajas-Korte, M. Klinge, G. Broberg

Paris, Musée du Petit Palais. *Lumières du Nord.* February–May, 1987. Essays by T. Burrolet, K. Berg, S. Sarajas-Korte, M. Klinge, G. Broberg

Oslo, Nasjonalgalleriet. *Christian Krohg.* March–May 1987. Essays by K. Berg, O. Thue, J.P. Munk, M. Malmanger, G. Johannesen